TOUCHED BY FIRE

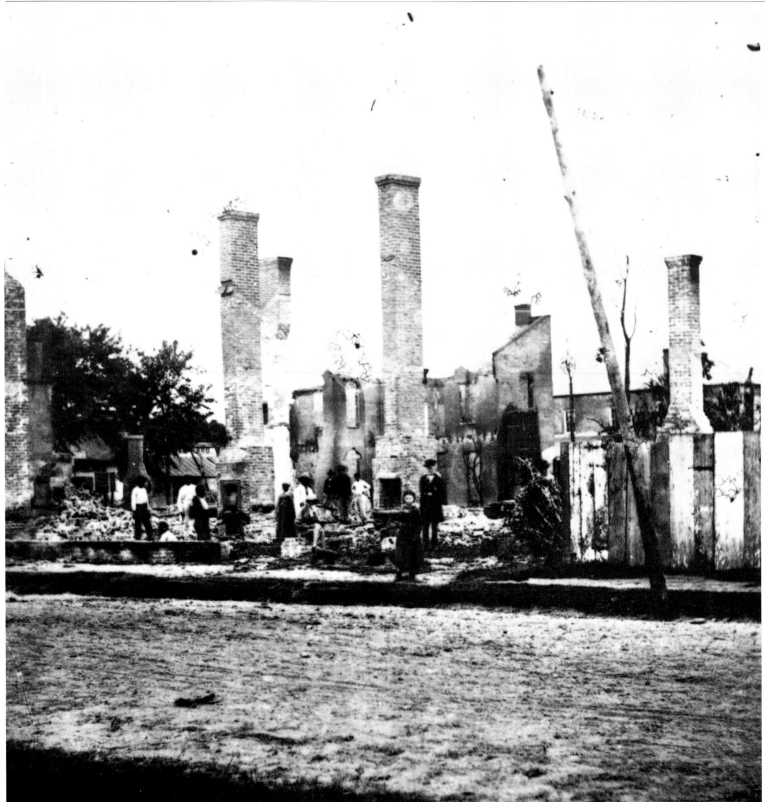

TOUCHED BY FIRE

A National Historical Society
Photographic Portrait of the Civil War,
in Association with CIVIL WAR TIMES

VOLUME ONE

★

William C. Davis EDITOR

William A. Frassanito PHOTOGRAPHIC CONSULTANT

BARNES
&NOBLE
BOOKS
NEW YORK

Designed by Patricia Girvin Dunbar
Jacket design by Christina Bliss

ISBN 0-7607-4832-2

03 04 05 M 9 8 7 6 5 4 3 2 1

Printed in Singapore

Contents

TOUCHED BY FIRE

Introduction to Volume One

William C. Davis

"THE MEMORIES of our great war come down to us and will pass on to future generations with more accuracy and more truth-telling illustration than that of any previous struggle," Capt. A. J. Russell declared in 1882, and for that "the world is indebted to the photographic art and a few enterprising and earnest men." And so, indeed, the world is still indebted. No human epic prior to our own century is so richly preserved for us, in all the grandeur and honesty of the camera's eye, as the American Civil War.

More to the point, it is an epic of which we never tire, and never shall, and this, too, we owe largely to the visual legacy left for us by those who photographed the war. It is something that we can actually *see*, not in stilted and idealized prints and paintings, but in images that show the real faces and places, as they really looked, and often with the romantic veneer stripped away. Perhaps that is the hold that the faded old plates have for us; they reveal that only the trappings of warfare differed from then to now. The underlying drama and pain are the same, then and now, as in all conflicts, of all times.

It is the face of that war that this volume, and the one to follow, seek to portray. The photographers of the Civil War — chroniclers like Alexander Gardner, Timothy O'Sullivan, Jay D. Edwards, Russell, Mathew Brady's numerous assistants, and scores of others — were more than far-seeing when they covered the conflict. They were prolific. The fifteen hundred or more photographers who plied their craft from 1861 to 1865 probably produced in excess of one million images, the overwhelming majority of them portraits of individual soldiers. More amazing than their quantity is the number that survive today: at least several hundreds of thousands. And despite all the images that are well known and often seen, more continue to come to light for the first time, found in dusty attics, old albums, flea-market bazaars, or forgotten shelves in some library or archive. Even after more than a century, they still reemerge, like the phoenix, from the ashes of that war.

They allow us today to look at the Civil War in a way previously not possible — to see more of it than ever before, and in greater perspective. There are many histories of the conflict — too many, some would argue — and there are several good

photographic works on it as well. It would be pointless to attempt to offer here simply more of the same. Rather, these two volumes approach the epic not chronologically, and not even in especially great depth of detail. That is all available elsewhere.

What they do seek to present is a flying overview of the war and its people from points of view rarely offered to the general public. These volumes will make no one an expert on campaigns and battles, leaders and strategy. But they will impart an understanding of some broader issues — issues like the nature of Civil War leadership and command, the spirit and story of the Civil War regiment and the men and boys who filled it, the role of the oft-forgotten navies, and the virtually continental scope of the conflict and its impact on the land. Special portfolios in each volume offer an in-depth look at the work of individual photographers who deserve better renown, and at the faces of the men whose war it was the most: Johnny Reb and Billy Yank. The texts, written by our foremost scholars of the war, are aimed at informing as well as entertaining.

And then there are the photographs, roughly five hundred of them in each volume, more than half appearing in print for the first time. They are what captivate us the most, and they have been selected both to expand upon and illuminate the text, as well as to offer a complete picture of America at war in its own house.

There is a special story of discovery about these images, for many of them had been forgotten and almost unknown until a few years ago, and a host of others have only just been brought out of three-quarters of a century of obscurity. Starting in the 1880s, a Massachusetts branch of a veterans' organization, the Military Order of the Loyal Legion of the United States, began to amass a collection of war photographs that eventually numbered more than forty thousand — the largest such collection in existence. But by the middle of this century, with all its original members gone, funds dwindling, and interest seeming to wane, the collection and the private museum housing it fell into neglect. Vandals broke in and stole some of the more than 120 bound volumes of images; dust and age began to take their toll on others. By the 1970s, the virtually forgotten collection

seemingly had no future. But then it was, happily, turned over to the U.S. Army Military History Institute at Carlisle Barracks, Pennsylvania, and the work of preserving the treasure that remained began. And also, after years of being virtually "lost" to view, the images once again became available: scores — hundreds — of them are unique and available nowhere else. The great bulk of the photographs in these two volumes come to us from this milestone collection.

An even greater tale of discovery, of lost-and-found, lies behind several score of other images here presented. The first attempt at a comprehensive history of this kind appeared in 1911 when Francis T. Miller and the Review of Reviews Company published the ten-volume *Photographic History of the Civil War*. It was a monumental work — seriously flawed, to be sure, with inaccuracies and misidentified images, and a lot of the war's mythology still accepted as fact. But it has remained the benchmark against which all other photo histories are measured. Miller's researchers covered the nation looking for images, collecting thirty-five hundred that were published and probably two thousand more that never appeared. Many of those originals subsequently disappeared and, often being one-of-a-kind negatives, they have not since been available for viewing or publication except as mediocre reproductions made from Miller's 1911 edition.

But they were not lost — only in hiding. Miller failed to return some to their original owners; others he had purchased. And when he ran out of financing for the project and sold out to the Review of Reviews Company, the images became that firm's property. After the company went out of business, the two thousand or more remaining images stayed in the hands of the *Review*'s publisher, Albert Shaw, and spent the next several decades in a barn in New York and following Shaw's family through several moves. Finally they came to light again in 1982, and now, after seventy years in the dark, they can be seen again.

It is a magnificent collection. First, there are hundreds of images that, though collected, were never published by Miller. Better yet, there are several hundred more negatives made in 1911 of photos that Miller had borrowed, then returned. In all too many cases, those originals now cannot be found. But here

we have perfect negatives made from them, negatives that allow a quality of reproduction far superior to the only other means of publishing them until now (copying from Miller's books). And the greatest treasure of all is surely the set of over sixty original glass-plate negatives made between 1862 and 1864 by the Baton Rouge photographer A. D. Lytle. Miller's agents bought these outright. So impressive are these photographs for their clarity and quality that a special chapter of this volume is devoted to Lytle and his work, with the images here reproduced taken directly from his original negatives. Happily, this whole collection of Shaw's, too, is now housed at the U.S. Army Military History Institute, resurrected from the dust.

There will be even more to see in the volume yet to come. The two presidents and the governments they led in trying to win the war, the role of industry in victory and defeat, and the part played by women and a surprising variety of ethnic groups await us. Forts, artillery, logistics, men of war, and a host of other broad subjects will appear, along with the portfolio depicting the face of Billy Yank, and a look at how the war has lasted through posterity. And all of it illustrated in the words of today, and the images of yesteryear.

It seems unlikely that we shall ever weary of looking backward through time to the people and events of those days long ago. The Civil War is too much a central part of our national consciousness. That we can still take the backward look is due in large part to the legion of intrepid men—and at least a couple of women—who waged their war with their cameras. Their work did not die with them. It goes on, as it does in these volumes, and it will continue so long as there are still forgotten attics to yield up fading treasures, so long as the world still holds people who yearn to look back to a time that is timeless.

Around the War

A portfolio of the America that
for four years went a little mad
and went to war with itself

It had been a quiet, peaceful land, untouched by war for nearly half a century, a land where a man could spend an afternoon quietly rowing or fishing in Virginia's James River. (USAMHI)

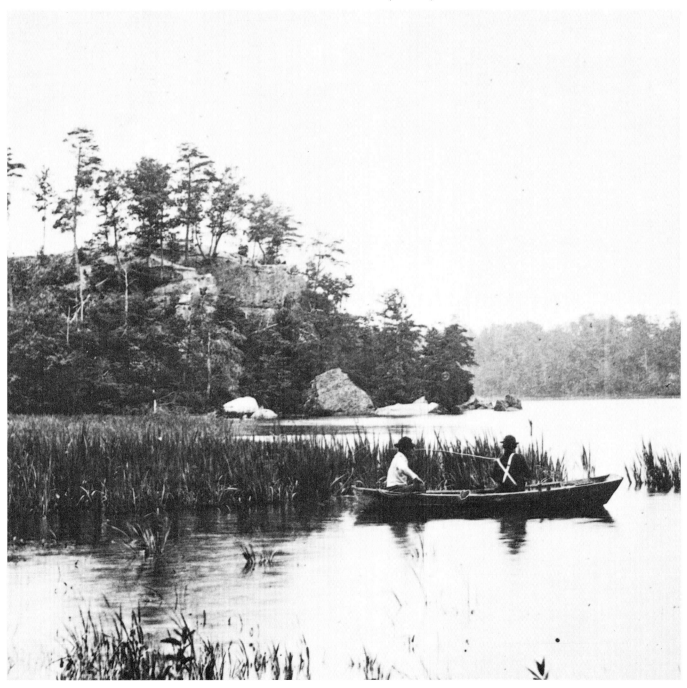

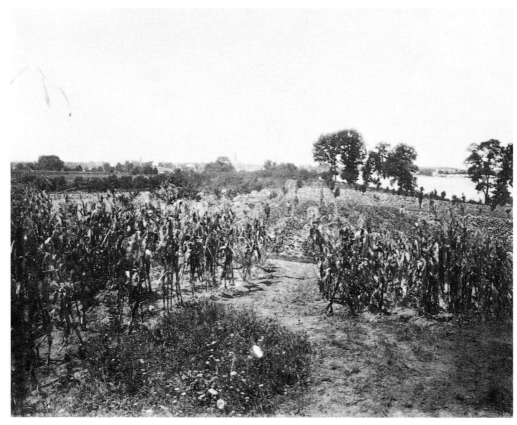

Still it was largely rural. Even near to state capitals like Annapolis, Maryland, with its nearby Naval Academy, there were fields of grain that fed its people. (USAMHI)

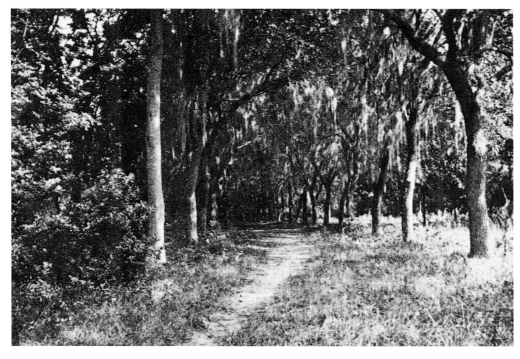

The moss-laden live oaks of Port Royal Island, South Carolina, spoke of a tranquil way of life that seemed destined to last forever. (USAMHI)

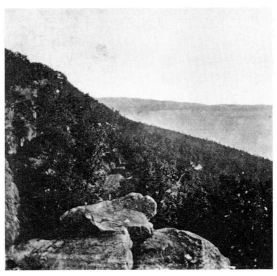

Natural wonders filled the landscape. From Umbrella Rock on Lookout Mountain, near Chattanooga, the daring viewer could see as far as he could imagine. (USAMHI)

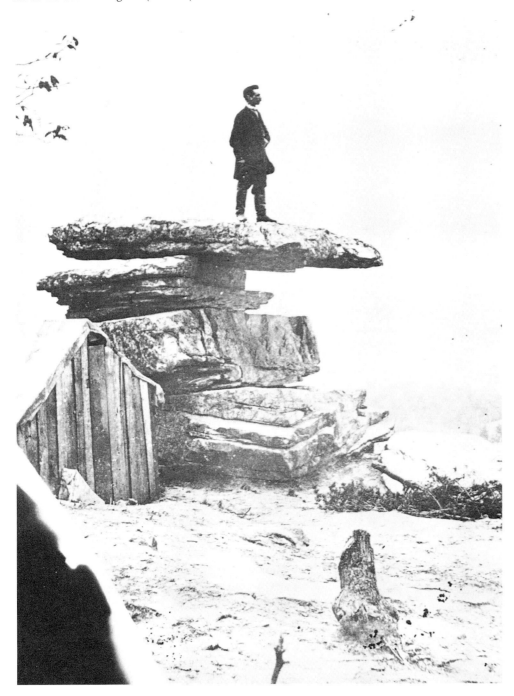

The rugged slopes of Lookout Mountain had retained their unspoiled beauty for untold centuries. (USAMHI)

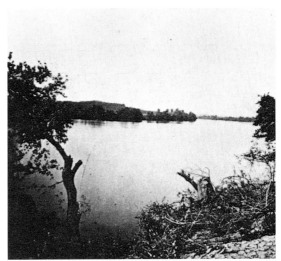

The Tennessee River flowing beneath it could just as easily have been any of a hundred peaceful streams that watered the land. (USAMHI)

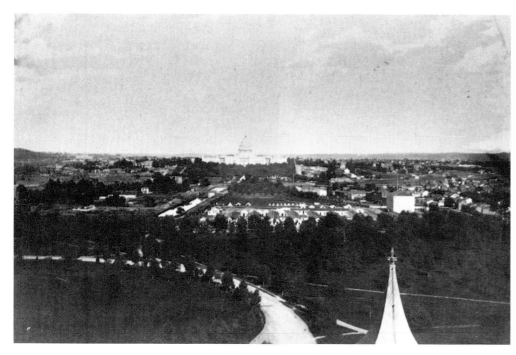

Of cities there were plenty, many of them larger than the nation's capital at Washington, D.C. It was still in many ways a country city, its major industry government. (UR)

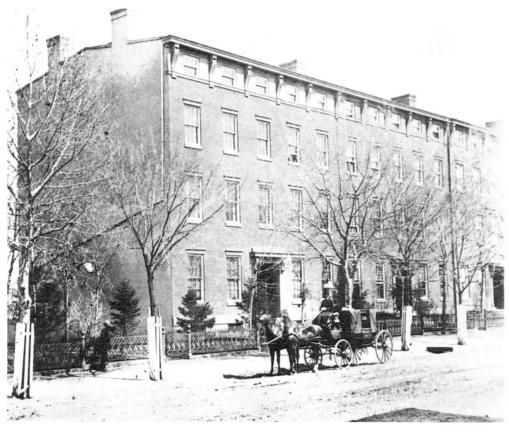

Only in recent decades had fine houses like those found in Boston and New York begun to appear on the capital's streets and avenues. Here on I Street, the homes of Sen. Stephen A. Douglas of Illinois and Vice-President John C. Breckinridge of Kentucky were just being completed in 1860, as the two vied with each other for the presidential nomination. (USAMHI)

Nearby Georgetown was hardly more than a
port city on the C&O Canal . . . (USAMHI)

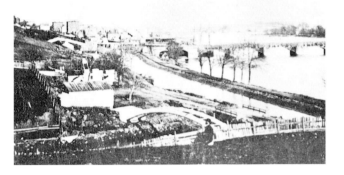

. . . while across the Potomac lay
Alexandria, Virginia. (USAMHI)

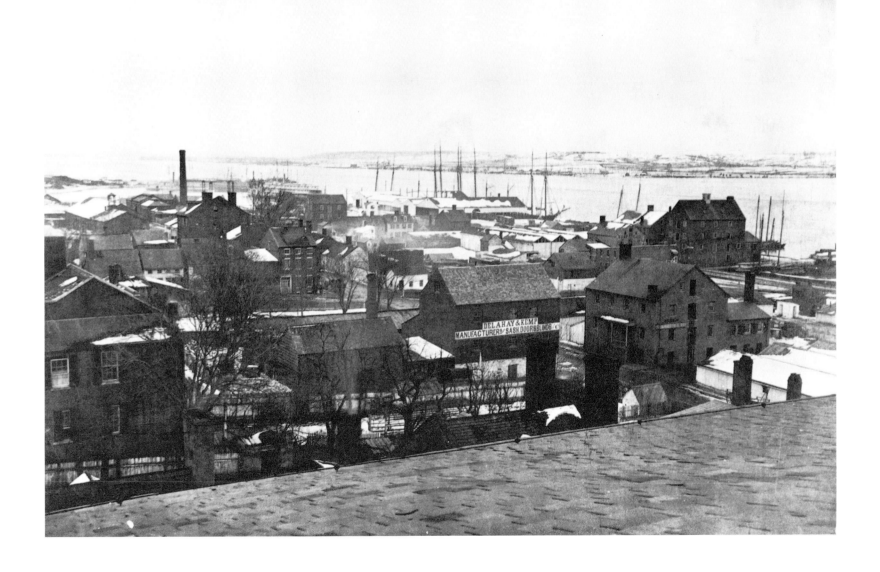

Farther south sat Richmond, an old and stylish city, dominated by the Grecian capitol building. (USAMHI)

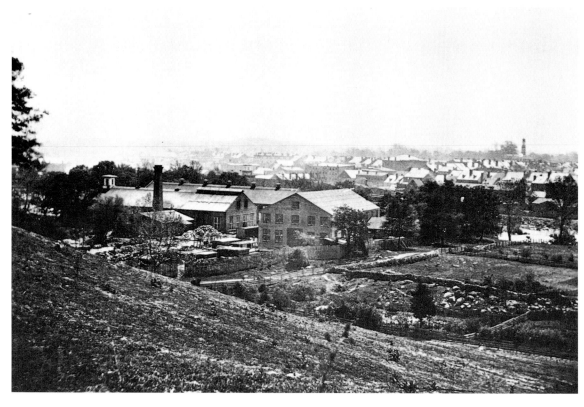

Just south of Richmond lay Petersburg, a major manufacturing and transportation center, one of the few in the otherwise industrially poor South. (USAMHI)

For the South was a land of small towns and quiet cities — places like Beaufort, North Carolina, where the width of the main street barely mattered: horse and carriage traffic hardly existed. (USAMHI)

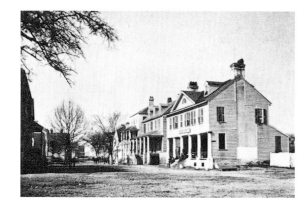

Government touched people very little here,
its main vestiges being a few public buildings
like the customs house in Beaufort. (USAMHI)

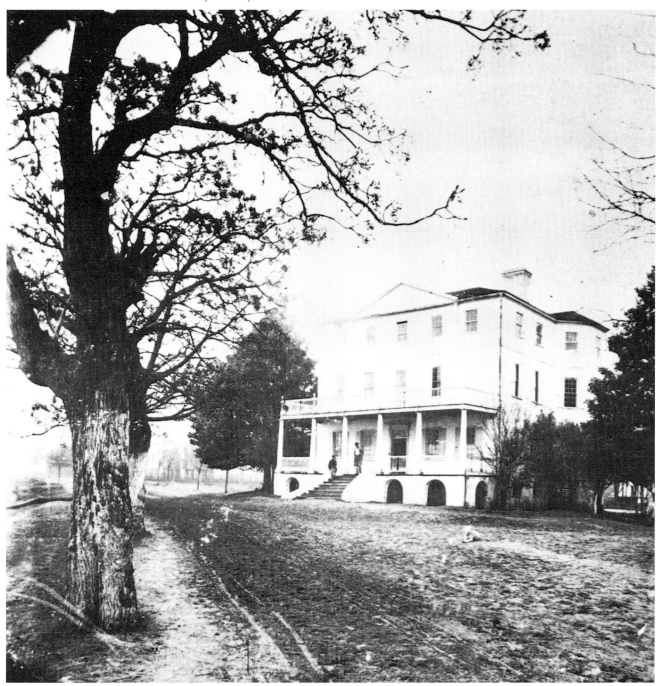

It was a land of riverside backyards . . .
(USAMHI)

. . . and peaceful public squares like the one
in New Bern, North Carolina. Not since the
last war with Britain, or perhaps the war
with Mexico, had local militia trooped in
these places for anything more than Sunday
show. (USAMHI)

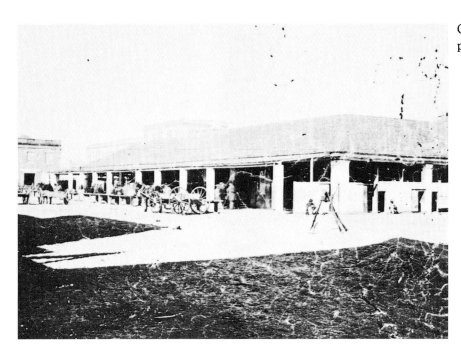

City markets like Savannah's bustled with produce and people. (USAMHI)

Saint Augustine, Florida, the oldest city on the continent, sat idly behind its seawall. (USAMHI)

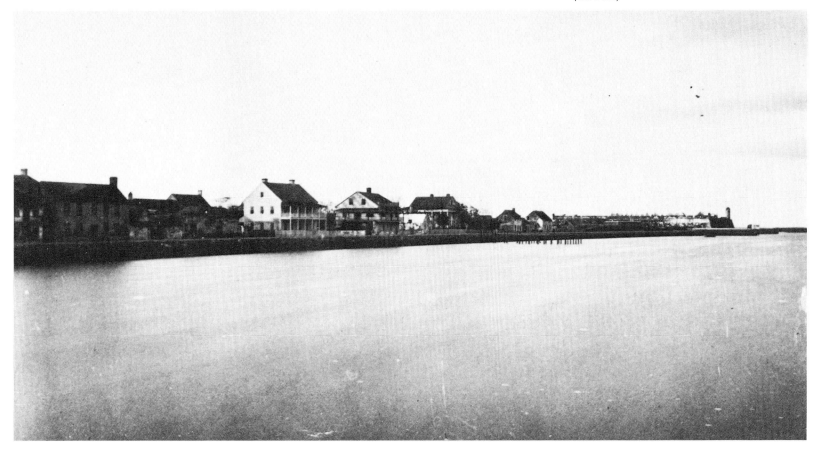

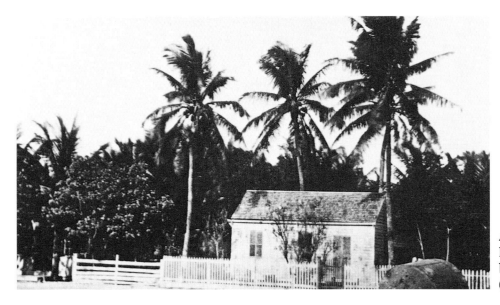

And subtropical Key West, though little known and seldom visited, was as lush and beautiful as any island paradise of any time. (USAMHI)

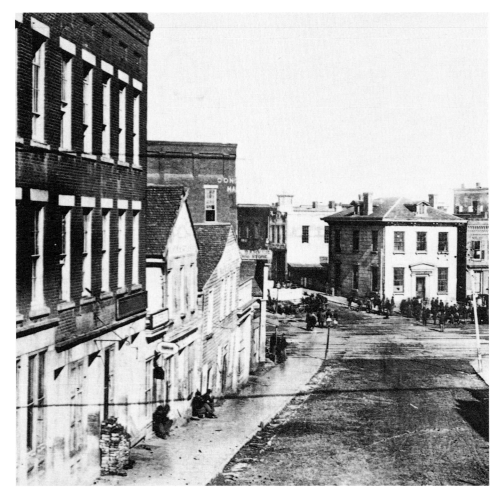

The cities of the Southern interior were by turns sluggish and teeming. Atlanta's streets were always busy thanks to its major railroad and trading connections. (USAMHI)

The hotels of the Mississippi River towns saw the comings and goings of tens of thousands who traveled and traded up and down the mighty stream. (USAMHI)

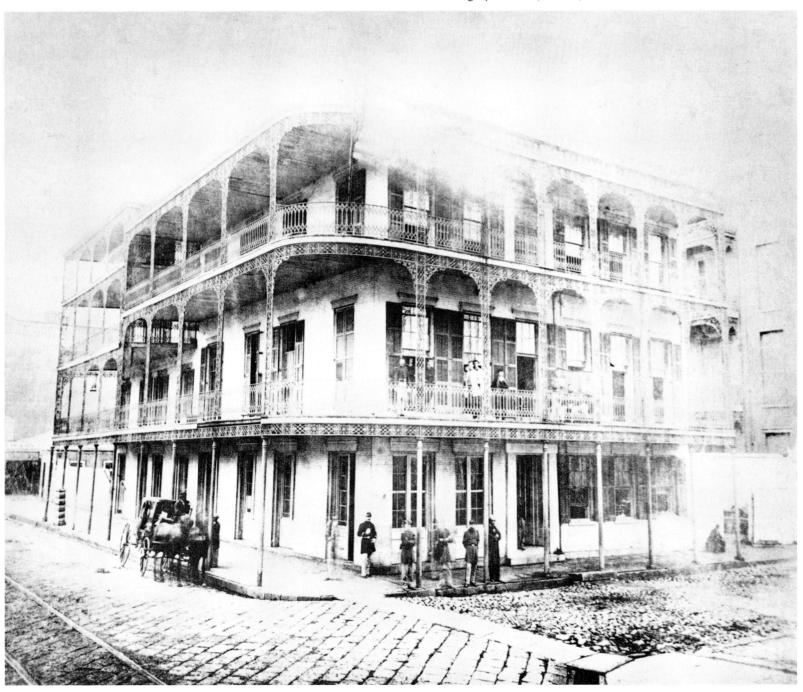

And New Orleans — dominated by Saint
Louis Cathedral, overlooking Jackson Square
— was the jewel of the river, and of Deep
South society. (USAMHI)

Rural though most of the South was,
industry was on its way. Railroad trestles
would bridge many of its streams. (USAMHI)

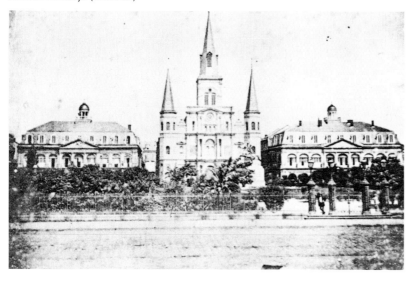

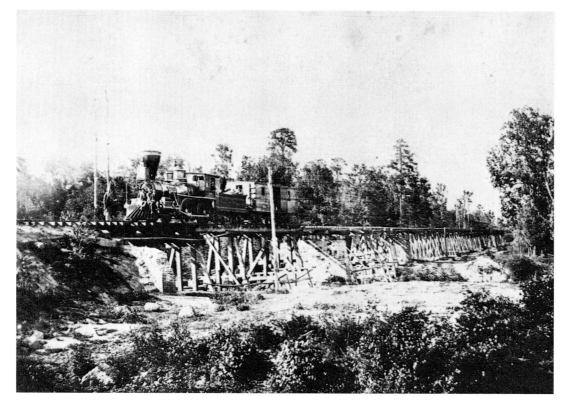

Small lines like the Wilmington &
Goldsboro Railroad in North Carolina
connected the seaports with the cities of the
interior, and with the rest of the South.
(USAMHI)

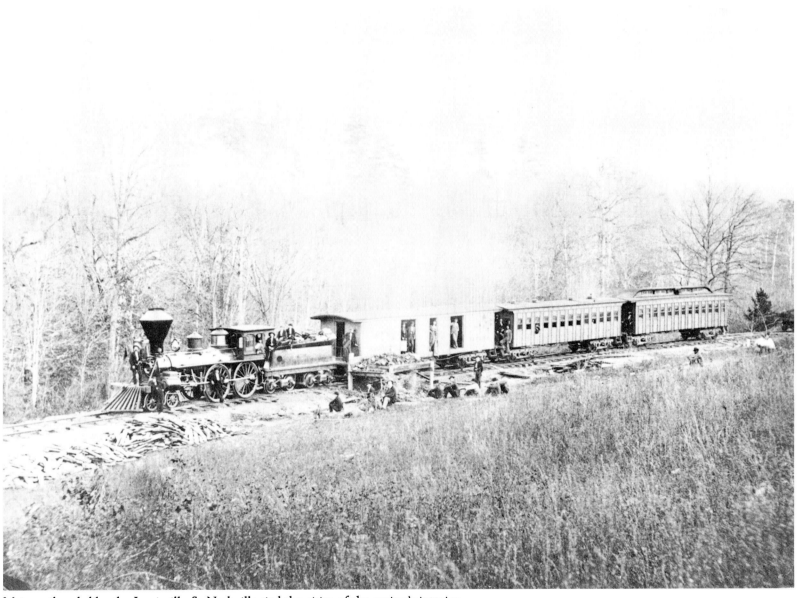

Major railroads like the Louisville & Nashville tied the cities of the region's interior in a network that, while thin and lacking in uniformity, could still move material — and men, if need be — with some speed from one state to another. The South's transportation was almost of an age to handle a war if necessary. (USAMHI)

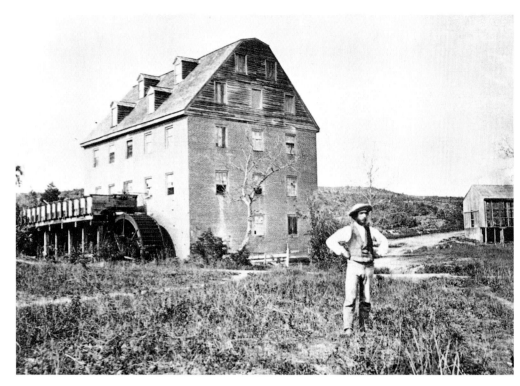

Manufacturing was close to keeping pace. All across the region there were mills like Cloud's, near Alexandria, where water- or steam-power could grind grain and drive machines. An A. J. Russell image. (USAMHI)

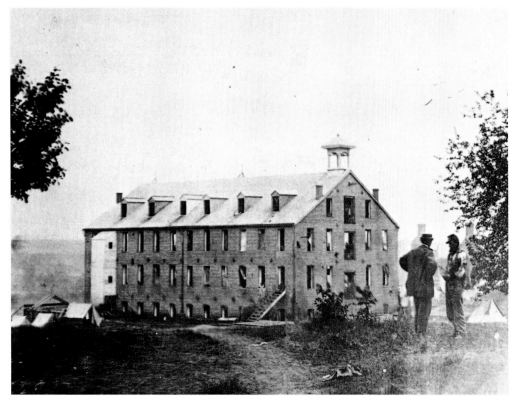

Warehouses near every city were ready to store the produce of the South's few factories and many fields. (USAMHI)

The spiritual welfare of the region seemed to be in good hands, and certainly in good surroundings—such as historic Falls Church, near Washington. (USAMHI)

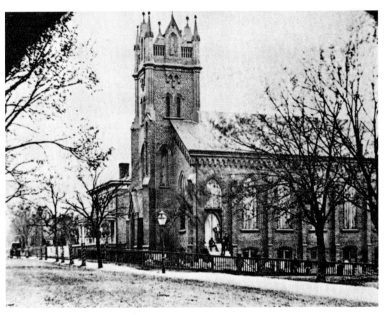

Indeed, churches were the most numerous public buildings in the South. (USAMHI)

Some were beautifully historic, like Alexandria's Christ Church, where Washington himself had been known to worship. (USAMHI)

There were even schools of religion, like Virginia's Fairfax Seminary — buildings large enough that they could be put to other uses if armies ever passed this way. (USAMHI)

Even some of the private homes of the South looked big enough to house more than families. (USAMHI)

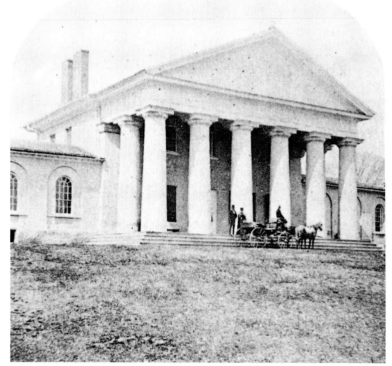

None was better known than the Lee family home, Arlington House, on the heights of Virginia overlooking the Potomac and Washington. In 1860 its head of household was Col. Robert E. Lee, U.S. Army. (USAMHI)

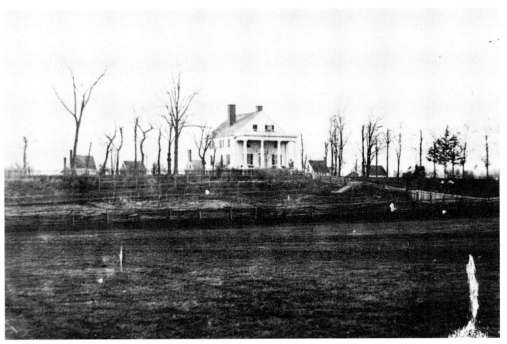

Farther to the south, in the heart of Virginia, the home of a public man like John Minor Botts, near Culpeper, presided over a small domain of farmland big enough to quarter an army. (USAMHI)

Homes in places like Yorktown, Virginia, nestled quietly in groves of trees. (USAMHI)

Other mansions presided over untold ancestral acres. (USAMHI)

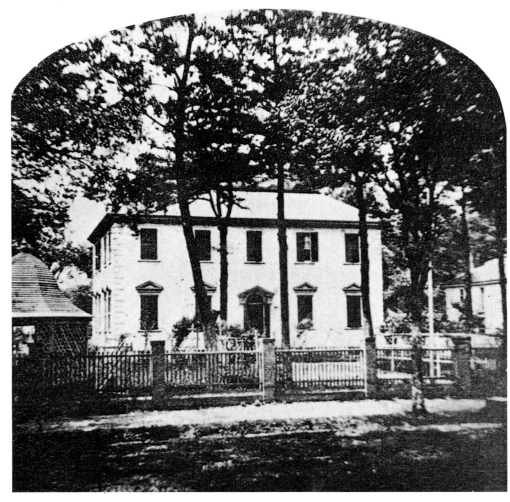

Down in North Carolina the homes looked almost somnolent, as if nothing could awaken them or their inhabitants from their peaceful existence. (USAMHI)

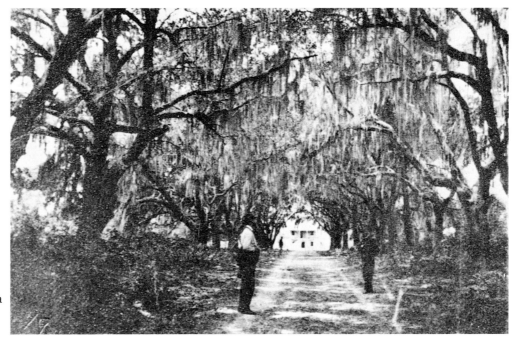

And then there were the plantation homes of the Deep South. Barnwell Plantation in South Carolina lay behind its avenue of undulating oaks in a setting emblematic of a way of life that its people had cherished for generations. (USAMHI)

It was a way of life that afforded to men and women of the aristocracy an indolence and tranquility hardly known elsewhere in the nation. (USAMHI)

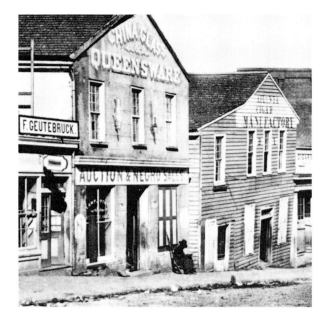

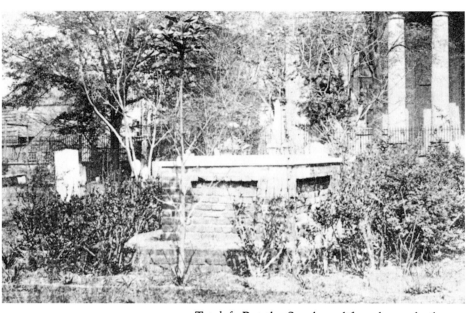

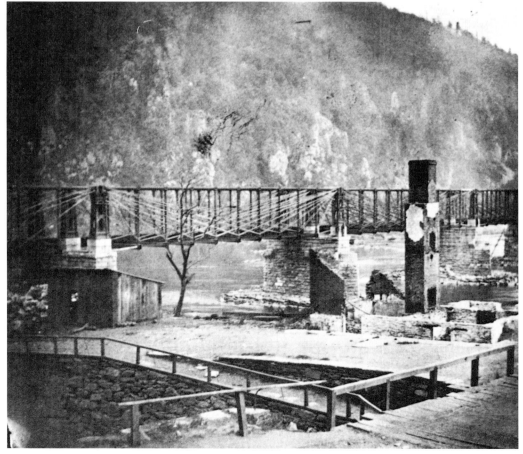

Top left: But the Southern life-style was built upon an institution that had by 1860 grown odious in the eyes of the civilized world: slavery. One of Atlanta's many slave markets advertised "Auction & Negro Sales." So offensive was slavery to the people of the North — and even to many in the South — that for two generations it had been driving a wedge between the two sections. (USAMHI)

Top right: Southern politics had evolved around slavery, so that the region's greatest statesmen were, by definition, slavery's foremost advocates. None had been greater than John C. Calhoun. Though dead and in his tomb in Charleston by 1860, his spirit lived on. (USAMHI)

Slavery had created ardent foes. Of all who championed freedom for the blacks, none did so more vehemently or dramatically than John Brown of Kansas. His 1859 raid on the armory here at Harpers Ferry, Virginia, electrified the nation but failed to ignite the slave revolution he envisaged. (USAMHI)

The raid cost Brown his life, but though his hanged body lay "mouldering in the grave," his cause — if not his soul — did go marching on, firing antislavery sentiments throughout the north. (USAMHI)

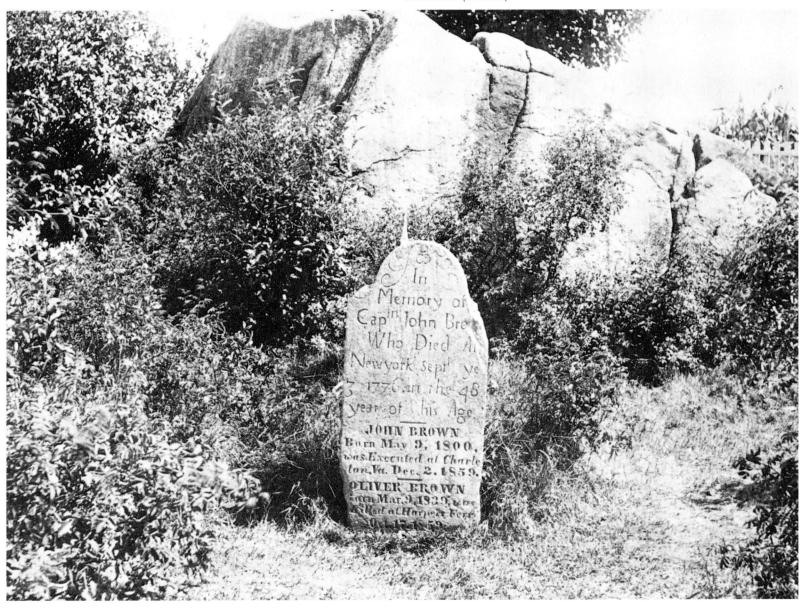

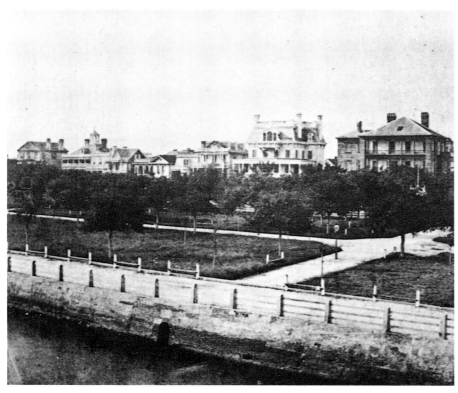

Finally, and predictably, it was Charleston that could hold the peace no longer. The fine homes on the South Battery looked out on the harbor and the Federal forts it contained. On April 12, 1861, the firing began, and it would not stop for four years. (USAMHI)

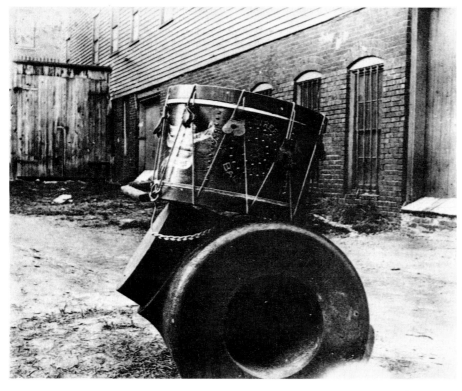

And then the drums and the guns echoed across the continent, from the Atlantic to the Pacific, from the Ohio to the Gulf. This drum was to be one of the first, beaten by Federal soldiers as they marched through Baltimore to Washington on April 19, 1861, only to be mobbed by Southern sympathizers. The drum, like the spirit of the Union it served, was lost for a time. It would not be recovered without the drumming of the guns. (USAMHI)

The landscape began to change, subtly at first, profoundly in time. The peaceful streams still had their fishermen. But now the waterways were muddied by the hoofprints of thousands of horses and millions of marching boots. The Hazel River in Virginia in the winter of 1863/64. (USAMHI)

Rivers once bridged by the iron rails saw their trestles destroyed to prevent an enemy's use, only to be rebuilt as the enemy advanced. Destruction and reconstruction were to be everywhere. (USAMHI)

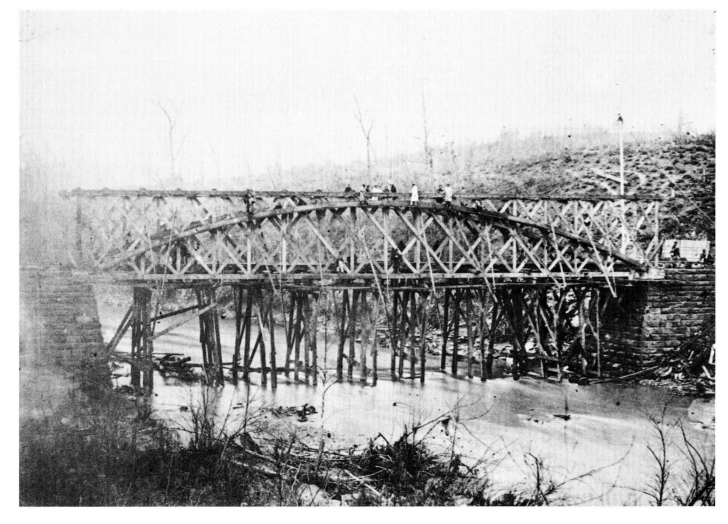

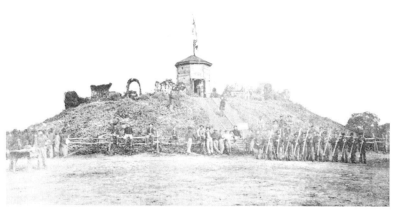

Even historic landmarks were turned to war's uses, like this Indian mound in Alabama, now a Federal officer's headquarters. (USAMHI)

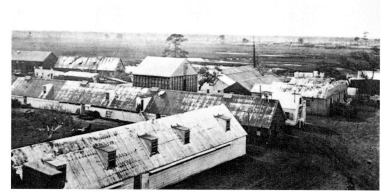

Places like Hilton Head Island, South Carolina, once peaceful plantation areas, became virtual cities of soldiers or, as here, headquarters of invading armies and blockading fleets. They would never be the same afterward. (USAMHI)

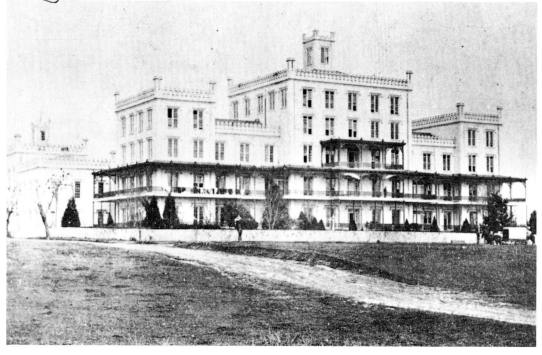

And any large building in the path of the armies was likely to be turned to another use: hospitalizing the thousands of wounded and the tens of thousands of sick. Like the innocence of the land itself, the men it raised were destined to die, in staggeringly tragic numbers. The Deaf and Dumb Asylum at Baton Rouge, now a Yankee hospital. (USAMHI)

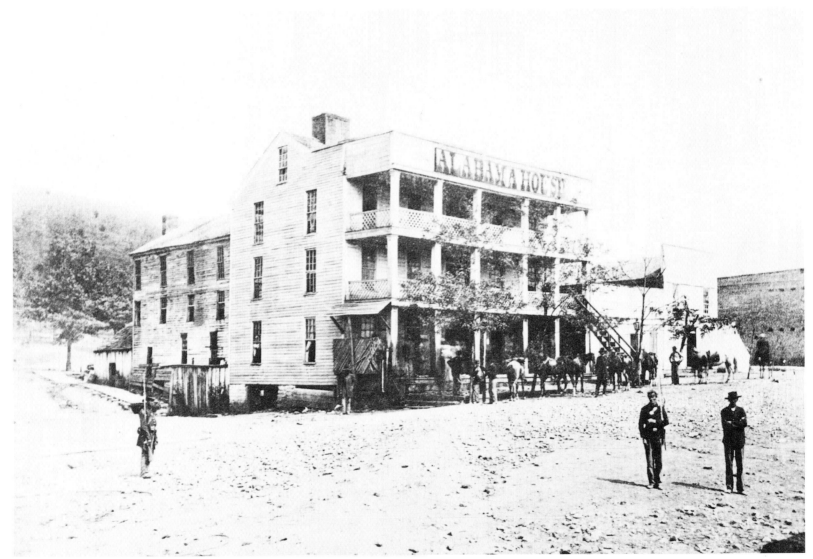

Any rural inn or tavern might find itself unexpectedly used as office or headquarters by a Union or Confederate officer, and often by both in succession. The Alabama House at Stevenson was to be no exception. Only the colors of the uniforms changed; the sounds of the marching soldiers would be ever the same. (USAMHI)

Even religious institutions were not immune from being turned to war's uses, as the Fairfax Seminary found out. (USAMHI)

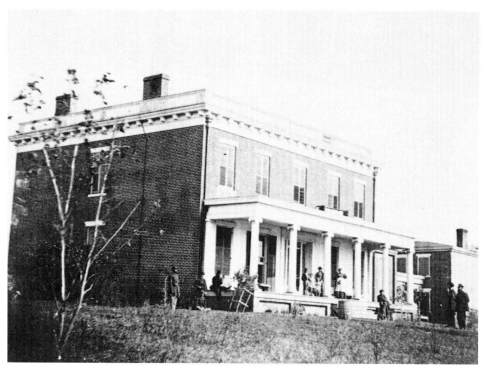

And the private homes of the South's gentry were soon enough commandeered by the invaders, as with the Aiken house in Virginia. (USAMHI)

No small farmhouse was safe from being surrounded by war. (USAMHI)

Places like the Globe Tavern near Petersburg would be swallowed by the armies. (USAMHI)

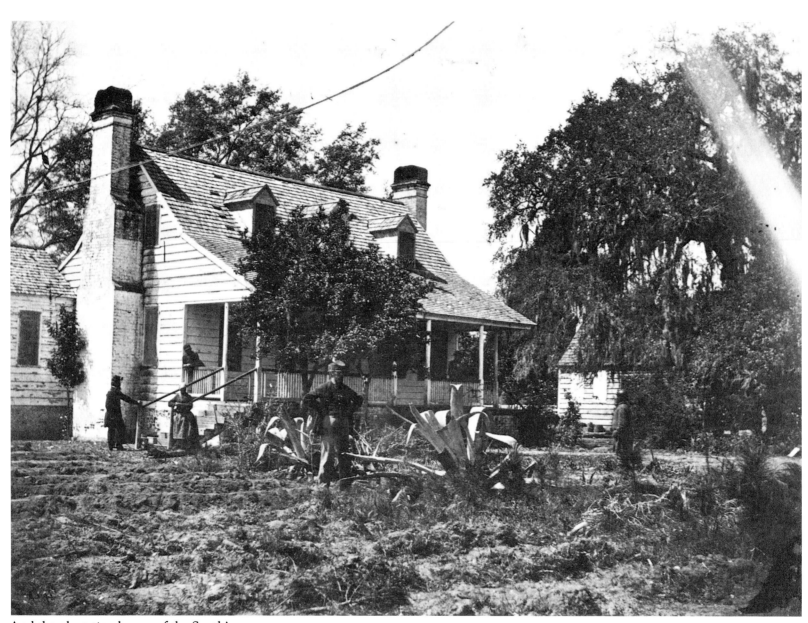

And the plantation homes of the South's
wealthy and landed gentry were fair game for
the uses of the military. Elliott's Plantation
on Hilton Head. (USAMHI)

The stately home of John Seabrook on Edisto Island, South Carolina, played unwilling host to Yankees for years. (USAMHI)

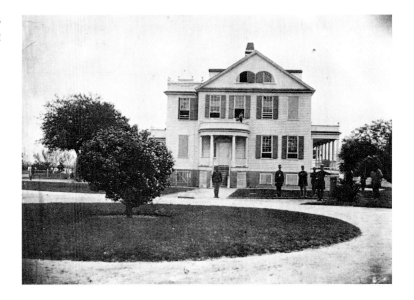

And the park he built beside it afforded leisure now to his enemies. At times even the life-style of the conquered would be considered spoils of war. (USAMHI)

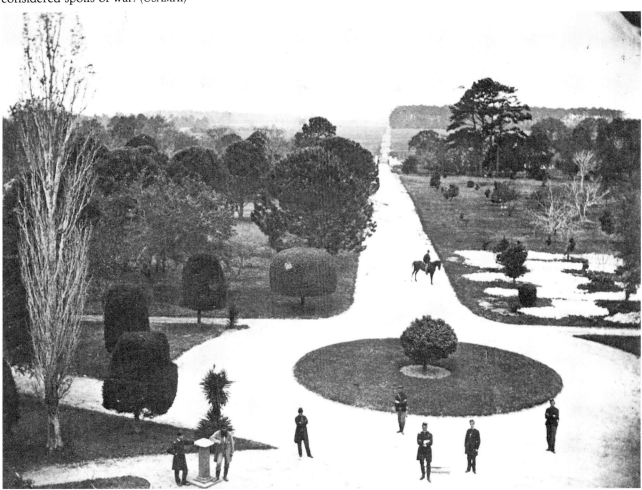

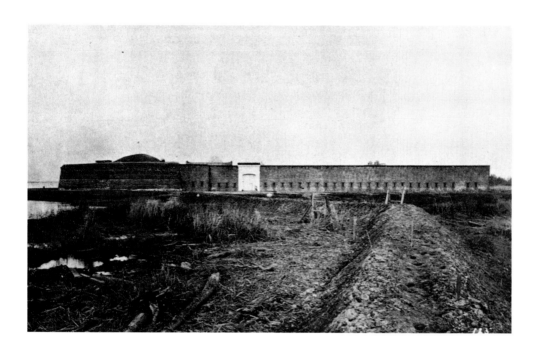

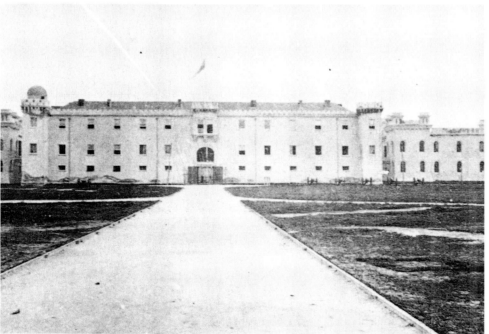

Top left: One by one the military installations of the South found themselves the targets of the Union's armies. Fort Oglethorpe was one of the few in Georgia to escape bombardment, but it could not prevent the Yankees from taking Savannah in the end. (USAMHI)

Top right: Places like the Oglethorpe Barracks, in Savannah, which once had been occupied by jubilant Confederates, echoed with Union voices once more. (USAMHI)

Bottom left: Military schools like Charleston's Citadel, which had trained officers for the Confederacy, fell once more to the Union as the city itself fell in 1865. (USAMHI)

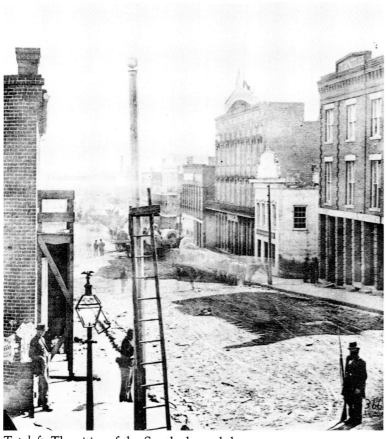

Top left: The cities of the South showed the mark of the war. Atlanta, once a hub of Confederate activity, teemed with Union soldiers after 1864. (USAMHI)

Top right: They were to be seen at every street corner. (USAMHI)

Bottom right: And carload after carload of them passed through on the rails, bound for the new war fronts deep within the Confederacy. (USAMHI)

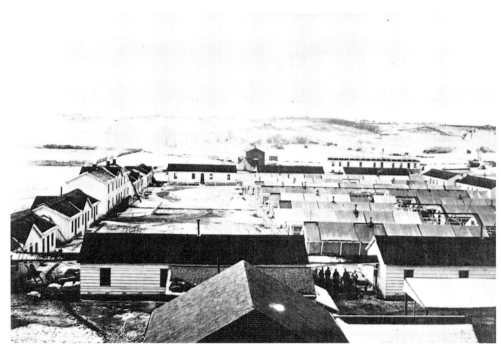

Wherever the armies went, they left behind them new things on the land—especially their cemeteries and their hospitals. Sickel Hospital in northern Virginia stands amid the snow-covered countryside in January 1865, with the Fairfax Seminary on the distant horizon. (USAMHI)

As they passed, the armies brought vestiges of the military life with them, even to the minutiae of the soldier's well-ordered existence. Here at the Armory Square Hospital in Washington, D.C., a sign on the lawn repeats a military order that must have dated back to the Romans of antiquity: "KEEP OFF The Grass." (USAMHI)

Alas, the war showed on the children, as their dress took on a distinctly military look by war's end. These boys outside Richmond's Saint John's Church might well have been looking forward to the day when they would be old enough to go forth and fight with the Confederacy. Happily, they would not shed their blood in this conflict, but they and their progeny would have to live with its consequences for generations to come. (USAMHI)

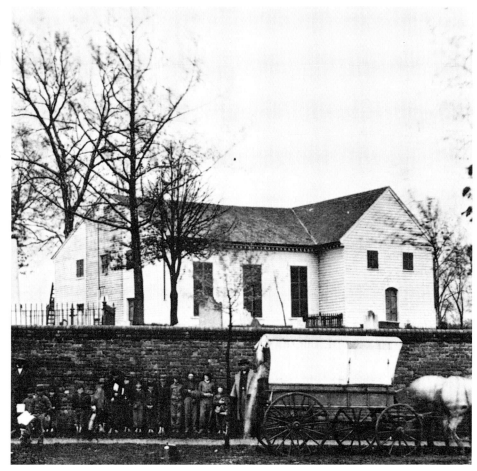

Happily, too, both for their posterity as well as for the victors', there would be a record of the best and worst of the war for them to see, that they might never forget. Men like Mathew Brady knew that something profoundly historic was happening in America in the 1860s. He, and they, resolved not to let it pass unrecorded. (USAMHI)

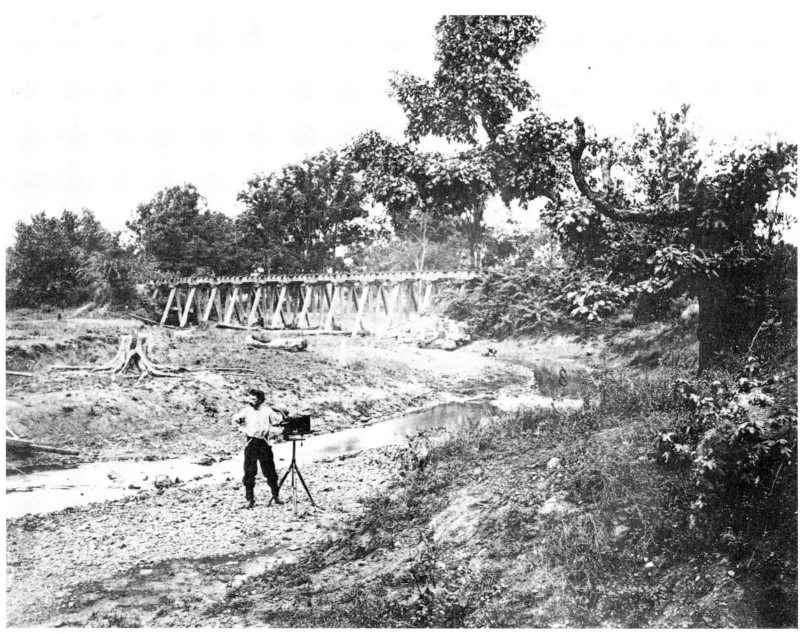

And so, like this unidentified photographer, they took their cameras and their frail portable darkrooms out into the fields, to follow the armies, to follow America's destiny wherever it led, and to see and retain the image of a national epic. (USAMHI)

The Embattled Continent

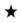

Herman Hattaway

Between Friday, April 12, 1861, when Fort Sumter was fired upon and replied, and Monday, April 2, 1866, when President Andrew Johnson proclaimed that the "insurrection is at an end and . . . peace, order, tranquility, and civil authority now exist in and throughout the whole of the United States of America," 1,816 days elapsed. During that time the American Civil War was fought: 10,455 battle actions of one kind and degree or another, variously described then and later as campaigns, battles, engagements, combats, actions, assaults, skirmishes, operations, sieges, raids, expeditions, reconnaissances, scouts, affairs, occupations, and captures.

Some of the battles were mammoth, most were not, but size mattered little to the participants. To anyone being shot at, every engagement brought moments of sobering importance. One soldier wrote after a battle: "When I go home it will take me months to describe what I saw on that terrible field." The same might have been echoed by all the combatants.

Yet it is interesting to note that although actions occurred at the rate of six and one-half per day, the typical soldier experienced firefights only occasionally. Hard work and boredom were more the norm than fighting: soldiers spent much time getting ready for, getting to, picking up after, and refitting. "Time is tedious here," one Alabaman wrote to his wife, "we see little of what is going on; we are part of a grand army whose tents are pitched on the ridges all about us as far as we can see. . . . [But] what it is destined to do, is kept profoundly secret by the generals in command and we can only guess." Five days later he was in the Battle of Shiloh.

How long any particular battle might last varied considerably. Most of them climaxed in but a short time, typically a single day or even just a few hours or less. Some of the greatest battles stretched over two or three days, such as Chickamauga or Gettysburg. The week-long Seven Days Battles was atypical of the Civil War and proved to be something of a harbinger of World War II–style combat. The campaigns and sieges, on the other hand, dragged on long: Vicksburg was besieged for six weeks and Petersburg nine months.

All of these, along with Antietam — the bloodiest single day of the Civil War (indeed, the bloodiest single day in the entire American military experience) — make almost everyone's list

of turning points. Yet battles, while sometimes cataclysmic, could never be totally decisive because Civil War armies lacked the power to annihilate each other. Technology, and developments in maneuverability and articulation of forces, rendered armies almost invulnerable to annihilation and almost always able to disengage, regroup, and fight again another day.

The distant killing power of Civil War–era fighting forces recently had been enhanced by the introduction of longer-range and more accurate rifled weaponry, and by engineering capabilities in the construction of entrenchments and forts. Some of the permanent works that were built, such as the fortifications encircling Washington, D.C., became so strong that one observer wryly opined that they ought to be renamed "fiftyfications." And as to field works, while in no previous American war had entrenchments been used extensively, in the Civil War they early became indispensable.

These things all tended to favor the side on the defensive. Indeed, one of the principal factors that made the war last as long as it did was the enormous inherent power and advantage enjoyed by defenders. The defense possessed roughly three times the strength of the offense. To overcome this, Civil War officers had learned the value of the "turning movement" from Winfield Scott during the Mexican War. But it proved difficult and rare during the Civil War ever to be able to reach an enemy rear with a large enough force to do the needed job.

So, even when the attacker "won" a battle, he usually lost more men than did the defender, because assaults were so costly. Indeed, any close engagement almost always dictated that both sides suffer immense casualties. The tactics used during the Civil War wasted untold numbers of lives. A Tennessean who had seen the results of the hopeless Confederate assault at Franklin exclaimed: "O, my God! What did we see! It was a great holocaust of death. Death had held high carnival. . . . The dead were piled the one on the other all over the ground. I never was so horrified and appalled in my life." Appalling casualties accompanied any period when troops were in close contact with the enemy—especially late in the war, during the 1864 campaigns, when assaults occurred frequently and the soldiers remained long exposed to losses from artillery fire, sniping, and skirmishing.

In this most costly of all American wars in terms of life—indeed, more costly than all of them combined through the Korean conflict—soldiers faced very unattractive odds. The precise numbers lost always have been uncertain and controversial. The best modern estimate lists 94,000 Confederates killed in battle or mortally wounded and 164,000 who died of disease, including between 26,000 and 31,000 Confederates who died in Northern prisons. The Federals lost 67,088 through battle deaths and another 43,012 to mortal wounds sustained in battle. There is precise information about other Federal deaths: 224,580 Yankees succumbed to disease, including 30,192 who died in prisons.

Total deaths in the Civil War amounted to well over 600,000: 365,026 Yankees (including 4,804 naval dead and others not specifically accounted for by the War Department) and 258,000 Rebels. About 18 percent of the slightly more than 2,000,000 individuals who served as Federals perished, while about 35 percent of the approximately 750,000 soldiers in the Rebel ranks died as result of the war. The common soldier faced unappetizing prospects. In the Union army, 1 out of approximately 30 men was killed in action; 1 of 46 died of wounds; 1 of 9 died of disease; 1 of 7 was wounded in action; 1 of 15 was captured or reported missing; 1 of 7 captured died in prison. For the Confederacy, 1 of every 19 white Southerners died because of the war.

Some 275,175 wounded Federal soldiers survived the conflict, as did at least 471,427 wounded Confederates. Many recovered fully, but huge numbers suffered permanent debilitation: about three-fourths of the 29,980 Union troops who underwent amputations survived; Confederate amputations were estimated at roughly 25,000.

And while the human damage wreaked by the war has to be regarded as vastly more significant than the other resultant physical damage, one is always shocked by the realities of the latter. The damage was lasting, even to this day: billions of dollars of losses in agriculture, industry, railroads, commerce, and education produced an almost cosmic jolt, from which the South simply never fully recovered.

The terrible mental strain of living through so obviously dangerous and damaging a war often induced in soldiers pro-

foundly sobering thoughts. One Union seaman might have been speaking for all of his compatriots when he wrote:

How strange, peculiar, and indescribable are one's feelings when going into battle. There is a light-heartedness — a quickening of all the springs of life. There is a thrill in every nerve — an exhilaration of spirit — a tension of every fibre. You see every movement, hear every sound, and think not only of what is before you, but of home, of the loved ones there — of the possibility that you may never hold them again. Some men review their lives, and ask themselves if they have left anything undone which ought to have been done — if their lives have been complete.

Ambrose Bierce, who survived his soldiering to become famous later as a writer, vividly told about one of the war's more bizarre ironies: "Among [the dead left in the Cheat Mountain country of western Virginia] was a chap named Abbott. . . . He . . . was killed by being struck in the side by a nearly spent cannonshot that came rolling in among us. . . . It was a solid round-shot, evidently cast in some private foundry, whose proprietor . . . had put his 'imprint' upon it: it bore, in slightly sunken letters, the name 'Abbott.'"

The soldiers ranged in age from, as far as we know, thirteen to well over fifty, but the mass of them were quite young. One estimate holds that more than a hundred thousand boys in the war were under sixteen years of age. Drummer boys, which many regiments had, were below the age of thirteen. We have more statistics on the Federal army than on the Confederate. The average age of the Northerners was just under twenty-seven, but almost one-fourth of the group were twenty-one years of age or less. The Confederate army, even though it drafted men as old as fifty (whereas the Northern draft stopped at age forty-five), as a group was probably somewhat younger still.

The youth factor was almost as prevalent among the generals as it was among the lower officers and enlisted men. U. S. Grant was not quite thirty-nine when Sumter was fired upon; William Tecumseh Sherman was only forty-one. The average age in 1862 of the 132 Union men who became major generals was thirty-nine, and that of the 450 who became brigadiers was thirty-seven. For the Confederates, R. E. Lee was fifty-four, but his famed subordinate Stonewall Jackson was only thirty-seven. At the war's outset, the average age of the South's 8 full generals was forty-nine; that of the 17 lieutenant generals, forty-one; of the 72 major generals, thirty-seven; and of the 328 brigadiers, thirty-six.

But whether any given soldier was nearest in age to ten-year-old Johnny Clem, the Yankee "drummer boy of Shiloh," or Union brigadier general Galusha Pennypacker, who still was not quite old enough to vote at war's end, or seventy-nine-year-old Maj. Gen. John Wool, the Civil War was a great leveler that wiped away any such distinction and — as Confederate Stephen D. Lee, the war's youngest lieutenant general, put it — became the "sublime" experience of his life.

This was especially true for those who experienced a great battle, and the greatest battle of all was Gettysburg. No one could improve upon Bruce Catton's remarks as he described the scene on the third day — the famous Confederate attack on Cemetery Ridge: "The smoke lifted like a rising curtain, and all of the great amphitheater lay open at last, and the Yankee soldiers could look west all the way to the belt of trees on Seminary Ridge. They were old soldiers and had been in many battles, but what they saw took their breath away, and whether they had ten minutes or seventy-five years yet to live, they remembered it until they died."

The larger conflict was, as Walt Whitman called it, a "strange sad war." The people of the North and South seem certainly not to have hated each other at the outset, but the war brought out the worst in some individuals. Not long after the conflict's end, Confederate general Jubal Early wrote John C. Breckinridge to say that "I have got to that condition that I think I could scalp a Yankee woman and child without winking my eyes"; and on the other side, an ex-Massachusetts soldier proposed Southern genocide: "I would exterminate them root and branch." During the war soldiers might on occasion have declared their own unofficial truce to engage in swapping and visiting, or they might have shouted warnings to enemy personnel, maybe even refused to shoot at them. But when one Maryland woman saw Confederate captain Francis W. Dawson's horse fall with him astride, she remarked, "Thank God, one of those wicked Rebels has broken his neck."

The Federals eventually codified into military law the already manifest hesitancy of most soldiers in the ranks to fire on enemy sentries, as well as prohibitions against "wanton" violence, unauthorized destruction, pillage, sacking. The Confederates, too, proclaimed it "not admissable [sic] in civilized warfare to take a life with no other object than the destruction of life," and hence delineated a series of restrictions on the way land mines might be used, in addition to issuing orders forbidding the shooting of enemy soldiers while they were bathing. But such orders were issued because some troops had engaged in the activities in question. If some soldiers refrained from firing, for example, upon enemy personnel attending to calls of nature, others considered such to be good targets. Feelings hardened, and not at all unique was the Union cavalry colonel who in late 1863 assessed the situation in northern Virginia by saying: "I can clear this country with fire and sword, and no mortal can do it in any other way. The attempt to discriminate nicely between the just and unjust is fatal to our safety; every house is a vedette post, and every hill a picket and signal station."

But they were Americans — on both sides — and deep down, everyone knew it. Each side went to war certain of the wrongness of the other's cause, each feeling sure that God would grant them the victory, and thoroughly convinced that the enemy could fight neither well nor long. The magnitude and duration of the struggle changed all that. Those doing the actual fighting could not help but cherish respect for their foe. Thus could the Union's chief engineer, Joseph G. Totten, assess the Confederates' coastal defense in Georgia: "A compliment," he said, "should be paid to the officers and men who built these batteries on the Savannah. I do not believe that any but Yankees could have built them. By Yankees, of course, I mean Americans." Not only did the two sides come from the same culture, take pride in the same heritage, and speak the same language, thus making communication easy; they also had things of substance about which to communicate.

Some 3.5 million slaves were present within the Southern social structure, while in the antebellum North there were so few blacks that many whites had never even seen one. This was one of the principal factors that made the two sections truly different. And Southerners — rather much more, perhaps, than Northerners — learned some sobering truths about blacks as the war progressed. Brave blacks? Good soldiers? How could this be? Southerners had insisted that blacks were inferior, uncivilized, incapable; slavery was good for them — indeed, it was necessary for them. But the war provided opportunities, and the blacks in countless instances rose to the frequently heroic and often costly occasion and showed otherwise. There were at least 68,178 fatalities among the Union army's 178,895 black enlisted personnel and its 7,122 black officers. Many Southerners deeply respected the achievements of the "Sable Arm." In the end, the South, too, decided to put freed slaves into uniforms. The Civil War was going to dictate slavery's demise no matter how the contest turned out.

Great wars, such as the Civil War, tend to make some of their own conditions, almost as if they have a personality and a will. Thus was it impossible for poor Wilmer McLean to relocate his family to a place along the banks of Bull Run, near Manassas Junction, Virginia. When a shell came crashing through one of his windows during the war's first great land battle, McLean decided that he had had enough. So he moved the residence to a quiet country village in the southern part of the state: Appomattox Court House. There Lee's and Grant's forces clashed for the last time, and there Lee met Grant to surrender, on April 9, 1865, in the parlor of McLean's house.

The McLeans, of course, were not the only bystanders to be swept aside by events. Mrs. Judith Henry was killed during the First Battle of Bull Run while lying in bed; her house was totally demolished by artillery fire crossing from both sides. Huge numbers of spectators, however, had willingly flocked to see that first big battle. Many of them were injured in the stampede to the rear after the Federal lines broke. Later, it was not so much the norm for onlookers to try to get close to the fighting; many attempted instead to scurry away. Such, for example, was the case before Gettysburg. When Lee's men neared Harrisburg, Pennsylvania, one reporter described the scene as one of "perfect panic." Alarmed and excited people loaded with baggage packed the crowded trains. Perhaps fearing rape, "every

woman in the place seemed anxious to leave," the reporter noted. But, unlike these Northerners, Southern women who fled invasion paths often encountered even greater hardships than those who stayed at home. And for many civilians, the war brought tragedy no matter what. One soldier wrote in his reminiscences about the burning houses and burning barns in Virginia: "Each time that we lighted our pipes that day, it was with the burning embers taken from the ruins of what a few hours before had been a happy home."

Whether innocent bystanders and victims or willing and sometimes vociferous participants, civilians truly shared in this war effort. Not least significant, to be sure, were the hundreds of thousands of citizens who only momentarily became soldiers. But note, too, the thousands of Negro slaves who were impressed into digging Southern entrenchments, so whites "could fight more and dig less." And think of civilian aides such as Governor Isham G. Harris of Tennessee, who served Albert Sidney Johnston at Shiloh, or fourteen-year-old Emma Samson, who once rode as a scout for Nathan Bedford Forrest (and years later was a darling of the United Confederate Veterans), or Capt. Sally Tompkins — one of the war's countless nurses and eventually the only woman to be commissioned in the Confederate army. Untold thousands of civilian workers labored directly in behalf of the war effort, such as the two thousand women who worked in the Confederate government's uniform factory in Richmond, and those who worked in the many other branch factories scattered from Virginia to Mississippi.

"We can't *help* it that the war after all *was fought* in Virginia," a sweet lady once said in defensive reaction to criticism of the too-frequent overemphasis by some students of the war in that state. Assuredly, many of the war's epochal events did occur in Virginia: 2,154 of the military actions — 20.6 percent of the total. But Tennessee, Missouri, Mississippi, and Arkansas were the next four leading theaters of the war by state, and together they were the scenes of 4,167 military actions.

Every Confederate state had hundreds of engagements on its soil — except Florida, which had 168, and Texas, which had 90. There even were 88 in California (largely against Indians), 75 in the New Mexican Territory, and even 1 in Vermont, when a small band of Confederates thrust from Canada to rob banks at Saint Albans and there ensued a firefight between them and a local militia.

Veritably, the war affected in some way almost all of the embattled continent. The conflict was far from exclusively fought — nor decided — in that epochal battle of Gettysburg where the South's forces were led by Virginia's great hero, R. E. Lee. The hills around Vicksburg and Chattanooga were as fateful as those in Pennsylvania.

Americans know that today, and they visit the Civil War battlefields by the millions every year. Gettysburg, Fredericksburg-Spotsylvania, Chickamauga, Chattanooga, Vicksburg, Kennesaw Mountain, Harpers Ferry, Petersburg, Fort Donelson, Antietam, Richmond, Tupelo, Fort Pulaski, Appomattox, Shiloh, Fort Sumter, Stones River, and Brice's Cross Roads attract a constant stream of visitors. But so, too, might one be inspired or learn something worthwhile on visits to the engagement sites at Pigeon's Ranch, New Mexico; Honey Hill, South Carolina; and Amelia Springs, Virginia; and much edification might await those who have not yet been to the skirmish sites of Turkeytown, Alabama; Pea Vine Ridge, Georgia; Crab Orchard and Barren Mound, Kentucky; Pest House, Louisiana; Klapsford, Missouri; Moccasin Swamp, North Carolina; Whippy Swamp, South Carolina; and Shanghai, West Virginia.

The Civil War was the great American Iliad, the ordeal of the Union, the great crimson gash in American history. The names of its battles endure, and will endure perhaps forever. The "awed stillness" that so impressed Joshua Chamberlain at Appomattox has been perceived and felt anew, year after year, by the countless numbers of pilgrims who have trekked to these scenes of former struggle.

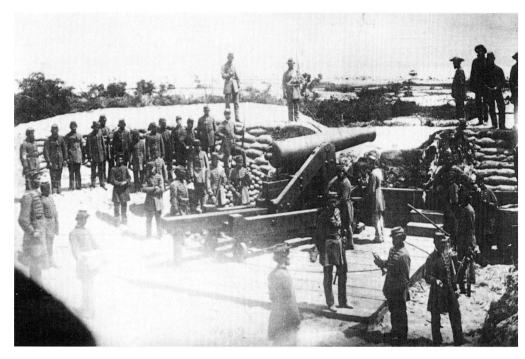

The war spread all over the land, even before the fighting started. Here in Pensacola, Florida, the once tranquil Gulf Coast began to see and hear guns. (USAMHI)

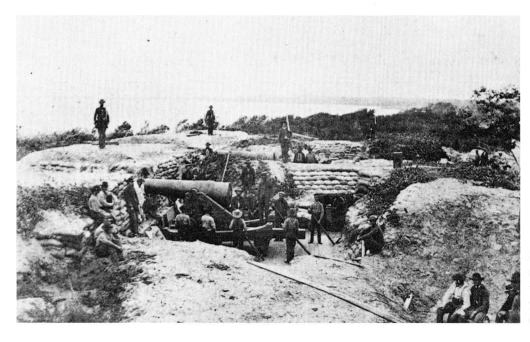

Sand batteries like this one aimed their guns at Florida's Fort Pickens, ready to open fire when ordered, and ready to plunge the nation into war. A J. D. Edwards image. (USAMHI)

Though they rarely fired in anger, they had scarred the land already. (SHC)

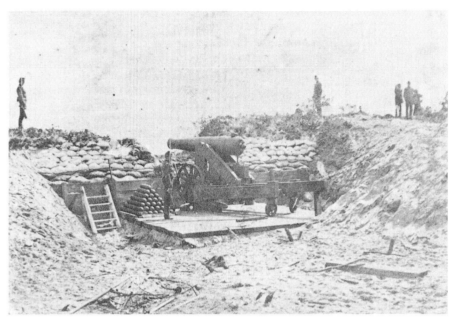

Elsewhere, guns did fire in anger. In northern Virginia, in July 1861, the first armies met near Centreville. (USAMHI)

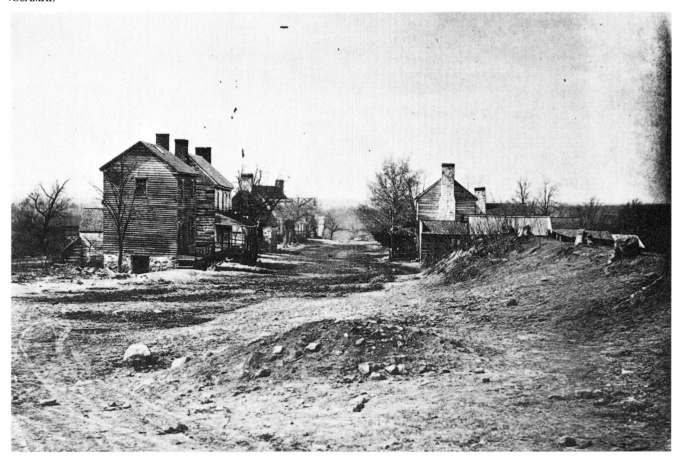

On July 18, 1861, they clashed near
Blackburn's Ford on Bull Run. (USAMHI)

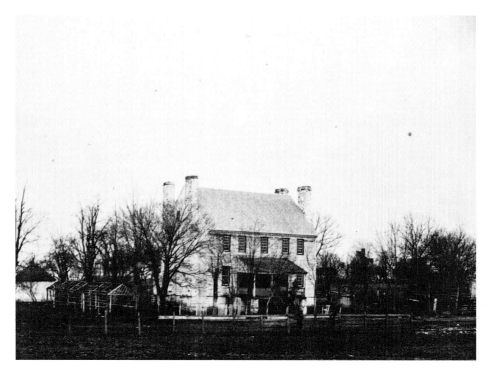

Once peaceful farmhouses became generals'
headquarters as the battle that many believed
would begin and end the war was fought in
the nearby fields. (USAMHI)

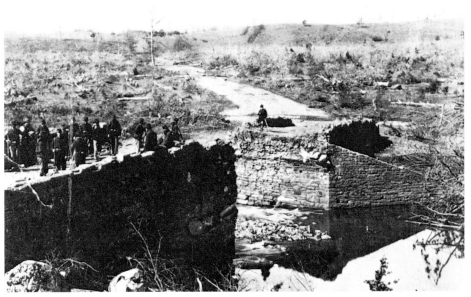

But what that first Battle of Bull Run began would not be stilled quickly, and the Virginia landscape that it left ravaged was only to be the first of many rural places injured by war. (USAMHI)

Quickly the war spread south and west. In April 1862, Fort Pulaski, Georgia, which had never fired a shot in America's previous wars, first heard the guns as American fought American. Federals bombarded it into submission and, in the process, demonstrated that the era of the masonry fortification was over. (USAMHI)

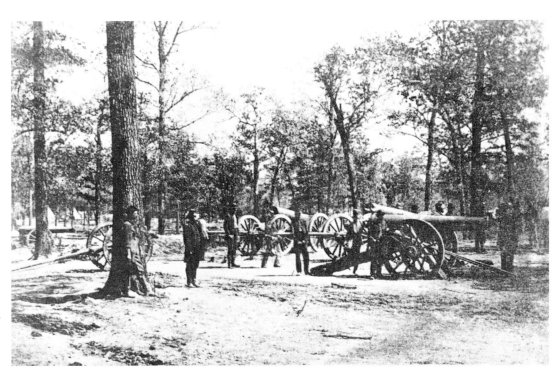

And out west in Tennessee, Federals demonstrated that the Confederates were not as invincible as they thought. At Shiloh, these and other guns drove back a Rebel attack and helped save western Tennessee for the Union. (USAMHI)

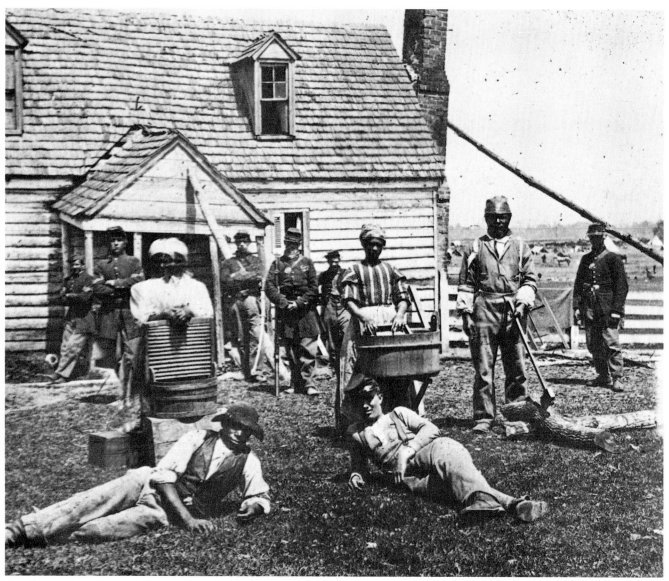

But always the war seemed to capture the
most attention in Virginia. Historic places
from the days of the Revolution echoed once
again to the booted heels of marching men.
Lafayette's headquarters at Yorktown would
play host to Yankee foot soldiers now. (USAMHI)

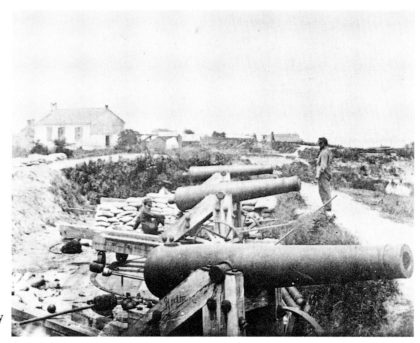

While along the banks of the York River, shore batteries bristled with guns planted by Confederate defenders. (USAMHI)

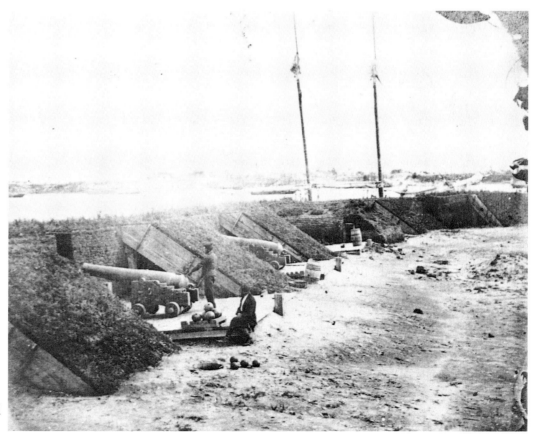

This Rebel water battery at Gloucester Point mounted fifteen heavy guns, ready to strike any enemy fleet. When Yorktown fell, so did they. (USAMHI)

In the campaign for the Virginia Peninsula, peaceful streams like the Pamunkey became major crossing places for the advancing Union army. (USAMHI)

And at places like Cumberland Landing, on the Pamunkey, tens of thousands of men from the Army of the Potomac rested briefly before going (so they thought) "on to Richmond." (USAMHI)

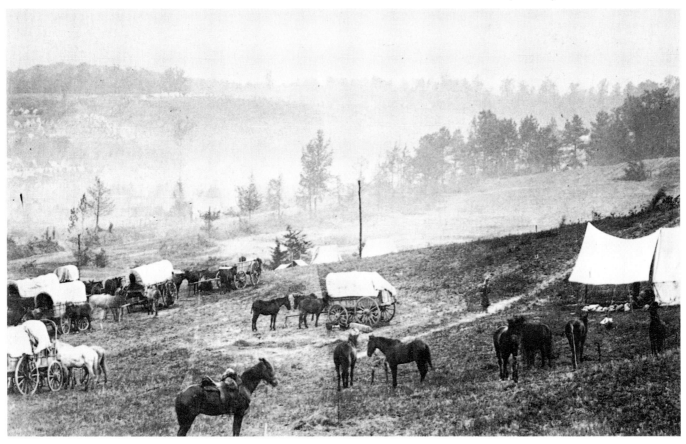

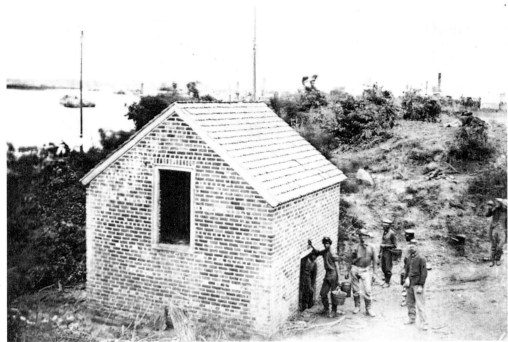

The Yankees thronged every dock and wharf on the Pamunkey — like White House Landing, shown here with the river full of craft in the distance. (USAMHI)

In what would be called the Seven Days Battles before Richmond, several little-known places like Mechanicsville became suddenly nationally important as Lee and McClellan battled for the Confederate capital. (USAMHI)

Though McClellan was unsuccessful, his fellow general John Pope was no more fortunate as he battled Lee on the old Bull Run battleground. The Confederates had fortified here at Manassas Junction before abandoning their works. (USAMHI)

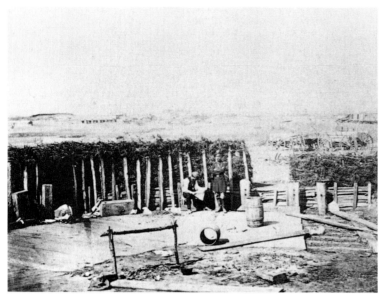

When next the armies met it was on South Mountain, as Lee invaded Maryland. It was in this field that a Yankee corps commander, Jesse Reno, was mortally wounded. (USAMHI)

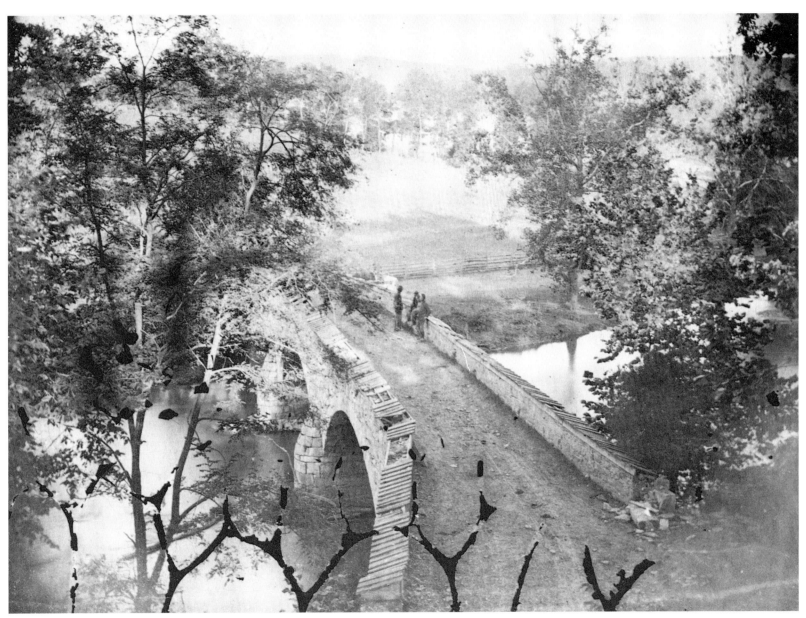

And then they were on to Antietam, the bloodiest single day of the Civil War. This image by Alexander Gardner or James Gibson looks across the famous Burnside Bridge toward the Union positions. Across this bridge thousands of Yankees attacked, running headlong into Rebel guns. (LC)

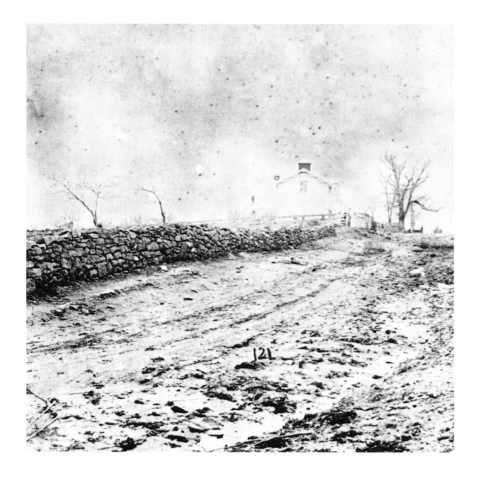

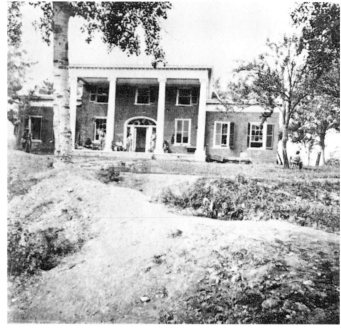

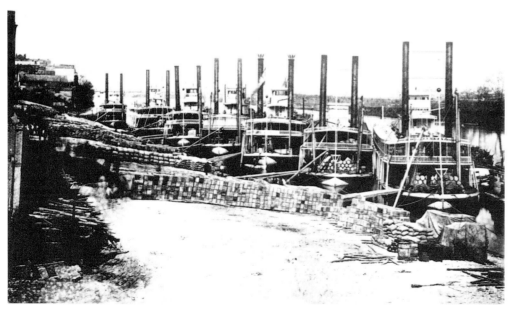

Top left: Bloody assaults came in December, too, when Ambrose Burnside sent brigade after brigade against this stone wall on Marye's Heights at Fredericksburg. Rebels firing from behind it devastated their foes. (USAMHI)

Top right: The Marye house itself showed the effects of the combat, and of the May 1863 battle fought on the same ground. Almost every pane of glass in the house was broken, and its brick walls were pocked by cannonballs. (USAMHI)

Bottom left: Meanwhile, out in the West, the Union juggernaut was moving more swiftly. Nashville was securely in Yankee hands, its wharves teeming with transport shipping to supply the Federals. (USAMHI)

In the spring of 1863, the campaigns began everywhere. In the fields and woods around Dowdall's Tavern, near Chancellorsville, the two armies in Virginia met yet again, in the greatest victory of Lee's career. (USAMHI)

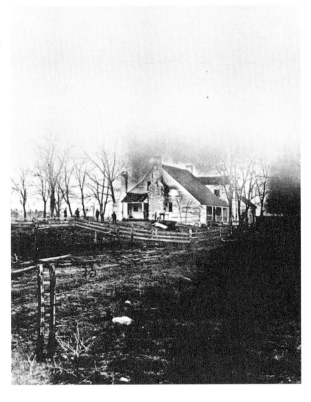

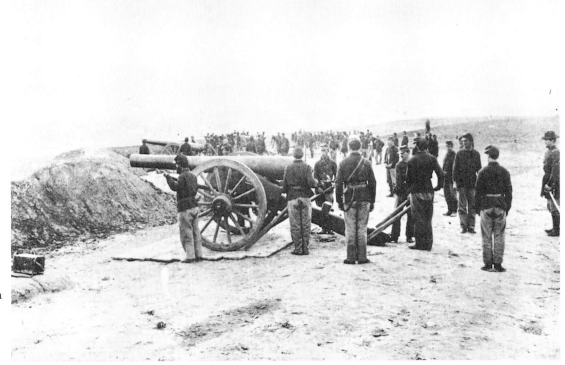

While Lee defeated his opponent at Chancellorsville, his subordinates were holding their own in yet another fight on the Fredericksburg battleground. This A. J. Russell image looks across the Rappahannock toward the city, from a Union battery. (USAMHI)

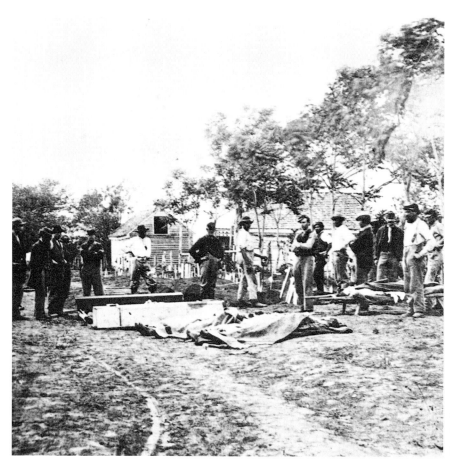

The casualties were terrible in the fighting. The war would bring thousands of headboards to Fredericksburg. (USAMHI)

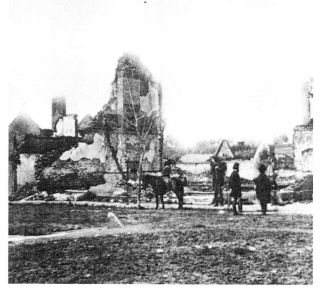

And much of the city itself was left in ruins. (USAMHI)

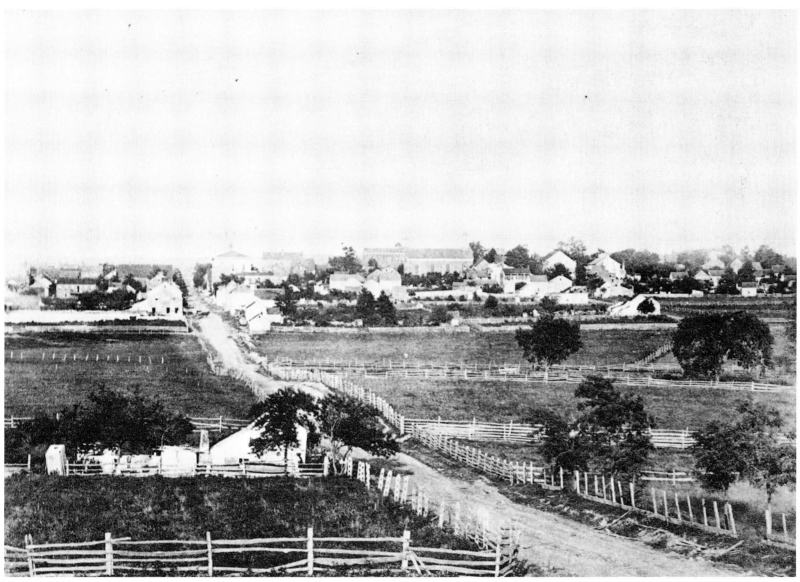

Then, less than a month after Chancellorsville, came the greatest battle of the war, the three days at Gettysburg. This is the view that many of Lee's Confederates saw when they first took the town on July 1, 1863. (KA)

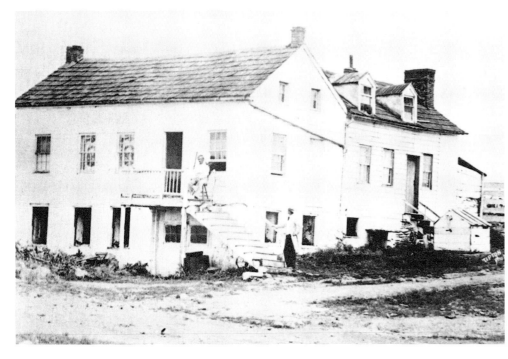

Even citizens turned out to defend their town, among them old John Burns, veteran of the war of 1812, shown here on his porch with an unidentified bystander. (USAMHI)

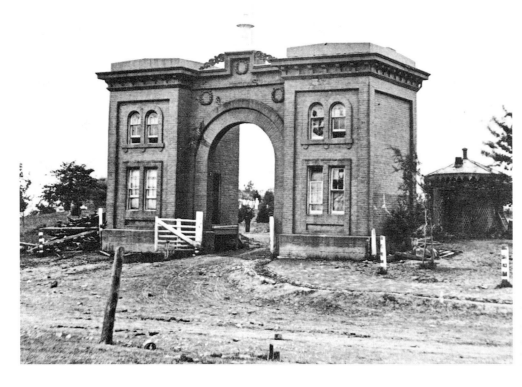

The fighting was ferocious as the Rebels tried to penetrate the Yankee line on Cemetery Hill, near this gatehouse to Evergreen Cemetery. (USAMHI)

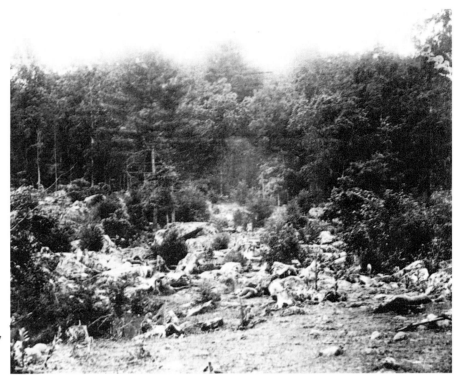

Most crucial of all in the first two days of fighting was the contest for Little Round Top. Alexander Gardner's image made a few days after the battle shows some of the bloated dead still unburied. (USAMHI)

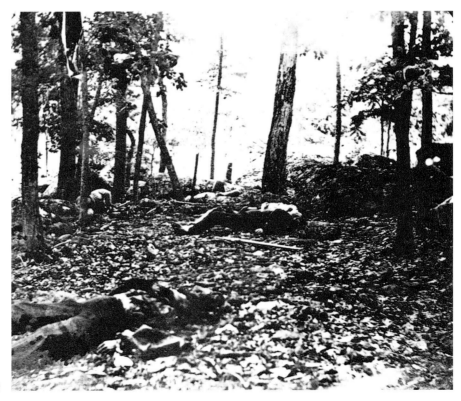

Indeed, the dead were everywhere. (USAMHI)

Corpses lay amid the rock outcroppings. (USAMHI)

And in the fields. (USAMHI)

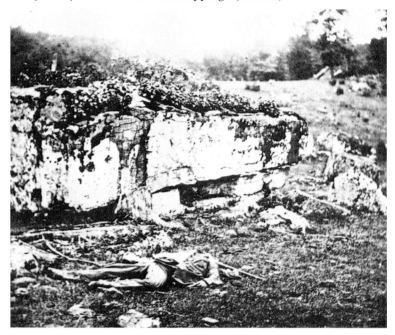

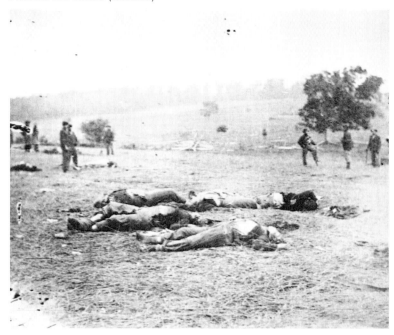

It required a major humanitarian volunteer effort to clean the town and bury the dead once the battle was done. (USAMHI)

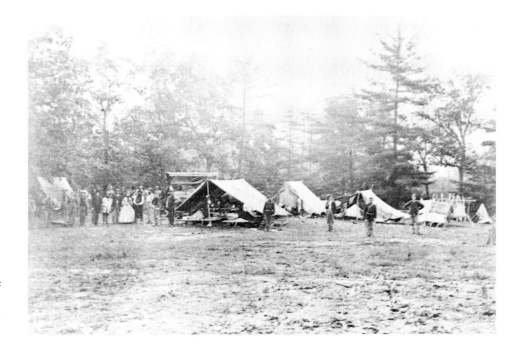

And the thousands of wounded had to be cared for at field hospitals like this one operated by the II Corps. Gettysburg had been scarred by war forever. (USAMHI)

At virtually the same time, the war for the Mississippi was raging, as U. S. Grant tried to take his greatest prize, Vicksburg. On the way he suffered setbacks, as here at Chickasaw Bluffs. . . . (USAMHI)

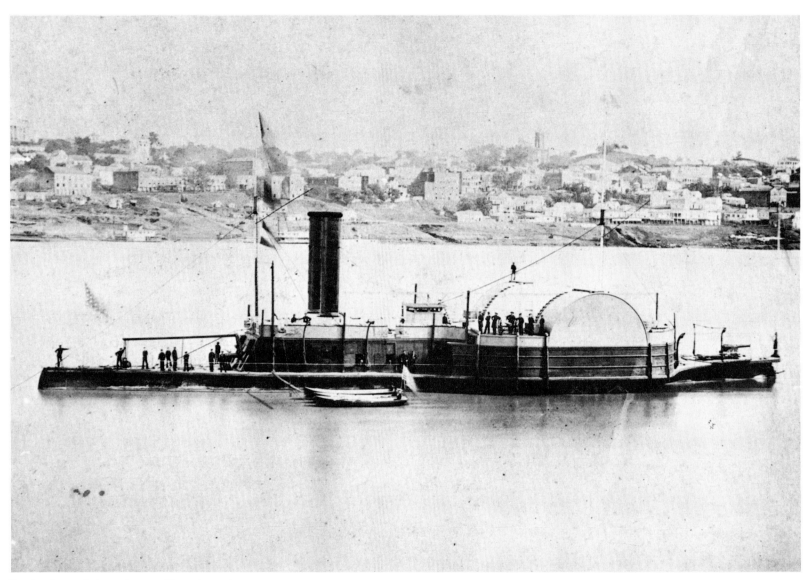

But in the end the prize was Grant's, and on July 4, 1863, Vicksburg surrendered. Sometime thereafter the Yankee gunboat ram *Vindicator* posed for the camera with the city in the background, symbolic of the might of the Union. (WLM)

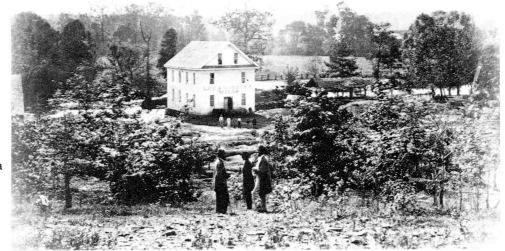

The conflict moved on into north Georgia in the fall, with the Union suffering its most complete defeat of the war along Chickamauga Creek, not far from Lee & Gordon's Mills. Almost a whole army was put to rout. (LC)

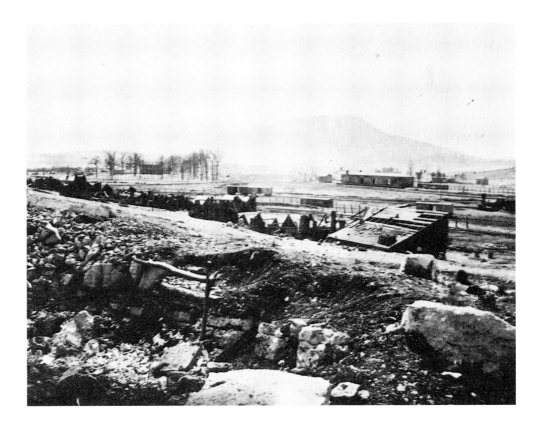

The vanquished were driven back to Chattanooga, in the shadow of giant Lookout Mountain. (USAMHI)

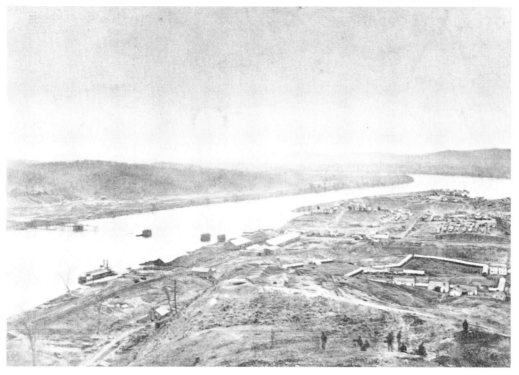

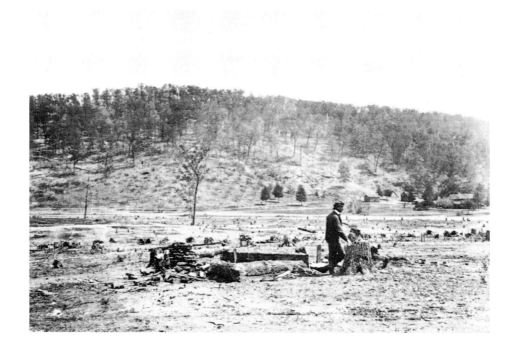

Top left: Here, with bridge construction under way along the Tennessee River, the Federals built up their fortifications to resist the besieging Confederates. (USAMHI)

Bottom left: And here, on Missionary Ridge, the Confederates established their lines, only to be driven off in one of the grandest infantry assaults of the war. The Union was on the move again. (USAMHI)

Bottom right: Elsewhere in Tennessee, the Yankees reclaimed Cumberland Gap, vital link between the east and west sides of the Appalachians. Here, in a previously unpublished print, Union camps dot the hillsides that shelter a cavalry unit. (KHS)

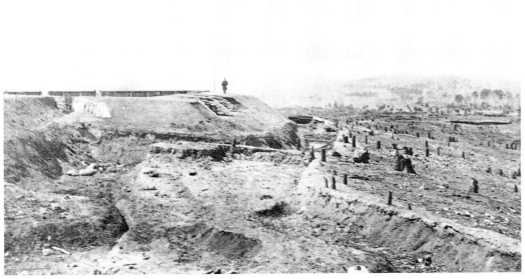

And then the Federals resisted a Confederate attempt to retake Knoxville, where the Rebels spent themselves in bloody attacks at Fort Sanders, shown here after the battle as a lone Yankee surveys the scene of the fighting. Everywhere the armies went on the continent, they seemed to leave the marks of their passing in the cleared fields and ravaged forests. (USAMHI)

Then came 1864 and the opening of new, major campaigns all across the continent. Once more the Army of the Potomac marched across the Rapidan and into the Wilderness near Chancellorsville, there to meet and fight Lee. (USAMHI)

A host of new places, like the unassuming Todd's Tavern, saw the coming of the armies, locked now in a death grip that would not loose until the end. (USAMHI)

Grant estabished huge supply bases on the Virginia rivers to succor his advancing army—bases like this one at Belle Plain, photographed by Russell on May 18, 1864. (USAMHI)

Bottom left: Every stream and river had to be bridged. The Pamunkey River in May 1864. (USAMHI)

Bottom right: The pontoon bridges crossed everywhere as the armies literally took their bridges with them. (USAMHI)

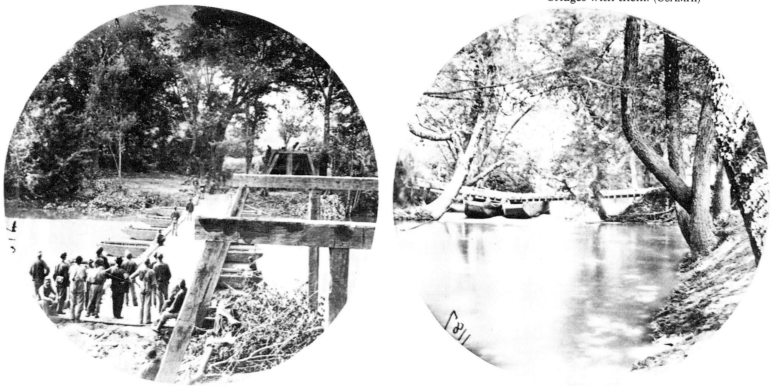

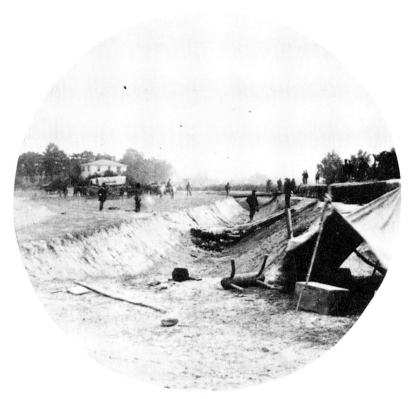

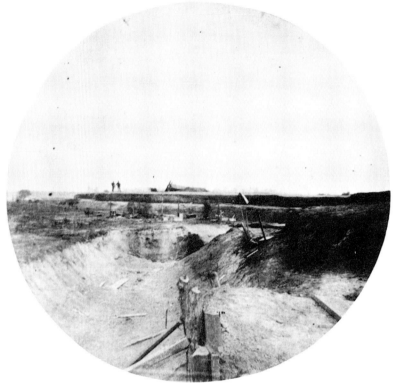

Finally the armies locked in the siege of Petersburg, and the Confederates clung to formidable earthwork defenses like these just recently captured. (USAMHI)

The Virginia city was literally ringed with trenches and fortifications. For as far as the eye could see, they snaked across the landscape. (USAMHI)

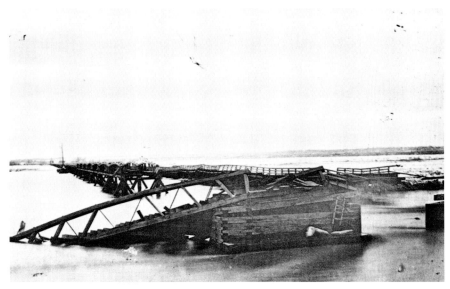

Even cruel weather, which could destroy bridges, could not deter him from his determination to have his quarry. (USAMHI)

His batteries surrounded the beleaguered Rebels. (USAMHI)

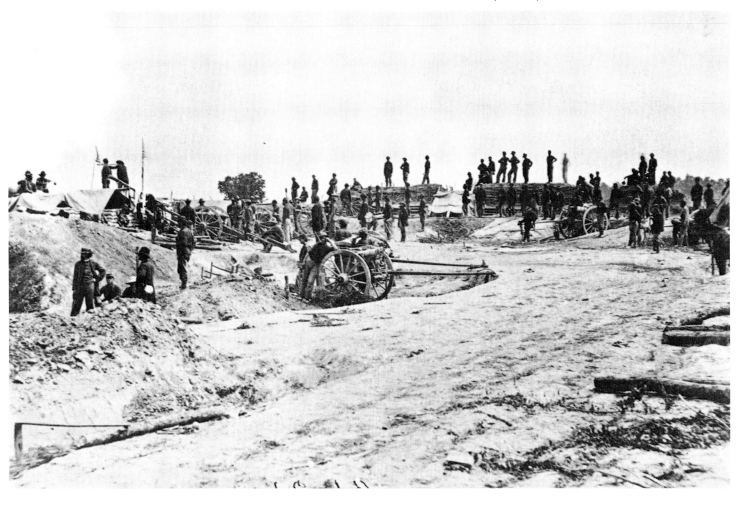

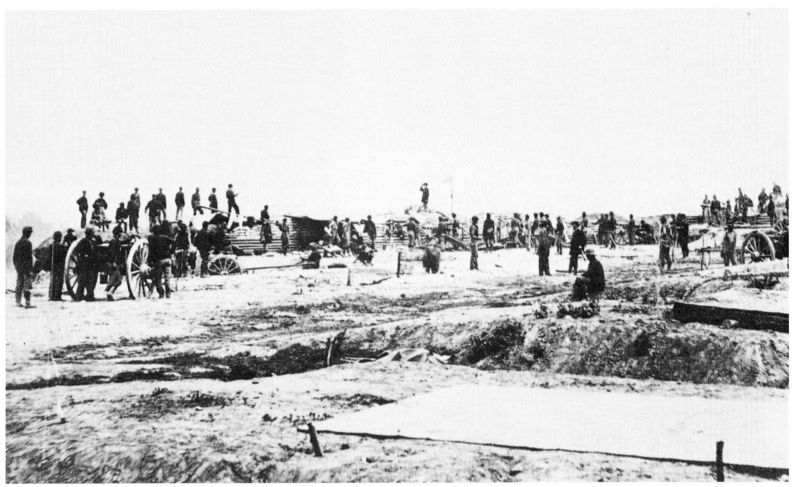

Everywhere they looked, Lee's Confederates saw an enemy determinedly staring back at them. (USAMHI)

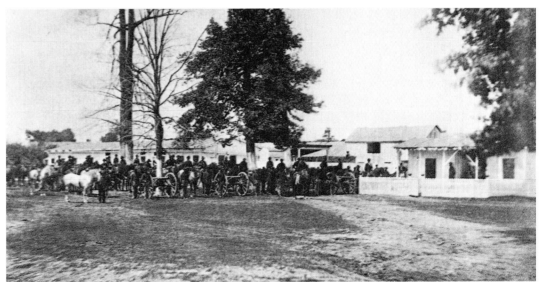

While the ten-month siege wore on, Grant's other armies advanced into the heart of the Confederacy. Units like this Missouri artillery battery joined with Sherman as he drove deep into Georgia. (USAMHI)

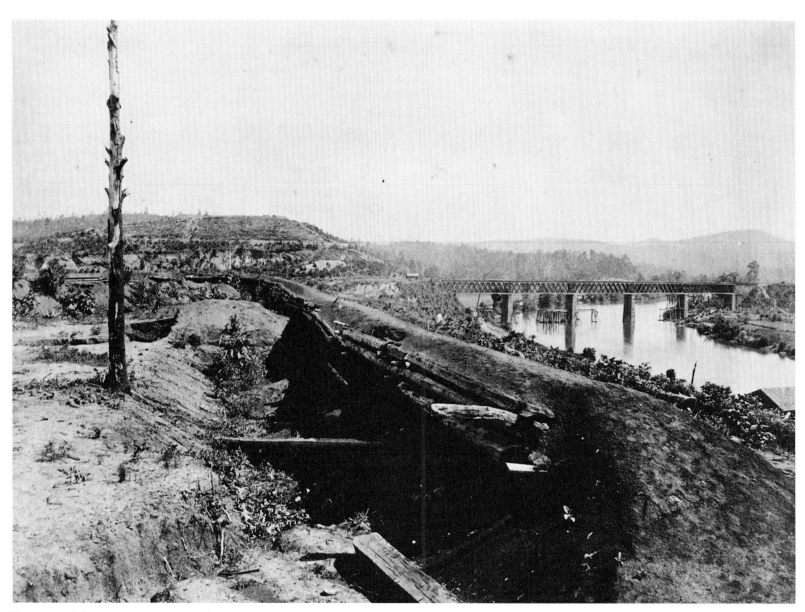

From one defensive position to another,
Sherman drove the Rebels before him,
marching over their defenses, as here at the
Etowah River bridge, shown in a George
Barnard image. (LC)

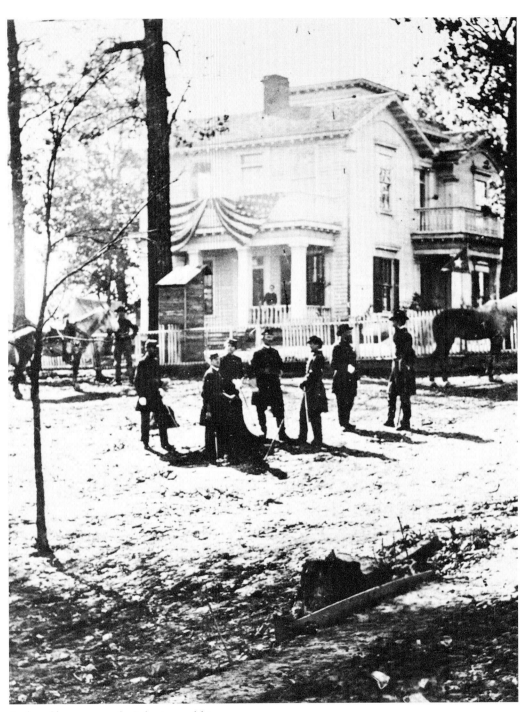

At last Sherman took Atlanta, and his
officers could pose in front of the
headquarters of their foe, Gen. John B.
Hood, with the Stars and Stripes proudly
draped from its balcony. (USAMHI)

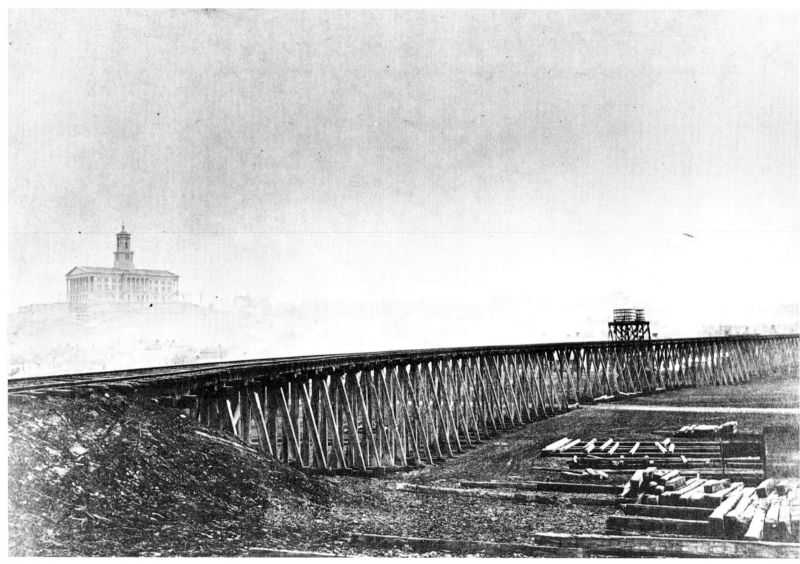

Hood's last gasp would be his attempt in late
fall of 1864 to reclaim middle Tennessee —
an effort that culminated in the debacle at
Nashville, where he almost saw his army
destroyed. The state capitol looks out over
the scene of some of the war's bitterest
fighting. (NA)

Even out in the Far West, the Federals were on the march, reclaiming Brownsville, Texas, and forcing the Confederates to evacuate across the Rio Grande on pontoon bridges like this. (USAMHI)

The Yankee drives could not be stopped. Sherman pushed on from Atlanta to the sea, and then marched northward through the Carolinas. Columbia fell to him, and its fall left much of the city devastated, like the state armory shown here. A lounging Union photographer sits in the foreground beside his wagon. (USAMHI)

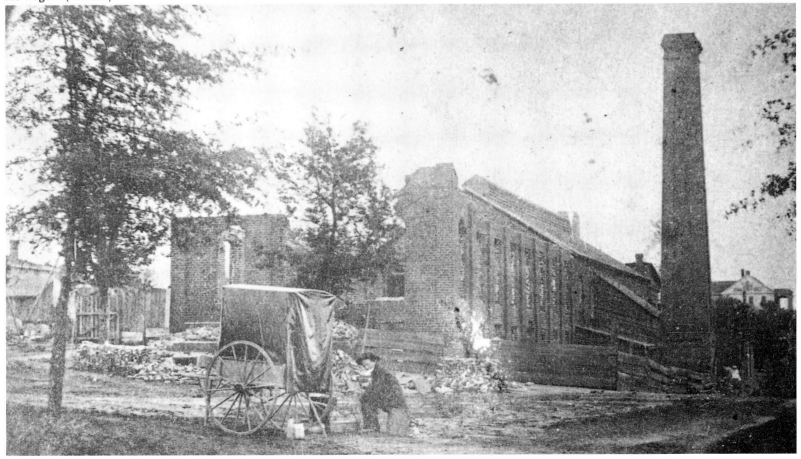

And the blockade grew ever tighter as one after another of the South's port cities fell — and with them the forts that guarded them, like Fort Fisher, North Carolina. (USAMHI)

Its interior ruin spoke for the state of the Confederacy as a whole as it approached its final days of nationhood. (USAMHI)

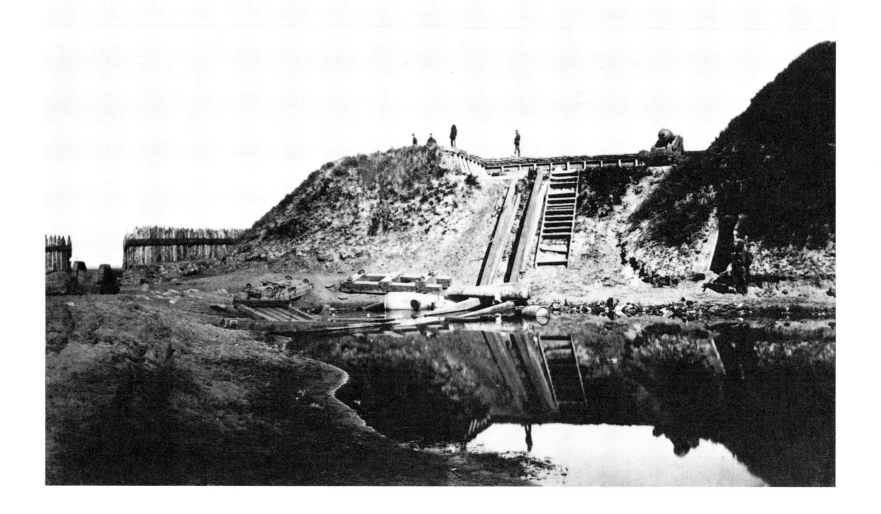

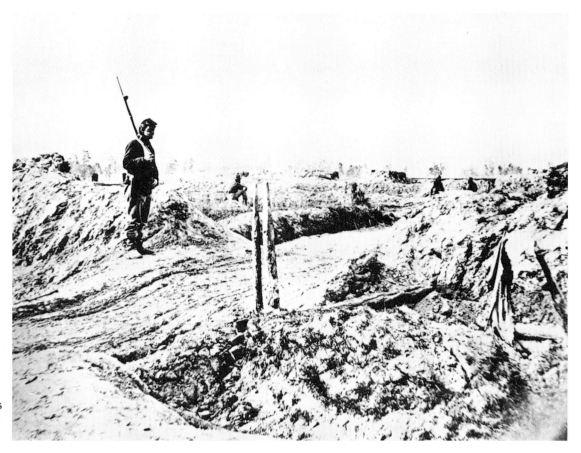

In the end, Petersburg, too, had to fall, leaving the miles and miles of muddy trenches and earthworks behind as Lee's Confederates desperately tried to escape Grant's encircling minions. (USAMHI)

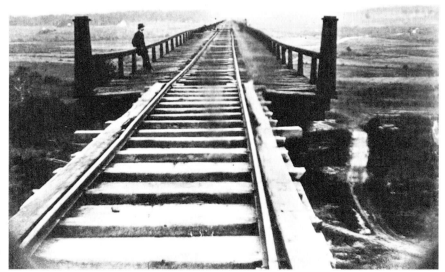

Lee tried to burn High Bridge, over the Appomattox River, behind him to stop Grant, but it did not work. It was only an issue of days and hours now. (USAMHI)

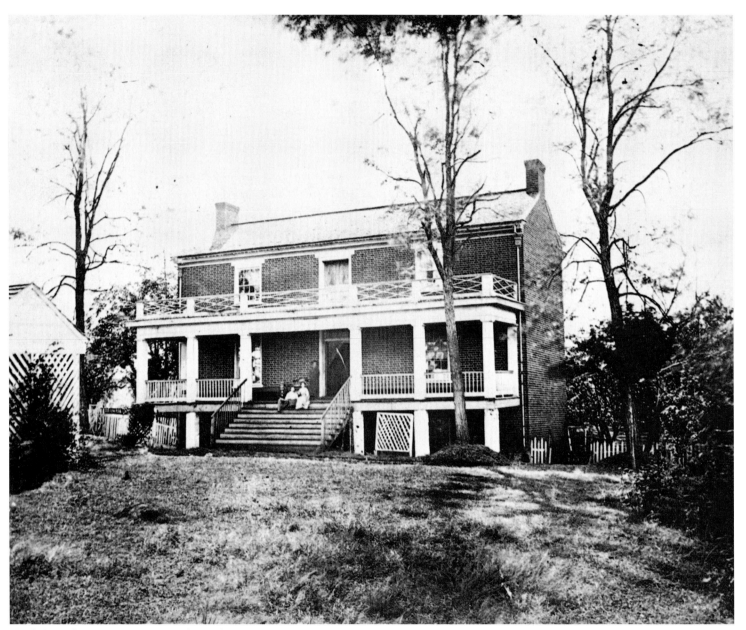

And then, finally, it was done. The embattled continent came to peace once more
as Grant and Lee met to accept the Confederate's surrender here at the McLean
house in the town known as Appomattox Court House, while the other Rebel armies
carried on for a few weeks more before they, too, succumbed. The land they left
behind them, like its people, would never again be the same. (USAMHI)

The Men in the Ranks

★

Perry D. Jamieson

WHEN THE WAR BEGAN, old army veterans were wryly amused by the enthusiasm and dashing uniforms of the volunteer regiments. The men of the Sixteenth New York wore straw skimmers, until they learned on the Virginia Peninsula in 1862 that their fancy white hats made excellent targets. There were colorful zouave regiments with baggy trousers and Turkish fezzes — units such as the Fifth New York, which took devastating losses at Second Bull Run, and the Ninth New York, which fought stubbornly at Antietam. The Thirteenth Pennsylvania Reserves came from the "wildcat district" of Forest, Elk, and McKean counties, and most of its members were lumbermen, who reported to the regiment in red flannel shirts. One soldier decorated his hat with a piece of deer fur, his comrades copied him, and the unit became famous as the Pennsylvania Bucktails.

Other units were conspicuous for their weapons or mascots. The Twelfth New Jersey fired "buck and ball" from their 69-caliber smoothbores, while Berdan's Sharpshooters boasted Sharps rifles. Col. Richard H. Rush's Sixth Pennsylvania Cavalry was known throughout the Army of the Potomac as Rush's Lancers. Maj. Gen. George B. McClellan suggested that the regiment be armed with lances, and its officers voted to accept the idea. The troopers received nine-foot Austrian lances, with eleven-inch, three-edged blades and scarlet streamers. The Eighth Wisconsin was called the Eagle Regiment: its mascot was Old Abe, a bald eagle. Perched on a stand near the regiment's flag, the bird of prey accompanied the Eighth on the march and into battle. Dozens of other regiments, now forgotten, were famous in their day.

Sometimes an entire brigade gained distinction. Brig. Gen. John Gibbon's Black Hat Brigade from the Old Northwest wore high-crowned black hats known in the old army as Hardee or Jeff Davis hats. The brigade was made up of three Wisconsin regiments and the Nineteenth Indiana, joined later by the Twenty-fourth Michigan. The brigade's performance at South Mountain won it an even more famous nickname: the Iron Brigade. The unit's fight on the first day at Gettysburg was among the finest brigade actions of the war. The Irish Brigade, raised by Thomas F. Meagher in New York City, consistently

encountered the Confederates in difficult positions, such as the Bloody Lane at Antietam and Marye's Heights at Fredericksburg. One Confederate officer remembered the brigade's courageous advance at Fredericksburg: "In the foremost line we distinguished the green flag with the golden harp of old Ireland, and we know it to be Meagher's Irish brigade." At Gettysburg, Fr. William Corby offered general absolution to the brigade before it entered the maelstrom of the second day's battle. "That general absolution was intended for all," Father Corby later wrote, "not only for our brigade, but for all, North or South, who were susceptible for it and who were about to appear before their Judge." In the western theater, Brig. Gen. William B. Hazen's brigade was remembered for its stubborn combats at Stones River and Chickamauga, while Brig. Gen. John C. Starkweather's brigade suffered heavily at Perryville and Chickamauga.

Southerners had their famous units as well. Five Virginia regiments formed the brigade known as Stonewall, which earned that nickname for itself, and its commander, at First Manassas. The 1862 campaigns wore down this outstanding brigade, until at Sharpsburg it had only 250 men in its ranks; and in that battle it lost another 11 killed and 77 wounded. Thomas J. ("Stonewall") Jackson's staff officer, Henry Kyd Douglas, quoted some of Jackson's dying words: "They are a noble set of men. The name of Stonewall belongs to that brigade, not to me." Hood's Texas Brigade, commanded by Kentucky-born Brig. Gen. John Bell Hood, stormed across battlefields of both theaters of the war. It was the only unit to break the Union line at Gaines' Mill, and suffered fearful losses at Second Manassas, Sharpsburg, and Gettysburg. In the famous "General Lee to the rear" episode during the Battle of the Wilderness, the soldiers of the Texas Brigade turned Traveller and his irreplaceable rider to the rear when Lee sought to lead a charge personally, before the brigade would go forward. During the Petersburg campaign, General Lee once observed: "The Texas brigade is always ready." Western soldiers knew the First Kentucky Brigade as the Orphan Brigade — its men fought the war isolated from their homes in the Upper South. After the brigade's hopeless charge at Murfreesboro, Maj. Gen.

John C. Breckinridge lamented: "My poor Orphan Brigade! They have cut it to pieces!"

The men of these brigades marched in columns, long streams of soldiers that filled the back roads of Mississippi, Tennessee, and Virginia. The standard tactical manuals of the day, William J. Hardee's *Rifle and Light Infantry Tactics* and Silas Casey's *Infantry Tactics,* called for the men to march at a route step of 110 paces a minute. During his famous Shenandoah Valley campaign, Stonewall Jackson insisted on a regimen that alternated precisely fifty minutes of marching at route step with exactly ten minutes of rest. Even at a slower pace, marching was tedious work. One Confederate wrote of a march during the Second Manassas campaign: "There was no mood for speech, nor breath to spare if there had been — only the shuffling tramp of the marching feet, the steady rumbling of wheels, the creak and rattle and clank of harness and accouterment, with an occasional order, uttered under the breath and always the same: 'Close up! close up men!'"

Stunning marches punctuated many campaigns. Jackson's "foot cavalry" made astonishing marches during the Shenandoah Valley, Second Manassas, and Chancellorsville campaigns. Maj. Gen. William T. Sherman's men completed their famous advance from Atlanta to Savannah in twenty-five days. At the opening of the Shenandoah Valley campaign of 1864, Lt. Gen. Jubal A. Early pressed his veterans to cover more than eighty miles in four days.

A poor march also might influence a battle or campaign. The men of Brig. Gen. Lew Wallace's division spent the afternoon and evening of April 6, 1862, in a disjointed march and countermarch of about thirteen miles, and arrived across Snake Creek too late to help their comrades in the desperate first day's fighting at Shiloh. Stonewall Jackson prodded his men to brilliant marches during his Shenandoah Valley campaign, but during the Seven Days Battles that immediately followed, confusion and tardiness characterized the movements of his command, while the Confederates missed a series of opportunities to strike a decisive blow against the Army of the Potomac. A mistake in marching orders delayed by several hours the arrival of Maj. Gen. William F. Smith's corps at Cold Harbor on

June 1, 1864. A staff officer explained to army commander George G. Meade that Smith had little ammunition, no wagons, and his corps was in a vulnerable position. "Then why in hell," Meade asked, "did he come at all?"

Moving a mass of soldiers from a marching column into a fighting line was a complicated business, requiring that officers master detailed drill-book instructions, such as those describing the four different "modes of passing from column at half distance, into line of battle." Brig. Gen. John Beatty, a volunteer soldier, complained that he spent the first summer of the war struggling to understand his drill manual. "The words conveyed no idea to my mind," he admitted, "and the movements described were utterly beyond my comprehension." Shortly after the war, one veteran commented that he "never saw a full company execute the facings" according to Casey's *Tactics* "without making mistakes." Yet Beatty and thousands of other officers studied their tactical manuals until they mastered them, and their men got into their places, if not always according to the book.

Regiments deployed into line of battle with a regimental flag, or perhaps the national colors, prominently displayed in their front rank. Civil War soldiers invested great emotion in these banners. In June 1863 a Confederate officer wrote proudly that his regiment had marched into Pennsylvania with its "red battle flag inscribed all over with the names of our victories." Three days after the bloodbath at Antietam, a New York infantryman recounted: "Our color guards were cut down almost to a man and Kimball, our hot headed Lieut. Colonel, finally seized the flag himself and wrapped it round him. Strange to say, he was uninjured." At Murfreesboro, the color sergeant of the Twenty-fifth Tennessee ripped his flag from its staff and hid it in his uniform to prevent it from being captured. This enterprising sergeant was taken prisoner, escaped, and proudly returned to his unit, with its flag. The officers of the Eleventh North Carolina burned their flag rather than surrender it to the Yankees at Appomattox.

The colors aroused unit pride, and they also served a practical function in battle. This was a black-powder war. A regiment deploying into line, advancing into a woodlot, and opening fire soon engulfed itself in an enormous cloud of white smoke. On a warm, calm day in heavy woods, the cloud would linger over the firing line, and it would become more dense as neighboring units added their volleys. The roar of artillery and shoulder arms drowned the voices of officers and the sound of drums, and enemy fire often cut down mounted officers. In the reigning smoke and confusion, many times the infantryman's best assurance of his regiment's location was a quick glimpse of the colors waving in the white cloud of battle.

The number of flags in an area suggested how many regiments were there. This maxim was illustrated by a postwar anecdote about Stonewall Jackson at Sharpsburg. Jackson, wanting to launch a counterattack, ordered a North Carolina soldier to climb a tree that commanded the Union ground beyond the East Woods. The general told the man to count the Federal flags in that sector, and when the Tarheel had reached thirty-nine, Jackson called him down. Stonewall had learned that there were too many Yankees, and he canceled the assault. General Lee used the same tactic in 1864 at Petersburg, during the Battle of the Crater. He had Col. W. H. Palmer count Union battle flags, as a measure of the extent of the break in the Confederate line.

The movement of the colors usually told the course of a battle. The flags often were at the forefront of a successful attack, such as the Federal advance up Missionary Ridge at Chattanooga. William B. Hazen reported of his brigade in that charge: "Not much regard to lines could be observed, but the strong men, commanders and color bearers, took the lead in each case, forming the apex of a triangular column of men." A concentration of flags might also mark a defeat. When the Confederates were repulsed from Cemetery Ridge at Gettysburg, they left behind them at least thirty colors.

The tactical manuals of the day provided that the colors be "on the left of the right-centre company." This put the flag at the center of a regiment's first line, where it was certain to attract heavy fire. Destructive volleys against a regiment's color guard could affect the unit's cohesion, disrupting what in the twentieth century would be called the "command and control" of the regiment. More important to nineteenth-century

soldiers, the flag was a trophy. Capturing an enemy's banner was undeniable evidence of a success in battle.

The tactical manuals called for a sergeant to serve as color-bearer — a soldier chosen by his colonel for his marching ability and "a just carriage of the person." This sergeant had a color guard of several corporals posted around him, but in the trauma of battle, any officer or man bold enough might pick up the flag if the color sergeant went down. The colonel of the Sixteenth Tennessee reported after Murfreesboro: "My flag-bearer (Sergeant Marberry) was disabled early in the charge. The flag was afterwards borne by Private Womack, who was also wounded. The flag-staff was broken and hit with balls in three places; the flag literally shot to pieces." When John Sedgwick's division was shot apart in the West Woods at Antietam, the color sergeant of the Thirty-fourth New York was wounded five times before dropping his flag. Nine days after Gettysburg, an officer of the Fourth Michigan described his regiment's defense of its flag in the Wheatfield: "A rebel officer had seized the colors of the 4th," Lt. Charles Salter wrote, "and Col. Jeffreys was defending it with his sword, when he was bayonetted by the rebels, as also the color bearer, and many others, who were trying to recover the colors."

While color-bearers attracted inordinate attention from the enemy, the truth was that every man who went forward with an assaulting line was in deadly peril. In 1864 William B. Hazen identified the main cause of this danger: the "accurate shooting rifle" had "replaced the random firing musket." The accuracy and range of rifle shoulder arms allowed defenders to deliver deadly volleys across hundreds of yards. Defending troops learned to increase this advantage with field entrenchments, which appeared more often and became more sophisticated as the war went on. Most Civil War battlefields were dominated by defending fire from well-protected infantrymen armed with rifles and artillerymen with smoothbore cannons. The chaplain of the First Massachusetts, who witnessed several charges during the May 1864 Battle of the Wilderness, saw that the defense consistently had the upper hand. "Whenever the Federal troops moved forward," he observed, "the Rebels appeared to have the advantage. Whenever they advanced, the advantage was transferred to us."

Assaulting troops often suffered horrifying losses. The Twentieth Massachusetts was one of many Union regiments that were broken apart in the senseless charges against Marye's Heights at Fredericksburg. The Twentieth advanced stubbornly and volleyed with the Confederates when the other regiments in its brigade fell back. It suffered over 160 killed and wounded, more than two-thirds of its number. While the second day's battle at Gettysburg hung in the balance, Maj. Gen. Winfield Scott Hancock called on the First Minnesota for a desperate assault. The regiment responded with an unsupported charge that cost the unit 82 percent of its effectives and left a captain in command of the regiment. During the bloodbath attacks at Cold Harbor on June 3, 1864, the Twenty-fifth Massachusetts suffered total casualties of 70 percent. The regiment had nearly reached the Confederate entrenchments, when, its colonel reported, it was "met by a storm of bullets, shot and shell that no human power could withstand." The survivors took what cover they could find and dug rifle pits with their hands and tin cups.

Confederate units also suffered enormous casualties on the offensive — staggering losses that the South, with fewer soldiers than the North, could not afford. In one of the war's fiercest counterassaults, Gen. John Bell Hood led his division into the Miller cornfield at Sharpsburg. The Fourth Texas, whose men were described by their lieutenant colonel as "half clad, many of them barefoot, and . . . only half fed for days before," lost more than 50 percent of its number in this action. The First Texas advanced on the left of the Fourth, carried 226 men and officers into the cornfield, and lost at least 182, roughly 80 percent of the regiment. Brig. Gen. George E. Pickett's charge at Gettysburg cost the South total casualties of over 6,400, about 62 percent of the soldiers who made the advance. Contemporary and postwar studies of several regiments put their total losses at more than 80 percent, and a few companies claimed losses of over 90 percent. Company A of the Eleventh North Carolina, in James J. Pettigrew's division, had entered the campaign with 100 men and officers. After the great assault on July 3, it was reduced to 8 men and a lone officer. The color company of the Thirty-eighth North Carolina was annihilated. Of the 32 field officers in Pickett's divi-

sion, only 1 returned to Seminary Ridge unhurt. On November 30, 1864, the Army of Tennessee suffered over 5,500 casualties in its assault at Franklin. A union staff officer recalled that the Confederates "threw themselves against the works, fighting with what seemed the very madness of despair." Six Southern generals were killed or mortally wounded, 5 were wounded but survived, and 1 was captured. More than 50 regimental commanders became casualties.

The fate of Maj. Gen. Patrick R. Cleburne's division at Franklin epitomized the heroic tragedy of many Civil War attacks. The division made a long advance, longer than Pickett's at Gettysburg, across open fields. General Cleburne lost two horses and then went forward on foot until he was killed in front of the Union entrenchments. His command was shattered by artillery and rifle fire, leaving hundreds of Southern dead and wounded strewn along the Columbia Pike and near the Federal works. In Brig. Gen. Hiram B. Granbury's brigade, the commander was shot in the face and killed, his chief of staff was killed, and three regimental commanders were reported missing. Ten days after the battle, Granbury's brigade, and all its regiments, were commanded by captains. "The wonder is," one Union infantryman reflected, "that any of them escaped death or capture."

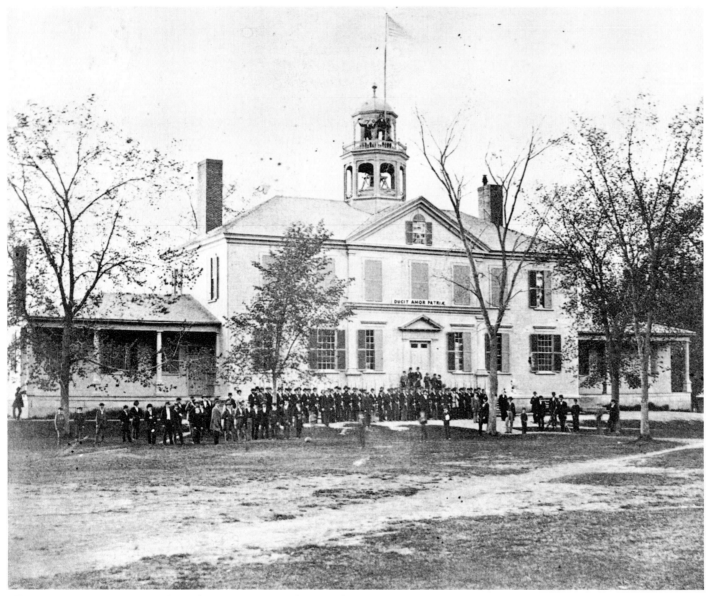

"Ducit Amor Patriae" reads the rather ungrammatical Latin phrase over the door. Its intent is clear. Imploring that they be led onward for the love of their native land, these citizen-soldiers, many of them still in mufti, present a scene repeated in thousands of small towns North and South as the young manhood of America stepped forward to enlist by the millions. (USAMHI)

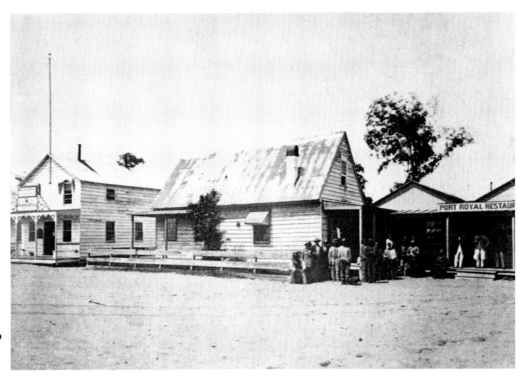

Recruiting stations like this one on Hilton Head, South Carolina, photographed on September 8, 1864, urged the two nations to send forth their sons to fill the newborn regiments. (USAMHI)

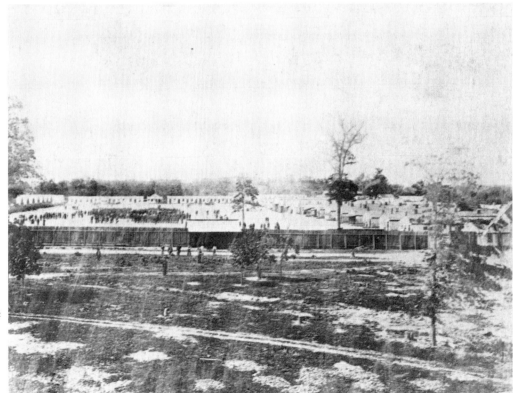

Once enlisted, the recruits saw their first taste of the military life in training camps like this one: Camp Butler, near Springfield, Illinois. Over and over again, they worked at their evolutions until they got them right — or as near right as American volunteers ever became proficient at drill. (USAMHI)

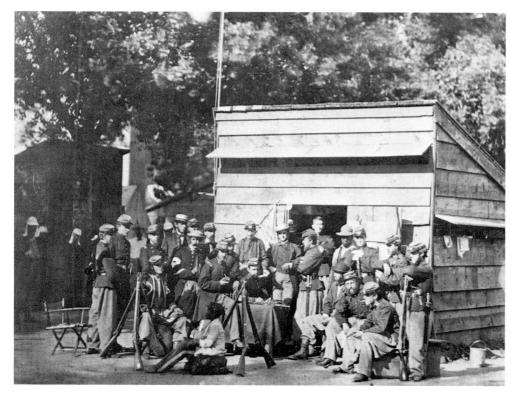

Once trained, their weapons at hand, the novice soldiers posed proudly before the cameras. Their uniforms new, their arms brightly polished, they were as innocent as the nations sending them to war. Men of the Twelfth New York in a Mathew Brady & Company image made in 1861. (USAMHI)

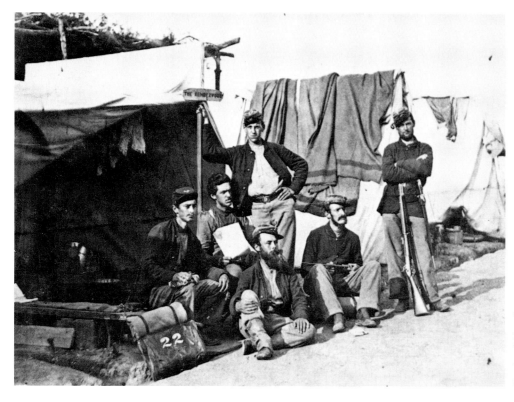

The Twenty-second New York State Militia, men of Company D, pose at Harpers Ferry, Virginia, well equipped, and with some touches of home about "The Rendezvous." (USAMHI)

The Confederates, too, had homey tents for the new recruits. The Clinch Rifles, men of the Fifth Georgia, proudly display the Stars and Bars, their new national flag, from their tent pole. Within only a few months after the outbreak of war, such a well-supplied Confederate tent will be a rarity. The bright weapons, the new uniforms and full knapsacks, even the tent itself, will seem like luxuries in the days ahead. Only the black servant is likely to remain a constant. (USAMHI)

Bottom left: The Oglethorpe Infantry, Company D of the First Georgia, show what a new Rebel regiment looked like drawn up in formation for the camera. (USAMHI)

Bottom right: Formations played a big role in the new regiments' training. An unidentified company of Yankees goes through part of their daily drill for the camera. . . . (USAMHI)

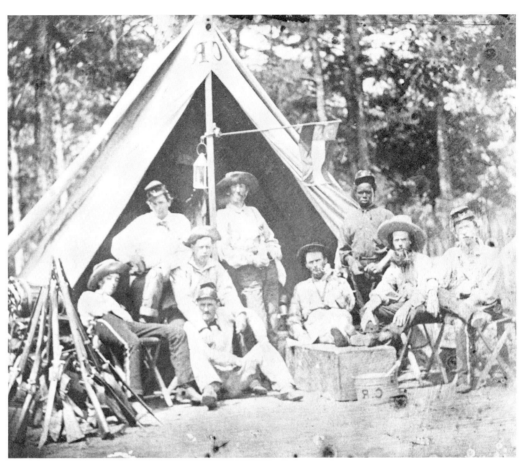

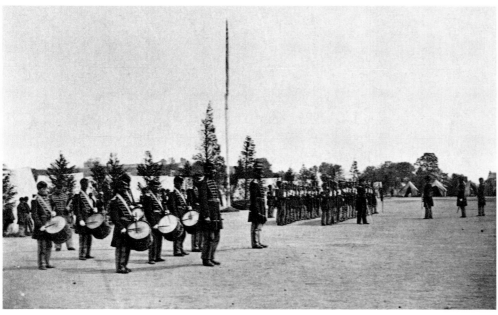

. . . And this time, the company poses with their musicians drawn up to provide the march step. (USAMHI)

The regiments spent their days in camps like this one near Alexandria, Virginia. Maj. A. J. Russell, the North's only official army photographer, made this image of the camp of the Eleventh United States Infantry on April 3, 1864. (USAMHI)

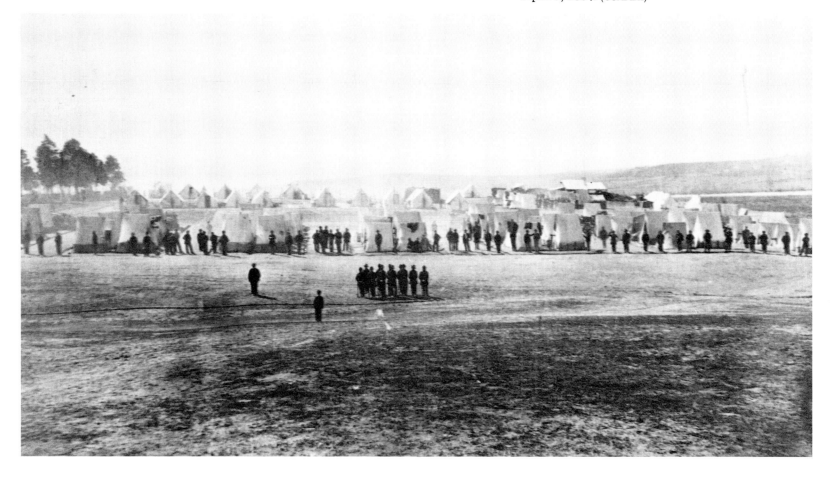

Tented camps in summer and log-hut winter camps sprang up all across the continent. Here, in Grove Camp, the Twenty-fifth Massachusetts passes a winter near New Bern, North Carolina. (USAMHI)

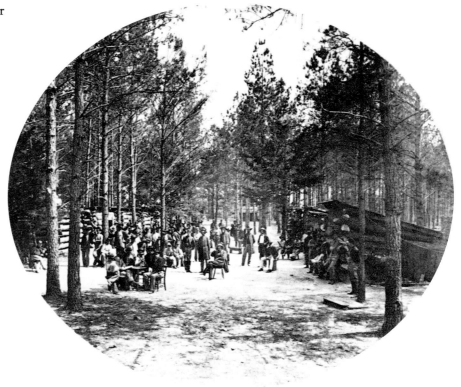

There were a few pastimes available to the soldiers of North and South: reading, letter writing, friendly games of cards and dominoes, and whatever else the boys could invent to fill their idle hours. Here, men of the Third New Hampshire's Company F divert themselves at Hilton Head in 1862. (USAMHI)

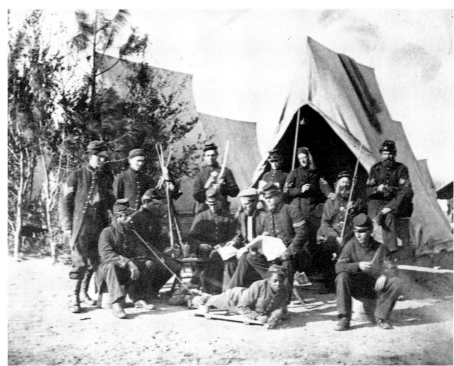

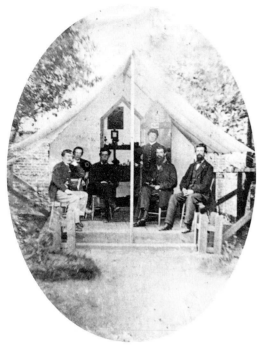

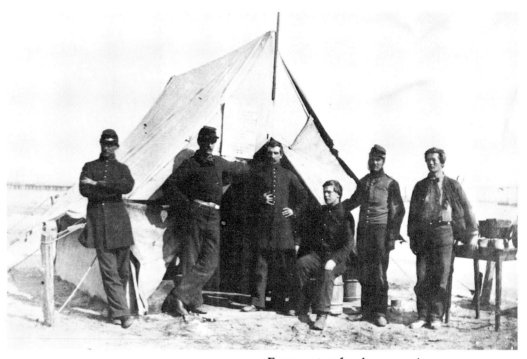

Just visiting with friends and messmates, like these men of the 153d Pennsylvania, got the soldier through another day. (USAMHI)

Even posing for the camera's eye was a novelty—so much so that very few images of the men in their camps have a truly "candid" look about them. A wooden pose was the order of the day. (USAMHI)

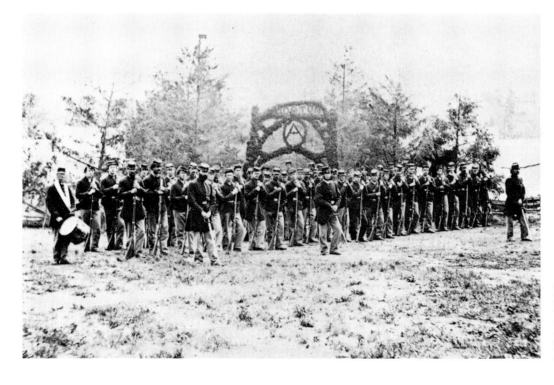

Posing grew to grander scales when regiments like the Thirtieth Pennsylvania embellished their winter camps with laurel archways. Here Company A stands proudly before their handiwork. (USAMHI)

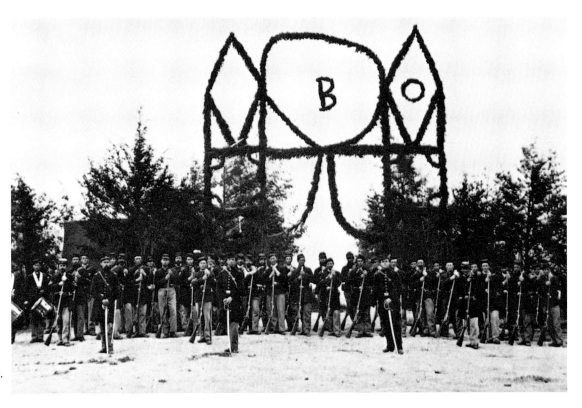

And nearby, Company B does the same.
(USAMHI)

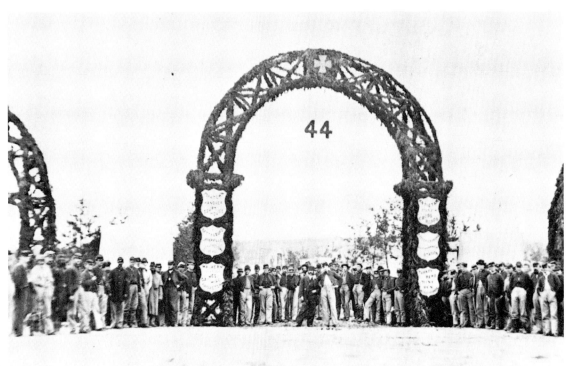

Some regiments even displayed their
battle credits, listing their defeats, like
Fredericksburg, along with their victories.
(USAMHI)

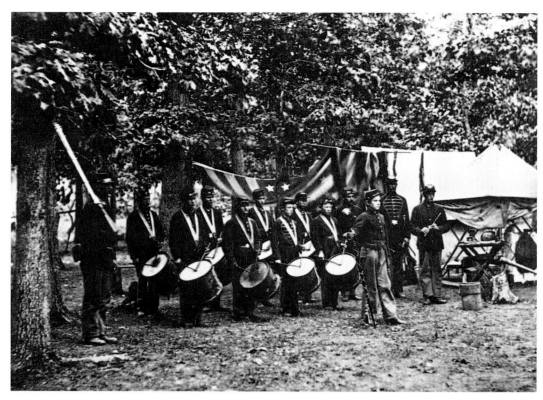

Of course, there were always bands to play. Here, the drum corps of the Ninety-third New York in August 1863. (USAMHI)

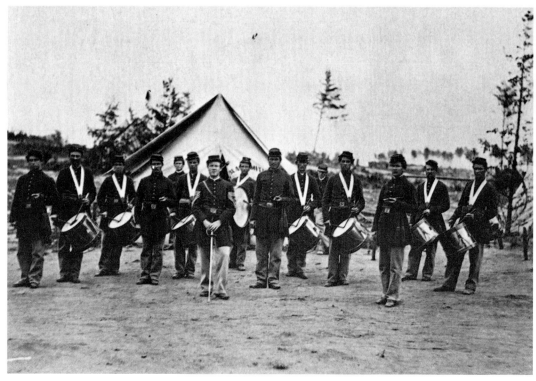

And here, the bandsmen of the Thirtieth Pennsylvania Reserves. In actual battle, when not drumming they were expected to act as litter-bearers, helping remove the wounded from the field. (USAMHI)

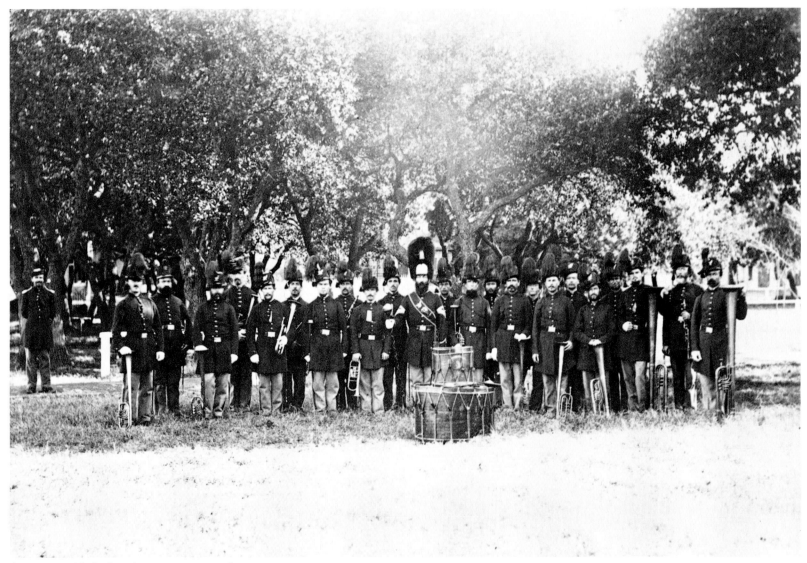

A more established and permanent installation could afford to maintain a more elaborate band. Fort Monroe, near Norfolk, Virginia, remained in Union hands throughout the war, and its beplumed bandsmen sported all manner of instruments. (USAMHI)

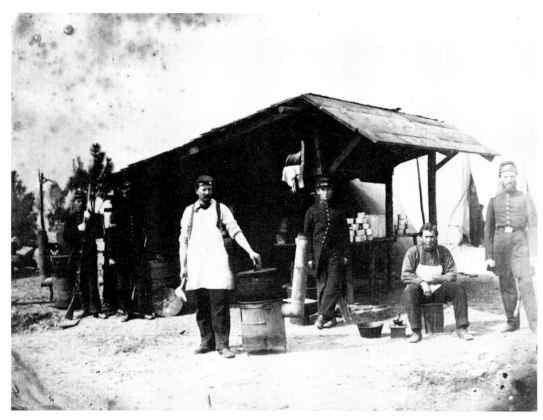

Of more immediate and more lasting interest to the soldiers in the Yank and Reb regiments was food — rarely appetizing, and often scarce. A good cook could be a popular fellow. The cook's galley of H Company, Third New Hampshire, at Hilton Head shows "cookie" at work, with the implements of his trade nearby. (USAMHI)

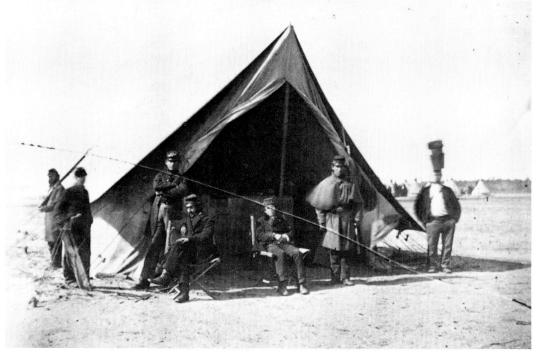

What the commissary did not supply, the men could supplement for themselves from the sutlers, quasi-official vendors who followed the armies. Some sutlers erected substantial stores to peddle their books and pies and candles and whiskey, but most set up less elaborate affairs, like this one — a simple tent with a bar inside. Very few were likely to boast a man like the fellow at right, unsteadily balancing a couple of buckets on his head. (USAMHI)

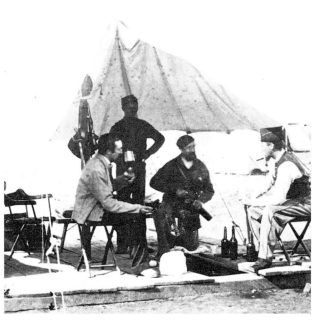

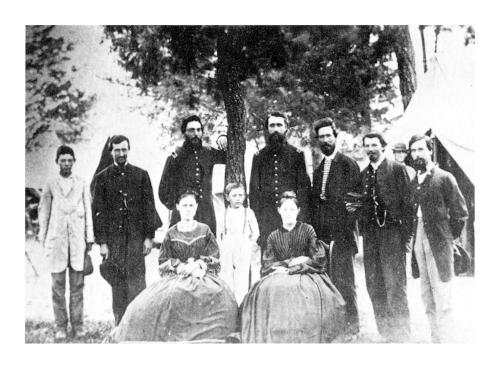

Top left: A bottle of wine was always popular with the boys, and these oenophiles had their own "cellar" beneath a floorboard. (USAMHI)

Top right: The fortunate, usually officers, might even entertain members of their family in quieter times. Men of the 125th Ohio here lounge for the camera with wives and sons. (USAMHI)

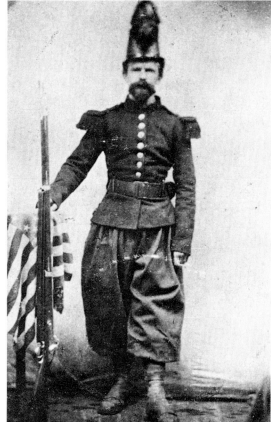

The camera was ever popular. The private soldier loved to stand for it in the studio, posing in full uniform, weapon at the ready. (USAMHI)

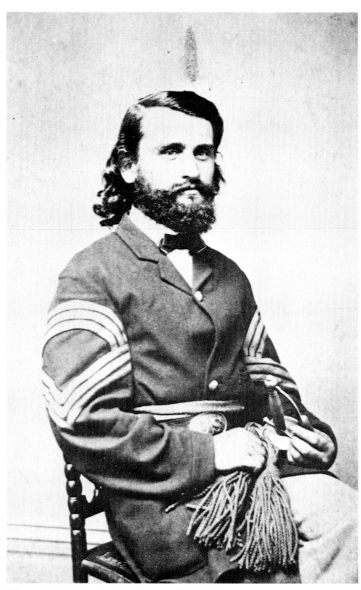

They slicked back their hair, polished their
buckles and buttons, and held fondly to their
swords and sashes, like Sgt. R. W. Bowles
here. (USAMHI)

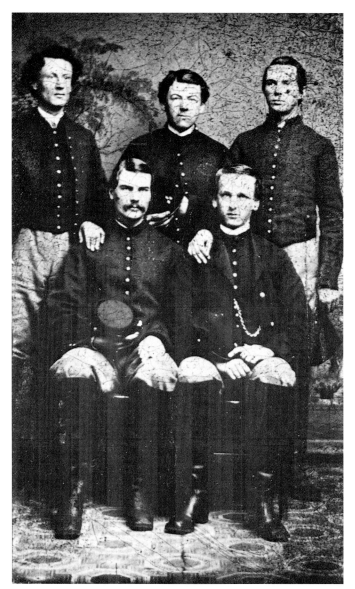

And groups of comrades like these five
unidentified Yankees formed a seemingly
endless procession into the tent studios to sit
for group portraits to send back home or to
keep as mementos of the most important
events of their lives. (USAMHI)

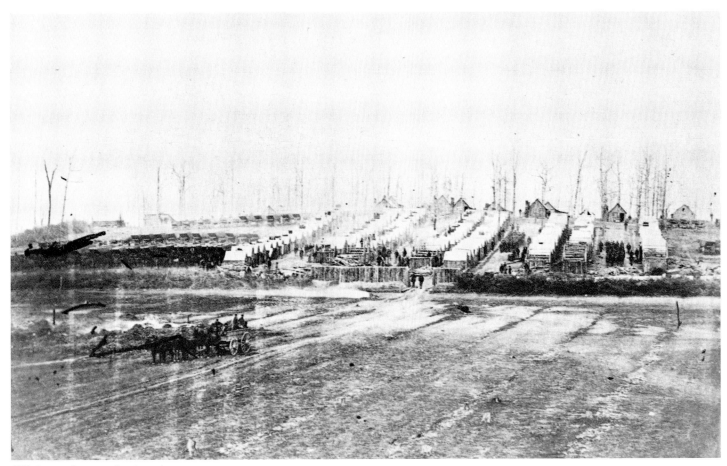

While on the march, their homes were quickly and simply erected and taken down again. But when the cold weather came, more permanent winter camps arose, like this virtual town of log-and-canvas houses built by the Fiftieth New York Engineers near Rappahannock Station, Virginia, in the winter of 1863/64. (USAMHI)

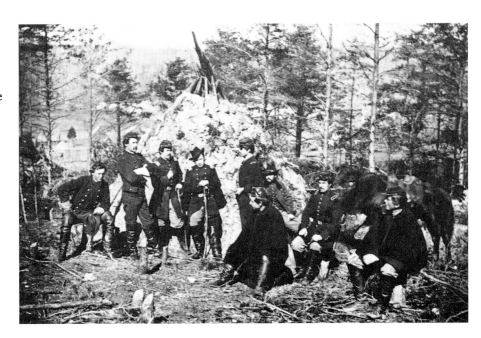

Whole forests could be denuded as the log houses — and, apparently, a log-and-mud smokehouse shaped like a teepee — were built. Here the structure serves as backdrop for members of the 164th and 170th New York. (USAMHI)

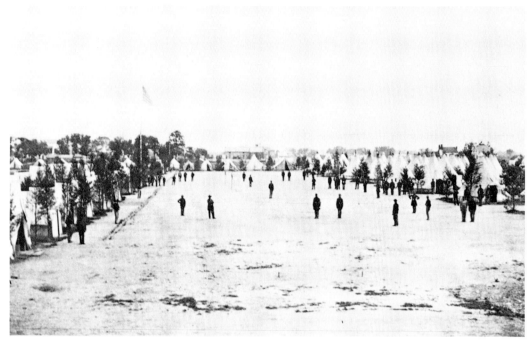

The round Sibley tents set atop wooden palisades in the camp of the 153d New York each boasted a tree or two outside its door. The soldiers tried to take something of home with them wherever they went. (USAMHI)

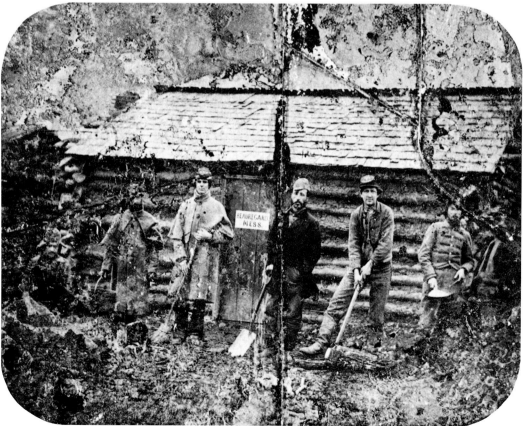

The Confederates, too, built winter quarters — though, as usual, they had to make do with less. Men believed to be from the First Texas built this log hut at Camp Quantico, near Dumfries, Virginia, in the winter of 1861/62. They named their "Beauregard Mess" for one of their Southern heroes, Gen. P. G. T. Beauregard, the man who took Fort Sumter. (RM)

Regiments doing more permanent garrison duty could luxuriate in much more lasting —and comfortable—quarters, like these barracks at Sandy Hook, New Jersey. (USAMHI)

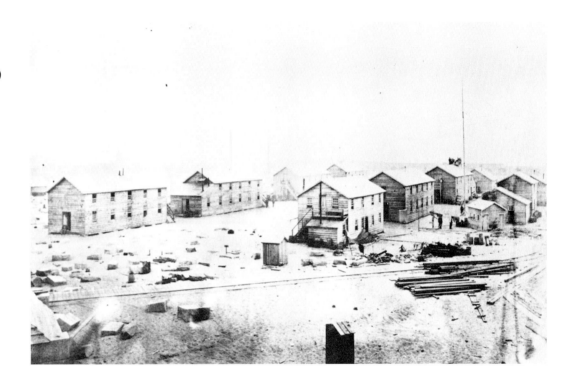

Bottom left: And on Bedloe's Island, in New York Harbor, the barracks were positively lush. (USAMHI)

Bottom right: Wherever they were, the regiments built more than their own quarters. They took their God with them, and built modest chapels for worship. Here, the church of the Fourth Massachusetts Cavalry. (USAMHI)

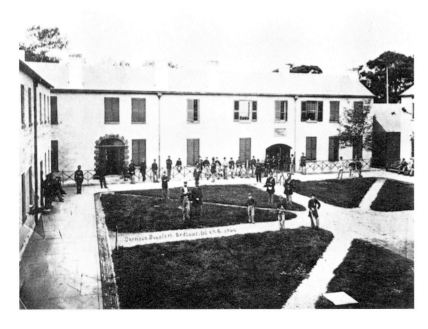

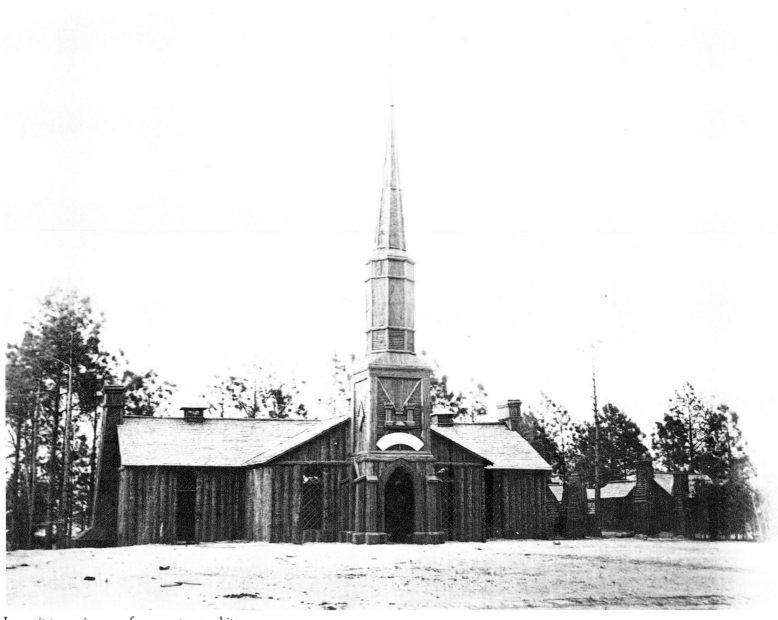

Leave it to engineers, of course, to go a bit
further, as some New Yorkers did with this
regimental church at Poplar Grove, Virginia,
in 1864. (USAMHI)

Top: When the men were ill, there were field hospitals for them, like this modest infirmary for the Third New Hampshire on Hilton Head. (USAMHI)

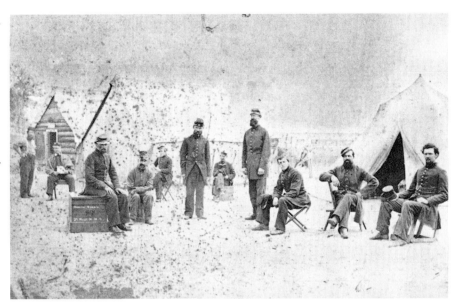

Bottom: When they misbehaved, there was always the provost marshal to police them and their camps. This is the provost's headquarters in the Army of the James at Bermuda Hundred, Virginia, in the winter of 1864/65. (USAMHI)

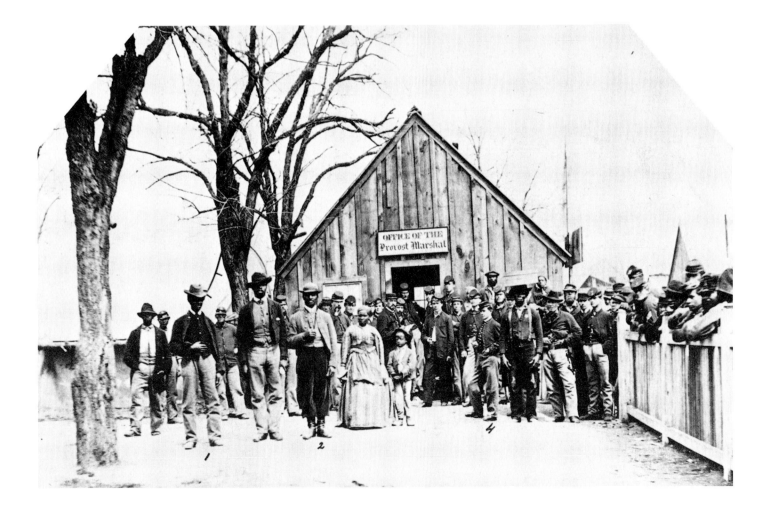

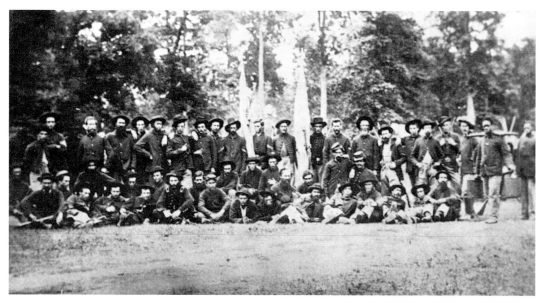

Conditions were much the same for the regiments whether they served east or west of the Alleghenies, though the westerners had a rawboned, more rugged look to them. These men of the 125th Ohio's Company C show the somewhat rumpled yet determined character of the men who did their fighting between the mountains and the Mississippi. (USAMHI)

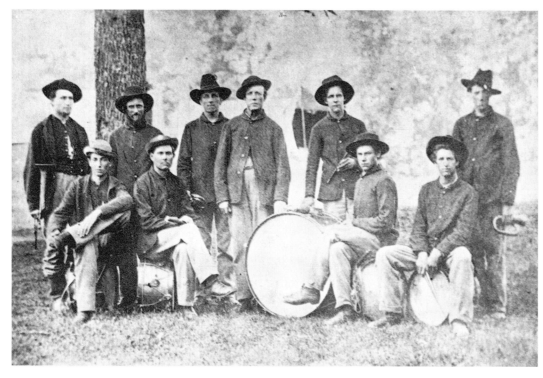

Yet they, too, had their bands. Here, the "Tiger Band" of the 125th Ohio. (USAMHI)

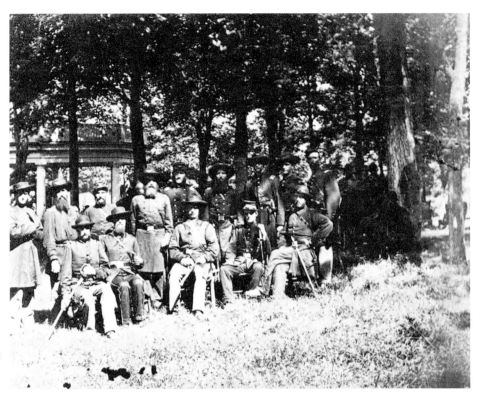

And they, too, liked to pose for the camera. Officers of an unidentified western regiment sit and stand stiffly in their full uniforms, and then, for the fun of it, . . . (USAMHI)

. . . they sit again in their shirt sleeves as the troops huddle round. (USAMHI)

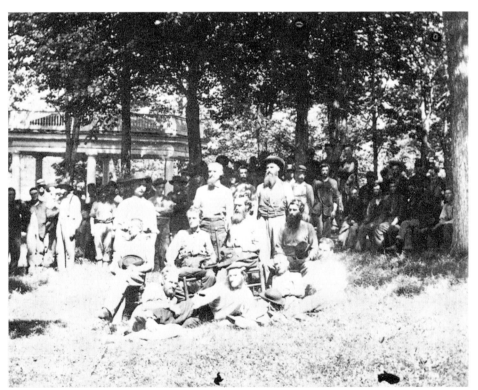

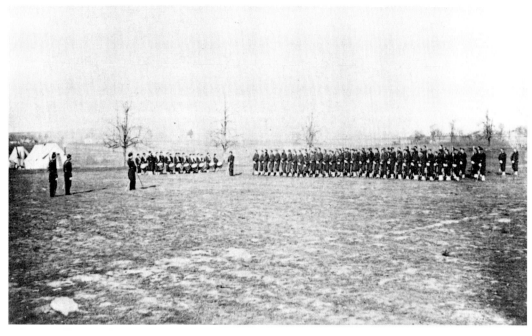

The variety of the uniforms that they wore, East and West, North and South, was dazzling. It is a shame that the cameras of the day could not capture in all their gaudy color a regiment of zouaves like the 164th New York at guard mounting . . . (USAMHI)

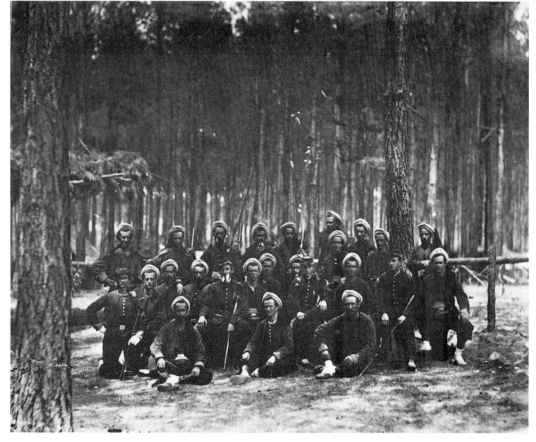

. . . or the 114th Pennsylvania, with its turbans, shown here at Petersburg, Virginia, in August 1864. (USAMHI)

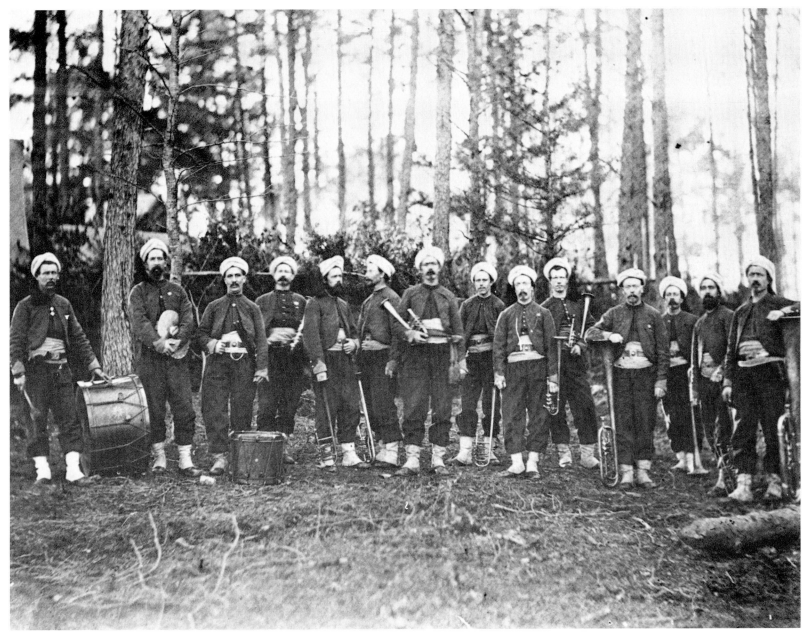

Even the 114th's band wore the outfit, which
looked more like a fraternal lodge's regalia
than soldier's dress. (USAMHI)

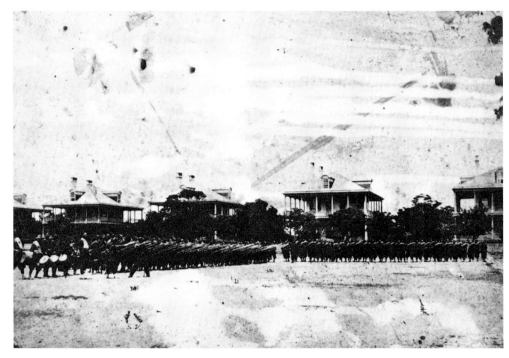

The Confederates had their fancy zouave units as well. Though they do not show well in this damaged old print by New Orleans photographer J. D. Edwards, Coppen's Louisiana Zouaves wore the colorful baggy pants and fezzes borrowed from the French army pattern. (SHC)

And here another New Orleans photographer has caught yet another Louisiana zouave unit standing at ease in 1861. (LC)

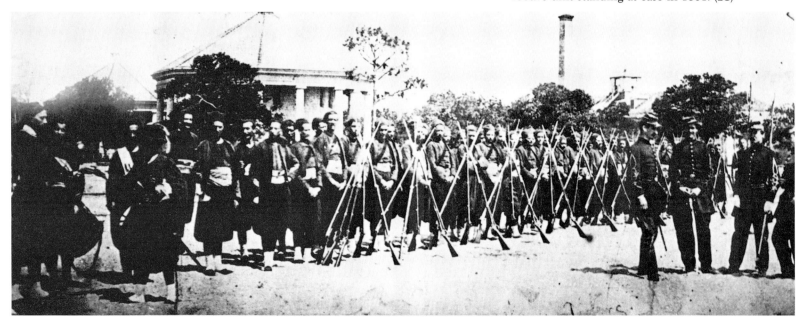

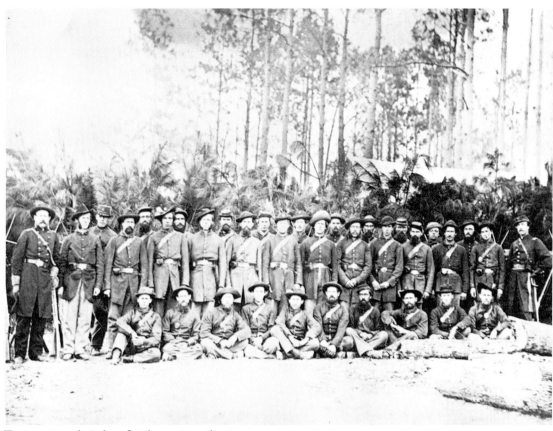

To augment their less flamboyant uniforms, Pennsylvanians like these of the 149th Infantry put buck tails in their hats. (USAMHI)

Some regiments were equipped entirely by donations. American residents in Paris provided the Eighteenth Massachusetts with everything from officers' tents to tin cups when it won a drill competition in the Army of the Potomac. Q.M. Sgt. Edward F. Richards models the uniform in a fatigue cap (*top right*) and a shako with plume. (USAMHI)

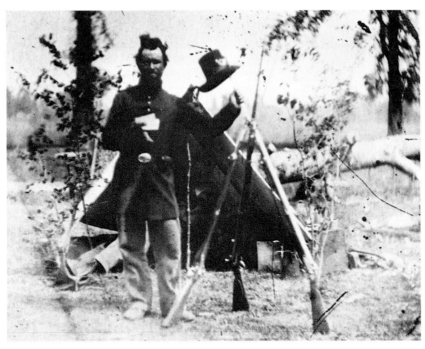

Even among the more commonly equipped regiments, there was still considerable variety. Some, for instance, wore nothing more distinctive from the average than the Hardee hat—though usually on their heads and not their bayonets. (RM)

The so-called regular regiments—like the Eighth United States Infantry, shown here at Fairfax Court House, Virginia, in June 1863 — wore uniformly standard clothing with almost nothing to set them apart from the volunteer outfits. (USAMHI)

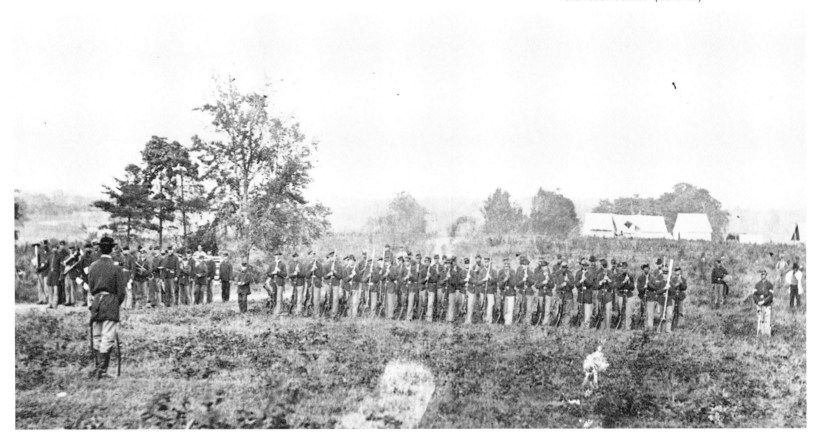

Some regiments adopted mascots, though none became more famous than Old Abe, the eagle that accompanied the Eighth Wisconsin through the war. Here he perches atop a Union shield as men of the regiment's color guard pose near Vicksburg, Mississippi. (OCHM)

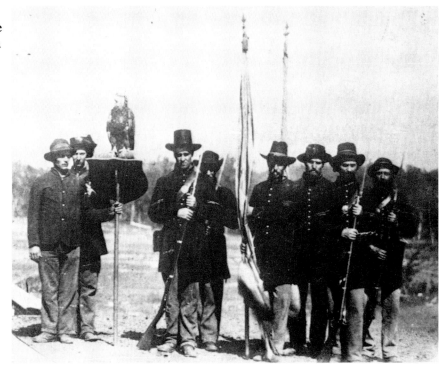

Particularly in the Confederacy, militia and home guard units that existed before the war enlisted en masse and wore their old uniforms into the new service. Men of the Kentucky State Guard pose here at their 1860 encampment at Louisville. A year later, wearing the same dress, most of them would go into the various regiments that formed the Bluegrass State's famous Confederate Orphan Brigade. (KHS)

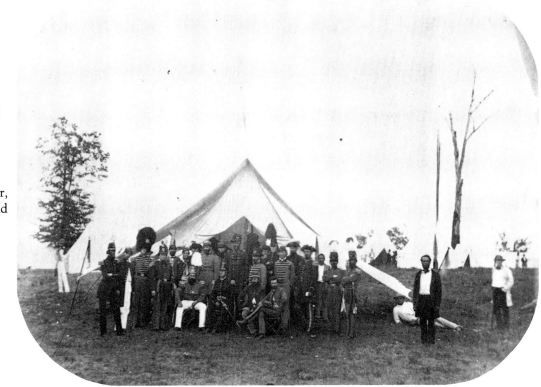

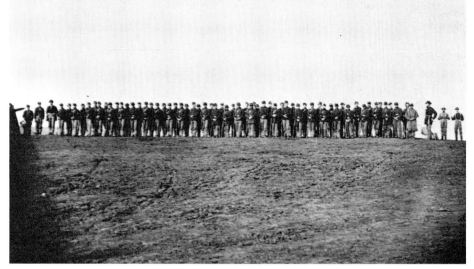

Whatever their background and nativity, the men in the ranks formed thousands of regiments North and South, and theirs was the task of fighting the war. The 139th Pennsylvania stands ready for the fray. (USAMHI)

They stood at attention all across the war-torn continent — like Company A of the First Connecticut Heavy Artillery, shown here in 1863. (USAMHI)

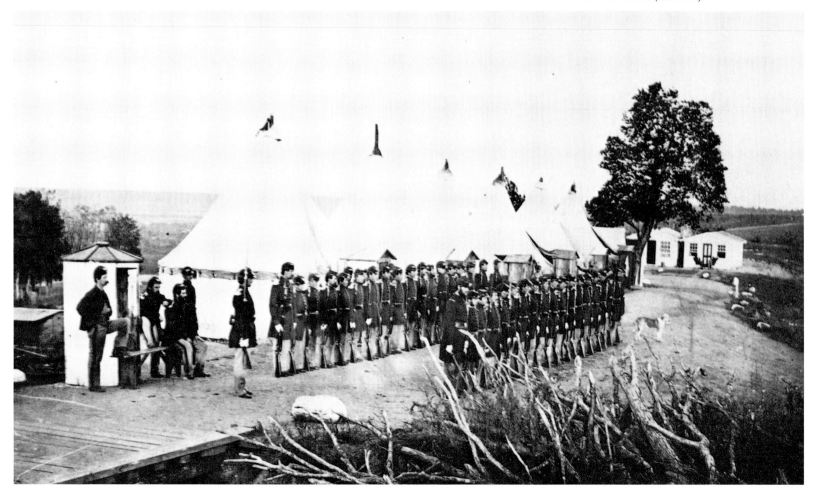

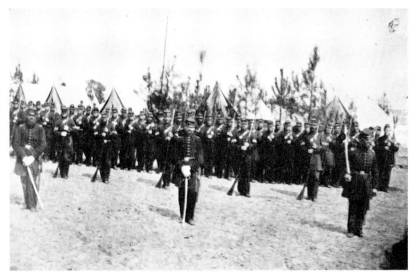

Top left: When not in battle, they could lounge like these men of the De Kalb regiment's Company C, in the old Confederate fortifications at Manassas, Virginia. (USAMHI)

Top right: They might stand doing garrison duty in exotic places like Hilton Head, South Carolina, where Company H of the Third New Hampshire looks martial indeed for the camera of H. P. Moore. (USAMHI)

Bottom right: Or they might sprawl about at their training camps, like this one in Readville, Massachusetts, where the Forty-fifth Massachusetts sits ready to march off to war. (USAMHI)

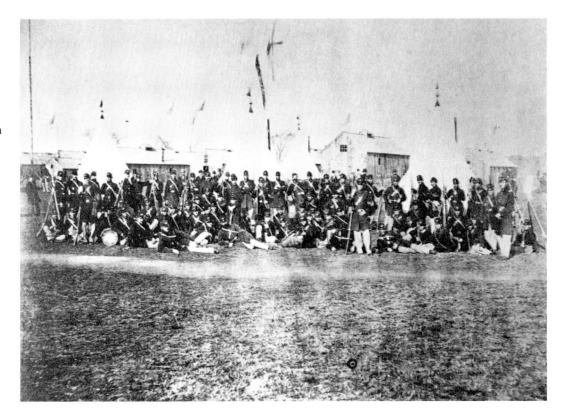

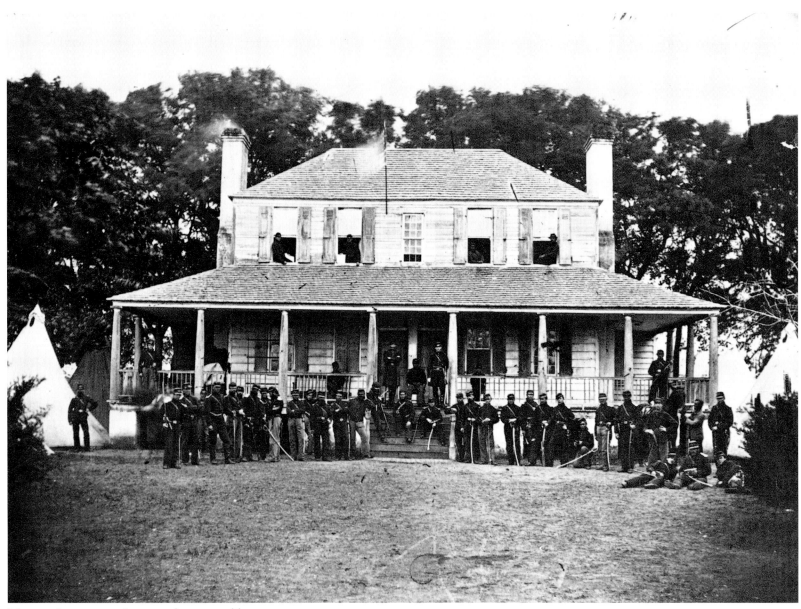

The cavalry were ready, too—horsemen like
these, of the First Massachusetts's Company
G, shown at Edisto Island, South Carolina,
in 1862. Already bloodied in battle, they
would do their part in this war. (USAMHI)

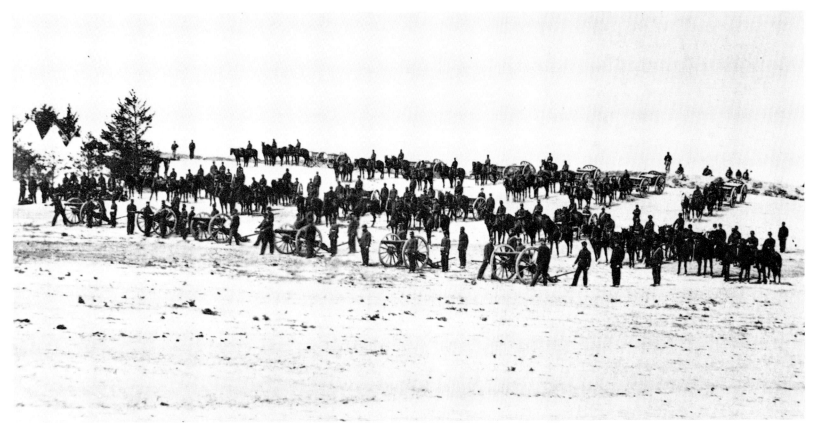

And so would the men who manned the big guns — men like those of Pennsylvania's famed Keystone Battery, with their cannons, caissons, and limbers ready for action. (USAMHI)

All across the continent they were marching. (USAMHI)

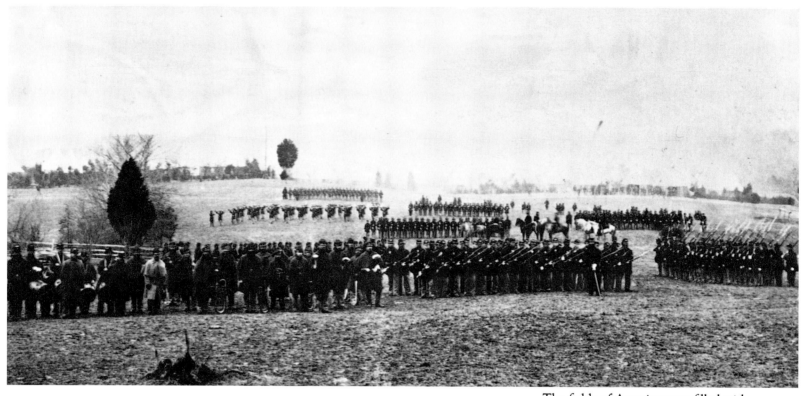

The fields of America were filled with soldiers practicing and drilling. The Second Rhode Island near Washington in the winter of 1861/62. (USAMHI)

They stood at dress parade, like these men of the First Rhode Island Cavalry near Manassas in July 1862. (USAMHI)

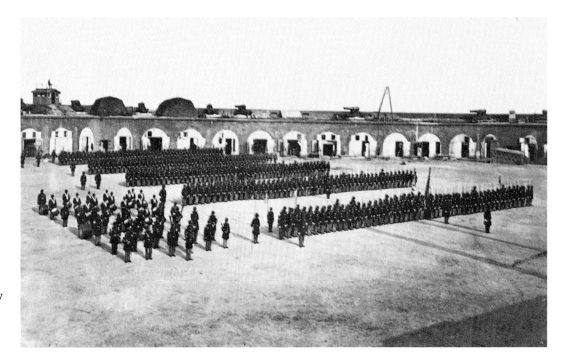

They stood rank upon rank in their masonry fastnesses, such as Fort Pulaski, Georgia, here held by the Forty-eighth New York. (USAMHI)

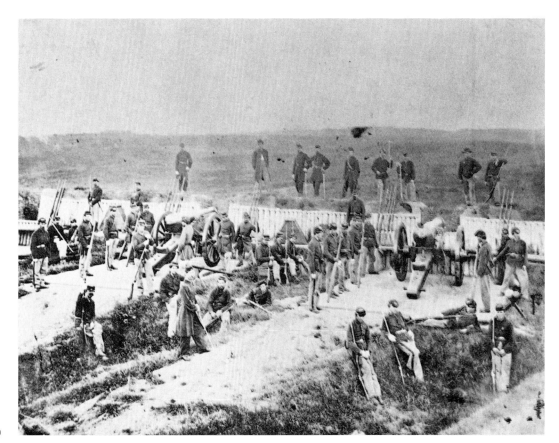

And they fought and bled in a thousand little, unknown places, like these men of the Second New York Heavy Artillery posing at Fort C. F. Smith, near Washington. (USAMHI)

Sometimes they took horrible losses. The
First Minnesota, whose officers are shown
here at Fort Snelling in 1861 before the
regiment went to the front, was almost
destroyed in the war. (MHS)

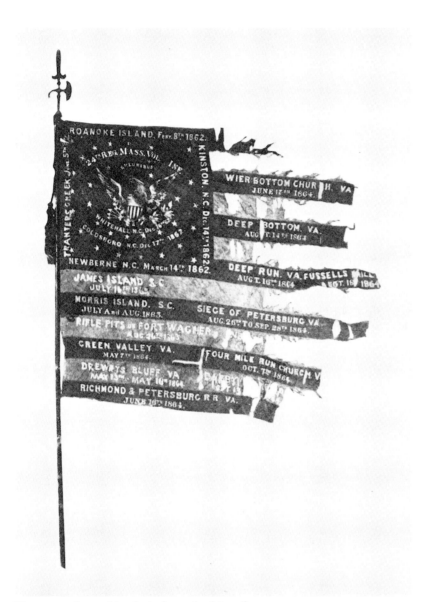

The story showed in their flags, the bits of fabric for which the men fought and died. The colors of the Twenty-fourth Massachusetts displayed the unit's battle credits, and showed the wear of the camp and the field. (USAMHI)

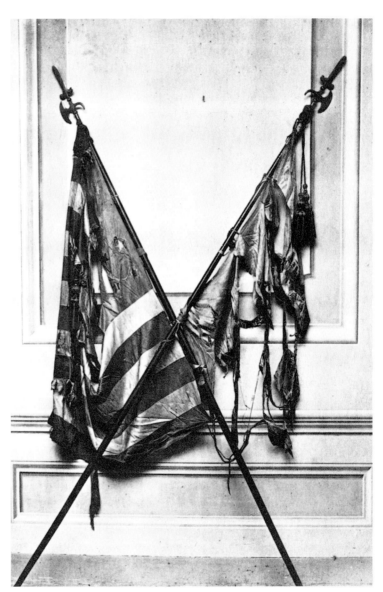

Those of the Nineteenth Massachusetts were reduced to hanging tatters by the rigors of battle. (USAMHI)

And here, the colors of the Fortieth Massachusetts are barely a memory of the once bright flags that went off to war. (USAMHI)

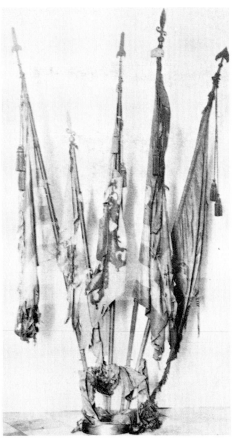

The banners, like the regiments who marched under them during America's greatest trial, have receded into dim memories only fleetingly recalled from the fading images of the past. During the Seven Days Battles near Richmond in the summer of 1862, some unknown Yankee dropped this tintype of his company on the battleground, where another Yank found it. This disappearing photograph is what we have left to remind us of them — and of the deeds of the men in the ranks. (USAMHI)

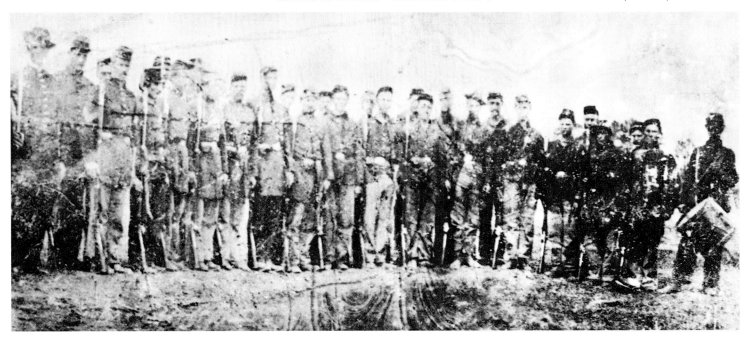

Of Ships and Seamen

Adm. Ernest M. Eller

SEAPOWER, which has helped shape America's destiny in every generation, played a role of first importance in the Civil War. The United States is a giant "island" nation. Blessed with vast resources, a benign climate, a free people, and open access to the oceans, she early seemed destined for world leadership. Had the war ended differently, this destiny might not have reached fruition. It *would* have ended differently except for the North's maritime superiority.

Although Lincoln, Lee, Grant, and others did at the time, too few since have comprehended the giant hand of the sea in this struggle between brothers. Had the North prosecuted the war afloat with less energy, or the South more effectively, the history of the nation could have been significantly changed.

The North laid the keel for certain victory in the first two years of the war, and that victory hinged on maritime superiority. The meaning of control of the water has seldom been more vividly brought home to American leaders than in the panic that engulfed them in March 1862. After the fall of the Norfolk Navy Yard in Virginia, the Confederates raised the USS *Merrimack* and converted the burned steam frigate into the CSS *Virginia*, a crude ironclad. On March 8, 1862, she steamed into Hampton Roads to sink the USS *Congress* and the USS *Cumberland*. Telegraph keys clicked madly. Consternation swept northward. At President Lincoln's emergency cabinet meeting desperation reigned. Some, striding about, kept looking out to see if the *Virginia* was coming up the Potomac!

In the unseen ways of Providence, during the night the USS *Monitor* — hastily built in five months, and nearly sunk by foul weather en route — eased into Hampton Roads. Even as the cabinet fearfully debated, she and the *Virginia* met in a dramatic duel of iron against iron. It was a draw, but this first battle of ironclads reverberated around the world. In the North, men relaxed from panic. In the South, high dreams collapsed. Overseas, England and France had begun ironclad navies, and their worth was improved. Now nations were shocked into the future.

Lincoln had proclaimed a blockade of Southern ports on April 19, 1861 — then largely a paper blockade. Only forty-two warships were in commission, and many of these cruised far-off

seas. The South, however, had no navy, and could never acquire an important one, whereas the North had a large merchant marine with trained seamen, along with ample facilities to build and convert. Strong warships provided the nucleus for the blockade. They were rapidly augmented by minor ones, mostly converted steamers, ferries, and tugs. By year's end, active warships had nearly tripled. By Appomattox, they had increased by over thirtyfold.

While a blockade can reduce a port's commerce, only capture can surely stop it. The North's first notable victories came from supremacy at sea, in amphibious assaults. Blockade-runners and Confederate privateers used Hatteras Inlet, not far from Hampton Roads. Two weak sand forts, lightly garrisoned, guarded it. In August, enough ships having become available, an amphibious Federal force under Flag Off. Silas Stringham and Gen. Ben Butler attacked. The warships' heavy guns outclassed and outranged those ashore and easily blasted the forts into submission for Butler's troops to occupy.

The next target was Port Royal, a magnificent sound about halfway between heavily defended Charleston and Savannah. In November Flag Off. Samuel Du Pont skillfully maneuvered the largest fleet the nation had ever assembled in and out past Port Royal's entrance forts. In five hours of heavy pounding of the defenders from the rear and sea flanks, he forced evacuation of the forts. The sound soon became an important advance base for resupply of the blockading fleet, much increasing effective time on station. Now the blockade strangled tighter and tighter. Increasingly, raids from the sea ravaged the coast and up the rivers, wasting Confederate resources, draining manpower from main armies, eroding strength. Attack from the sea is hard to counter because of the inherent concentration of strength at the point of decision, swiftness of assault, and ease of surprise.

Had the war come a generation earlier, the outcome may have been different. Navies now had awesome capabilities. Through the centuries warships had gained increasing effectiveness in operations against the land. By 1861 the accelerating Industrial Revolution had brought quantum leaps—as in steam and iron, more powerful and accurate guns, protective

armor. No longer were ships restricted by wind and tide. Now, with engines, they could come and go at will, even upstream in swift rivers. The increased speed, precision, and flexibility that steam gave to attack from afloat time after time proved decisive in combined or purely naval operations. Armored in iron, naval vessels became terrifying movable forts that could steam in close to advantageous positions. Rapidly firing their huge guns, they could overpower all but the heaviest fixed guns ashore.

The change to steam had been especially rapid on rivers. Industrial growth also increased the availability of iron for armor and stronger guns. These advances early forged Northern success on the western rivers. Comdr. John Rodgers, a hard-bitten old sea dog, went west in May 1861 to start an inland navy. Driving hard, he converted three river steamers and had them ready for service under the army with naval and pickup crews by early August. Immediately, in independent and combined operations, they began to demonstrate the immense benefit of strength afloat. Meanwhile, he contracted construction of semi-ironclad gunboats that would dominate the upper rivers.

On the same day that Port Royal fell, an amphibious operation down the Mississippi under little-known Brig. Gen. Ulysses Grant struck at Belmont, Missouri, to break up a concentration of Confederates threatening Federals advancing in this pro-Southern area. Striking swiftly by water, he surprised and routed the Confederates. Then, as his troops plundered their camp, Confederate reinforcements surprised and routed them. Grant's men fled to the transports as well-directed grape and canister from the wooden gunboats helped check the pursuers. Grant himself galloped to the bank and rode aboard just as the last boat cut its lines and pulled clear.

Debouching into the Ohio only twenty miles apart, the Tennessee and the Cumberland rivers open highways across Tennessee. Each had a guardian fort some miles upstream, and there the effect of inland seapower became dramatically evident in February 1862. The first armored gunboats having become available, a joint operation sailed up the Ohio to attack Fort Henry on the Tennessee, which was poorly sited on low

ground. Landing the troops some miles below the fort, Flag Off. Andrew Foote, another rugged old salt, steamed to the very muzzles of the fort's cannons. On the swollen river his great guns loomed down on the defenders. In a fierce duel at point-blank range, the guns afloat knocked out those ashore, forcing surrender before the troops could arrive. The wooden gunboats now raced upriver across Tennessee to Muscle Shoals, Alabama, capturing ships (including a prospective ironclad), destroying supplies, spreading terror — an omen of the future.

Fort Donelson on the Cumberland, better situated on high ground, came next. Plunging fire from this much stronger position repelled the first attack of the tinclads, as the lightly armored gunboats were called, but they returned to rain death into the fort while Grant's troops overcame the defenders.

Fatefully, the Confederates had lost the water highways. No barrier now stood between the invaders and Nashville, a principal arsenal and industrial city many difficult miles away by land, but a different matter for steamboats. As Foote's gunboats raced upriver for the kill, the Confederates hastily quit gun batteries and abandoned Nashville with its needed factories and mountains of supplies.

Heavy guns on the water, spearhead for the army, made it possible to win in days of little cost what could not have been won in months of hard fighting, if at all, without them. A Nashville newspaper ruefully and forebodingly observed, "We had nothing to fear from a land attack but the gunboats are the devil."

The Confederate lines that extended far up into Kentucky had been breached. Now Federal troops poured through like a torrent. Supported and supplied along the water highways, Grant pressed south following the Tennessee River. On April 6 and 7, in the Battle of Shiloh — two shattering months for the South since Fort Henry — the Confederates surprised the invaders near Pittsburg Landing and drove them back to the river. "We were within . . . 150 to 400 yards of the enemy's position," reported Maj. Gen. Leonidas Polk, "and nothing seemed wanting to complete the most brilliant victory" over the demoralized Federals. Then wooden gunboats hurried to

the point of decision "and opened a tremendous cannonade of shot and shell" into the Confederates. This hail of projectiles broke up the attack and swung the delicate balance of battle to the Union.

Meanwhile, the river ironclads, augmented by mortar boats, spearheaded an advance down the Mississippi. One after the other, "impregnable" positions fell to the mighty cannons and troop envelopment facilitated by control of the water. The record echoes like the clank of doom's chain rumbling out: Columbus, Kentucky, "Gibralter of the West," in March; strongly armed Island No. 10, "Key to the Mississippi," in April; Fort Pillow, last bastion before Memphis, in June. Now defenseless, this important commercial and industrial city surrendered to the gunboats on June 6, with troops soon following to occupy.

The Federal advance did not go uncontested, despite the fearsome tinclads. In addition to fortified positions that held out until outflanked, the Confederates vigorously developed from limited resources what naval strength they could. In 1861 they began to arm river craft as makeshift gunboats, then rams; they also began strong ironclads, but failed to give them high priority early enough. Although far outclassed, the little Southern warships gave battle. On one occasion, dashing out from Fort Pillow's protection, rams defeated two Union ironclads, sinking one. In a final gallant but doomed battle to save Memphis, the squadron sacrificed itself. With fort and warships gone, Memphis fell, and the Federal fleet ran on downstream to Vicksburg.

While combined operations rocked the Confederates on the upper rivers, a typhoon that would strike a mortal blow gathered to the south. Adm. David Farragut impatiently waited with some of the Union's most powerful warships while Comdr. David Porter's twenty mortar boats hurled huge projectiles day and night into the forts guarding New Orleans. Thousands of shells rained in. The mortar ammunition was nearly gone. The forts grimly held on. Would they prove impassable barriers?

Daring the "impossible" of forcing upstream past strong forts with wooden ships, Farragut lined his vessels' sides with

heavy chain, rope, and hammocks. Then, during the midwatch darkness that opened April 24 — a day of doom for the South — in a melee of shot and bursting shells, of fire rafts and death, the fleet drove past the guardians of New Orleans, and in the battle destroyed the small Confederate squadron that valiantly engaged. Steaming on upstream, the fleet reached the center of the South's largest city — its wealthiest, and a major shipping and export center. The flotilla's big guns, which the defenders could not match, loomed over the city, demanding surrender. One of the mighty unfinished ironclads that could possibly have saved the city, given a few more days to complete construction, floated by burning in a stream of blazing cotton bales and river craft — an image of the destiny of the South. Fewer than three thousand Yankee seamen had dealt a blow from which the Confederacy could never recover. Farragut appropriately called all hands to quarters to "return thanks to Almighty God for His great goodness and mercy."

Confederate captain John Maffitt later lamented: "The grand mistake of the South was neglecting her Navy. All our Army movements out West were baffled by the armed Federal steamers. . . . Before the capture of New Orleans the South ought to have had a Navy strong enough to prevent its capture. . . . Neglect of the Navy proved irremediable and fatal."

The government did try, but too late. The political leaders guessed wrong by initially embargoing export of cotton, instead of shipping freely and concentrating on obtaining warships. They failed to perceive until too late the awesome influence upon land operations of loss of the water.

The catastrophe of New Orleans cut off most of the South's cotton exports. Occupying this thriving port, and with the ultimate capture of Vicksburg, the Federals had sundered the South and opened the way to the sea for the North's vast and rich heartland.

The Vicksburg campaign was long and bitter. Farragut soon ran past the fortifications to join the river fleet. But over a year of joint operations and give-and-take conflict — including the short, brilliant career of the ironclad CSS *Arkansas*, which inflicted considerable damage on the Federal fleet — went by before the stronghold fell. Cut off by water and land, starving and with resources exhausted, the stouthearted defenders finally capitulated on July 4, 1863.

This campaign, with warships and troops working closely together, ended the first phase of naval support in combined operations. Through the remaining years, the role of strength afloat remained crucial. There were continual operations with troops along the streams — combined operations large and small, spreading destruction wherever gunboats would float. Often even a few big naval guns played a critical role. Unceasingly, warships interdicted Confederate troop movements, knocked out gun positions, assured the flow along the river highways of the armies' huge logistic needs. Day and night, they pressed the blockade along the coast and waterways, tightening the death noose.

In the East as in the West, Confederate concentrations and defenses were seldom safe within range of warships. Almost daily, attack from the water destroyed resources and installations, frustrated plans, disrupted or influenced troop movements. Even major Confederate campaigns had to consider pressure from the water. In his brilliant offensives, Lee was limited to inland sweeps clear of navigable waters. In his resolute defense of Richmond, he ever had the one-sided handicap of Federal control of the waterways.

The blockade tightened. Following Port Royal, other harbors fell or were ravaged. As Lee had perceived early in the war, "wherever [the enemy's] fleet can be brought," except at powerful fixed positions, "we have nothing to oppose its heavy guns, which sweep over the low banks of this country with irresistible force." By 1864 the South's only important exits to the sea — and these were heavily blockaded — were Mobile, Savannah, Charleston, and Wilmington. In August of that year, with a squadron that included new monitors, Farragut burst past the entrance forts, through minefields, into Mobile Bay. He lost the monitor *Tecumseh*, but captured the ironclad CSS *Tennessee* and closed the bay.

Against the ever-growing Federal navy, the Confederates had even less chance in these last years. Yet at every opportunity, ingeniously and valiantly, they struck hard. On January 1, 1863, improvised "cottonclads" dashed out of Galveston to

rout the small blockading squadron. Later that month, the ironclad rams *Chicora* and *Palmetto State* steamed from Charleston in a fog to shatter blockaders. Protected by iron or cotton, rams were especially effective in several minor engagements.

The Confederacy began building some fifty ironclads of sorts, but, hampered by limited resources, scant facilities, government priorities, and vigorous Federal advances, as at New Orleans, got only a few into effective action. Their chief value to the South was in the delay completed ones imposed on Union movements, and in their large roles in helping to save Savannah, Charleston, and Richmond down to the closing days of the war.

Moored mines called "torpedoes" were extensively used, and claimed their first victim in sinking the USS *Cairo* during the Vicksburg campaign; their greatest success came in sinking the powerful *Tecumseh*, eliciting Farragut's historic shout, "Damn the torpedoes!" Despite imperfect firing devices, these lurking menaces destroyed two score Union vessels by Appomattox — dark omen of the future and today's deadly sophisticated mines. Had the South pushed their production early on, they could have had large impact.

Boats mounting spar torpedoes had some effect, notably in damaging the ironclad USS *New Ironsides* off Charleston. The submersible *H. L. Hunley*, a converted boiler propelled by men turning cranks, on a dark night steered into the Charleston blockading squadron and rammed a torpedo into the USS *Housatonic*. The victim sank, but so did the *Hunley*. For the third time, dedicated men perished in her; but this notable first sinking by a submarine cast long shadows ahead to the increasingly more potent undersea monsters of our time.

The chief material injury to the North at sea came from commerce raiders, especially the *Alabama*, the *Florida*, and the *Shenandoah*. Her crew unaware of the end of the war, the latter continued to destroy whalers in the Bering Sea through July 1865. The Confederate cruisers dealt damage that the American merchant marine would not recover from for generations. Besides vessels lost, Yankee shipowners transferred hundreds to foreign registry. Yet this economic loss had little effect on the final outcome. With control of the oceans, the Union could still draw on the resources of the world, whereas the South, with far greater need, got only crumbs past the blockade in these last years.

The ceaseless and overwhelming benefits of power afloat continued inexorably for the North through 1864 and into early 1865 as hope ended for the strangled, sundered, and battered South. With the navy controlling the rivers, Grant maneuvered south of Richmond. Setting up a tremendous headquarters — supply base at City Point, protected by the navy — and with logistic needs pouring in by ship, his army settled in for victory.

Cutting loose from river and railroad supply routes, Sherman took Atlanta, then marched to the sure haven of sea support at Savannah. Thence he set his march north, close enough to the coast for ready support or retirement. The Confederates evacuated Charleston, which lacked landward defenses. After an initial setback, a massive amphibious attack force, shielded by the heavy fire of the largest fleet the United States would assemble until the twentieth century, took Fort Fisher. Lee's last gateway for necessities abroad slammed shut.

Desperately in want, Lee's weakening army struggled on with prospects shrinking daily. The Confederate ironclads on the James tried to attack Grant's base at City Point, but were frustrated. Success could have had momentous effect on the campaign. At last history's noblest and one of her ablest generals surrendered his tattered but undaunted faithfuls at Appomattox. Genius ashore, lacking indispensable power afloat, had succumbed to the combined, crushing force of might on land and sea.

None of man's ceaseless wars has brought out more heroism, fortitude, and sacrifice on both sides than was exhibited from Bull Run to Appomattox. Yet anyone studying all aspects of the war finds it difficult to escape the conclusion that the North's superiority afloat, against gallant resistance, helped swing the balance to victory.

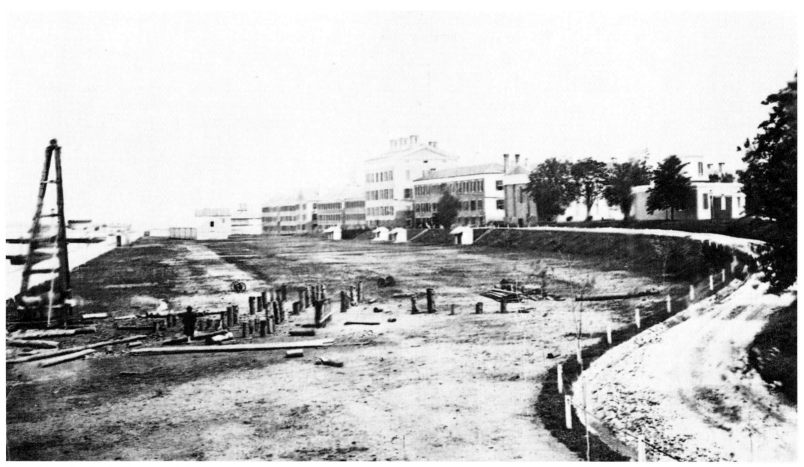

One thing that both Union and Confederate
navies had in common was the training
ground of their officers, the U.S. Naval
Academy at Annapolis. (USAMHI)

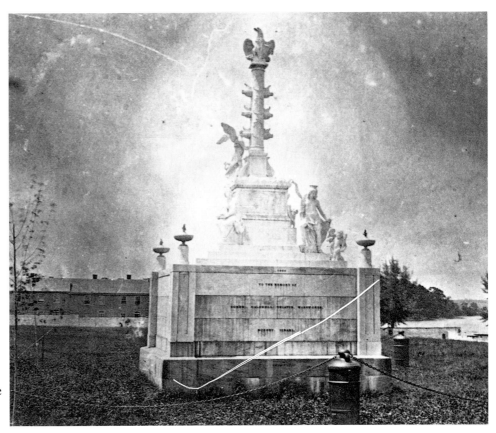

Another was that, thanks to their training there, officers of both sides revered the same naval heroes of old — men memorialized in monuments at the academy. (USAMHI)

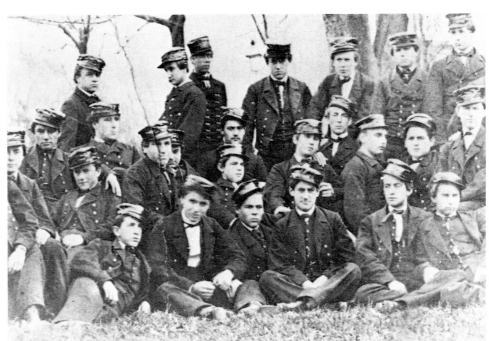

And as midshipmen, they had all been young together once. During the war, the Union moved the academy to Newport, Rhode Island, where these young men gathered for the camera, but their faces might easily have been those of a score of classes before them. (NHC)

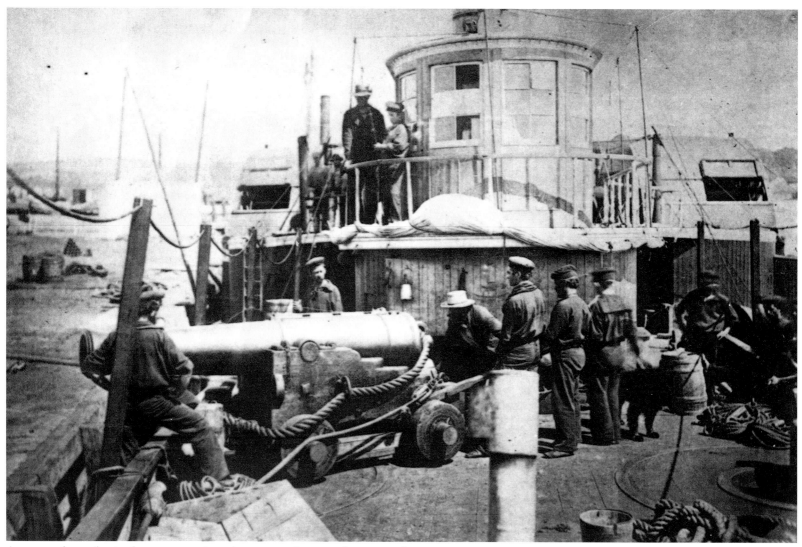

As everywhere else in the young nation, the war on the water began in a hesitant and makeshift fashion. The first U.S. officer killed in a water action was Comdr. James H. Ward, who was patrolling the Potomac in his little converted side-wheel steamer *Freeborn*. On June 27, 1861, off Mathias Point, he was sighting one of his three guns when an enemy bullet gave him a mortal wound. This 1861 image is a reenactment. The man kneeling behind the gun on the *Freeborn* is wearing Ward's hat and jacket, and posing just as Ward was when hit. The new war was still a novelty when men could restage its tragic events. (USAMHI)

Top right: Many of the Union's warships were makeshifts, including converted Staten Island ferryboats like this one, the *Commodore Morse,* whose fore and aft decks were lightly protected with iron bulwarks and ungainly mounted naval cannons. (USAMHI)

Bottom left: Some of these ferryboats would do good service for years, and their officers were justly proud. Despite their previous histories, these were warships now. (USAMHI)

Bottom right: With the need to transport large numbers of men and supplies, Uncle Sam turned to other commercial vessels, since the existing merchant fleet far outnumbered the naval ships available. Steamers like the *Sacramento* of the Pacific Mail Steam Ship Company soon found themselves pressed into service. (USAMHI)

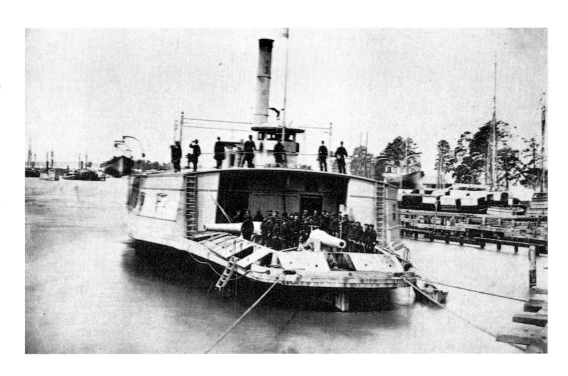

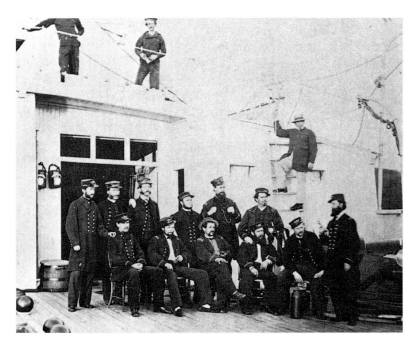

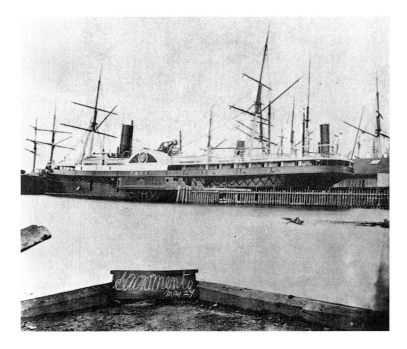

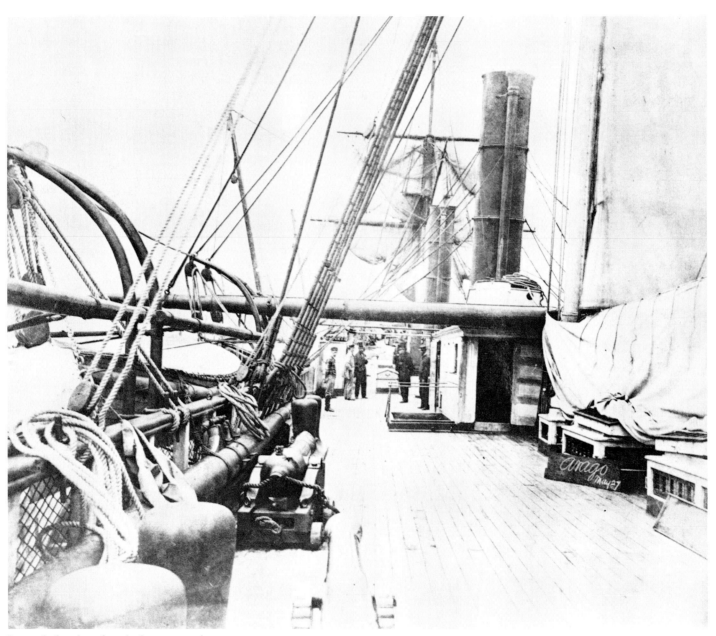

It needed only a few deck guns, and any
peaceful vessel like the *Arago* could find itself
transformed into a warship. (USAMHI)

The Confederates, too, had to make do at first, either with what they could capture from the Federals or what they could convert. J. D. Edwards's camera caught this view in Pensacola, Florida, in early 1861, of the side-wheeler *Fulton*, which was just being refitted when the navy yard fell to the Rebels. Now, they hoped, the ship and all that ammunition in neat pyramids before it, would be used against the Yankees. (SHC)

The Union's first blow — and in the end, its most effective — was the blockade. Scores of warships like the USS *Marblehead* would do seemingly endless months of duty in patrolling Confederate harbors. (USAMHI)

Here Edwards's camera captured a
Yankee ship — perhaps the flag of truce boat
Wyandotte — lying at anchor off Fort Pickens,
near Pensacola. Confederates would see this
and a lot more enemy ships at their harbor
mouths, slowly strangling the South. (SHC)

But only Edwards and one or two others
would ever record the scene of the Yankee
blockaders. Here, he caught the *Macedonian*,
again in front of Fort Pickens. (USAMHI)

Every kind of vessel joined the blockade while the North feverishly rushed to build its fleet. Side-wheelers like the old USS *Mingo* . . . (USAMHI)

. . . joined more sleek vessels, like the *Boxer*, which itself had the look of a blockade-runner, . . . (USAMHI)

. . . and more workmanlike vessels, like the USS *Magnolia*, of the East Gulf Blockading Squadron. Wherever there was Southern coastline, the Yankees tried to stop commerce. (USAMHI)

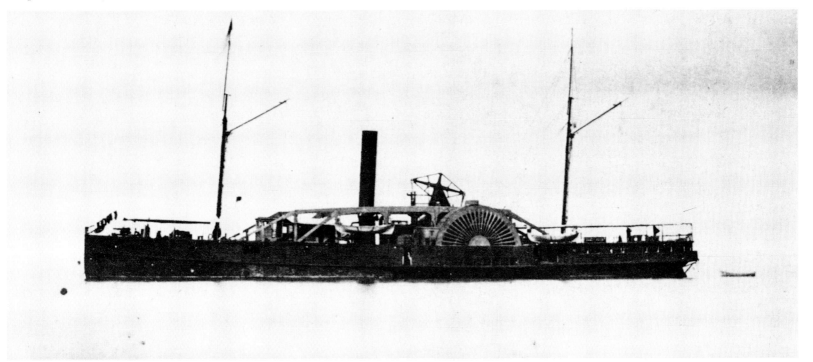

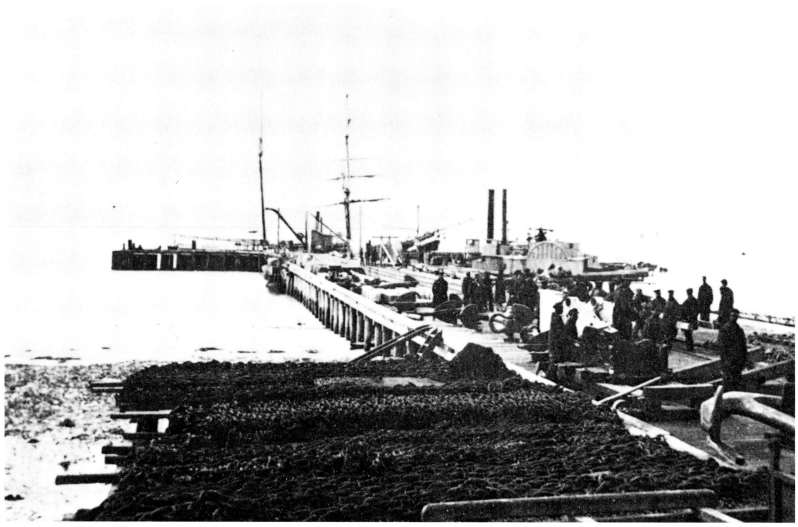

Halting Confederate trade required
substantial bases on the enemy coastline, in
order to refit and supply the blockaders, and
Hilton Head, South Carolina, became one of
the first and best. Captured in 1862, it
remained in Yankee hands thereafter, and
the line of warships coming into it was as
seemingly endless as the anchor chains laid
out in the foreground here. (USAMHI)

It required a few alterations. Mr. Pope's house, with its fine ocean view, became . . . (USAMHI)

. . . a signal station, for communicating with the ships at sea. (USAMHI)

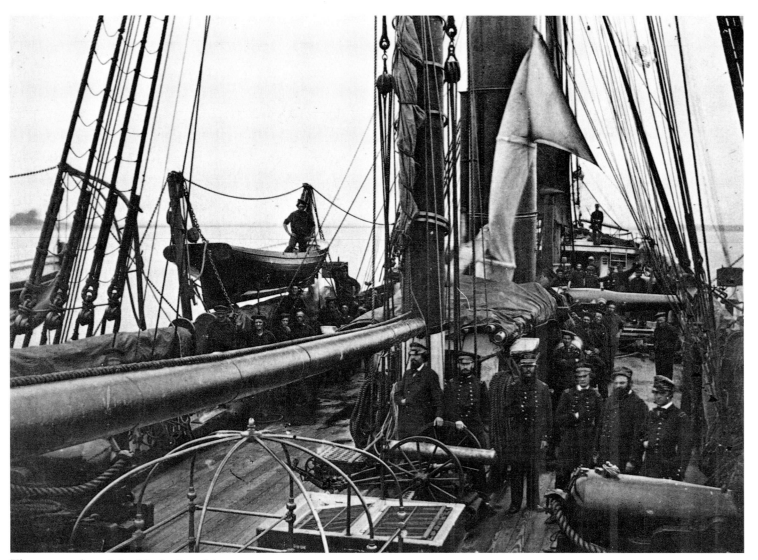

The scenes aboard the blockading ships themselves were much the same no matter the vessel. The gun deck of the USS *Pocahontas* is quite shipshape, from the polished guns and neatly coiled ropes, to the canvas wind vane (in front of the stack) used to catch breezes and divert them into the bowels of the ship. (USAMHI)

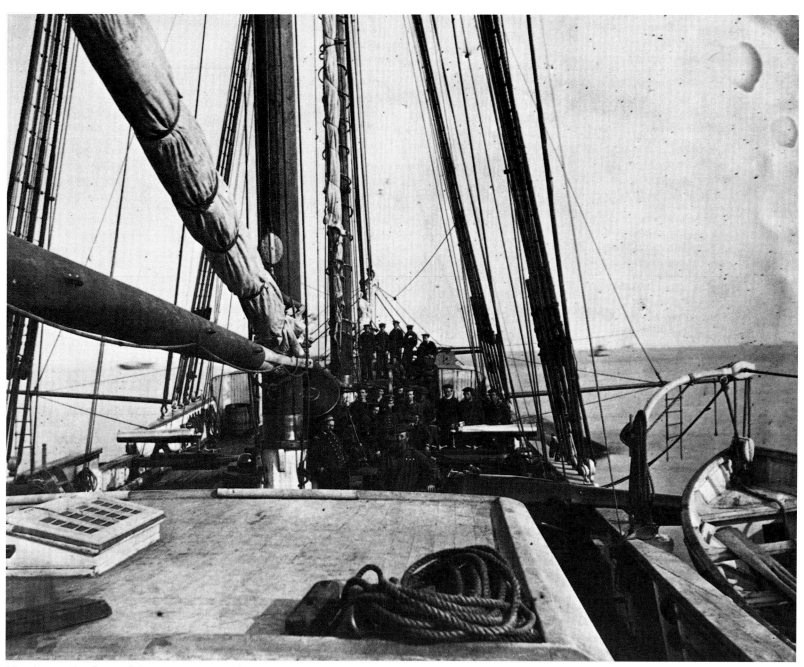

Mostly just the faces of the crewmen and the guns they served differed. Here a mortar schooner's big gun looms behind the mainmast. (USAMHI)

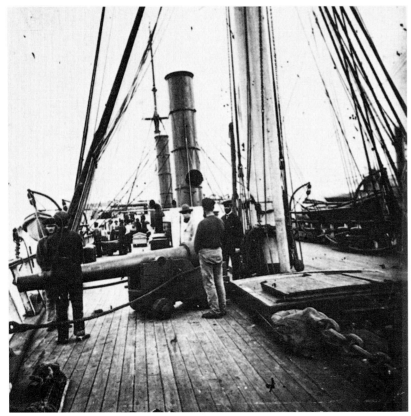

Top left: Looking forward there were guns. (USAMHI)

Top right: Looking aft there were guns. (USAMHI)

Bottom left: Seemingly on every deck in the hemisphere there were guns. (USAMHI)

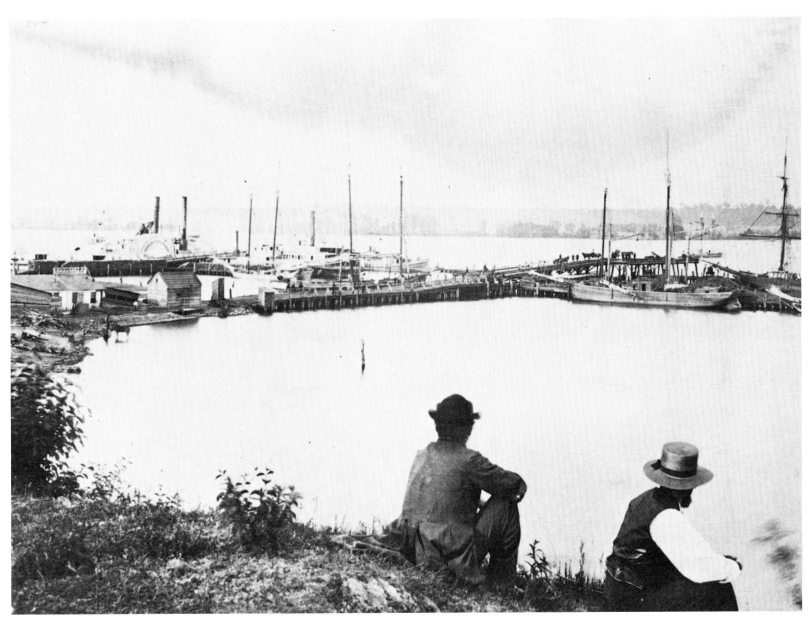

All those ships required a lot of fuel, and the
Union navy maintained huge coal wharves
like this one at Alexandria, Virginia, to keep
its ships steaming. (USAMHI)

Every river and inlet on the Confederate coastline had to be watched, and none more so than the James River, where transports supplied Grant's army in 1864 and naval vessels vied with enemy shore batteries. (USAMHI)

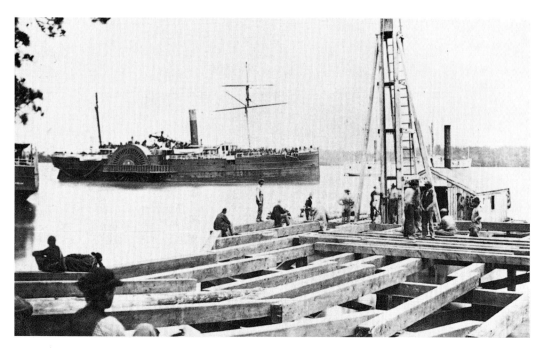

Wherever it went, Lincoln's navy built its own docks, as here at City Point, on the James. (USAMHI)

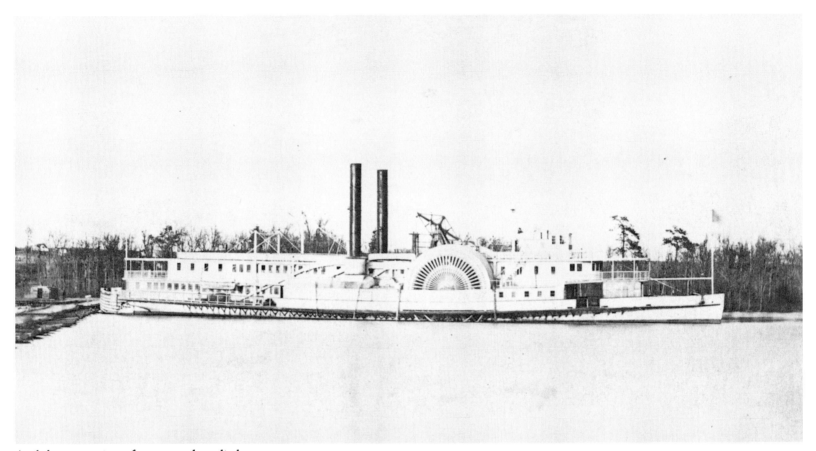

And the procession of steamers that plied
the rivers, unloading at those docks and
heading back north for more, was endless.
(USAMHI)

Now and then, the warships of both sides
contested the rivers, and when they did meet
in battle, it could be epic. No fight in naval
history is more famous than that between
the CSS *Virginia* — of which no photograph
survives — and the USS *Monitor*. The
Monitor's foredeck and turret appear here in
this 1862 image, showing well some of the
dents made by enemy shot during the battle.
(USAMHI)

Another dreaded Confederate ironclad was the *Albemarle*, which severely damaged several Yankee ships in North Carolina's Roanoke River before intrepid raiders sank her. The ironclad appears here after being raised in 1865. (NHC)

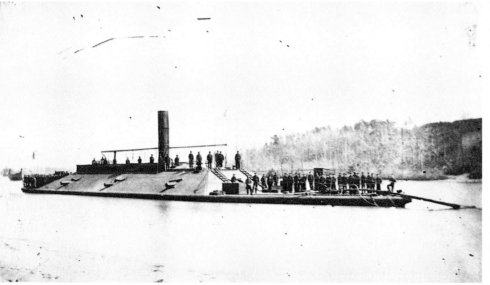

More formidable still was the CSS *Atlanta*. She was deemed sufficiently powerful that after the Federals captured her in 1863, they put her in the Union service on the James. (USAMHI)

Sustaining all these warships required a massive transport fleet — unsung heroes of the war on the water. The steamer *Liberty* shown in September 1864. (USAMHI)

The transport *Westmorland*, photographed in June 1864. The forest of masts behind her gives evidence of the number of ships in port at any one time in the Union's harbors. (USAMHI)

Top left: The names of many vessels have been forgotten. (USAMHI)

Bottom left: As have the names behind the faces that sailed them in supplying the Union war effort. (USAMHI)

Yet there were faces that could never be forgotten. Adm. David G. Farragut, the premier naval hero of the war, played the leading role in opening the Mississippi to the Yankee ships. (USAMHI)

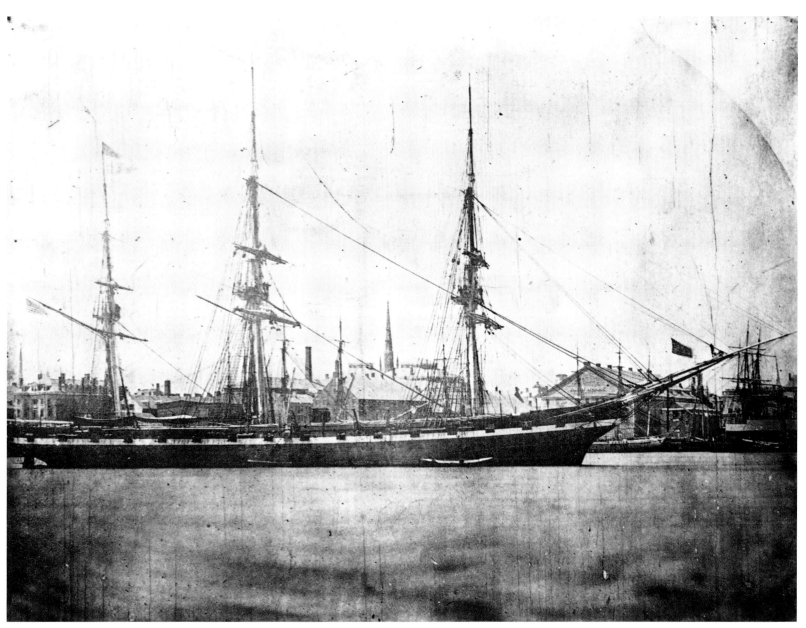

His famous ship *Hartford,* shown here at
Boston around 1859, took him from victory
to victory on the river and in the Gulf. (LC)

Other ships accompanied Farragut when he took New Orleans in April 1862. The USS *Portsmouth* (at left), lined with guns from stem to stern, was one of the most formidable. (USAMHI)

Bottom left: Old river "woodclads" like the *Conestoga*, shown here in an A. D. Lytle image, fought with Farragut in opening the Father of Waters. (USAMHI)

Bottom right: Another, damaged, Lytle image shows the USS *Albatross*, one of Farragut's warships, whose commander, John Hart, died apparently of suicide while on the river. In a spirit of brotherhood stronger than the hatred of war, the Freemason was buried ashore at Saint Francisville, Louisiana, by fellow Masons who were Confederates. (USAMHI)

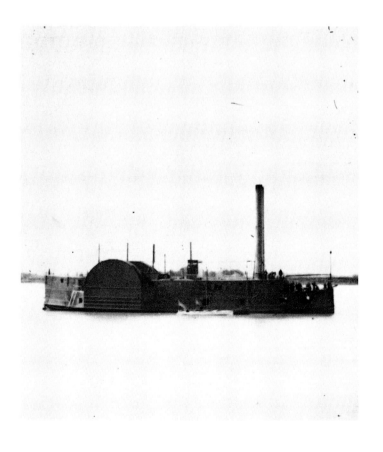

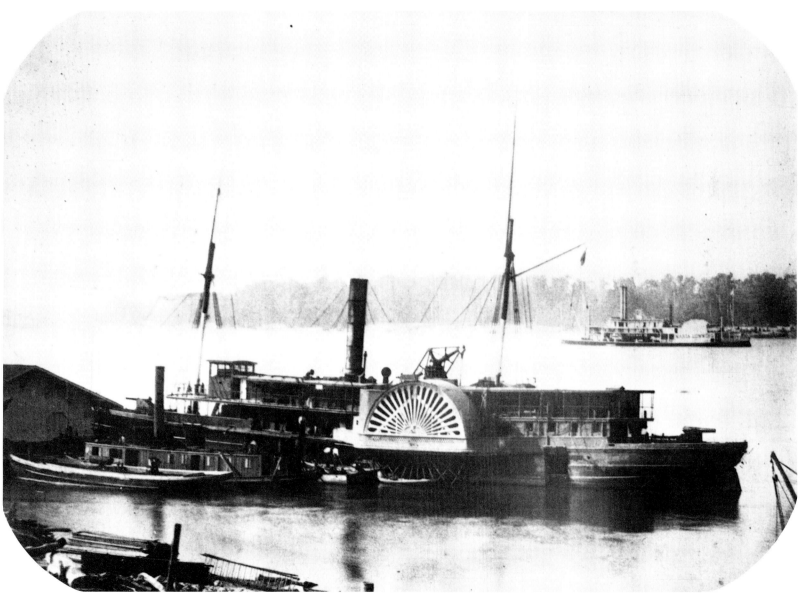

Captured Confederate ships were turned to Yankee uses here on the Mississippi, too. The CSS *General Bragg* fell into Union hands and thereafter plied the Mississippi for its onetime enemies. (USAMHI)

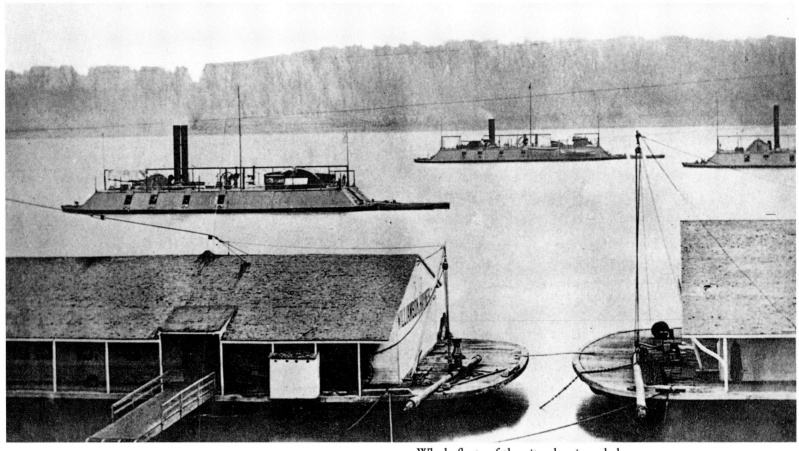

Whole fleets of the city-class ironclads steamed on the western waters in support of land operations. Beyond the moored barges in the foreground, the *De Kalb* sits at left, with the *Cincinnati* in the center and the *Mound City* at right. (NYHS)

They were mighty behemoths. The *Louisville* here rests by the bank off Memphis. (USAMHI)

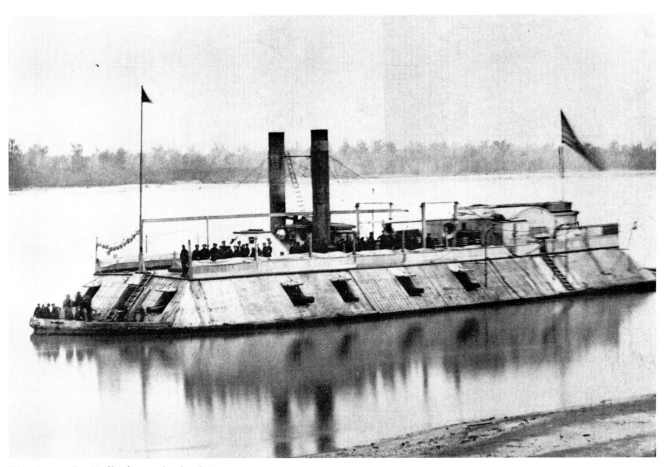

The *Baron De Kalb*, formerly the *Saint Louis*, was arguably the first ironclad of the war, having been launched October 12, 1861. With her thirteen guns, she was easily one of the most powerful. (USAMHI)

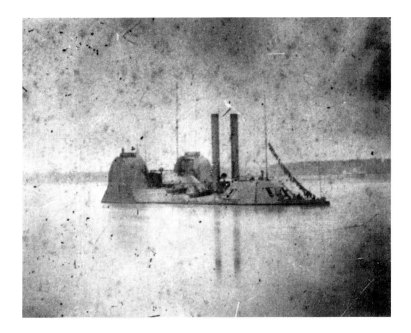

Yet there were even bigger river giants on the Mississippi. Lytle's camera caught the mammoth *Choctaw*, off Baton Rouge. (USAMHI)

One of Farragut's trusty subordinates on the river was his stepbrother, David D. Porter. (USAMHI)

From his flagship the *Black Hawk*, Porter assisted vitally in the taking of Vicksburg as well as in later campaigns on the western rivers. This image shows her off Memphis in June 1864, just a few months before an accidental fire destroyed the valiant ship. (USAMHI)

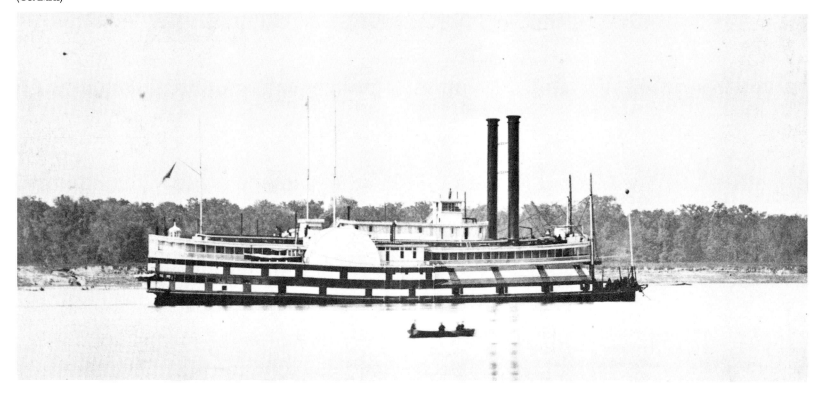

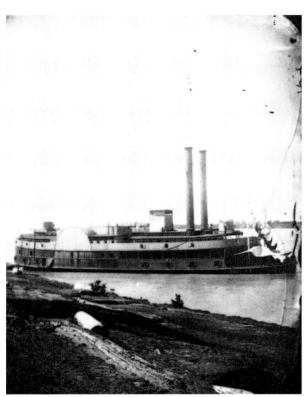

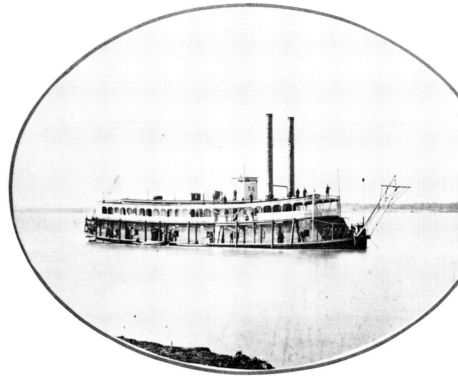

Top left: Scores of the little tinclads patrolled the waters of the Mississippi and its tributaries. Many of their names are unknown, as with this substantial-looking vessel caught by Lytle's lens. (USAMHI)

Top right: For other tinclads we have names and numbers. Lytle photographed the *Nymph*, No. 54, as she lay anchored off the Baton Rouge shore. (USAMHI)

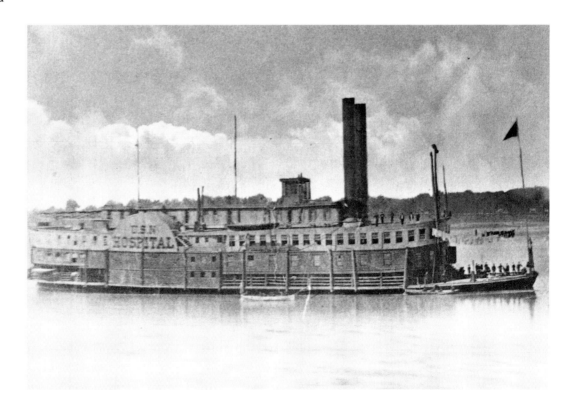

There were even hospital ships, the first of their kind, to house and care for the naval wounded. The *Red Rover*, a captured Confederate vessel, was a familiar sight on the Mississippi. (USAMHI)

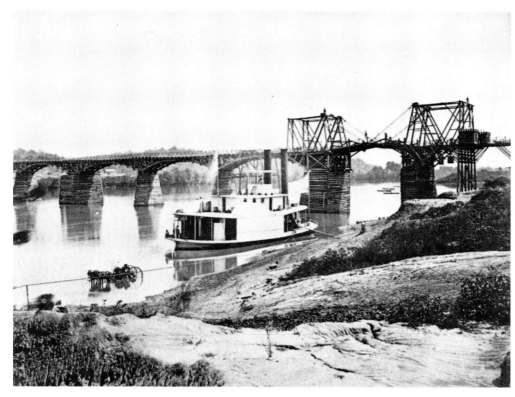

Up some of the broader tributaries, like the Tennessee River, smaller supply steamers kept up a constant pace as they shuttled war materiel to the troops fighting in the interior. A besieged army in Chattanooga was virtually saved by the supplies brought upriver by little ships like this one. (USAMHI)

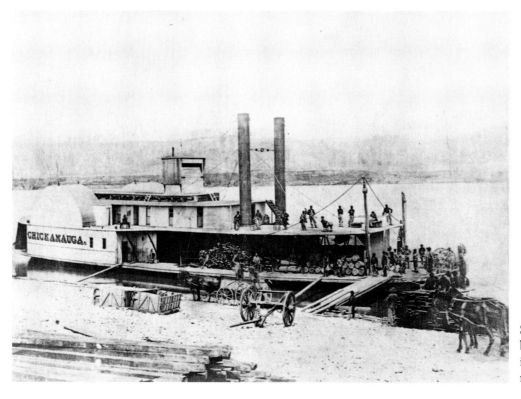

Some of the little steamers bore the names of battles, like the *Chickamauga*, but more important than that, they carried tons of needed supplies. (USAMHI)

As quickly as possible those supplies were unloaded and, empty, the little vessels went back downriver for more. (USAMHI)

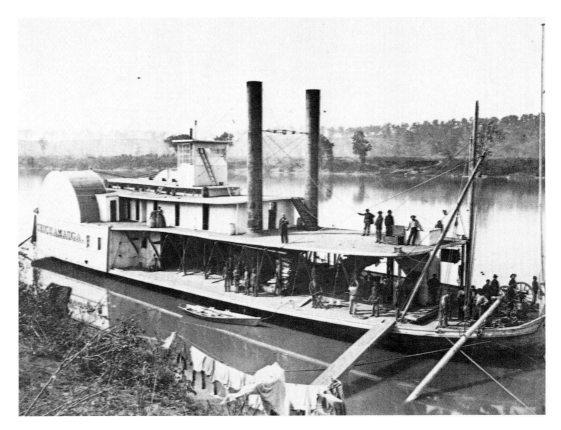

The transports came in for their share of fighting, too, when Confederate cavalry became fond of attacking them from the shoreline. In the campaign up Louisiana's Red River, the *Black Hawk* (a different ship entirely from Porter's flagship) was attacked by Rebel batteries on the banks. Some of the holes from enemy shot are still visible. (USAMHI)

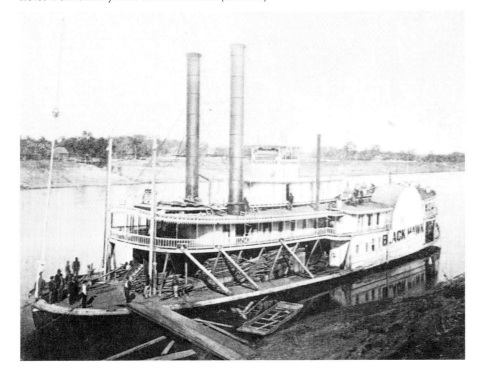

Of course, there was a war of sorts on the oceans as well, though it was largely one of hunter and pursued. Mighty Union warships like this unidentified steamer cruised the waters of the world looking for the dreaded Confederate commerce raiders. . . . (CA)

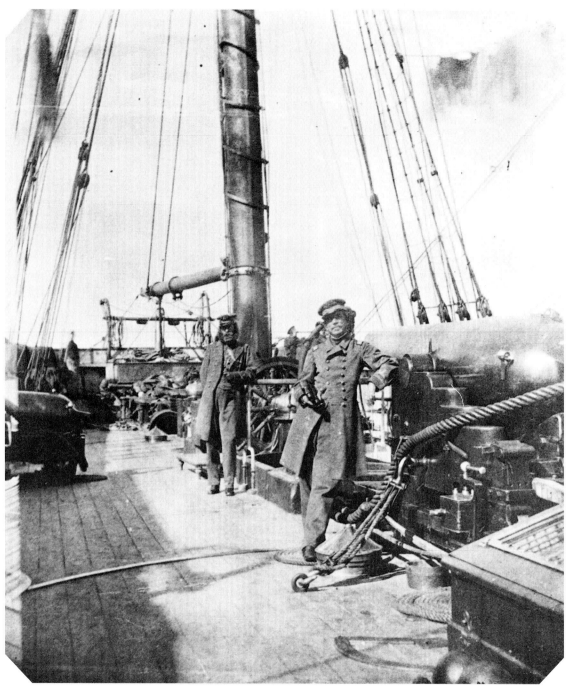

. . . Their most sought-after quarry was this
man, Capt. Raphael Semmes, and his ship
the *Alabama*. Man and ship were both
photographed here, probably off Cape Town,
South Africa. Semmes's executive officer,
John M. Kell, stands in the background. (IMP)

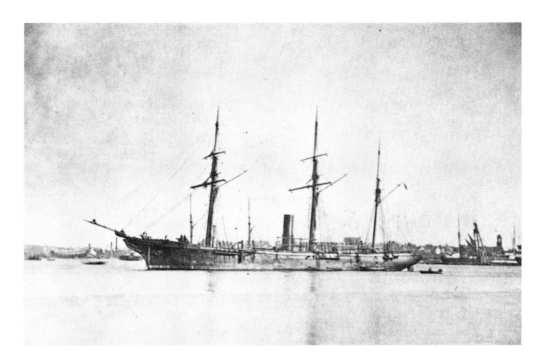

Almost as feared as the *Alabama* was the CSS *Florida*, the large vessel in the center of this image made at Madeira in 1864. Federal naval authorities used this photograph in the hope that it would help identify the ship when and if she were found. (NA)

Top right: Ships like the *Kearsarge* successfully hunted down the Rebel raiders. (WG)

Bottom right: Men and officers of the *Kearsarge* pose with one of the guns on the quarterdeck just a few days after they met and sank the *Alabama* off Cherbourg, France, in June 1864. Their hunt, at last, was at an end. (USAMHI)

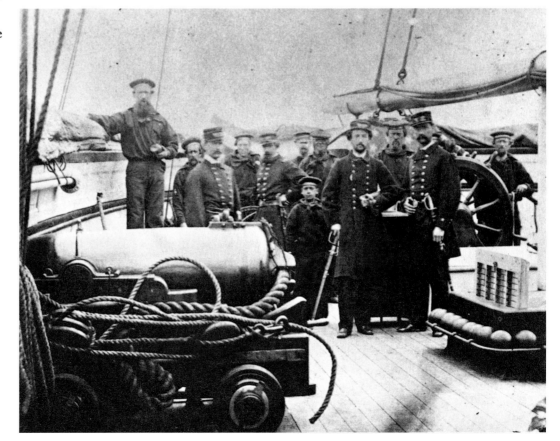

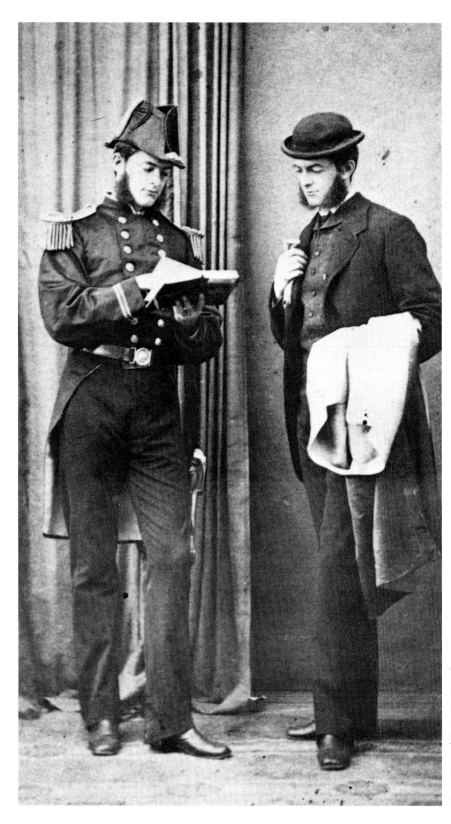

When not hunting prey, or carrying supplies, or polishing the brass and cleaning ship, the sailors of North and South lived much the same life. They loved to pose for the camera just as much as their comrades in the armies. Some even posed for "trick" images that showed the same man twice — like Joseph B. Upham, shown here as a civilian and as a first-assistant engineer. (USAMHI)

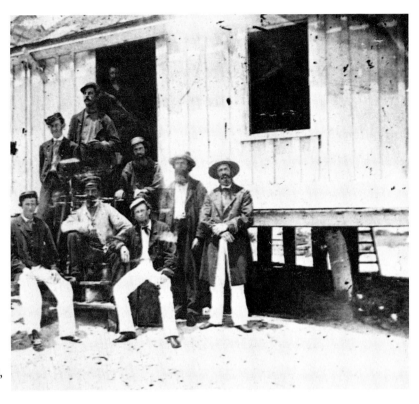

Wherever a camera appeared, so would they, even in front of a naval bakery. (USAMHI)

Posing for pictures was a welcome break from the routine of blockade or sea duty. (USAMHI)

And sitting for the camera gave the seamen a
memento to remind them that in this war
they, too, had done their part. (USAMHI)

Johnny Reb

A portfolio of the Confederate
fighting man in camp and field

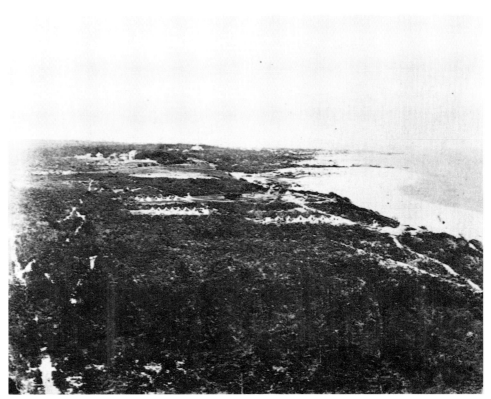

Above all, he was a country boy. Probably raised on a farm in the rural South, Johnny Reb came to the war with simple ideals and a kind of rough-hewn innocence that showed on the face of this unidentified private of the Army of Tennessee. (WA)

Top right: They flocked by tens of thousands to their banners in the early days of the war. Indeed, even before the firing on Fort Sumter, camps like those shown here at Pensacola, Florida, sprang from the Southern earth. J. D. Edwards of New Orleans was one of the few Southern photographers to take his camera outdoors to catch the look of the rustics in rebellion. This heretofore unpublished image taken from a lighthouse looks off toward the Warrington Navy Yard in the distance. (USAMHI)

Bottom right: Pensacola teemed with soldiers from Mississippi and Louisiana in the early months of 1861, Johnny Rebs anxious to stand in formation for Edwards's lens. (USAMHI)

Mississippi regiments encamped behind the lighthouse . . . (TU)

. . . and were delighted to line up for a pose. Uniforms for Johnny Reb were still more a dream than a reality in these early days. (LC)

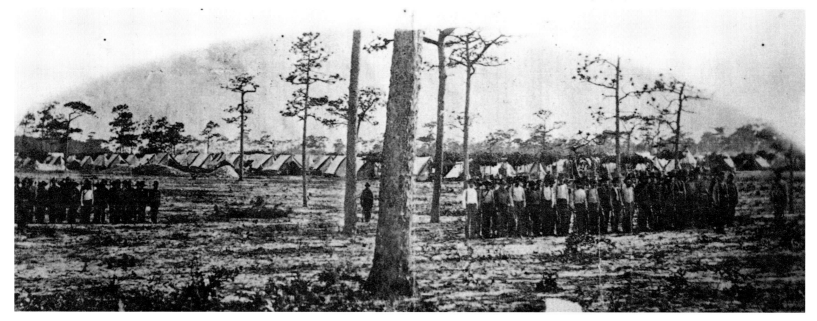

Even the damage and fading of more than a century cannot dim the enthusiastic and determined stance of these Mississippians. (PHS)

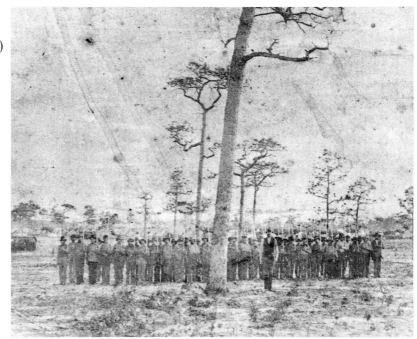

Edwards captured a wonderful record of the look of Confederate soldiers in their camps. Later, with the Union blockade making photographic supplies scarce, it would have been almost impossible to record this scene of the Perote Guards as they self-consciously posed at camp chores and entertainments. (TU)

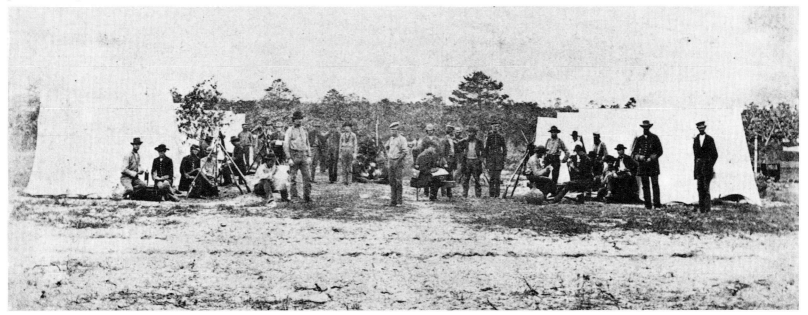

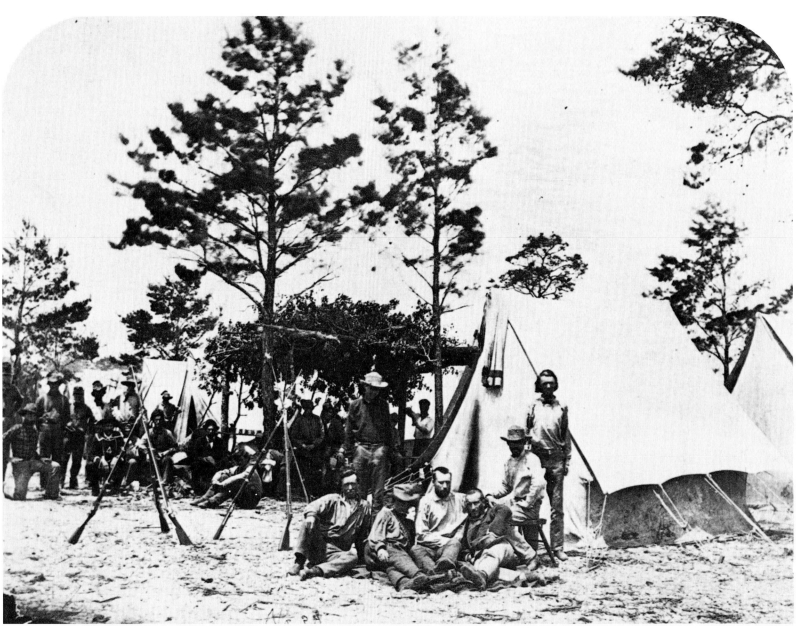

These men of the Ninth Mississippi display the wonderful variety of clothing that
the boys took with them to war — some dressed for a day in the fields, others in
formal attire, and a few in costumes seemingly drawn from comic opera. (RP)

Their tent streets were simple enough, with wooden and brush "shebangs" constructed to give shade from the hot sun. (USAMHI)

Probably a view of the Orleans Cadets from Louisiana, this Edwards image shows a wonderful variety of camp poses: lounging, bugling, fatigue duties, mock boxing, and an awkward corporal saluting an officer. (FSU)

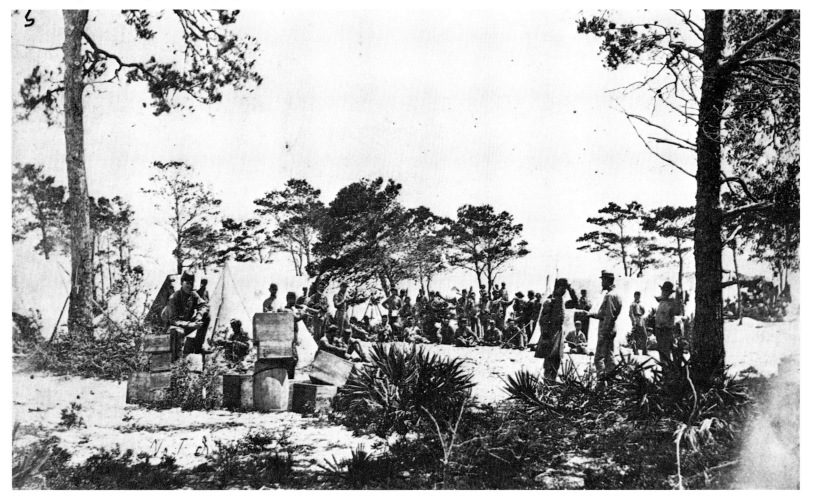

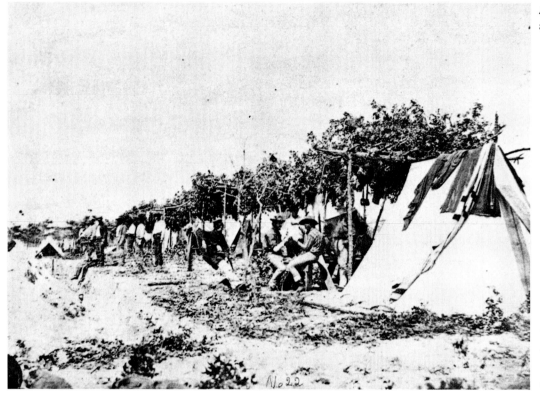

A good game of cards was the best pastime of all. (RP)

In those pre-Sumter days, when there was no real shooting war yet, lounging and drilling were about all a Confederate had to do. Rebs like these Alabamians at Pensacola complained in their letters home that there would be no war for them to fight in. (LC)

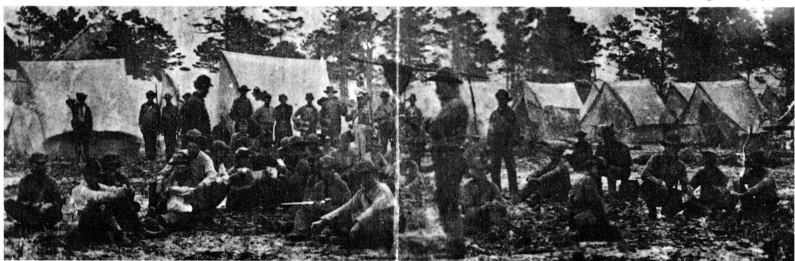

Instead, they sat in their tents, read their books, wrote their letters, and mended their clothing, like these boys of the Ninth Mississippi's Company B, whom Edwards photographed during the war's first spring. (PHS)

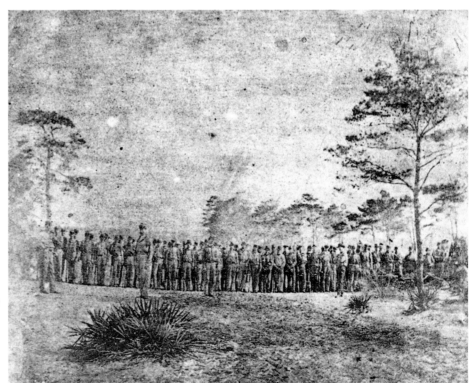

Of course, there was plenty of work for the new Southern soldiers to do, wherever they were stationed. Though photographs survive from only Pensacola and a very few other places, the regimen was much the same everywhere. Daily parade and drill was inescapable, as it is here for the Orleans Cadets. (TU)

The Louisiana Zouaves were quartered here at the marine barracks in the Warrington Navy Yard, and they, too, can dimly be seen at parade in front of it. (TU)

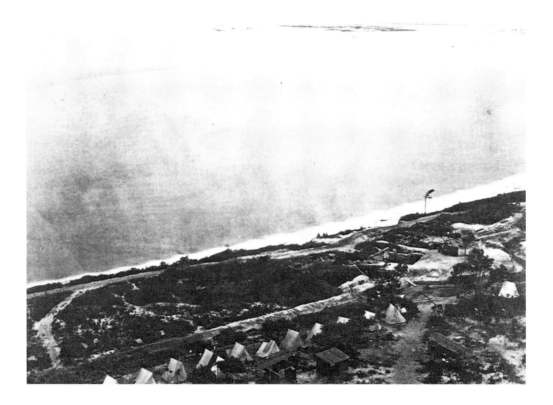

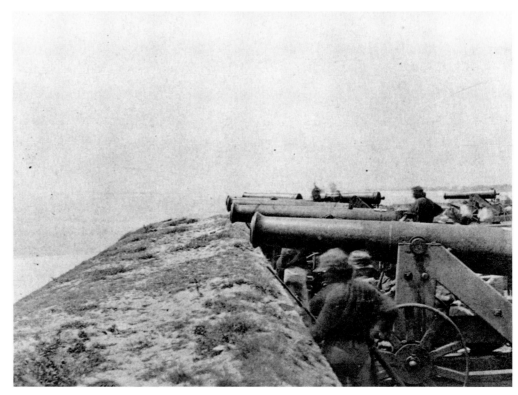

Top right: And Johnny Rebs had their forts and batteries to man. Here, in another previously unpublished Edwards image taken from the Pensacola lighthouse, Rebel camps as well as gun emplacements can be seen. Off in the far distance stands Fort McRee, its guns, like all the others at Pensacola, trained on Fort Pickens, which the Yankees had refused to abandon. (USAMHI)

Bottom right: These Confederates man a large battery in what is perhaps Fort Barrancas, an old earth and masonry stronghold outside Pensacola. Edwards's image, published here for the first time, shows the Rebs poised and ready — though, as it turned out, the guns they are manning were rarely fired during hostilities in the four-year war. (USAMHI)

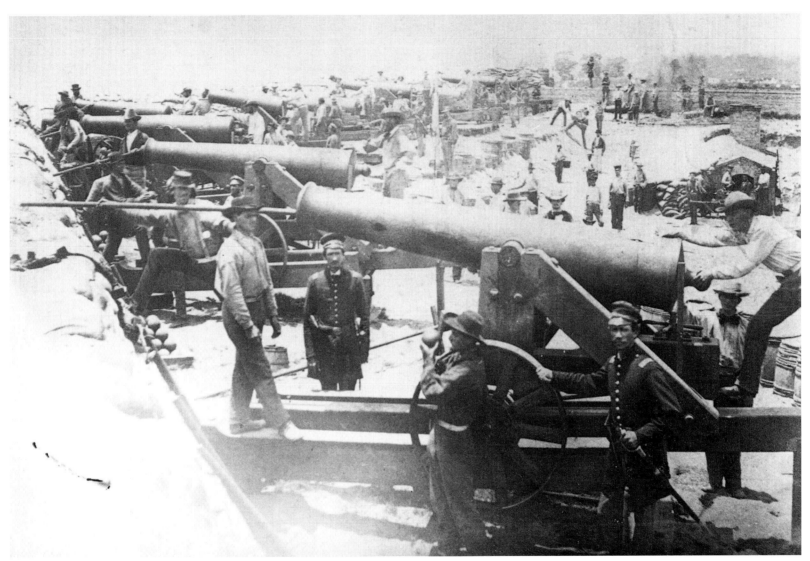

But the Confederates were ready to fight if the war did come to them. This and several other Edwards images are no longer known to survive in the original, but old negative copies made in 1911 have recently come to light that allow a wonderful look at the poses, faces, and uniforms of these Southrons inside a well-manned water battery. (USAMHI)

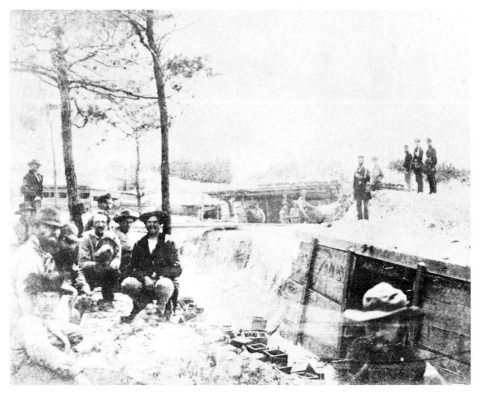

Another of the newly discovered negatives shows the earth-covered bombproofs and dugout ammunition magazines that were intended to protect men and powder. With nothing but time on their hands, these Confederates — and thousands of others elsewhere throughout the war — spent a lot more time with spades in their hands than weapons. (USAMHI)

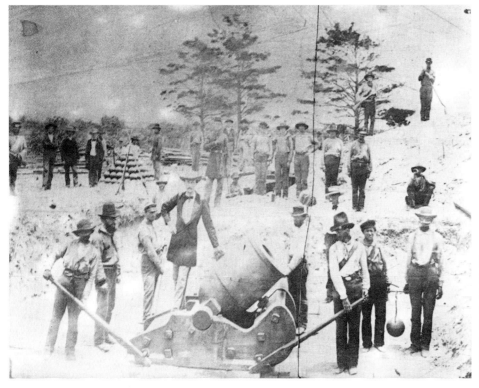

Sometimes one could only tell an officer by the shoulder straps hastily attached to his frock coat, as with the dapper fellow standing on the mortar carriage. In time, most Confederate units would become better uniformed, but there would always be a bewildering variety of headgear, shoes and boots, and equipment. (USAMHI)

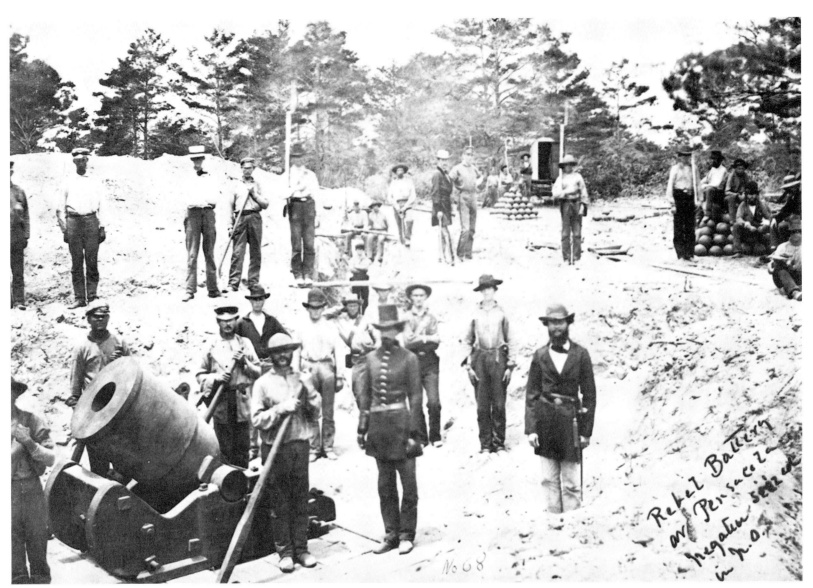

No two hats are the same in this view of the same mortar, in which men have traded places to pose for Edwards. The lighthouse that afforded him panoramas of the area is visible in the background at left. (NA)

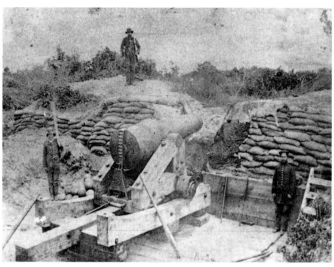

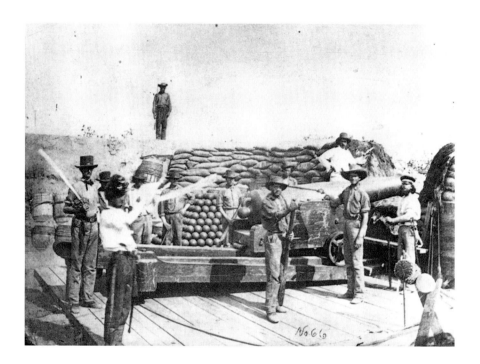

Top left: Wherever there was a cannon — like this ten-inch columbiad in a sand battery manned by the Perote Guards of Mississippi — young Rebs could be found to pose proudly for Edwards's camera. (PHS)

Top right: There were smiles, brandished swords, and an air of men who thought this war was going to be a lark, their only concern being that it might end before they got in a good lick at the Yanks. They would not be disappointed. (USAMHI)

Bottom right: Probably the most uniformly soldierly-looking Confederates that Edwards found were these Rebels manning Fort McRee. The fort itself has now all but vanished thanks to erosion, and the old image, too, no longer exists except in this long-lost 1911 copy negative. Happily, it still remains as testimony to the pioneering work of Edwards the photographer, and to the visage of Southern manhood in the first bright days of the war. (USAMHI)

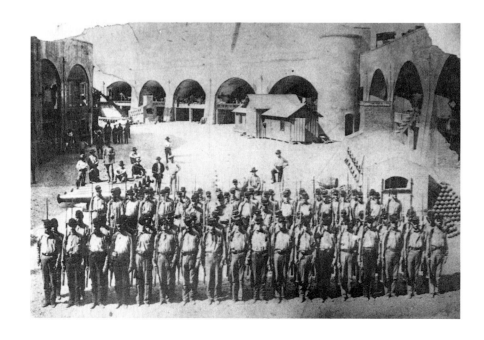

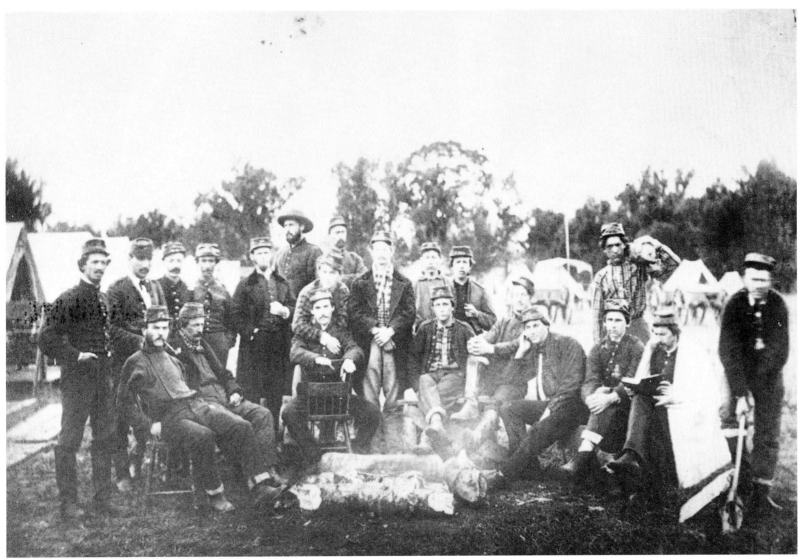

J. W. Petty of Poydras Street in New Orleans was another pioneering artist who left behind a priceless record of the Rebels of '61. His series of images of New Orleans's famed Washington Artillery is the best record that has survived of a single Confederate unit in all its wonderful variety. Most of these images, too, were lost until recently. (USAMHI)

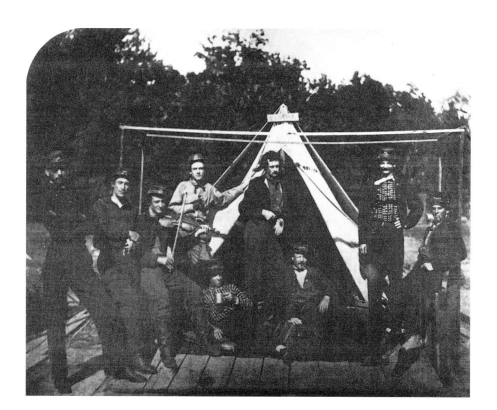

Just where Petty made his images is unknown, but probably it was while the unit was mustering before leaving New Orleans. Quarters were makeshift, to say the least. (USAMHI)

Top right: These messmates of the tent dubbed "Bastile" would prove themselves fierce fighters in the war ahead. The Washington Artillery would serve both east and west of the Alleghenies, compiling an enviable combat record. (USAMHI)

Bottom right: The calm of their pose belies their ferocity in battle. (USAMHI)

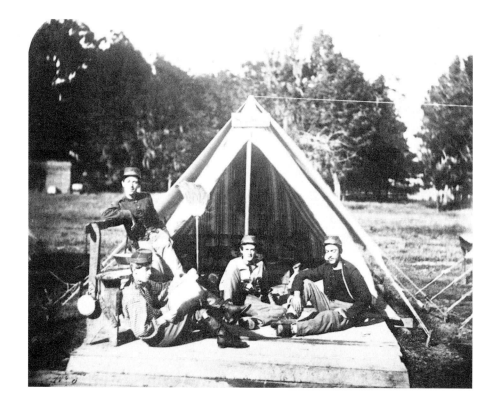

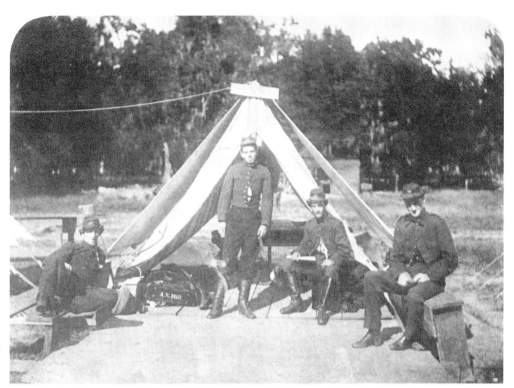

This group named its tent after the first Confederate victory in a land battle—Big Bethel, Virginia—which means that Petty's image must have been made after June 10, 1861. (USAMHI)

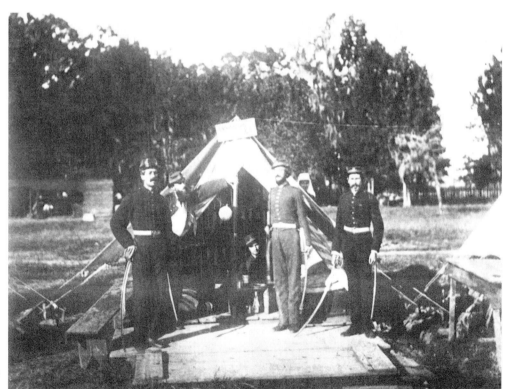

Harkening back to the days of the Revolution, several artillerists stand proudly at attention in front of "Lexington of '61." The Confederates all looked toward the Spirit of '76 for inspiration and example in their own revolution. (USAMHI)

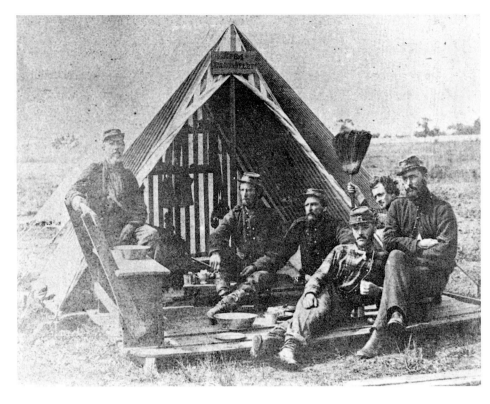

Petty was apparently sufficiently taken with the striped tent of the boys of "Carondelet" that he . . . (CM)

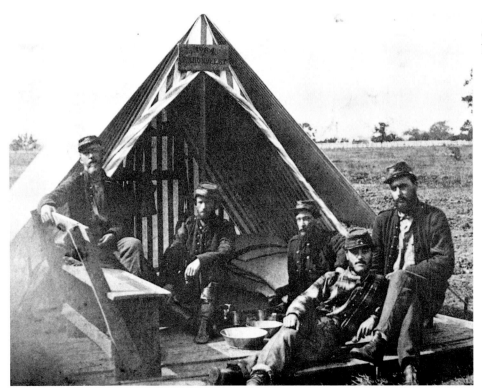

. . . photographed them twice. Such a scene of luxury would be a real rarity two years hence in the Confederate army. (JPR)

It may have been Petty who photographed these men at Camp Lewis, near Carrollton, Louisiana. There were several companies of the Washington Artillery; these images show the Fifth Company. (CM)

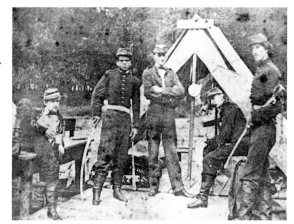

Some of these Louisiana officers had a distinctly professorial look to them, yet the boys in the ranks came to love and respect them in time. They would follow them anywhere. (USAMHI)

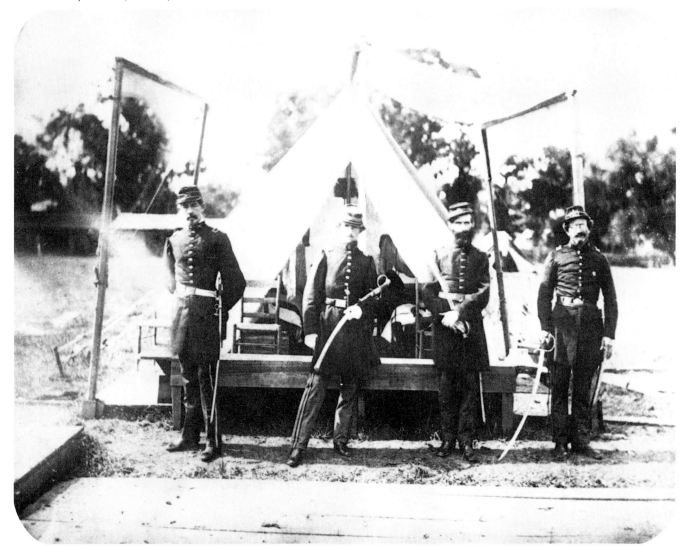

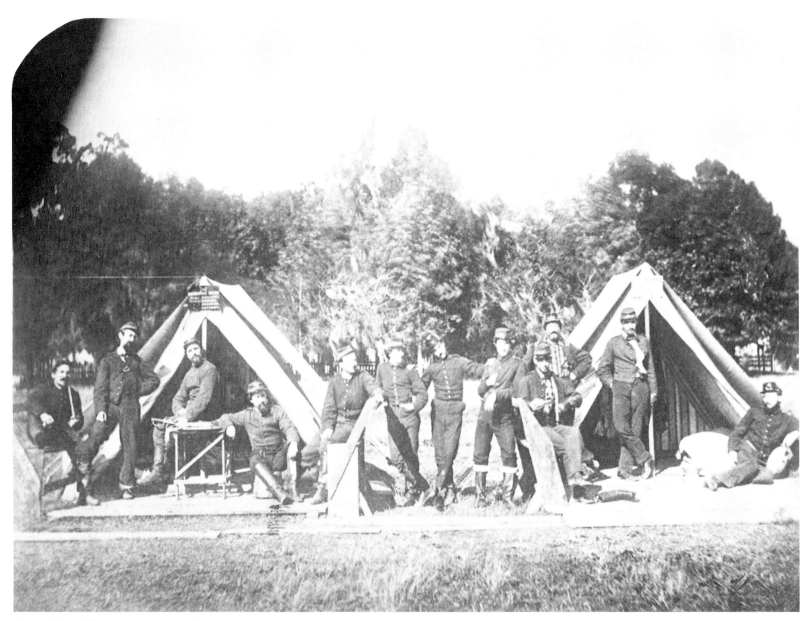

"Dixie's Land" says the sign on the tent at right, and that was what all Confederates were fighting for. (USAMHI)

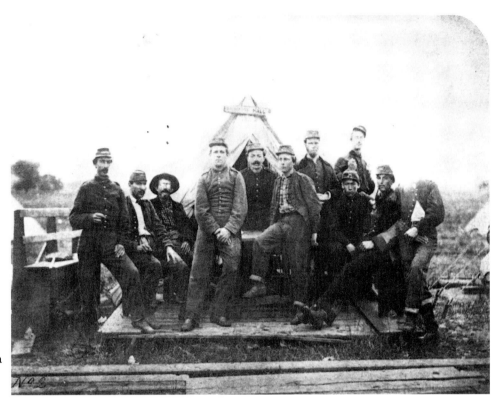

These Johnny Rebs called their home "Richmond Hill." Theirs are the faces of an innocent America about to grow up in a hurry. (USAMHI)

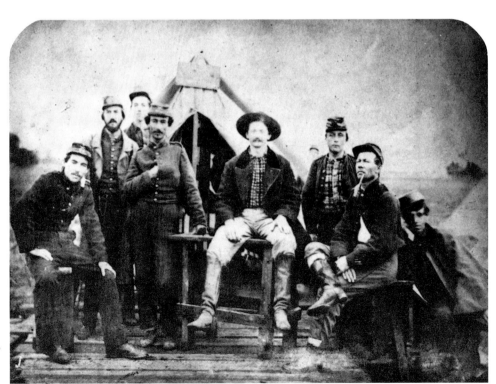

The lad at right might clown about, wearing a mess plate on his head, but a few years from now Johnny Reb would be fortunate to have such a dish, much less anything to put into it. (USAMHI)

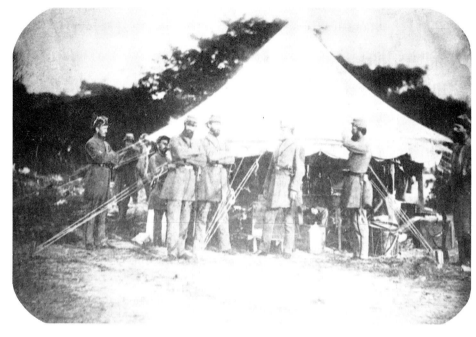

Another famed Confederate unit named for the Father of His Country was the Washington Light Infantry of Charleston, South Carolina. No one knows who made a brief series of images of them in 1861. Here their officers stand before a tent brimming with equipment. (USAMHI)

Bottom left: A few of the boys sit in the shade . . . in full uniform. The truly "candid" pose seems not yet to have been invented. (USAMHI)

Bottom right: The "Music Hall" of the Washington Light Infantry could boast a fiddler or two and a bugler (leaning on his rifle, at left). Rebs took their songs with them wherever they went. (USAMHI)

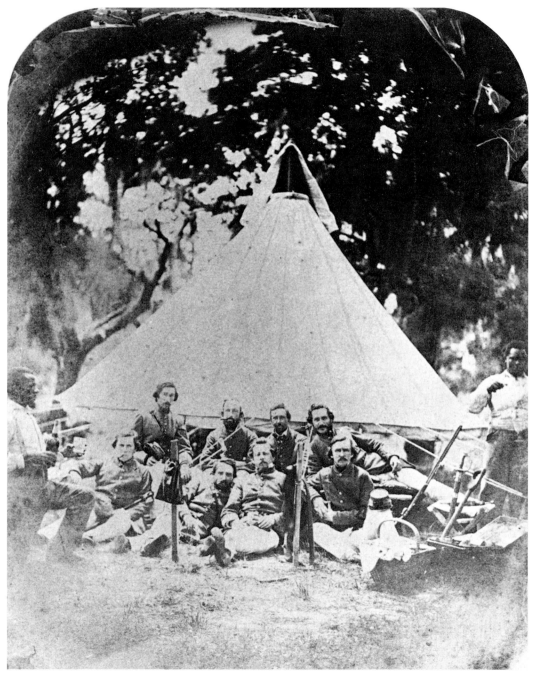

And in the early days of the war, the more affluent took the luxuries of home with them, too, including their body servants, seen here about to serve their masters from ample picnic hampers. (WLI)

Many a Johnny Reb brought a slave to the war with him, and many of those slaves served faithfully throughout the war. Andrew Chandler sits below with his servant Silas. Before the war, many Southern states prohibited blacks from even carrying weapons. Now that had changed. (SC/RSY)

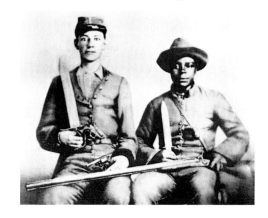

Less pretentious were these Texans, standing before their "Wigfall Mess" at Camp Quantico, Virginia. They would have to perform their own camp chores. (USAMHI)

Top right: More telling than anything else are the faces of Johnny Reb. (WA)

Bottom right: He loved the flag for which he fought, and upon which this bearded young Mars leans. (HP)

Like this Texan, Johnny Reb looked young for the most part, but the war aged him quickly. (WA)

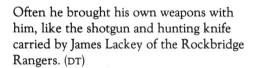

Often he brought his own weapons with him, like the shotgun and hunting knife carried by James Lackey of the Rockbridge Rangers. (DT)

He loved the flamboyant dress of the cavalryman. (HP)

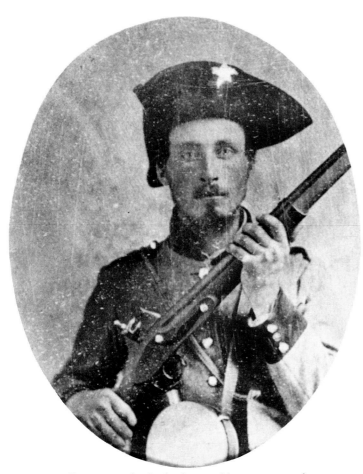

Sometimes he looked more like a vestige of the Revolution, with an old flintlock rifle and a tricorn — like Thomas Gooch of Company C, Twentieth Mississippi. (MC)

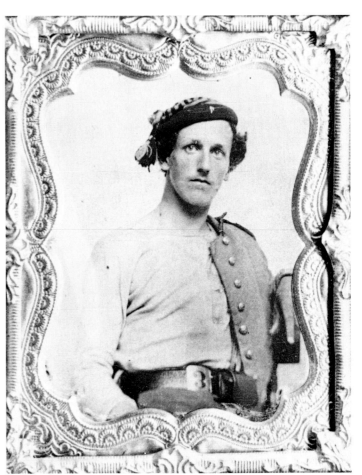

When he could, Johnny Reb adopted the zouave and other forms of fancy uniform, even if he only wore it by half. (HP)

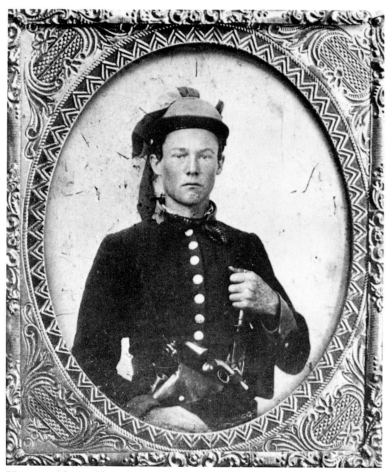

He armed himself to the teeth when he could. (WA)

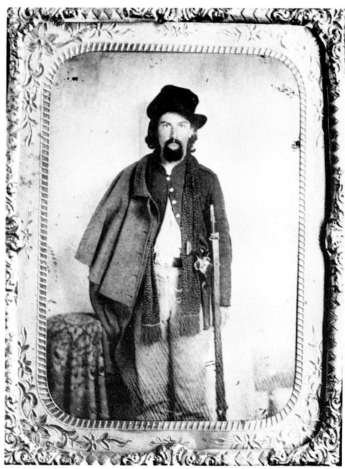

What he lacked in worldly sophistication, he made up for in pure determination. (HP)

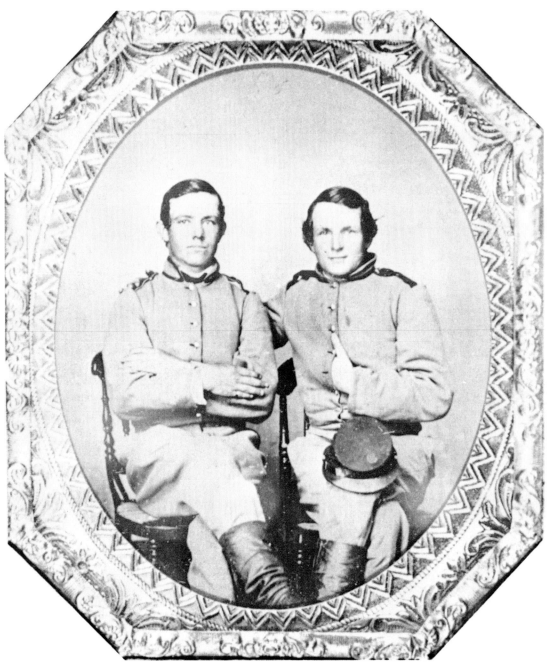

He went to war with his friends, to fight for
them and his state. Two Virginians — Reggie
T. Wingfield and Hamden T. Fay — sit for
the camera. (JM)

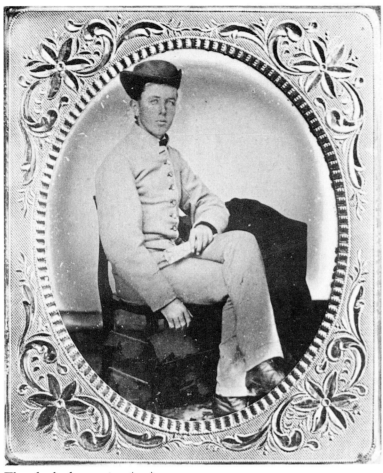

They had a lot to give. (WA)

Most of all, like
Sam Cocke, they
gave their youth. (PC)

They went to war with antiquated weapons
and dressed in homespun, like William
Presgraves of Virginia, photographed on
September 26, 1861. He would die the
following year. (JAH)

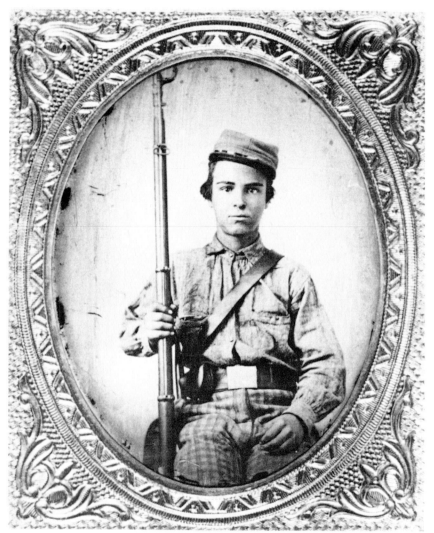

And if they survived the storm at all, it would
be as men — their boyhood, like their cause,
lost forever. (PC)

A Yankee in Dixie
Baton Rouge Photographer
A. D. Lytle

★

Charles East

Francis trevelyan miller and the Review of Reviews Company editors who worked on the ten-volume *Photographic History of the Civil War* set out to cover the war from both sides, and in so doing to uncover images taken by Southern photographers whose work could stand alongside that of their Northern counterparts Mathew Brady, Alexander Gardner, and others. Publication of the commemorative volumes in 1911 was in fact an outgrowth of the movement toward reconciliation and reunion. Among the editors were two of the sons of the Southern poet Sidney Lanier, who had no doubt grown up with stories of their father's exploits as a Confederate signal officer and blockade-runner; among the contributors would be former Confederate officers, as well as the editor of the influential magazine *Confederate Veteran*, whose blessing was important to the success of the project.

The discovery that the Southern photographers were not adequately represented came as early as 1910, and we know from an obscure account of his travels through the South in the early months of 1911 that a former journalist and advertising man named Roy M. Mason was hired to visit Richmond, Charleston, Atlanta, and other cities in a last-minute effort to find the Southern Mathew Bradys. On February 12, 1911, Mason arrived in New Orleans and checked into his hotel. as he had done in a dozen other cities. He then made the rounds of the city's newspaper offices to inform the editors of his mission, and subsequently stories appeared in at least two of the papers.

Someone in Baton Rouge, upriver from New Orleans, saw one of the newspaper stories and wrote a postcard addressed to Mason at the Saint Charles Hotel, saying that he had Civil War naval photographs. Mason immediately took the train to Baton Rouge, but discovered that the "photographs" were "woodcuts, copies, engravings, only one original, which I borrowed. But," Mason recalled, "he told me that A. D. Lytle, a local photographer, had some photographs. I called, and found a veritable mine. Lytle had been a Confederate spy, and had sent through to the Confederate secret service photographs of every camp, battery, regiment, headquarters and lookout tower of the Union army of General [Nathaniel P.] Banks, and of [David D.] Porter's and [David G.] Farragut's fleet upon the Mississippi."

Lytle still had all the glass negatives, but no one in Baton Rouge would undertake to make prints from them for Mason in less than a week. "The photographer demanded a large sum for his treasures, and I wired to the powers that were. The sum arrived, and I departed with the drama of the Red River and Port Hudson expeditions on glass plates in my arms." Mason goes on to tell how he had prints made from the Lytle negatives while in New Orleans and then sent the prints and plates to the Review of Reviews offices in New York. "I returned once more to Baton Rouge to get all the data I could in regard to the Lytle photographs, and then went up the Mississippi to Natchez and Vicksburg."

Mason's excitement over the discovery of the Lytle photographs was obviously communicated to the editors in New York, and when the ten-volume work was published at the end of the year and in the early months of 1912, the name A. D. Lytle for the first time entered the history of American photography. At least eleven of Lytle's photographs were reproduced in the first volume — one of these a wartime photograph of his Baton Rouge gallery, which shares a page with the famous full-figure portrait of Mathew Brady in linen duster, "just returned from Bull Run." Throughout the work over fifty of his images appear, more generous treatment than any of the other Southern photographers received.

The Lytle photographs show a small city in the lower South, the state's capital until 1861, at an extraordinary time in its history. First occupied by the enemy army in May 1862, and under the guns of the Federal fleet from then until the end of the war, Baton Rouge early in 1863 became the staging area and hospital for the Federal campaign against nearby Port Hudson, and a base of operations for General Banks's ill-fated drive up the Red River the year following.

Most of the wartime views that we can identify as being his seem to have been taken in either the spring or summer of 1862 (the first period of Union occupation) or between December 1862 (when the city was reoccupied) and July 1863 (the surrender of Port Hudson). What we see are cavalry camps, public buildings used to quarter troops or to serve as makeshift hospitals, soldiers standing at parade, officers seated amid their tents at posed leisure — and a vast array of naval vessels, from mon-

ster ironclads and the smaller tinclads to Porter's flotilla of mortar boats waiting to be towed to positions just outside the range of Confederate guns along the bluffs at Port Hudson.

One interesting aspect of Lytle's career and his subsequent placement among great Southern photographers — and this is also true of the New Orleans photographer J. D. Edwards — is that he was Northern-born and only on the eve of the war could claim to be a Southerner. Lytle had traveled through the South taking pictures in the late 1850s and had spent several months of 1859 in Baton Rouge, but it is doubtful that he decided to locate there permanently until 1860, when he advertised in one of the local papers for "a small house with three or four rooms, in a central part of town." Any person having such a house, he said, "can find a good paying tenant."

Andrew David Lytle was born in Deerfield, in Warren County, Ohio, April 4, 1834, the son of David Lytle, a tanner. Not long after his father's death in 1838, young Andrew's mother, Dorcas Mounts Lytle, married a man named John Waldron, who died a little over a year later. By 1850 the widowed Dorcas Waldron was living in Cincinnati with her four children, one of them sixteen-year-old Andrew. On June 20, 1855, Andrew married Mary Ann Lundy, whose father was an engraver and a manufacturer of gold pens, and at about this time, if not earlier, he began his apprenticeship under one of the Cincinnati photographers, possibly the well-known daguerreotypist William S. Porter. In 1856 Lytle was working as a daguerreotypist at 83 West Fourth Street — the same address as that given for Porter.

During the 1850s Lytle joined two military organizations that may have been as much social as military, and in one — the Rover Cadets — he held the rank of captain, a title that seems to have stuck with him. He began to travel through the Southern states as a photographer even before he left Cincinnati, and after two years of such traveling, in 1857, he located at Baton Rouge. The earliest actual record of his having been in the city is an advertisement that appeared in one of the Baton Rouge newspapers on December 18, 1858, announcing that "the World Renowned Artists LYTLE & GIBSON, have arrived in our city, and taken Rooms in Heroman's Brick Block, where they are prepared to execute work in the various branches of

the PHOTOGRAPHIC ART. They also make the celebrated LYTLEOTYPE, which is made by them only.''

It is clear that Lytle and his partner, whose first name is unknown, were itinerants—two in a succession of traveling photographers who passed through Baton Rouge from time to time before 1860. They occupied a gallery on the upper floor of the three-story Heroman Building, the newest and finest building of its kind in the city, and their popularity may have kept them longer than they had intended. The *Daily Advocate* reported that their rooms were "crowded every day, with the elite and fashion of our city, to procure one of their highly celebrated pictures, made of glass, iron and paper." In April and May of 1859, Lytle and Gibson advertised that they would shortly be leaving, and they were gone by the middle of June— off for Mississippi, where they said they would remain for the summer.

The death of the Lytles' two-year-old son Andrew David Lytle, Jr., occurred during their stay in the city, and it is possible that one of the reasons why they decided to settle in Baton Rouge rather than in some other city is that the little boy was buried there.

Lytle returned to Baton Rouge in the fall. In the November 18, 1859, issue of the *Daily Gazette & Comet*, "Lytle & Co." announced that they were located on Main Street across from the Harney House hotel, and this is the location where Lytle continued to operate a gallery for more than fifty years. It occupied the second floor of a building on the south side of Main, only a block or so from the levee and the river.

There was one more departure for Mississippi in June of the following year, but Lytle was back in Baton Rouge by August —and, advertising for a house for himself. It would be a few years more before he and his wife owned their own home on the Boulevard, not far from the governor's mansion. The events that were about to engulf them would be catastrophic, but they did not know it. The victory of Lincoln in the No-vember 1860 presidential election set the stage for the secession of Louisiana and the other Southern states, the formation of the Confederacy, and the war that was to follow.

In Baton Rouge the gathering of first the legislature and then the secession convention kept Lytle busy with his portrait work, which was always the bread and butter of his photography business. As the excitement mounted and the city teemed with young men organizing themselves into military companies like the Baton Rouge Fencibles and the Pelican Rifles, he was even busier, according to the columns of the local newspapers. "Lytle's Gallery is crowded every day with 'our boys' getting their pictures before leaving for the wars," the *Daily Advocate* reported not long after the opening shots at Fort Sumter. Apparently, when the war came Lytle employed his experience with the Rover Cadets in drilling two or three companies for the Confederate service. He held no rank in the Confederate army, and neither did the men he was drilling, though the lo-cal militia companies were later mustered into Confederate service.

In the first year of the war, many of those who came to Lytle's gallery to have their pictures taken were young men about to be soldiers, or soldiers wearing their first uniforms and about to go aboard a steamboat headed upriver to Vicksburg and Memphis or downriver to New Orleans—sons of the Confederacy. With the arrival of Farragut's fleet and the occupation of Baton Rouge by troops under the command of Brig. Gen. Thomas Williams in May 1862, the officers and men—and gunboats and guns—of the Union army and navy became his subjects. Most of the white families of the city fled in the summer of 1862 and did not come back to claim their homes and pick up their lives until the end of the war. Lytle, however, remained—or if he left, was gone only briefly. He continued to operate his gallery through the period of the occupation, and when the war was over he quickly established himself as a leading citizen of Baton Rouge and the city's premier photographer. When Roy Mason came upon him in 1911, Lytle was in his mid-seventies and his health was failing, though he was to live for another six years. The old man died on the afternoon of June 8, 1917, at his home on the Boulevard; his wife had died nineteen years earlier.

The recognition that came to Lytle in his old age with the publication of the *Photographic History of the Civil War* was deserved attention, but it has been clouded by the question of Lytle's supposed role as a Confederate secret-service agent, or, as Henry Wysham Lanier called him in a preface to the ten

volumes, a "camera spy" for the Confederacy. In the opening pages of the first volume, under a photograph of the First Indiana Heavy Artillery at Baton Rouge that is identified as having been taken by Lytle, the caption reads: "With a courage and skill as remarkable as that of Brady himself this Confederate photographer risked his life to obtain negatives of Federal batteries, cavalry regiments and camps, lookout towers, and the vessels of Farragut and Porter, in fact of everything that might be of the slightest use in informing the Confederate Secret Service of the strength of the Federal occupation of Baton Rouge." The caption writer, who may have been Mason, added: "In Lytle's little shop on Main Street these negatives remained in oblivion for near half a century," until they were "unearthed by the editors of the 'Photographic History.'"

In his preface Lanier tells us that Lytle took "a series of views . . . for the specific use of the Confederate Secret Service," explains how the photographer was able to obtain his chemicals during wartime, and introduces another element to the story: "Mr. Lytle's son relates that his father used to signal with flag and lantern from the observation tower on the top of the ruins of the Baton Rouge capitol to Scott's Bluff, whence the messages were relayed to the Confederates near New Orleans; but he found this provided such a tempting target for the Federal sharpshooters that he discontinued the practice." References to Lytle in several of the subsequent volumes give essentially the same information.

Lanier's mention of Lytle's son Howard as a source presents the possibility that information concerning his father's role as a Confederate secret agent originated with Howard and not with his father. On the other hand, Howard's story of his father's having signaled from the observation tower atop the fire-gutted State House (the building burned the night of December 28, 1862) may simply have been a postscript or addendum to the story that the old man himself had already told: of his having passed photographs along to the Confederates. In other words, one may have been only incidental to the other. The sense of Mason's account is that he met and talked with Lytle — that it was the photographer himself who "demanded a large sum for his treasures." Roy Mason never mentions Howard Lytle,

though Mason must surely be the source for Lanier's statement; and, given the fact that Howard and his father were close and worked out of the same gallery (by now A. D. Lytle & Son), it seems likely that Howard was present on the occasion of both of Mason's visits.

The truth about what role, if any, the Baton Rouge photographer played as a Confederate secret agent has never been — and may never be — determined. Those who reject the story out of hand can cite the absence of evidence that Lytle served in any Confederate unit, though that, given the circumstances of the time and place, is hardly conclusive. Another argument, that Lytle's photographs would have been of little use to the Confederates — would have told them nothing more than they could have learned otherwise — is a retrospective one. We know a great deal more about military intelligence than was known in 1862 and 1863, and it is clear both from the official correspondence and from other sources that as the Union army and navy converged on Port Hudson in the early months of 1863, the Confederates were grasping for information — and had set up a rather extensive network for gathering it. The signal stations strung along the Mississippi River for some twenty-five miles, from Baton Rouge to Port Hudson (the one nearest Baton Rouge on the east bank of the river was very likely at Scott's Bluff), were only a part of their operations.

The officer in charge of Confederate Signal Corps operations in the vicinity of Baton Rouge in the early months of 1863 was Capt. J. W. Youngblood, who reported directly to Maj. Gen. Franklin Gardner, the officer in command at Port Hudson. Gardner in turn relayed the information to his superiors. "I have reliable information from Baton Rouge" is a phrase that recurred in Gardner's official correspondence, as he awaited the coming of the Union army then gathering in the former capital. The Signal Corps unit was rather amorphous in nature. In addition to those assigned to the unit, there were also those whose status was no more than quasi-official, as well as others who remained civilians. When, in July, they learned that General Gardner had surrendered Port Hudson, many of them simply faded away. Thus, they were not among those surrendered.

It is in this context that Lytle may have turned over photographs to someone with the intention of their being used by the Confederates. It may have been someone attached to the Signal Corps in either an official or an unofficial capacity. It may have been a civilian. Whoever it was, the best guess is that the Signal Corps was the channel. There is, as a matter of fact, one sentence in a biographical sketch of Lytle published in 1892 that lends credence to the theory. This is not necessarily Lytle himself speaking, but it must surely be an account drawn from information supplied by him; and what it tells us is that he "attached himself to the Confederate Signal service, with which he was connected at the fall of Port Hudson." Lytle's connection with what the sketch calls the Confederate Signal service is almost certainly the basis for the story that resurfaced twenty years later in the *Photographic History*.

The question of whether Lytle was a secret agent, whether he worked with or for the Confederate Signal Corps or the secret service, will continue to intrigue us, but it should not divert us. What is important about Lytle — the reason he merits our attention — is that he was there when the war came to his particular corner of the Confederacy, that he took the pictures — and, of course, that he kept them, until the day when someone like Roy Mason came climbing the stairs to his gallery.

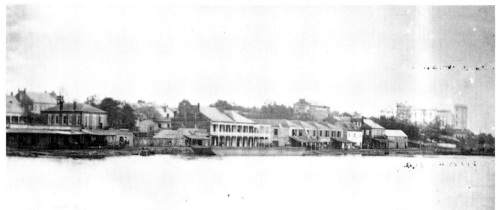

The waterfront of Baton Rouge, with the Louisiana State House standing at far right. Like all of the images in this chapter, this photograph is reproduced from a print made directly from A. D. Lytle's newly discovered glass-plate negatives. (USAMHI)

A street scene in Baton Rouge, perhaps before a parade or some other public festivity, as whites and blacks line both sides of the road. The artist signed his own work here, "Lytle, Photographist." (USAMHI)

Even though a state capital in time of war,
Baton Rouge was a quiet town as captured on
Lytle's plates. (USAMHI)

Tree-lined side streets and picket fences led
the way between the public buildings and to
and from the river. (USAMHI)

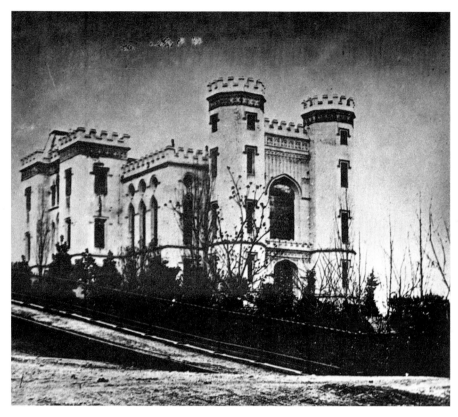

The State House, built in the 1840s, dominated the small city. (USAMHI)

The substantial home of Samuel M. Hart on Church Street gives little evidence of the service it later saw as headquarters for a Yankee general. (USAMHI)

Lytle liked to take his camera up to Baton Rouge's high places, usually church steeples, to capture his elevated views of the city. (USAMHI)

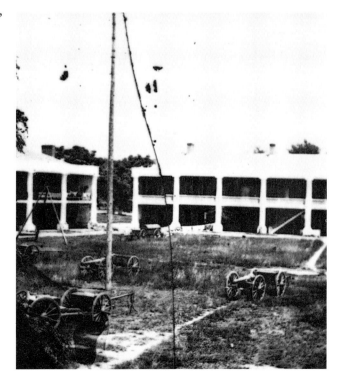

Another of his favorite subjects was the Baton Rouge Barracks, looking a bit disheveled here with the laundry hanging out to dry. (USAMHI)

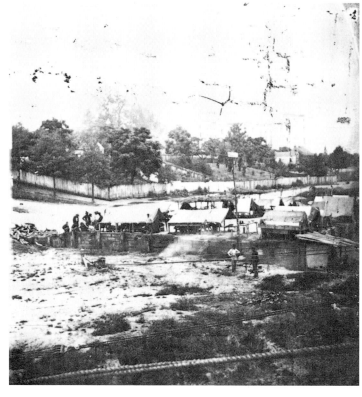

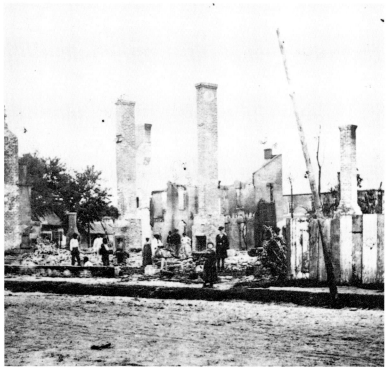

Top left: Lytle liked the private dwellings, too, many of which were occupied by Federal officers after the city fell to the Yankees. (USAMHI)

Top right: Most of all, he turned his camera toward evidences of the war that had swept the city. All around the fringes there were camps of laborers and soldiers. (USAMHI)

Many of Baton Rouge's homes and businesses were burned when the Yankee commanders needed to clear a path between the city and the river for their artillery. This was one of the saddest images to come before Lytle's lens. (USAMHI)

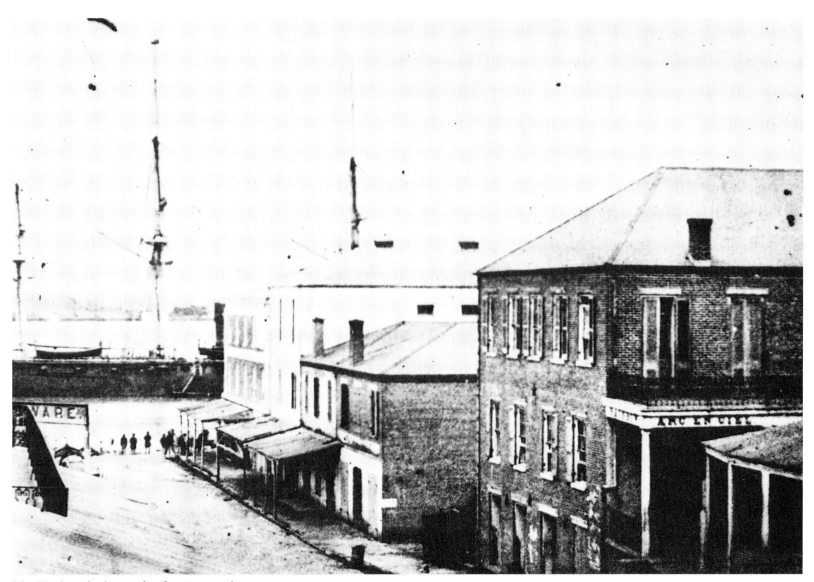

The Yankees had come by the river, and, inevitably, Lytle devoted most of his plates to the ribbon of water that brought the war to Baton Rouge. Adm. David G. Farragut's flagship *Hartford* is believed to be the vessel lying off Main Street. (USAMHI)

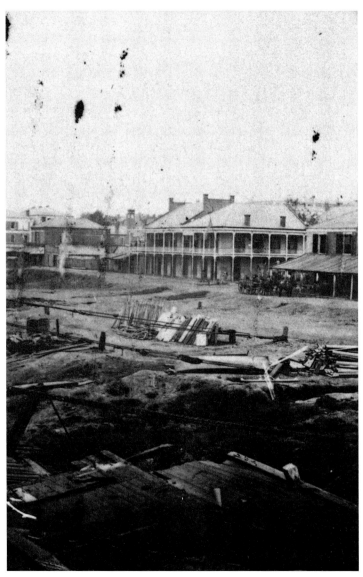

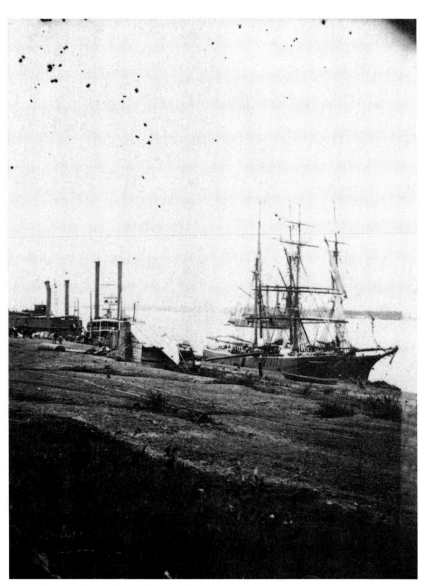

The waterfront would be jammed with naval hardware and refuse for years. (USAMHI)

And always the gunboats lay at their moorings on the bank. Two mortar schooners sit at right, while at far left rests the wooden gunboat *Tyler*, its starboard stack a bit awry. (USAMHI)

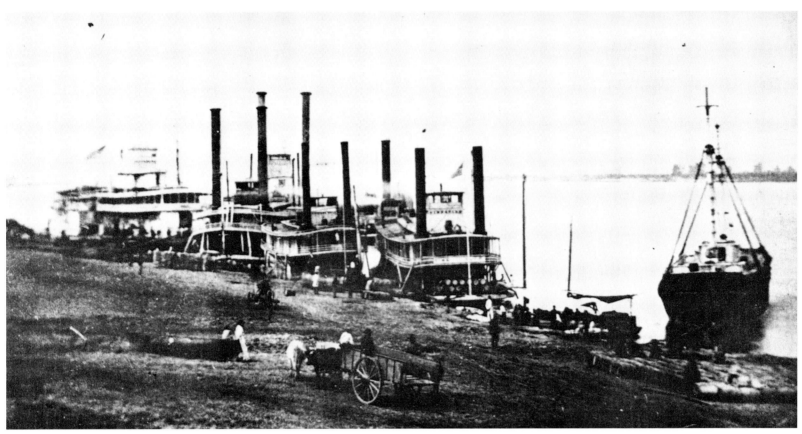

There were regular commercial steamboats —
packets — coming and going. (USAMHI)

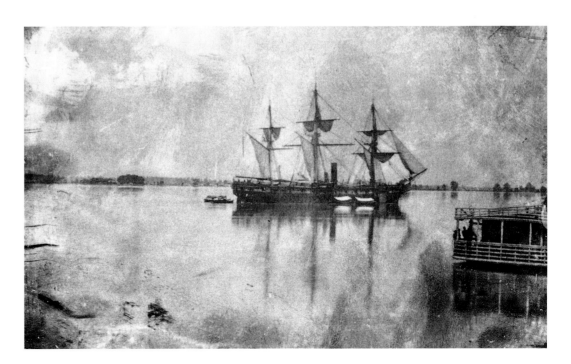

But Lytle's real interest was the warships.
Here what is believed to be Farragut's
Hartford rests at anchor out in the stream.
(USAMHI)

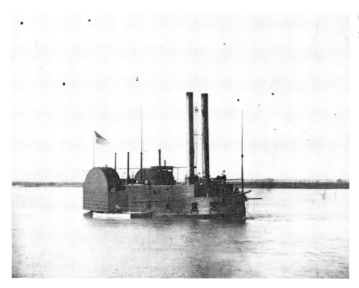

One of the workhorse "woodclads" of the river fleet, the *Conestoga*. (USAMHI)

A host of other gunboats, called tinclads because of their light armor, went up and down the river and paused for Lytle's camera. Most had names, but for some only numbers are known—like the No. 53. (USAMHI)

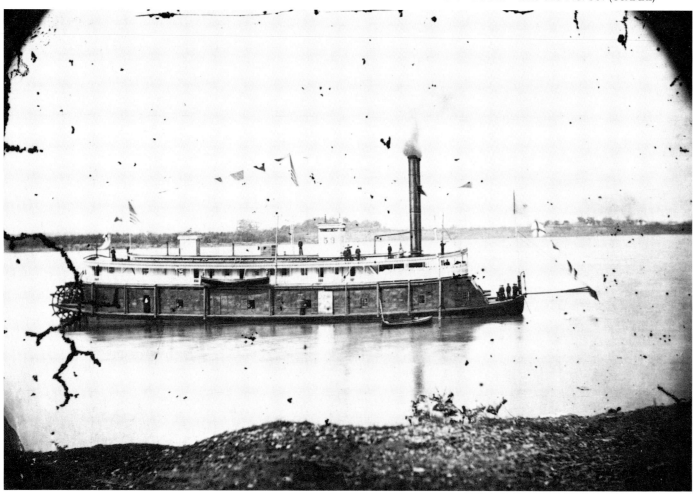

There was little uniformity among the tinclads, since many were simply prewar river steamers converted to military use. No. 8 was seen all up and down the Mississippi. (USAMHI)

This one, its number indistinguishable, bore a combination of straight and sloping sides, with a rounded bow and only half a cabin deck. (USAMHI)

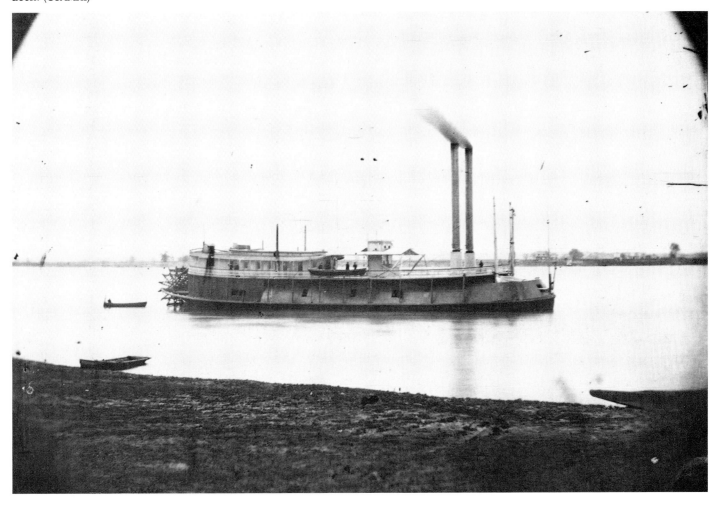

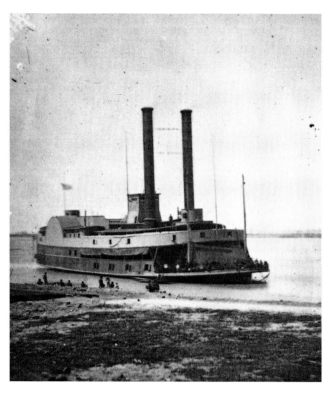

A perfect example of an ersatz tinclad, this unidentified vessel actually has two turrets, one fore and the other aft. The ship fairly bristles with guns. (USAMHI)

Bottom left: Farragut's fleet included more conventional ships like the *Albatross* . . . (USAMHI)

Bottom right: . . . and even a few captured Confederate ships, most notably the *General Sterling Price*. Seized in 1862, this vessel somehow captivated Lytle's imagination, for he made more images of it than of any other ship. (USAMHI)

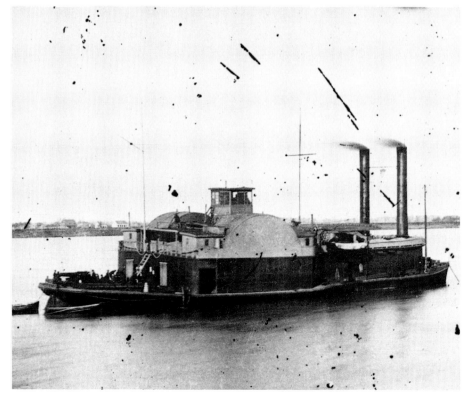

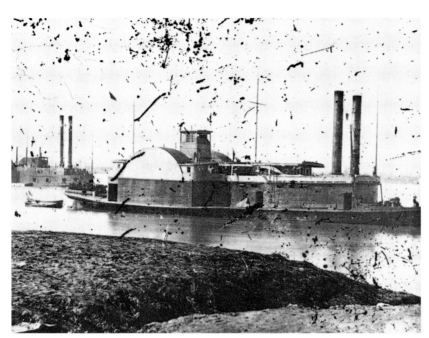

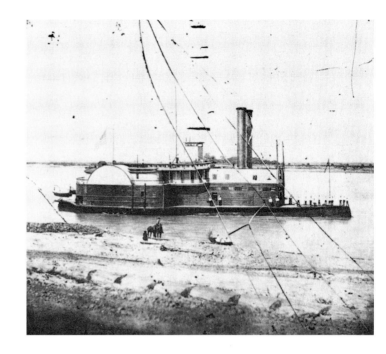

Top left: The *Conestoga* rests aft of the *Price* in this image. A few weeks after this photograph was made, the *Price* accidentally rammed and sank the other ship. (USAMHI)

Top right: The ram *Defender* was often mistaken for the *Price*. Its job was a simple one: to sink its reinforced prow into an enemy hull. (USAMHI)

This is believed to be the artillery transport that carried Gen. Thomas Williams's body away from Baton Rouge after he fell in the August 5, 1862, battle. The photograph was presumably taken after the ship was sunk by the Confederates and subsequently raised. (USAMHI)

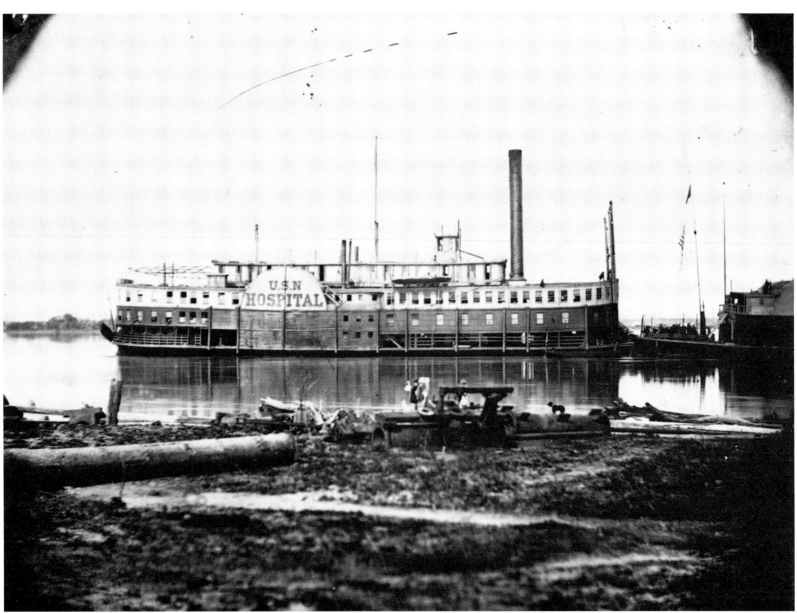

Here another Civil War innovation, the
hospital ship, stands for Lytle just aft of the
Price. This one is the *Red Rover*, a captured
Rebel transport. (USAMHI)

There were great leviathans in the Yankee fleet for Lytle to look upon. The USS *Essex* was one of the earliest and largest major ironclads on the river. (USAMHI)

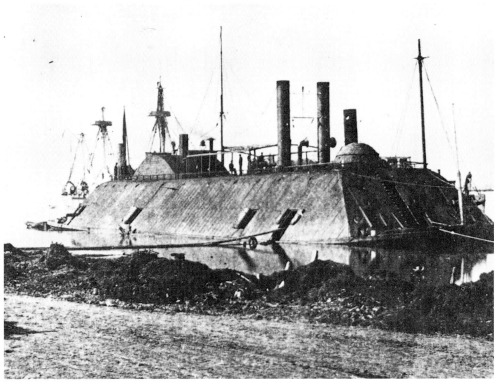

Bottom left: The huge USS *Choctaw* was even larger, and more dreadful-looking. Her mammoth sidewheels and towering twin smokestacks dwarfed the single-stacked tinclad at her aft. (USAMHI)

Bottom right: Mounting relatively few guns, but of high caliber, she looked virtually invincible. (USAMHI)

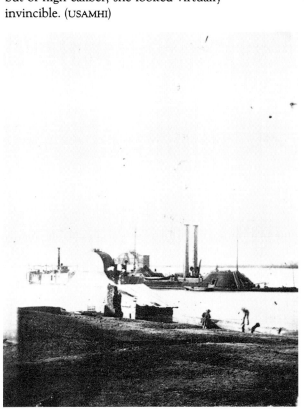

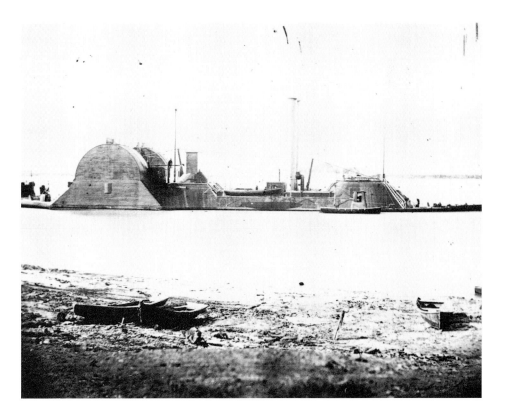

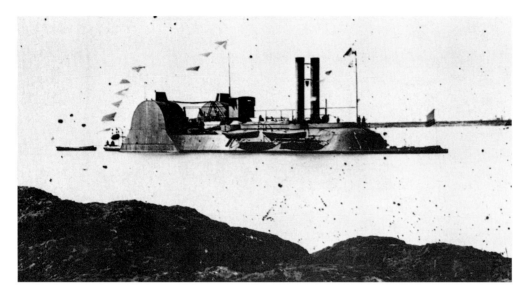

Equally formidable was the *Lafayette*. Lytle never tired of pointing his lens toward these ungainly engines of war. (USAMHI)

The men who served these warships also interested him. This group of seven naval officers is unidentified, though they appear to be aboard one of the tinclads. (USAMHI)

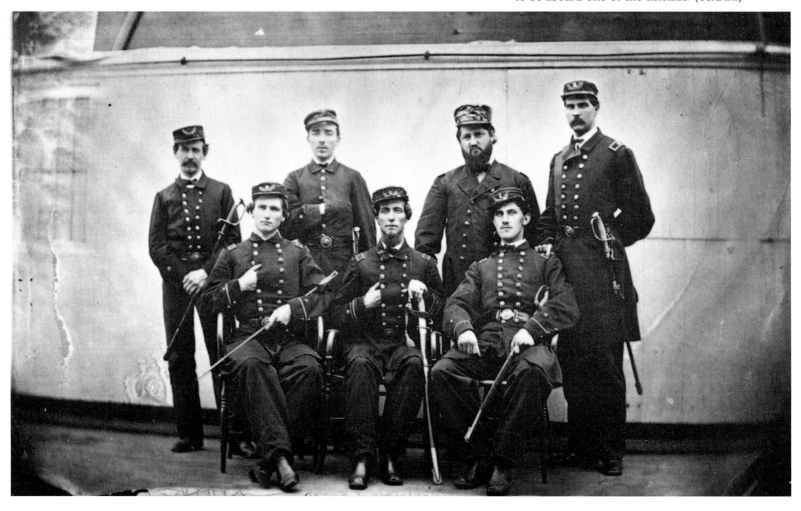

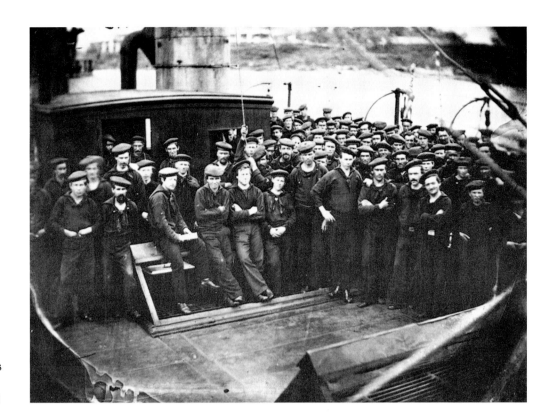

The name of their ship, *Choctaw*, appears on the hatbands of some of these sailors, photographed aboard the vessel. (USAMHI)

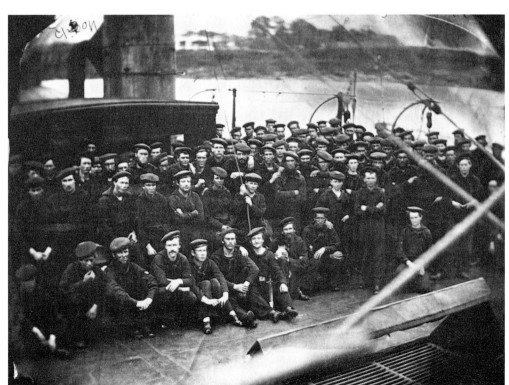

Some of his photographs, like this other view of the *Choctaw*'s sailors, Lytle may have printed in quantity to sell as souvenirs. (USAMHI)

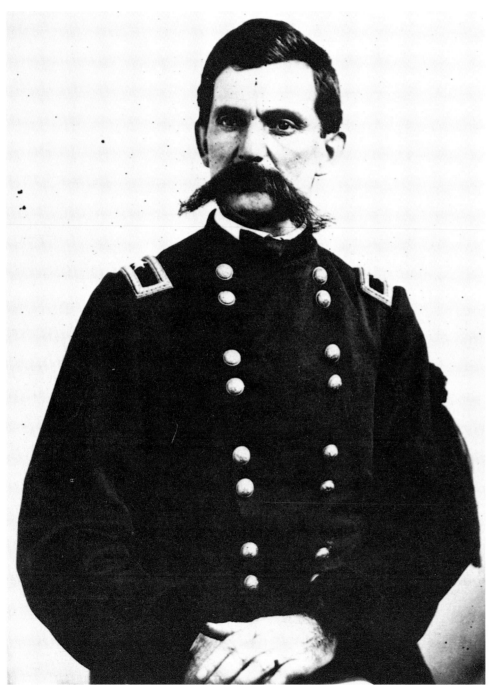

Lytle did a brisk portrait business, with studio poses like this one of Brig. Gen. Joseph Bailey, who appears to be wearing a mourning badge on his left arm, perhaps indicating that the image was made at war's end after the murder of Lincoln. (USAMHI)

Or like this fine portrait of Brig. Gen. Edward J. Davis. (USAMHI)

Some of those Lytle photographed are lost
to history. This brigadier defies positive
identification. (USAMHI)

As does this one — though he might be
William P. Benton, who stayed in the South
after the war and died in New Orleans's
tragic yellow-fever epidemic of 1867. (USAMHI)

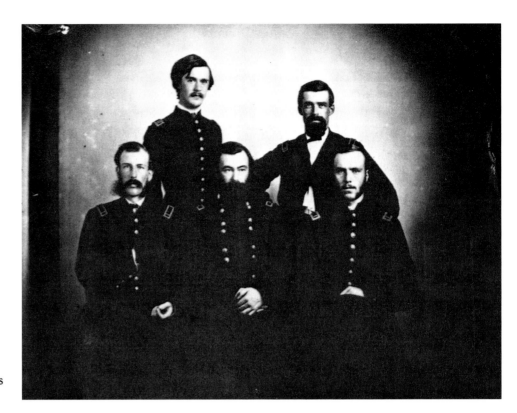

Benton — or whoever he may be — poses with fellow officers for Lytle. (USAMHI)

General Bailey and fellow officers pose in a rare interior setting. (USAMHI)

Lytle even tried mass-producing souvenir photos for the Yankees who came to Baton Rouge. He made photographic montages of portraits of all the officers of regiments, like the First Indiana Heavy Artillery . . . (USAMHI)

. . . and the Ninety-second United States Colored Troops. These could sell in large quantity, and help subsidize the photographer's passion for recording Baton Rouge's war on glass. (USAMHI)

Judging from this beautiful portrait of
Confederate colonel Randall L. Gibson,
it would appear that Lytle managed to work
his lens early in the war, before the Rebels
lost Baton Rouge. Yet very few of his
Confederate portraits are known to survive.
(USAMHI)

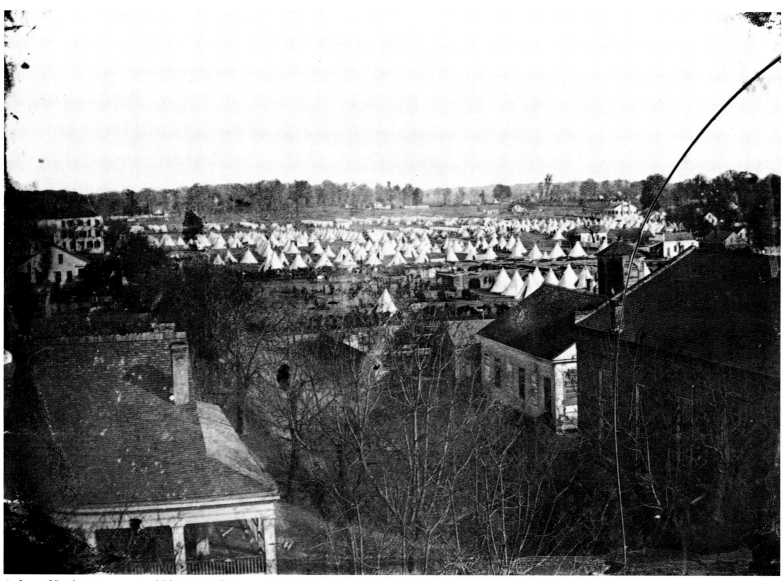

A few of Lytle's images would become almost famous, and none more so than this winter 1862/63 picture of the camps of the Seventh Vermont and Twenty-first Indiana. It is perhaps the finest image in existence of Yankee camps in the South. (USAMHI)

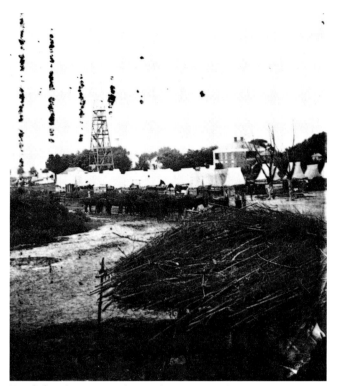

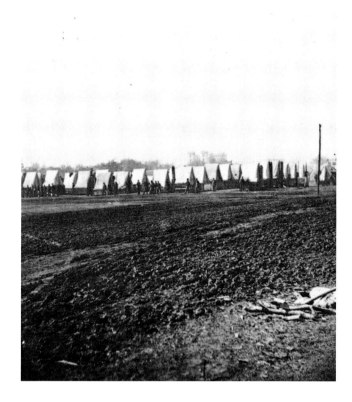

Top left: The camp of an unknown cavalry regiment outside the city, with a Yankee signal tower in the distance. (USAMHI)

Top right: Lytle seems to have often posed his outdoor views with some landmark in the background, usually the State House, which here rises behind the winter quarters of an unknown Yankee regiment. (USAMHI)

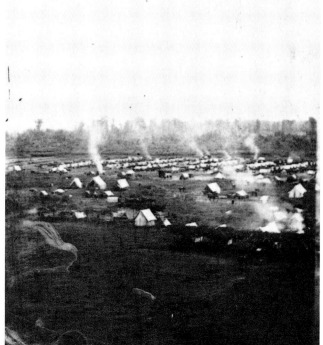

The smoke rising from campfires marks yet another Federal camp. Like their Confederate enemies, the Yanks, too, erected shebangs of brush to protect themselves from the merciless Southern sun. (USAMHI)

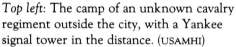

Lytle's camera caught Federal camps stretching to every point of the compass from Baton Rouge. (USAMHI)

Lytle made a beautiful image of Massachusetts's artillery posing before the Baton Rouge Barracks. He seems to have had no problem persuading these Yankees to hold still for his camera. (USAMHI)

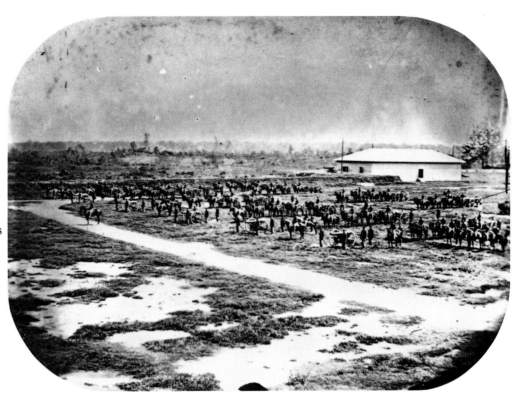

Another of Lytle's more famous images is this one of the First Indiana Heavy Artillery. It has long been supposed to have been taken in his presumed secret-service capacity for the Confederacy, though that would seem suspect. The South did not need Lytle's photographs to know what a Yankee battery looked like. (USAMHI)

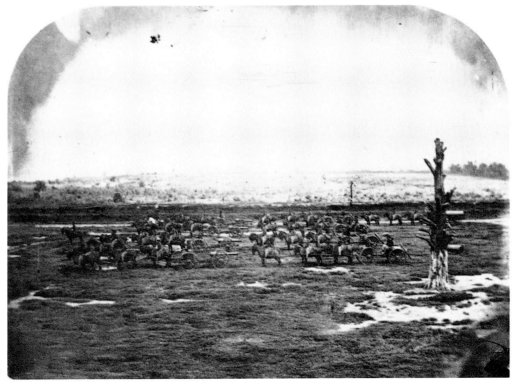

Another of the supposed secret-service images of the First Indiana. In fact, to today's eye, there appears to be little, if any, useful military information to be found in it. (USAMHI)

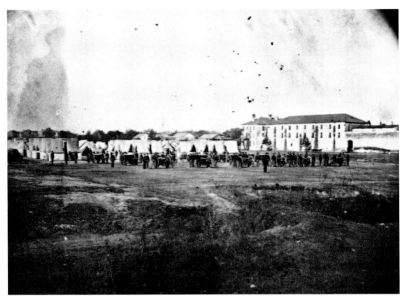

The Louisiana State Penitentiary shares the plate with the First Wisconsin Light Artillery in one of Lytle's finer unit pictures. (USAMHI)

Lytle liked group images of the Federal soldiers who filled Baton Rouge's streets, and he often made portraits of smart-looking outfits like this one posing before the courthouse where they may have been quartered. (USAMHI)

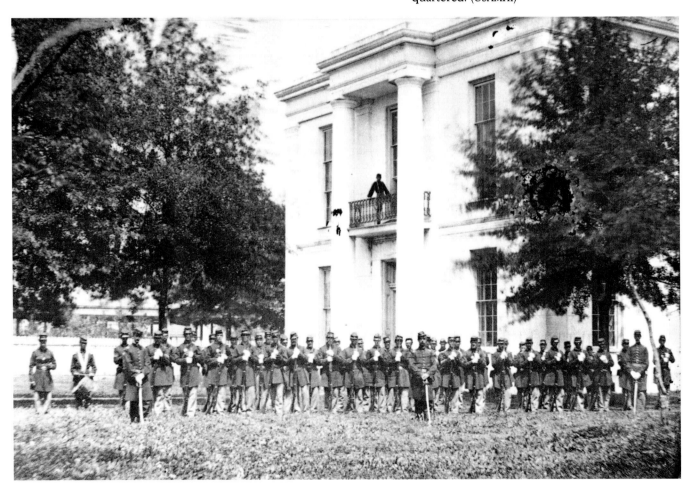

Yet another view of troops in front of the courthouse. (USAMHI)

Outside the city, Lytle caught this image of a company of the Thirteenth Connecticut. (USAMHI)

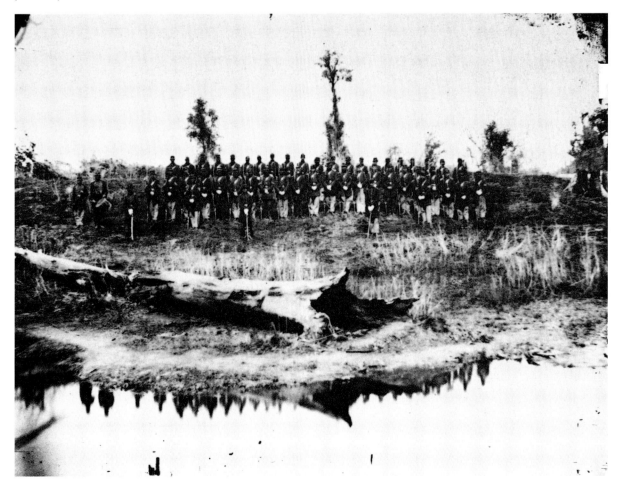

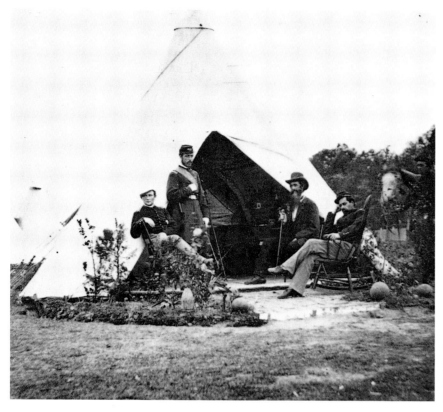

Three Yankee officers and a civilian lounge before a tent whose well-equipped interior includes even an étagère, probably liberated from some Baton Rouge home. (USAMHI)

Maj. Gen. Christopher C. Augur sits in a rocking chair to the left of his fellow officers, amid a uniquely military display in the campsite garden. (USAMHI)

One thing that Lytle's camera preserved most of all was the fact that life, even amid war, went on in Baton Rouge. Here he caught a bandwagon out politicking for a state senatorial candidate. (USAMHI)

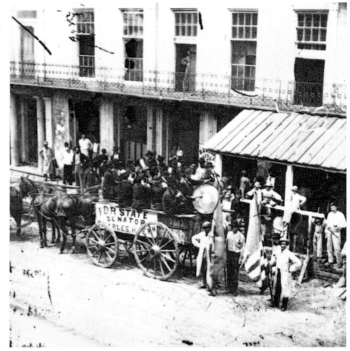

And here, on the grounds of the old state arsenal, his lens offered testimony to the end of the war at last, as the photographer surveyed the captured artillery of the final Confederate army east of the Mississippi to surrender. (USAMHI)

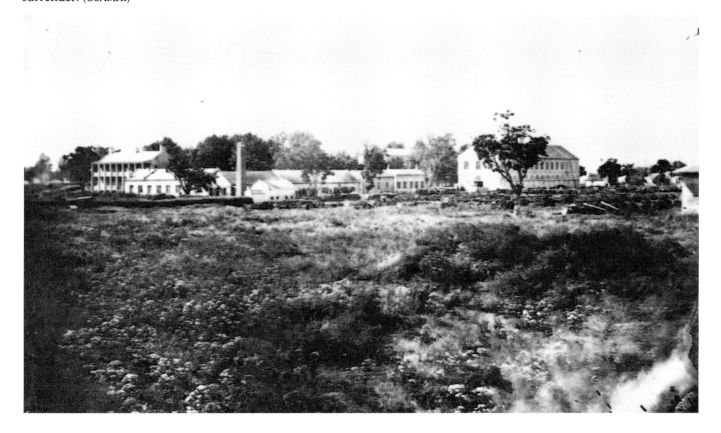

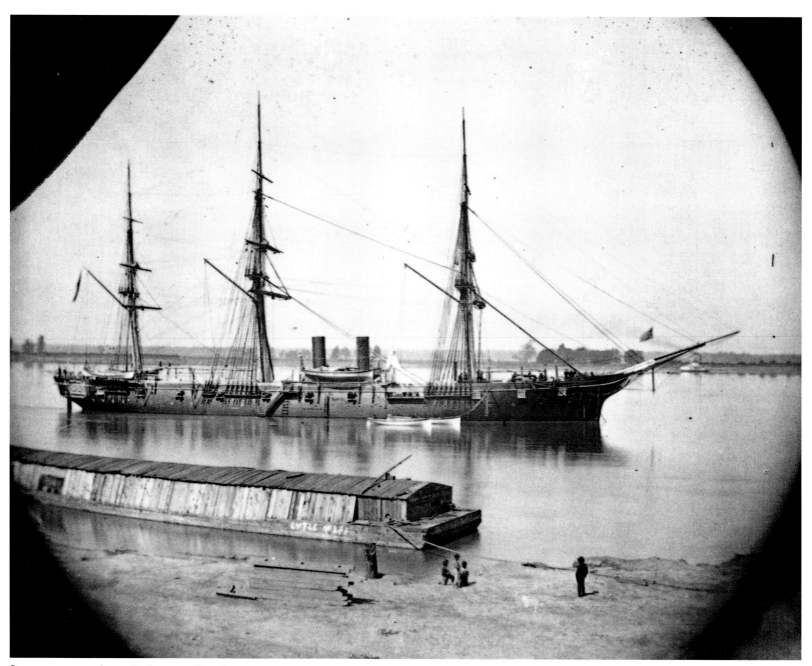

Seventeen years later, Lytle was still in Baton Rouge, recording the return of one of the most famous veterans of the war on the Mississippi: the 1882 visit of the refitted *Hartford*. Truly, A. D. Lytle and his camera were a unique partnership in their witness to war. (USAMHI)

The Men Who Led

Richard J. Sommers

I̱ₙ war, men are nothing; *the* man is everything." So said Napoleon, thinking of himself as "*the* man" who inspirited and directed the war. He exaggerated, of course. Yet leadership unquestionably is crucial to war: if not leadership by one emperor-commander, then collective command by all the men who led.

Certainly this was true of the Civil War. Command very much remained a subjective art practiced by the commander himself, aided only by a tiny staff and untrammeled by modern staff planners, resource managers, and detailed doctrines. And those commanders were leaders. In camp, march, and especially battle, they set examples to give their troops tone, courage, and inspiration.

Such leadership particularly prevailed at intermediate command levels. Commanders' basic administrative unit was the regiment. Numbering 1,000 to 1,200 men at full strength, entirely of one combat arm (infantry, cavalry, light or heavy artillery, or engineers), most regiments were raised by states or territories, then mustered into national service. They bore state names and numerical designations by state and branch of service. In contrast to thousands of these state volunteer units, both national governments directly raised barely 150 volunteer regiments, mostly Negro; and the Federal regular army was tiny, the Confederate regular army minuscule.

Almost all troops thus were not career men but citizen-soldiers who enlisted only for the war. At regimental level, so were their leaders. Admittedly, many former professional soldiers initially rejoined the army as colonels commanding state regiments. Even future army commanders U. S. Grant (Twenty-first Illinois), Samuel R. Curtis (Second Iowa), and John B. Hood (Fourth Texas) briefly led regiments. Again, in mid-1862, the U.S. War Department finally authorized regular officers leave to command volunteers. Adelbert Ames (Twentieth Maine) and Eli Long (Fourth Ohio Cavalry) were among those thus transferring, but many soon received higher command and rank.

Most leaders remaining with regiments were not such ex-regulars but citizen-soldiers like their men. Many colonels, indeed, helped raise the regiments they were then elected or

appointed to command. These inexperienced commanders sometimes proved inept and resigned or were forced out. Yet, overall, they deserve praise, not scorn. There were not enough regulars for all command positions, so who could better fill those offices than lawyers, bankers, teachers, politicians — leaders from civil life from whom their citizen-soldiers customarily sought guidance? This was America's historical militia system of republics, and it continued working reasonably well in the Civil War. If not always initially, then later, through the crucible of war itself, able leaders rose to command regiments. Some of these citizen-colonels of 1861, indeed, earned corps command by 1864: Northerners John A. Logan, John M. Palmer, Alfred H. Terry, and Francis P. Blair, Jr.; Southerners John C. Breckinridge, Nathan Bedford Forrest, Wade Hampton, and John B. Gordon.

Promotion came more often to leaders tabbed for brigade command, as regiments were marshaled into armies in 1861. These were the more promising regular officers and the more influential civil leaders. Much was expected of them, and many subsequently achieved high command, if not always high success. Of the approximately 130 Federal and Confederate brigadier generals in 1861, 38 became army or department commanders, including Yankees George G. Meade, Edward Ord, William S. Rosecrans, George H. Thomas, and Benjamin F. Butler, and Secessionists Thomas J. ("Stonewall") Jackson, James Longstreet, Edmund Kirby Smith, Theophilus H. Holmes, and Richard S. Ewell. Resignation, removal, illness, or casualty eliminated others. Only 5 of those early brigadiers remained at that level in 1865.

Combat caused much such attrition, for brigades were the chess pieces of battle, the units of tactical maneuver. Brigadiers led those pieces into the fray to set examples and keep at least some control. The maelstrom of war marked some for promotion, others for removal, still others for disablement or death. Mortality rates were frightful. Of 583 Northern generals, 47 were killed in battle, 27 at brigade level — among them Joshua Sill, Strong Vincent, and Hiram Burnham. Confederate casualties were even worse: 77 of 425 generals were slain, 53 of them brigadiers, like George Doles, John Gregg, and States

Rights Gist. Adding those colonels killed while commanding brigades heightens the attrition rate, especially for Yankees. Whereas the South usually conferred rank commensurate with office, the Union, from midwar onward, consistently lagged one rank below office. Over 40 Federal colonels were killed at the head of brigades, even divisions, to which they had not yet been promoted.

Not rank but role defined a brigade: its tactical function and the manpower to accomplish it. Cavalry and artillery were peripheral to battle. Improvements in weapons and tactics largely banished cavalry from battlefields until late war. Rather than group horsemen with infantry, cavalry stayed separate in small brigades of three to five regiments to guard, screen, pursue, and raid. Artillery, in contrast, served with infantry, but experience soon suggested that, instead of one battery per brigade, cannons functioned better when controlled at higher levels. Graycoats combined batteries into an artillery battalion of three to six companies per infantry division, and Unionists grouped batteries into an artillery brigade of four to fourteen companies per corps.

Artillery supported, and cavalry screened, but the burden of fighting remained with the infantry. Brigades 3,000 to 4,000 strong were adequate for such fighting and were about as much as one leader could control in the confusion of combat. Secessionists needed only four or five regiments to achieve such strength, for individual replacements joined existing regiments, thus enabling recruits to benefit from serving alongside veterans and enabling each regiment to maintain strength. Except when casualties were annihilating, as at Spotsylvania and Nashville, or home-state recruiting bases were inaccessible (for Texans serving in Georgia, for instance), Southerners preserved regimental strength reasonably well until the last two years of the war.

The North, too, sent replacements to existing regiments, but it raised manpower principally by creating new ones: big, bright — and inexperienced. Casualties and illness eroded old regiments down to 100 to 200 men, but political reality precluded eliminating those state outfits except when enlistments expired. Maintaining a brigade at desired strength often re-

quired eight to twelve little regiments. Sometimes regimental attrition forced divisions, corps, even whole armies to reduce to more realistic size. Adding new regiments to brigades was what enabled divisions and corps to become leaner. This Union system of recruiting and replacement was clearly inferior to the South's. It was the fundamental disparity in *overall* manpower, not the system mobilizing it, which offset that Northern disadvantage.

Another difference — this one's benefit less clear-cut — was that Secessionists, with their heritage of states' rights, intentionally brigaded regiments by state. Although, on each side, the national government, not states, created brigades, the Confederacy by 1862 arranged for each brigade, whenever possible, to contain regiments from only one state. The North, however, with its broader outlook, usually brigaded together regiments from different states. While one-state Federal brigades did exist, much commoner were brigades with regiments from four or five states, especially as tiny regiments were grouped into big brigades in 1863 and 1864. With such diversity, Yankee brigades lacked the state pride of Butternut brigades, but the forge of battle soon kindled within Northern soldiers intense loyalty to their own brigade, however cosmopolitan its composition.

This state-versus-national focus found its counterpart among brigadiers. In both armies, regular and volunteer generals were presidential appointees. Only militia generals were appointed by state governors. Rarely did Union militia generals take the field. Emergencies requiring militia occurred more often in the invaded Confederacy.

Even among Secessionists, though, volunteer generals leading volunteer troops did most fighting. Yet President Jefferson Davis usually appointed Confederate brigadiers from the same state as their respective brigades. Doing otherwise provoked outbursts from state governors and legislators. Fewer such problems troubled President Abraham Lincoln. Although he shrewdly apportioned appointees among states, he needed not assign them to state brigades since the North had few such units.

In 1861, Davis and Secretary of War Judah Benjamin favored extending state homogeneity to the next command level: divisions. Generals P. G. T. Beauregard and Joseph E. Johnston, however, dissuaded them for fear that disaster to such a division would ravage the given state's manpower. Of all infantry divisions in the two main Confederate armies, just George Pickett's Virginians *after* Gettysburg and Benjamin F. Cheatham's Tennesseans intermittently throughout the war came exclusively from one state. Only the relatively quiescent Trans-Mississippi Army was, by 1864, completely organized into infantry divisions by states: three from Texas, one each from Louisiana, Arkansas, and Missouri.

In contrast, Bluecoats, with few state brigades, had fewer state divisions. Even these, moreover, were usually short-lived. Ironically, the Civil War's most famous state division wore blue: the Pennsylvania Volunteer Reserve Corps. Successively under George A. McCall, John F. Reynolds, Meade, and Samuel W. Crawford, it repeatedly saw heavy fighting, from 1861 to 1864.

Whether from one state or many, divisions served as units of tactical control. With primitive communications over far-flung, often wooded battlefields, a division could rarely attack en masse. Division commanders instead maneuvered brigades, which did the actual fighting. Light cavalry divisions usually contained two brigades if Southern and three if Northern, whereas heavy infantry divisions in the Confederate army generally numbered four to six brigades, as opposed to three or four in the Federal army.

Controlling so many brigades in battle required not just bravery but also tactical skill. Each side exercised particular care in selecting promising veterans, usually regulars, to lead divisions. Forty-one such Yankees headed divisions when the armies began moving in March of 1862. Some, like William T. Sherman, Fighting Joe Hooker, and George Thomas, became army commanders. Others, like Silas Casey, Alexander Asboth, and Benjamin Prentiss, were soon shunted aside. The majority rose at least to corps command, but, overall, that initial group proved disappointing — not in terms of competence, but in their mediocrity. Only the winnowing experience of war brought to the top the promising brigadiers, colonels, and captains — like Charles Griffin, Romeyn B. Ayres, William B.

Hazen, Joseph A. Mower — who so graced Northern division command by 1865.

Gray divisional generals shone right from the start. Some, admittedly, were inept, like George B. Crittenden and Benjamin Huger, but most were outstanding commanders. Spring 1862 saw among Southern division commanders Stonewall Jackson, James Longstreet, Richard Ewell, D. H. Hill, and William J. Hardee. Soon rising to that level were A. P. Hill, Richard H. Anderson, Jubal A. Early, Patrick R. Cleburne, and John S. Bowen. As promotion and attrition subsequently created vacancies, able officers like Robert E. Rodes, Joseph B. Kershaw, and Edward C. Walthall received divisions. Throughout the war, Confederate armies drew strength, leadership, and cohesion from a good, solid group of division commanders. This was especially true in Virginia, considerably true in Tennessee through Georgia, and less so in Mississippi and the Trans-Mississippi — which is not coincidental, for many officers who had fallen short in the East, like Theophilus Holmes and William W. Loring, were reassigned west of the great river.

Divisions, like brigades and regiments, were traditional American military organizations. Union general in chief Winfield Scott, indeed, initially organized armies on the pattern he used so successfully in Mexico in 1847. In March 1862, however, each side introduced a higher formation, created by Napoleon in 1805 but new to Americans: the corps. That month, the Federal Army of the Potomac was organized into five corps, and the Confederate Army of the Mississippi was grouped into four corps. By January 1863, all major armies had adopted corps structure.

The Butternuts eventually created nineteen infantry corps and nine cavalry corps, numbered in respect to each army. There were thus five "I Corps," corresponding to five armies. The North initially followed that pattern but in autumn of 1862 began redesignating corps in respect to the armed might of the Union. Hence, there was only one "I Corps," which happened to serve in the Army of the Potomac. Other early I Corps were renumbered XI, XIII, and XX. Altogether, the Bluecoats had thirty-six infantry corps, numbered I through XXV, with numbers from some deactivated corps reassigned to new corps. There were also seven cavalry corps.

These corps contained anywhere from two to six divisions, but usually three or four. In 1862, a cavalry regiment or brigade sometimes served with an infantry corps. Experience, however, taught each side not to fragment its horsemen but to concentrate them into their own divisions or corps. That year, Jeb Stuart, Joe Wheeler, and Earl Van Dorn led big Gray cavalry divisions, expanded into corps in 1863. In 1863 also, Northerners began forming cavalry corps under George Stoneman and David S. Stanley. Only then did Federal mounted units come into their own.

Cavalry corps could raid, screen, pursue, and fight. They not only fought each other but also engaged on borders of battlefields and increasingly on battlefields themselves — not with outmoded mounted saber charges but with dismounted carbine fire, often with repeaters. Infantry corps, however, were too big to fight tactically. They instead provided grand tactical and tactical control: the maneuvering of divisions up to, onto, and on battlefields. In broader panorama, moreover, corps served as army commanders' chess pieces of strategic maneuver, just as brigades were division commanders' battle chess pieces.

Controlling grand tactics and maneuvering with strategic latitude required great initiative, ability, and judgment. For his seven corps, Napoleon selected his most promising generals and made them marshals. Neither in rank nor ability did the first eight Union corps commanders equal Napoleonic precedent. Irvin McDowell, Edwin V. Sumner, Samuel P. Heintzelman, Erasmus D. Keyes, Nathaniel P. Banks, Alexander M. McCook, Charles C. Gilbert, and Thomas L. Crittenden were variously ill-starred, overrated, inept, or mediocre. By autumn 1863 only influential politician Banks retained major command at the front. War's winnowing influence eliminated the others and elevated abler men. Whether regulars like A. J. Smith, politicians like John Logan, or cavalrymen like James H. Wilson, Federal corps commanders by 1864 were generally officers of superior ability. Indeed, through ability, many good corps leaders earned army command, among them Meade, Sherman,

and Philip H. Sheridan. Yet other corps commanders did not survive to receive promotion, for bullets respected no office. Jesse Reno, Joseph Mansfield, John Reynolds, and John Sedgwick were killed leading corps in battle.

Mortality among Confederate corps commanders was even higher: Stonewall Jackson, Thomas Green, Jeb Stuart, Leonidas Polk, A. P. Hill. Ability among Southerners was also higher for early corps commanders, like Jackson, Longstreet, Hardee, and Kirby Smith. Such ability soon peaked, however, for only Jackson demonstrated aptitude for still higher army command. The others proved disappointing at army level. Their replacements, moreover, often had difficulty even making the great leap from the technical expertise of tactics to the command latitude of grand tactics. Sound division commanders like A. P. Hill, Anderson, and Ewell failed to measure up as corps leaders. Of later corps commanders, only Forrest, Hampton, Gordon, and Richard Taylor really shined. Whereas the North progressively raised better officers from brigade to division and corps command, the South did not sustain the high quality of early leadership. Not only in manpower but also in command ability, Butternut resources ran low by war's end.

Most corps were mobile units of grand tactical and strategic maneuver. Some, however, were territorial commands for protecting geographical areas. The Confederate I Corps (West Louisiana), II Corps (Arkansas), and III Corps (Texas) each controlled a district within the Trans-Mississippi Department/ Army. More often, those territorial corps were really small armies of independent departments, like the X Corps (Department of the South). And some were just garrisons, like the VIII Corps (Middle Department), with few mobile field forces.

Responsibility for territorial command rested at department level, and each department usually had its own army. Almost invariably, the department commander was the army commander. Early in the war, an army consisted of several divisions, but by late 1862 most armies contained several infantry corps or "wings," plus a cavalry division (later corps). Gray armies usually had three to five corps, while Blue armies had five to nine. Supporting engineer, provost, and signal troops also reported to army headquarters; and it was to armies that independent quartermaster and commissary departments delivered supplies.

Such broad control underscored the army's mission as the principal force for waging war. It defended its territory and invaded enemy territory. It conducted strategic maneuvers to apply overall force to military advantage, and it initiated or received battle. Once battle began, though, prevailing command principles left responsibility to chief subordinates. Much more than the army commander himself, corps and division commanders wielded the brigades that actually fought battles.

Federal armies and departments customarily were named for nearby rivers or bodies of water, whereas Secessionist armies and departments drew names from their geographic areas. Even when remote from their namesakes, most armies kept their names. Of all armies, only the Army of the Potomac had no department, yet the need to protect Washington and cover the North constrained it quite as if it had a fixed territory.

Sometimes strategic territory was so vast or the need to coordinate force was so great that no one army or department sufficed. To provide theater command, military divisions controlled several adjoining departments. Both sides created such structures, but Federal will and manpower put them to better use, especially in the region between the Appalachians and the Mississippi. There, under Henry Halleck, Grant, and Sherman, enough manpower existed to create a group of armies, each targeting a specific goal: the capture of Corinth, of Chattanooga, of Atlanta. Subsequently, Grant essentially continued that approach of directing several armies, against Richmond and Petersburg.

By then, he was general in chief of all Federal armies, the first such officer actually to take the field. Of his predecessors, Halleck remained in Washington; George McClellan was relieved just as active campaigning started; and Scott, who retired in 1861, was too old for field duty. Whether in Washington or the field, the general in chief was expected to coordinate all land forces, but again only Grant did so successfully.

The Secessionists had no real counterpart. R. E. Lee served briefly as general in chief in 1862 but was not reappointed until

February 1865, too late to do much good. His predecessor, the discredited Braxton Bragg, was more military adviser to President Davis than commander, and no one even nominally filled that office from June 1862 through February 1864. West Point-educated Davis reserved to himself overall conduct of the war.

The president greatly respected one of his best appointees, Lee. The great Virginian — with his audaciousness, tactical skill, and strategic vision — more than any other man, gave substance to Southern efforts for independence. However, other of Davis's choices, like John C. Pemberton, Holmes, and particularly Bragg, proved disappointing. With misguided loyalty, Davis retained them in command far too long. Presidential preference could not save Hood, whose disastrous army command lasted only six months, nor could it save Albert Sidney Johnston from a Yankee bullet — the only Southern army leader killed in battle. Still other army commanders, Beauregard and Joseph Johnson, killed themselves off feuding with Richmond instead of fighting Bluecoats. Above the pettiness and ineptitude towers Lee, but even he could not preserve the Confederacy single-handedly.

Neglecting able officers and retaining inept ones hardly characterized Davis's counterpart. Lincoln, if anything, gave officers too little time to succeed at army level. Turnover was high, and death accounts for little of it: only Nathaniel Lyon and James McPherson. Politics, irascibility, rivalry, overcaution, promotion beyond ability, occasionally even ineptitude more often proved the undoing of Union army commanders: McClellan, John Pope, Ambrose E. Burnside, Hooker, Don Carlos Buell, Rosecrans, Curtis, Banks, Butler, and Franz Sigel. But that terrible turnover, costly in lives and time, did create vacancies to which men who succeeded at lower levels could rise. Grant, Sherman, Meade, Thomas, Sheridan, Ord, and John M. Schofield ascended to army, theater, even overall command, and these were the generals who would win the Civil War.

Theater and army, corps and division, brigade and regiment — this was the command structure of the Federal and Confederate armies: the system for mobilizing, organizing, and wielding force to military advantage. But it was only a structure. It came alive, fell short, achieved success, prolonged the struggle, won the war according to the character and competence, weaknesses and strengths of the officers assigned to those commands — for they were the men who led.

For the Union, it was tragic from the first that one of her most capable soldiers was also one of her oldest. Lt. Gen. Winfield Scott was seventy-four years old at the outbreak of the war, yet still he would leave his mark on the prosecution of the conflict. Had he been ten years younger, he might still have led in the field. (USAMHI)

Alas, with Scott too old, and too few other generals available, the Union had to look in many directions to find leaders. For Lincoln, it would take years of trial and error before he found the right ones. For over a year he tried Maj. Gen. George B. McClellan, a favorite with his soldiers, but a man afraid to use them in battle. (USAMHI)

More would follow McClellan, among them his friend Ambrose Burnside. Reluctant to accept command of the Army of the Potomac until forced to, he proved a disaster. His lasting legacies were his dreadful losses at Fredericksburg and his name, forever tied to the sideburns that he wore. (USAMHI)

Some became early heroes without ever firing a shot or hearing a bullet whine. Maj. Gen. John A. Dix had been a politician, and U.S. secretary of the treasury just before Fort Sumter. When he told a subordinate in New Orleans, "If anyone attempts to haul down the American flag, shoot him on the spot," he was rewarded with a general's stars. (LC)

There were others whose careers seemed to have prepared them for command, men of the stripe of Maj. Gen. Henry W. Halleck. He would be a disaster in the field, but an able chief of staff. (VM)

Maj. Gen. Thomas Crittenden came from an important and influential Kentucky family, and it was politically expedient to elevate him to high command. He would not, in the end, prove to be up to it. (KHS)

Indeed, the early — and continued — Union habit of giving high commands to politicians proved almost invariably unfortunate. Maj. Gen. Franz Sigel helped mightily with enlisting thousands of fellow German immigrants. In the field he was almost incompetent. (USAMHI)

And Maj. Gen. Benjamin F. Butler was little better, yet so influential that he retained his command almost until the end of the war. (SC)

Top left: Others were better, if only marginally. Abner Doubleday never invented baseball, as legend says, but he helped defend Fort Sumter at the war's start, and that won him a generalship, and eventually command of a corps, though he never shone again as brightly as he had when firing the first gun to reply to Charleston's batteries that April 12, 1861. (WRHS)

Top right: Some of the politicos showed real promise in command. John A. Logan had been an ardent opponent of Lincoln's in the election of 1860, but he stood unswervingly for the Union in 1861. Made a colonel out of political expedient, he quickly rose through ability, and in time commanded the XV Corps and even, briefly, the Army of the Tennessee. (USAMHI)

Bottom left: Men who lacked the connections of Butler or the flamboyance of Doubleday still climbed high on their own merits, and few more so than Andrew A. Humphreys, who rose to corps command in the Army of the Potomac and, for a time, was chief of staff to its commander. (WLM)

Leadership could be at times a matter of flair and youthful exuberance, as much as ability. That George A. Custer possessed all three few would deny. Seated here at left, with Maj. Gen. Alfred Pleasonton, commander of the Cavalry Corps of the Army of the Potomac, Custer would shine as bright as any star in this war. His radiance would endure long after his flame was extinguished at the Little Big Horn in 1876. (USAMHI)

Flamboyance could be contagious. Many of Custer's officers affected his dress, and scores of other Federal leaders—like this man, identified only as "General Brayman"—showed an affinity for his flowing locks. (KHS)

A few of the Union's leaders were heroes of another war: the one with Mexico from 1846 to 1848. George Washington Morgan had so conducted himself then as a colonel that he was given the brevet — largely honorary — rank of brigadier, the youngest man in that war to receive such a promotion. In the Civil War, too, he would rise, eventually commanding the XIII Corps. (KHS)

And then there were the young, men like Adelbert Ames of Maine. A brigadier general at twenty-eight, his war career was distinguished from start to finish, yet ultimately he would be best known as the last survivor of all the generals of the Civil War. He died in 1933, aged ninety-eight. (SSC)

There were the undeniable greats. George Gordon Meade was the man who finally led the Army of the Potomac to major victory at Gettysburg, and thereafter he led it capably until the end. (KA)

Maj. Gen. Philip H. Sheridan became the Union's most ruthless and trusted cavalryman. Short, stocky, pugnacious, he stands here at center surrounded by other names legendary among Yankee horsemen. James H. Wilson sits at right; Alfred T. A. Torbert stands next to him, in Custer-style garb. Wesley Merritt sits at center, destined to become one of America's most distinguished soldiers. David M. Gregg sits at left, with Thomas Davies standing beside him. They were undefeatable. (MHS)

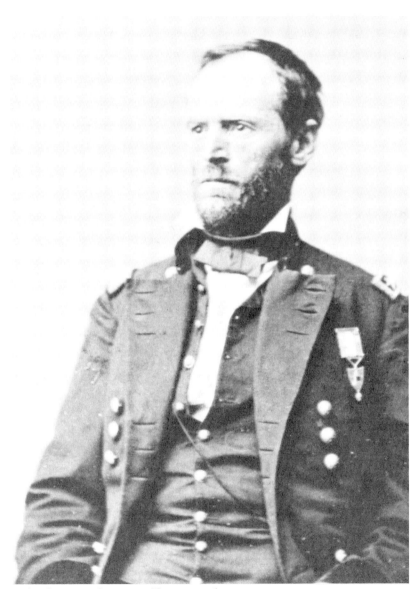

And, of course, there was Sherman — he who could make war hell, who split the South, took Atlanta, marched to the sea, and enjoyed the unswerving trust and confidence of his friend and commander . . . (NA)

U. S. Grant — the Union's essential soldier. Here he appears as he did early in the war, when just given his first general's star, and with the triumphs of Vicksburg and Chattanooga — and Appomattox — in the future. (USAMHI)

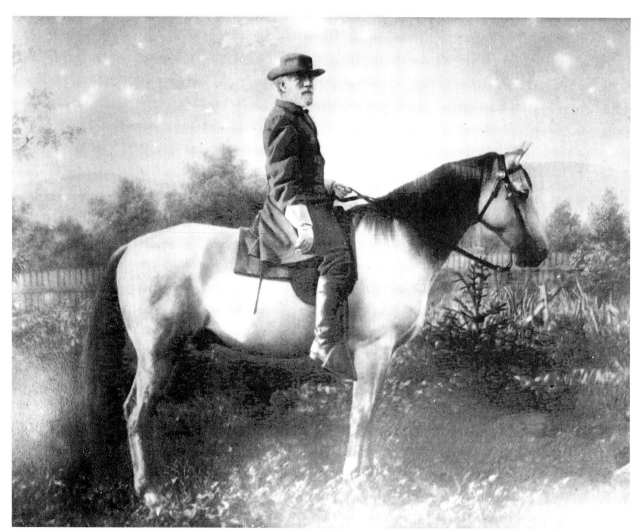

Across the lines there was talent aplenty, as well, some of it destined to become legendary. No soldier in American history, even Grant, would enjoy the aura of greatness that surrounds Robert E. Lee, shown here after the surrender on his war-horse Traveler. Grant was a soldier of the future; Lee was a soldier of the past, and of all time. (USAMHI)

Top left: High command went to Braxton Bragg, who should have been a great general but proved instead to be contentious, inept, frequently unstable, and perennially controversial. Yet for almost two years the Confederacy's major army west of the Appalachians would suffer under his leadership. (CHS)

Top right: Lt. Gen. Richard Taylor was the son of a U.S. president as well as a general, Zachary Taylor, and rose from an obscure colonelcy to a high position in the Confederacy. At the end, he would be the last general east of the Mississippi to surrender his army. (ADAH)

Bottom right: Contention seemed to infect Confederate leadership from the first, impeding the undeniable talents of generals like Pierre G. T. Beauregard, the hero of Fort Sumter and First Bull Run. This postwar portrait shows a proud officer who all too seldom saw merit in the ideas of others. (KHS)

Almost as difficult, though formidable when fighting in harness under Lee, was Lee's old war-horse Lt. Gen. James Longstreet. He appears as a brigadier here, sometime in the summer of 1861. He would outlive all the other high-ranking generals of the Confederacy. (LFH)

The South, too, had its gifted amateurs — surely none more talented than John B. Gordon of Georgia. He began the war as a captain, and ended it a major general and corps commander. No one compiled a finer record as a combat leader. (NA)

And there were men of principle, men like Simon Bolivar Buckner of Kentucky. At war's outset, both sides offered him a general's commission. Only when he had exhausted every effort on behalf of his state's attempt to stay neutral did he cast his lot with the Confederacy, ultimately rising to lieutenant general. He would survive the war by nearly fifty years, honored North and South. (KHS)

The haunting eyes of John Bell Hood bespeak a leader who felt the war's tragedy as few others. It cost him a leg, ruined an arm, saw him rise to the rank of full general, only to waste his army's blood at Atlanta and again at Franklin and Nashville. Like so many after the war, he would spend his remaining years arguing, trying to write and win with the pen what his sword had lost. (WRHS)

Those who did not fall in battle risked the monotony of capture and imprisonment. Here a host of officers, most of them Kentucky cavalrymen, pose in Fort Delaware prison, outside Philadelphia. Seated third from left is Brig. Gen. Robert B. Vance. Standing second from right is Basil W. Duke; as a brigadier, he would take over the slain John Morgan's cavalry after being released from prison. (USAMHI)

One captured Confederate general, William N. R. Beall, was even put to work for his fellow prisoners. Given his parole for not trying to escape, he was released to open an office in New York City where he sold Southern cotton to raise money to clothe and feed Rebel prisoners. (KHS)

For all of those who led, there was more than glory: there was risk and danger. For a few risk lay in their own foolishness, as with Confederate major general Earl Van Dorn, a dashing and able cavalryman who was killed in the end not by a Yankee bullet, but by a jealous husband. A previously unpublished portrait of the flamboyant Van Dorn. (ADAH)

Even more dashing was the inimitable John Hunt Morgan of Kentucky, Rebel raider without equal. Hunted down by his enemies, he was killed in his nightshirt on September 4, 1864. (KHS)

The Yankees had their casualties, too. Brig. Gen. Robert Nugent suffered his wound while leading his regiment, the fighting Irish of the New York Sixty-ninth. (USAMHI)

Brig. Gen. James S. Jackson of Kentucky was wearing the Union blue when he defended his native state against an invasion, and at the Battle of Perryville, Kentucky, on October 8, 1862, he was killed instantly by a bullet. (KHS)

James Mulligan was another one who died. At Winchester in Virginia's Shenandoah Valley, he was wounded and being carried from the field when he saw his regiment's flag about to be captured. "Lay me down and serve the flag!" he shouted. His men did as bidden, and he was taken instead, dying a few days later. (USAMHI)

And Maj. Gen. John Sedgwick, beloved commander of the Union VI Corps, exclaimed during the Battle of Spotsylvania on May 9, 1864, that the enemy "couldn't hit an elephant at this distance." Moments later he fell dead with a bullet in his brain. (KA)

Whoever they were, these men who led,
they were serious at their work. Officers of
the Ninth Michigan, their colonel seated at
left behind the table, pose at the headquarters
of the Army of the Cumberland at Chatta-
nooga in February 1864. Atlanta and the
battles for it lie ahead of them. (USAMHI)

By contrast, the tranquility of the tent of A. J. Hill, adjutant for the Third New Hampshire at Hilton Head, South Carolina, almost belies the fact that there is a war going on at all. (USAMHI)

The leaders were not all generals, and the men who led the men in the ranks took themselves very seriously indeed. Here, just two weeks after the Battle of Fredericksburg, the officers of the 153d Pennsylvania stand to have their tintype made. (USAMHI)

Folded arms gave an air of calm authority to
Lt. George Myrick of Company E, Fifth
Massachusetts. (USAMHI)

To be sure, they liked the individual portrait
the best. Capt. Archibald McClure Bush of
the Ninety-fifth New York. (USAMHI)

Arms could be folded south of Mason and Dixon's line, too. Maj. J. J. Lucas, CSA. (USAMHI)

And every leader had to make at least one try at the Napoleonic hand in the blouse. This unknown Rebel officer is no exception. (KHS)

Three officers of the Seventeenth United States Infantry try a casual pose in their greatcoats . . . (USAMHI)

. . . while four officers of the Seventeenth Michigan appear even more casual, walking sticks in hand. Yet Lt. Col. Edmund Rice, at left, has already made a daring prison escape in this war. (USAMHI)

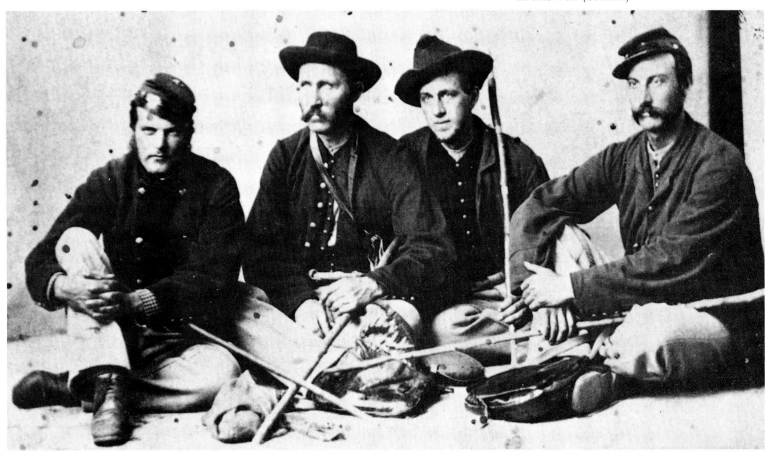

Seven officers stationed in New Bern, North Carolina, share a news sheet for the camera. (USAMHI)

No leader could resist a pose at a scenic spot like the summit of Lookout Mountain. Generals and privates alike came here to stand above the clouds. (USAMHI)

Col. John E. Mulford of the Third New York was able to pose by a greenhouse in captured Richmond at war's end. (USAMHI)

The seated group with the Stars and Stripes in the background was an ever-popular pose, as demonstrated by these officers of the Twenty-second Massachusetts at Beverly Ford, Virginia. (USAMHI)

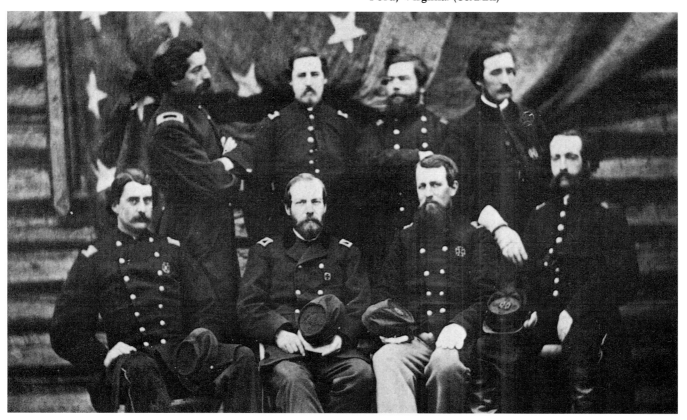

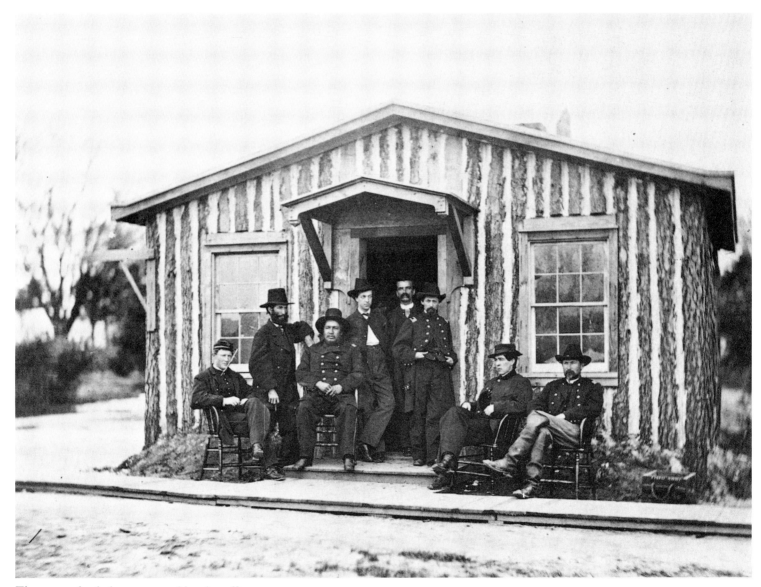

The men who led were served by the officers
of their staff, and staff work rose to its own
in this war. Grant enjoyed one of the finest
staffs of anyone — many of them seated here,
including Col. Ely S. Parker, an Indian
officer seated second from left. (USAMHI)

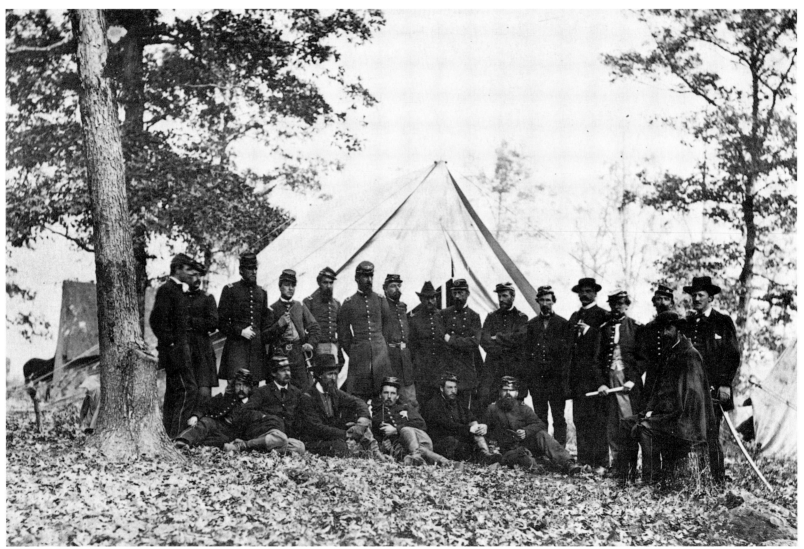

Most of these young officers were attached
to McClellan's staff in the fall of 1862.
McClellan, and dashing leaders like him,
could always attract the best and brightest
young men to run their headquarters. The
luster of the commander often rubbed off
onto them, or so they hoped. (USAMHI)

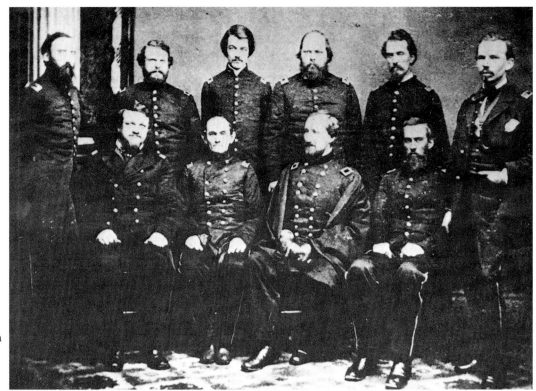

No general was happy without a photograph of himself with his trusted staff. Brig. Gen. William S. Rosecrans sits second from the right, wearing a cape. (NA)

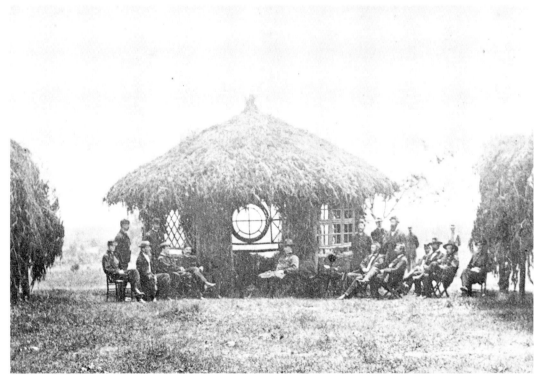

Maj. Gen. Horatio G. Wright sits in the doorway of an arboreal camp building, with his officers to either side. (USAMHI)

Brig. Gen. J. J. Abercrombie chose to sit in a chair in front of his headquarters, his staff behind him and a band ready at the side. (USAMHI)

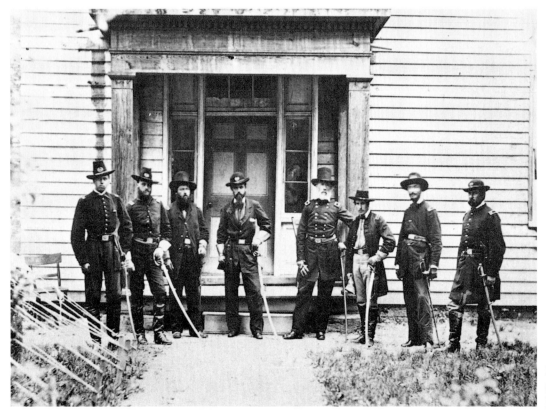

Brig. Gen. E. V. Sumner acted less aloof, standing toe to toe with his staff, including his son at his elbow. (USAMHI)

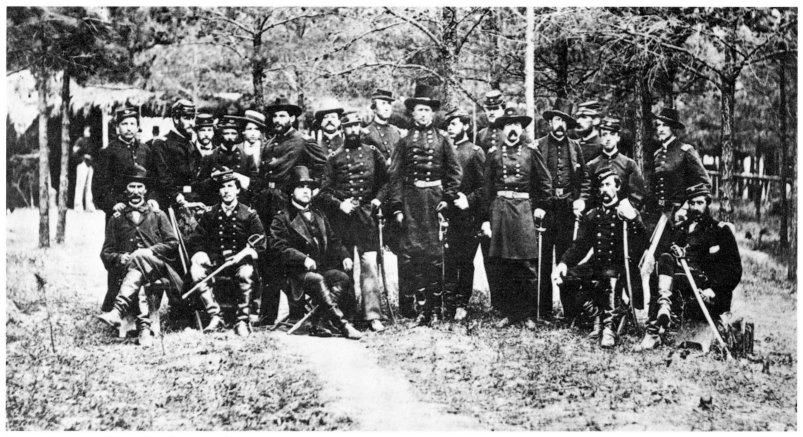

No one was more devoted to the men who helped him lead than Maj. Gen. Joseph ("Fighting Joe") Hooker. Standing tall at center, he posed with them in Virginia when he commanded the Army of the Potomac. (USAMHI)

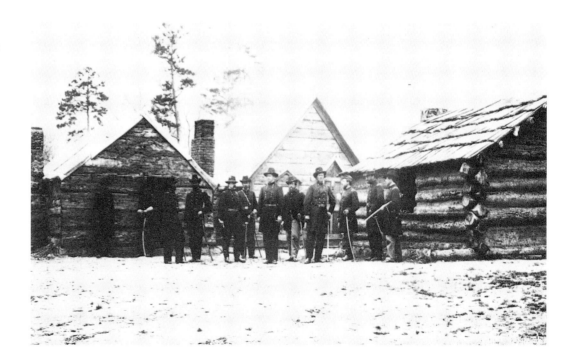

And when he went out west, he posed with them atop Lookout Mountain. (USAMHI)

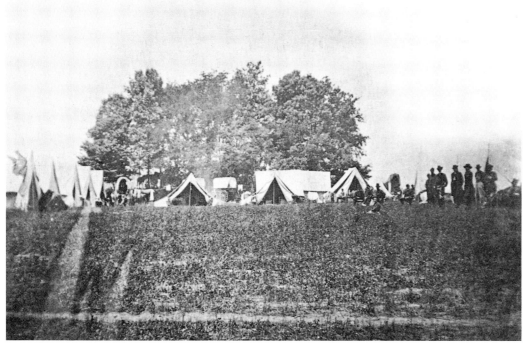

Top left: Yet staged poses were not the way in which the soldiers in the ranks remembered the men who led them to battle, to victory or defeat. They remembered them in their headquarters in garrison, as here, in New Bern, North Carolina. (USAMHI)

Top right: They remembered them deep in the South, fighting to take the Rebel cities — as Maj. Gen. Quincy Gillmore, from his headquarters here at Hilton Head, fought to take much of South Carolina. (USAMHI)

And most of all, the soldiers remembered their generals out in the field at the end of the day's march, with orders to give, letters to write, and the wagons ready to hit the road again in the morning. Gen. George H. Thomas's headquarters of the Army of the Cumberland near Cassville, Georgia, in mid-May 1864. They are on their way to Atlanta. (USAMHI)

Comrades

A Story of Lasting Friendships

★

Albert Castel

IN ONE SENSE the typical Civil War soldier, Northerner or Southerner, never left home. More often than not the volunteer who answered the summons of the drums in the spring of 1861 joined an outfit — company, battery, regiment — made up in large part of men from his own locality and with whom he already had a greater or lesser acquaintance. Thus it was rather common for brothers and even fathers and sons to enlist together, for college students to switch from Latin drills to military drills under the command of one of their professors turned officer, and for most of the young men of a village and its vicinity to go off to war as a group. Later, when replacements were needed to bolster thinned ranks, usually they came from the same communities that had supplied their predecessors.

Raising troops in this fashion had a terrible drawback: too often a few minutes of carnage in a single battle destroyed a regiment and so plunged whole towns and counties into mourning. On the other hand, it possessed several compensating advantages for the soldier himself. Unlike modern-day recruits, he did not go into service a stranger among strangers. Right from the start he had companions, possibly boyhood pals, who helped him cope with the psychological and emotional strain of being far from home for probably the first time in his life and of adjusting to army ways. Moreover, should he fall ill, which was far too likely, he could count on them to do their best to take care of him, visit him when possible in the hospital, and — at the worst — comfort him in his last moments. Finally and most important, being surrounded by friends profoundly influenced his conduct in battle. When going into combat, especially the first time, he feared death — but also feared disgracing himself before his comrades and having them report to the people back home that he had played the coward. And once actually engaged in battle, the sight of a friend being killed or mangled could infuriate him and cause him to fight fiercely for vengeance. Wrote one Yankee soldier following the Battle of Gaines' Mill, June 27, 1862:

My two tent mates were wounded, and after that . . . I acted like a madman. . . . I snatched a gun from the hands of a man who was shot through the head, as he staggered and fell. At other times I

would have been horror-struck, and could not have moved, but then I jumped over dead men with as little feeling as I would over a log. The feeling that was uppermost in my mind was a desire to kill as many as I could. The loss of comrades maddened me.

Without question one of the main reasons Civil War soldiers generally displayed such tremendous courage, determination, and an ability to keep going despite hideous losses is that their common home ties fostered strong personal ties. For the same reason, their desertion rate, high as it sometimes was, would have been higher still had not so many of them felt as did a Johnny Reb from Tennessee, who informed his wife early in 1864: "I would hate to be a deserter and have to run from home. . . . I want to be among the list who can return free from disgrace that would sink not only me but wife and children . . . beneath the dignity of the best class of Tennesseans for all time to come."

Combat — Civil War soldiers called it "seeing the elephant" — itself strengthened the sense of comradeship. Regardless of victory or defeat, if a particular unit fought well, its members developed great group pride and confidence. For example, as a result of their first engagement, in which they repulsed a larger enemy force, the men of the Twentieth Ohio, in the words of one of them, "acquired the belief that we were invincible in battle." Numerous other regiments in both armies felt the same way, as did Potomac's Iron Brigade; Cleburne's division, with it's unique "full moon" banner; and the XV Corps of Sherman's army, whose badge was a cartridge box inscribed with the figure 40. Soldiers belonging to these elite organizations possessed not only a high esprit de corps but a special relationship to each other that was a prime factor in their combat effectiveness.

Most of the time, however, the troops were not fighting but, in the words of one of their songs, "tenting on the old camp ground," occupied with the never-ending routine of drills, inspections, and, as one Indiana private put it, "wash, iron, scrub, bake — wash, iron, scrub, bake." In order to alleviate this daily drudgery, they organized "messes," usually numbering four to twelve men, who shared their food and the task of preparing it by taking turns making the fire, doing the cooking, and cleaning up. A mess also included, if it was not identical with, tentmates or those living in the same hut or other shelter.

At the beginning of the war, tents were large affairs, accommodating up to twenty men (as in the case of the Sibley model). Later, in the interest of greater mobility, the Union army issued each enlisted man a 5'2"-by-4'11" canvas shelter half. By fastening their respective halves together by means of the buttons and buttonholes that lined three sides of the sheet, a couple of soldiers made a pup tent, which they suspended from a rope tied between two muskets stuck upright into the ground via their fixed bayonets. Normally, the men who paired off on this fashion already knew one another well; if not, they likely would become "the warmest of personal friends" in short order. The Confederates often lacked tents of any kind and so made do with only blankets, especially during active campaigning. But if the weather became too bitter and they had an opportunity, two or more of them likewise would band together to improvise a shelter out of branches, brush, or whatever else came to hand.

All through the war, in both armies, the existence of the average soldier revolved around his messmates and tentmates. It was with them that he played cards, went into town on leave, sometimes got drunk, conducted private foraging expeditions, discussed political and military affairs, shared boxes of food from home, marched the endless miles, and — when the time came — stood in the battle line. One of them, too, would be his particular "chum" or "pard," the comrade with whom, in the words of a poem of the day, he "drank from the same canteen":

> There are bonds of all sorts in this world of ours,
> Fetters of friendship and ties of flowers,
> And true lover's knots, I ween,
> The girl and the boy are bound by a kiss,
> But there's never a bond, old friend, like this —
> We have drank from the same canteen.

Religion both provided and promoted a different kind of comradeship. Men who think seriously about death are inclined to think seriously about God. Few did the former at the

outset of the war — most assumed it would be over soon and took it for granted that they would live. But after seeing thousands of their fellows die, they began to realize that the same thing could happen to them — in fact, the chance of it happening increased with every battle. So more and more of them turned to religion and, in the process, to one another. Before the 1863 and 1864 campaigns, great revivals of the camp-meeting variety took place, notably in the Confederate armies. Writing from Dalton, Georgia, on the eve of the Atlanta campaign, one young Southern soldier reported to his sister: "I have never seen such a spirit as there is now in the army. Religion is the theme. Everywhere, you hear around the camp-fires at night the sweet songs of Zion. This spirit pervades the army."

Of course, once the fighting resumed, many a soldier who had "seen the light" quickly slid back into darkness: living and killing like wild beasts tend to have that effect. Yet in most regiments, Union as well as Confederate, there were at least some men who attended Sunday services if they could or met together to pray and discuss the Bible. Such soldiers, however few in number, possessed a relationship that went beyond the normal camaraderie of the camp.

When the "boys of '61" marched off to war, they expected to come marching back in a few months, victorious and glorious. Obviously, it did not work out that way. Instead the war went on and on, as did all of its tedium and misery and horror. Consequently, despite the good friends and occasional good times of the army, the strongest desire, the fondest dream, of the average soldier came to be getting a furlough to go home. Furloughs, however, were hard to get. Not until the winter of 1863/64 did either army grant them in large numbers, and in the case of the North it was done to induce the veteran troops to reenlist (if they did not, they would not be allowed to go home until their term of service expired — supposing they lived that long).

After receiving a furlough, the soldier headed home joyfully and was greeted the same way. But then something strange happened to many of them, particularly single men. Although everybody was nice and did everything possible to make their stay pleasant, they began to experience, as one Illinoisan confessed, an "uneasiness at home, a feeling of being in 'hot water.'" They discovered that they no longer had much in common with old friends, that they missed their army comrades, and that they even had an "eager longing for the hardtack and army rations of the front." When the time came to return to the army, they were secretly glad, and when they got back, some declared that they wished that they had not gone home at all.

This reaction is easily explained. The soldiers had undergone ordeals and formed associations that set them apart from civilians. Indeed, in certain ways they now had more in common with the enemy across the front than with friends back home. After all, *he* knew what it was like to be shot at, to march all day in the mud, and to try to sleep at night in pelting rain. Ever more frequently, as the war dragged on and when opposing lines were close and there was a lull in the fighting, troops on both sides arranged informal truces, then met to chat and trade Rebel tobacco for Yankee coffee. On occasion some of them visited the enemy's trenches or spent the night in his camp, and there were several instances of Federals attending parties behind Confederate lines! Needless to say, the generals frowned on such fraternization and issued strict orders against it. Hence, whenever it occurred, each side posted lookouts to give warning if a high-ranking officer approached. In that case the soldiers scrambled back to their respective positions, sometimes shouting to the men with whom they had been visiting, "If I have to shoot at you, I hope I miss." When not busy trying to kill each other, Billy Yank and Johnny Reb rather liked each other.

In the spring of 1865, the drums stopped beating. In small groups or alone the defeated men of the South made their way home, often wondering if it still existed. The triumphant men of the North proceeded by regiments and batteries to various army camps, where they turned in their weapons and obtained their discharges. Victor or vanquished, they all knew that they had taken part in a great adventure, that they had made history, and that it was unlikely they ever again would be involved in something both so awful and so awesome. "Ours," declared

one of them later, "is a generation touched by fire." But what they cherished most was the comradeship forged in the heat of that fire; it was this that made the war something besides the hell that Sherman said it was.

One evening in February 1864, during a campaign in Mississippi, Maj. Benjamin F. Stephenson, surgeon of the Fourteenth Illinois, and Chaplain William J. Rutledge, of the same regiment, talked about what the troops would do when they left the army. Rutledge commented that "it would be but natural to suppose that men who had shared so much suffering, privation, and danger would wish to form some sort of association, that they might meet again to preserve the friendships and memories of the past." Stephenson agreed, and both promised to join in forming such an association after the war ended. As a result, they met again in Springfield, Illinois, in March 1866 and drew up the constitution and rituals for what they decided to call "The Grand Army Of The Republic," an organization open to all men who served in the United States Army, Navy, or Marine Corps between April 12, 1861, and April 9, 1865. The following month, the first GAR post came into being at Decatur, Illinois; on November 20, 1866, the first GAR national convention met in Indianapolis; and before long, GAR posts existed throughout the North and even in most Southern states.

In spite of this auspicious start, however, for a number of years the GAR contained only a small minority of Union veterans, mainly because of its close identification with the Republican party (Democrats charged that its initials really stood for "Grafting Army of the Republicans"). Not until the passion of Reconstruction-era politics cooled down and the GAR devoted itself to strictly nonpartisan (and highly successful) endeavors to increase veterans' benefits did it become truly representative of the former Federal soldier, ultimately achieving, in 1890, a peak membership of 409,484.

Other important Union veterans' organizations included the Military Order of the Loyal Legion of the United States, whose membership was restricted to officers and prominent civilian leaders; the Society of the Army of Tennessee, formed at Raleigh, North Carolina, on April 14, 1865, after news of

Lee's surrender arrived; the Society of the Army of the Cumberland; and the Society of the Army of the Potomac. In addition, there were numerous more specialized or limited organizations, such as the Union Ex-Prisoners of War Association, the National Association of Naval Veterans of the United States, the Signal Corps Society, and the short-lived Colored Soldiers League (the GAR did not formally bar Negroes, but its posts were almost universally white). For many an old soldier, however, the most pleasant and meaningful association took the form of attending the reunions of his regiment or battery. Here he met his closest comrades of the war and with them could sit in "the bivouac of memory around the old campfire . . . and smoke our pipes together once again."

Confederate veterans made no attempt to establish a Southern-wide organization for a quarter of a century following Appomattox: the economic plight of the South made it impractical, and political considerations made it inadvisable. Apart from local and state associations, the only major organizations to emerge during that time were the Society of the Army of Northern Virginia, the Society of the Army of Tennessee, and the Veteran Confederate States Cavalry Association. Then, in June 1890, these three groups combined to form the United States Confederate Veterans at a convention in New Orleans. Filling a great emotional need, the UCV flourished; by 1900, it had chapters in every Southern state and several Northern ones as well, and its semi-official journal, the *Confederate Veteran*, had become a commercial success and a treasure trove for future historians (as are the publications of the Military Order of the Loyal Legion).

It was only a matter of time before Federals and Confederates began to do what they had done occasionally during the war — fraternize. In 1881, Union veterans from New York and Boston accepted an invitation to participate in New Orleans's Mardi Gras festival ("We of the South are anxious to show to you of the North that the war is over"). During the next six years, no less than two dozen formal Blue-Gray meetings took place, plus many more informal ones. The climax came July 1–3, 1888, when representatives of the Army of Northern Virginia joined old soldiers of the Army of the Potomac at

Gettysburg. Twenty-five years earlier these men had engaged in the greatest battle of the war; now they lined up on opposite sides of the stone fence that the Federals had defended and the Confederates had tried to take during Pickett's charge and reached across it to shake hands. Similar Blue-Gray gatherings occurred at Fredericksburg, Antietam, Kenesaw Mountain, and — biggest of all — at the dedication of the Chickamauga and Chattanooga National Military Park, September 18–20, 1890, during which forty thousand Northern and Southern veterans met to reminisce about the old times that, with the passage of the years, seemed in so many ways to have been good times.

Well into the 1900s, the veterans' organizations remained strong and active. Then, inevitably, they began to decline — at first slowly, but soon, ever more rapidly. After World War I, the American Legion and the Veterans of Foreign Wars spoke for veterans when it came to political and pension matters. By the eve of World War II, the legions of young men who had marched to the beat of the drums between 1861 and 1865 were reduced to a few thousand relics — treated, to be sure, with great veneration, but also apt to be regarded as curiosities. In 1949 the GAR held its last convention, and two years later so did the UCV; in each instance only a pathetic handful of members attended. Neither organization, however, officially ceased to exist until the deaths of the last-known surviving Union and Confederate soldiers: Albert Woolson, former drummer boy with the First Minnesota Heavy Artillery, who died in Duluth on August 2, 1956, aged 109, and Walter W. Williams, allegedly a teenage member of Quantrill's guerrillas, who passed away at the age of 110 in Houston, Texas, on December 19, 1959.

In another generation, few Americans will be able to recall so much as seeing someone who fought in the Civil War. Nevertheless, the memory of the men who wore the blue and the gray will not die. They saw to this themselves, with the letters, diaries, and memoirs they wrote and that have been preserved, and through the photographs for which they posed. By these means, they transcend time and provide for people today and tomorrow comrades from the past.

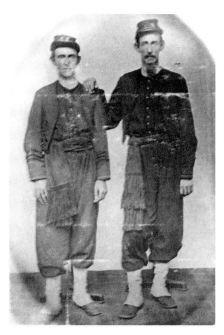

Top left: The camaraderie that arose between the men in the ranks during the war would stay with them for the rest of their lives. (USAMHI)

Bottom left: High and low, officers and privates, theirs was a common bond of affection, nurtured in adversity and hardship, that only death could sever. (KHS)

It grew in the endless hours they spent in their camps, passing idle time in reading or writing, fighting anew their old battles and boasting of what they would do in the conflicts to come. (USAMHI)

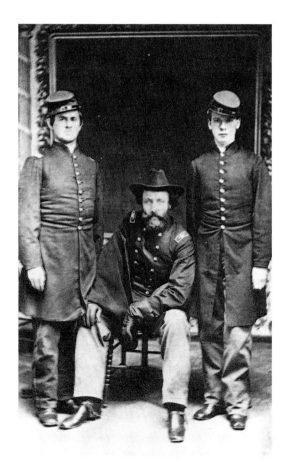

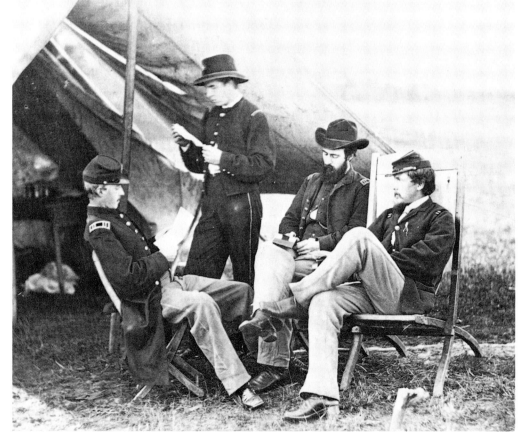

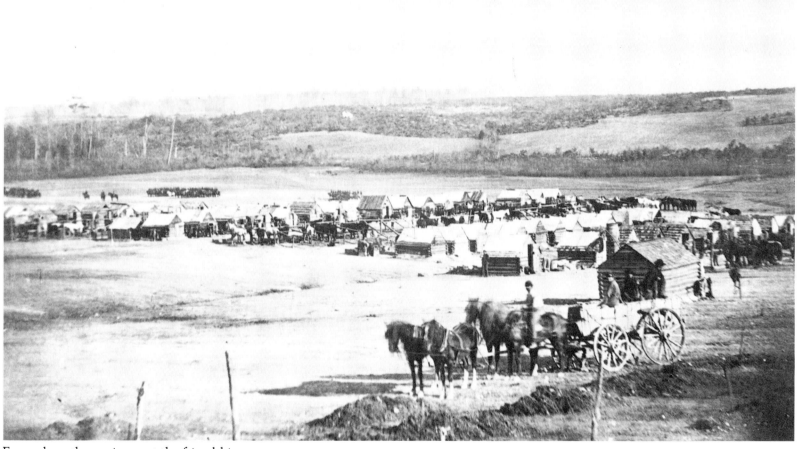

Everywhere the armies went the friendships
grew — and in winter quarters like these
most of all, for there was so little to do in the
cold months that the men had to rely upon
one another to pass the time. (USAMHI)

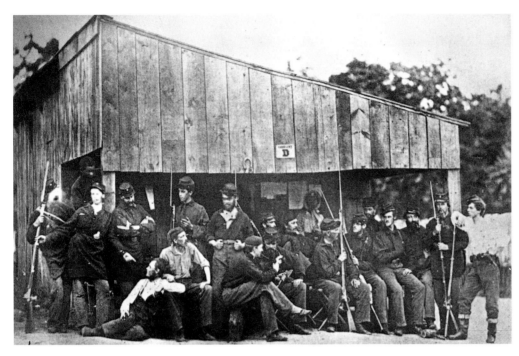

The bonds arose even as the first regiments volunteered—like the First Rhode Island, shown here in 1861. (USAMHI)

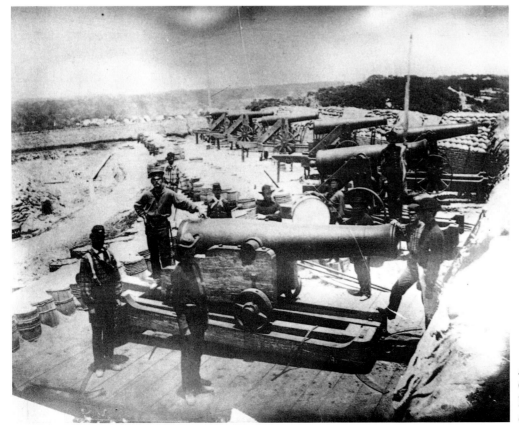

Across the lines it was the same. These Confederates of 1861, at their guns in Pensacola, Florida, would remember these days and their compatriots always. (USAMHI)

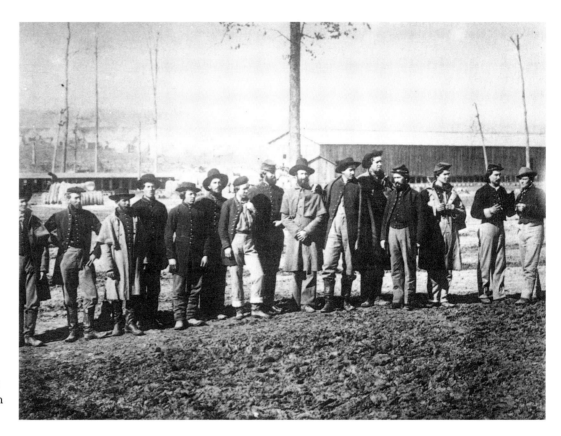

They loved to pose with each other for the camera, and were not ashamed to stand arm in arm. (USAMHI)

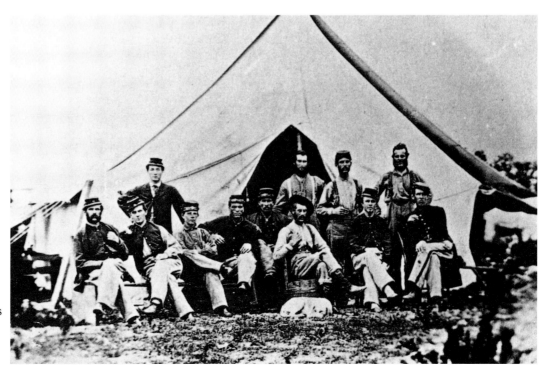

Of course, when they could, they had "man's best friend" with them as well. Men from Massachusetts and New Jersey units mingle for the cameraman. (USAMHI)

They played games, like these men of the Third New Hampshire seen at dominoes on Hilton Head in 1862. (USAMHI)

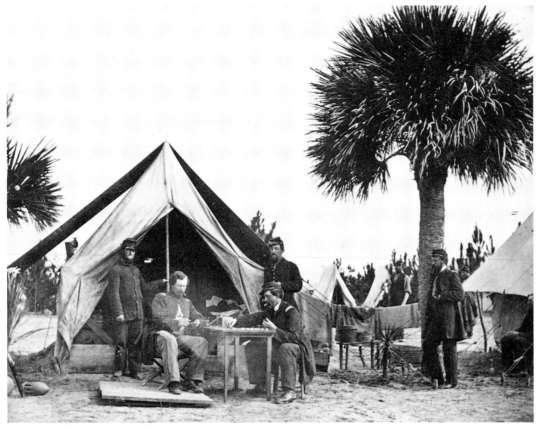

Bottom left: They made household items of the paraphernalia of war, even furnishings to decorate their spartan quarters. (USAMHI)

Bottom right: Those who could be visited by their children or friends shared them with their mates. (USAMHI)

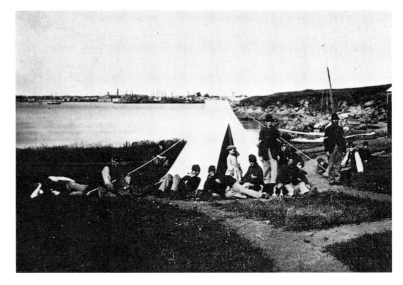

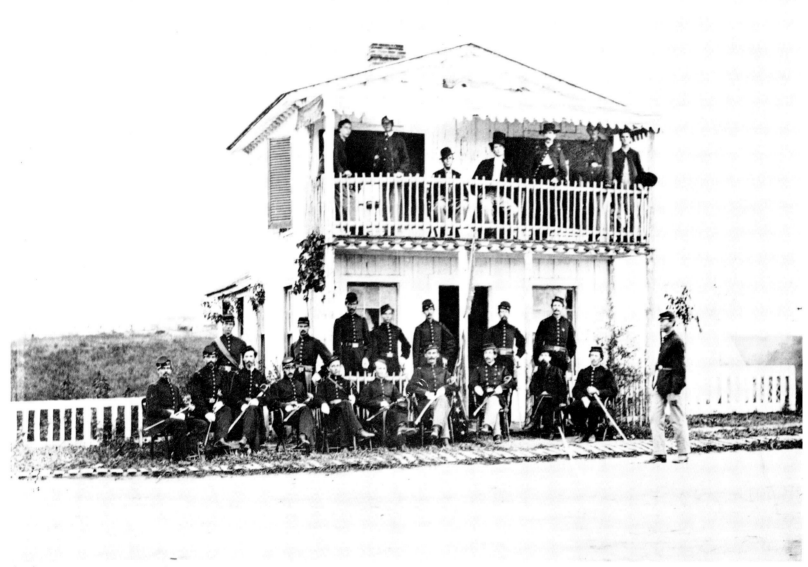

And any visitor, even a top-hatted dandy, was a good excuse to dress up for the camera. Officers of the Second New York Heavy Artillery in 1865. (USAMHI)

The fortunate might spend a few months in quarters like these atop Lookout Mountain. (USAMHI)

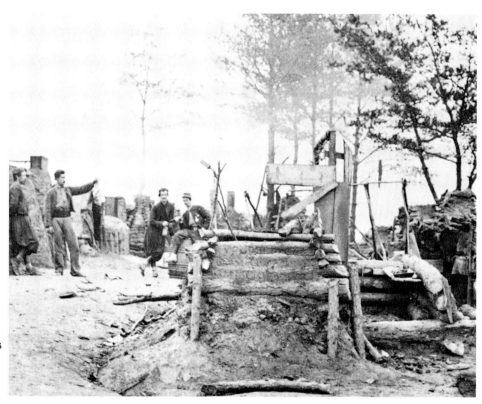

But most wintered in rude lodgings like these, somewhere in Virginia. With amenities all too few, and the winters cold, the men took comfort in their friendships with each other. (USAMHI)

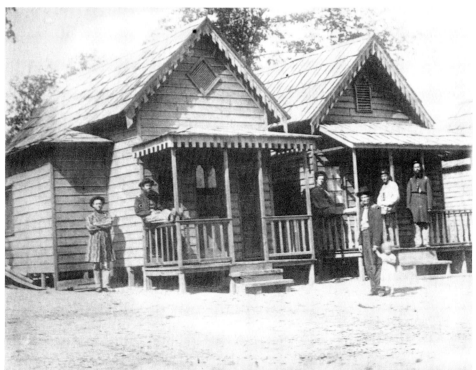

They loved to clown and preen, whether just with an elongated cigar in the mouth, like the man seated at left, or by wearing what for all the world looks like a carpet. (USAMHI)

Soldiering seemed to involve an awful lot of sitting and standing around, as with these army scouts off duty at City Point, Virginia. (USAMHI)

A local store was always good for some kind of diversion — a new book, newspapers, perhaps a cake or pie to supplement the day's rations. Atwood's store on Hilton Head, in 1863. (USAMHI)

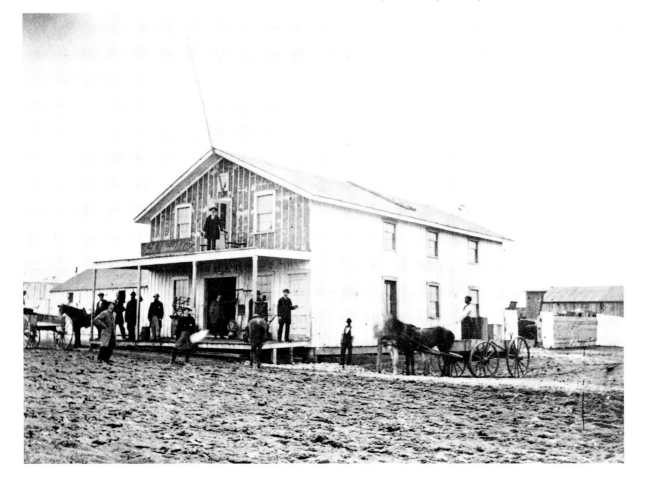

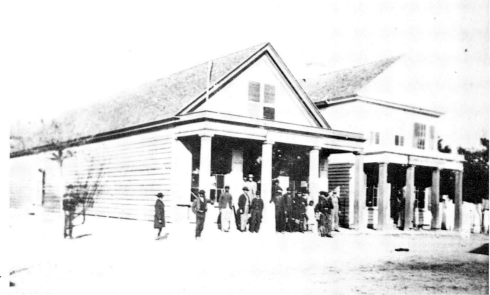

Fyler's store in Beaufort, South Carolina, was always a popular spot for lounging Yankees to spend some spare hours together. (USAMHI)

The shade of some trees outside the Bank of North Carolina in New Bern was just as welcome. (USAMHI)

The telegraph office was a good place to get the latest news and gossip, as well as to meet friends for talk. (USAMHI)

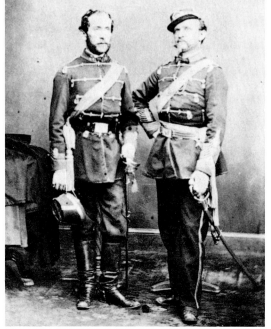

The camaraderie was not restricted to the men in the ranks. The officers, too, like these resplendent leaders — the brothers D'Utassy of the Thirty-ninth New York — acquired a lifetime fondness for each other. (USAMHI)

But the greatest affection resided among the men in the ranks. Battery M of the Second U.S. Artillery at Culpeper, Virginia, in September 1863. (USAMHI)

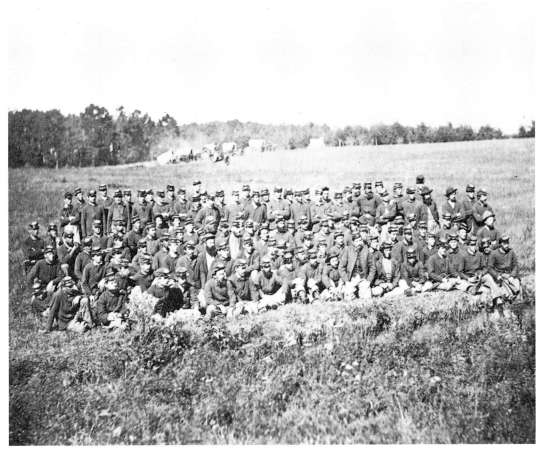

Bottom left: Among the men on the water it was the same. Rarely would their contributions to the war be recognized for their worth, but no one ever undervalued the comradeship of men like these Mississippi River sailors aboard a tinclad. (USAMHI)

Bottom right: Like the old hymns they sang, their bonds of affection would last "till suns shall rise and set no more." Company F of the Forty-fourth Massachusetts, at Readville in September 1862. (USAMHI)

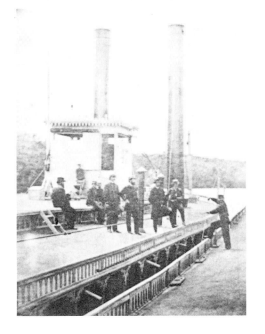

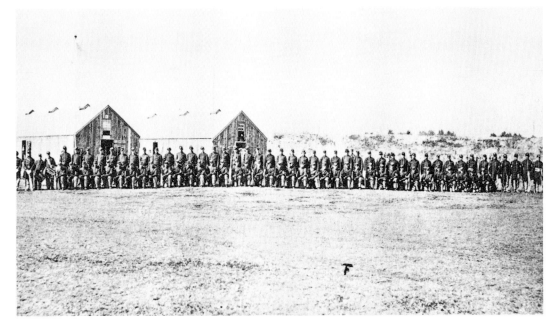

Very special ties of friendship grew in extreme adversity, and nowhere more so than among those who fell into enemy hands and languished in prison. These men, captured at the First Battle of Bull Run in July 1861, are confined in Charleston's Castle Pinckney. By later war standards, their accommodations are palatial. (USAMHI)

Indeed, even though prisoners of war, there is about them still an air of lightheartedness — they dubbed their quarters the "Musical Hall, 444 Broadway." (USAMHI)

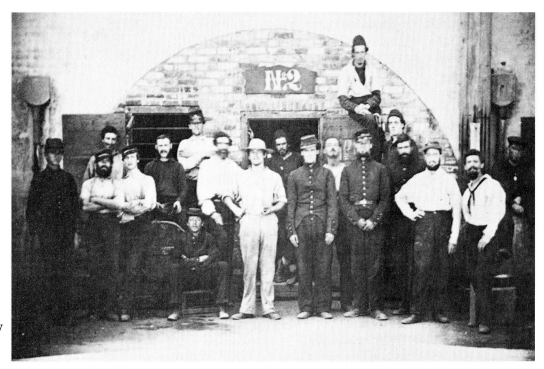

These early prisoners, soon to be exchanged for Rebel captives and released, are the lucky ones. In years to come they may even look back on their captivity as a lark. (USAMHI)

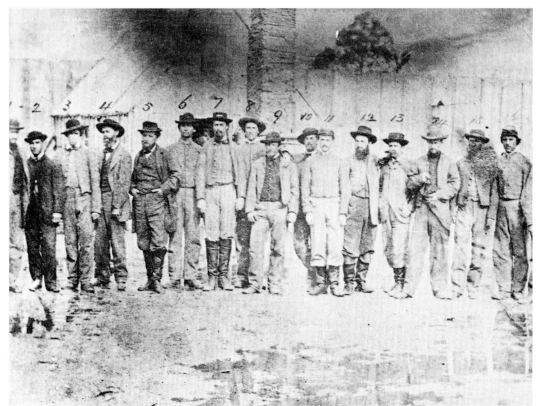

For later prisoners it would not be so pleasant. There is already a different look in the eyes of these Confederates imprisoned at Maryland's Point Lookout. War has become harder now, and they need each other more than ever. (USAMHI)

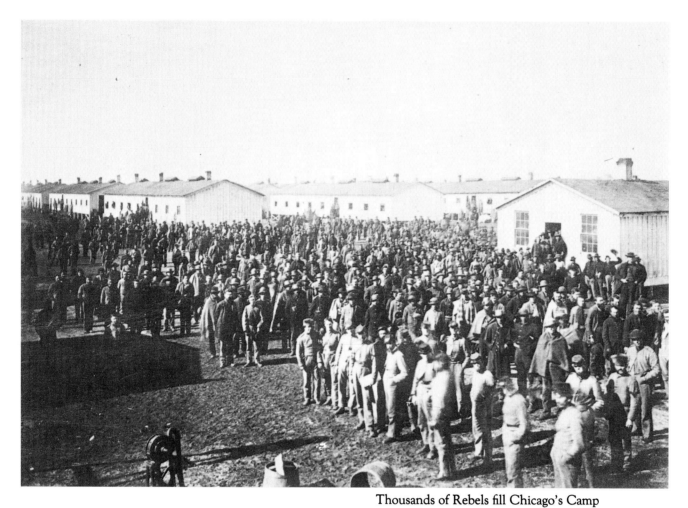

Thousands of Rebels fill Chicago's Camp Douglas. Many will die here of disease and poor conditions. (USAMHI)

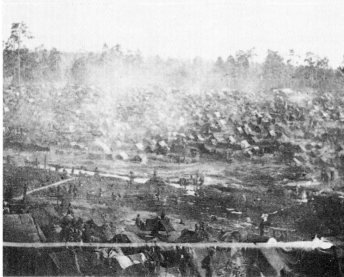

And worst of all, of course, would be Camp Sumter in Georgia, known to posterity simply as Andersonville. For thousands incarcerated in this living hell, only their friendships kept them alive. (USAMHI)

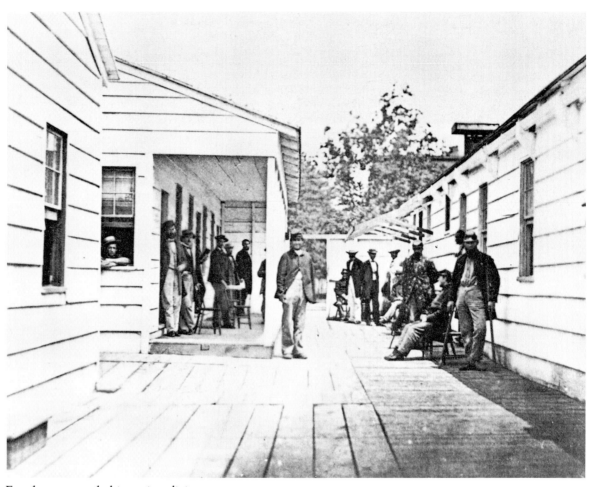

For those wounded in action, living through the days or even months in hospital similarly required the support of their comrades. Even in the better hospitals, like this one in Washington, D.C., recovery depended almost as much on luck and encouragement as on medicine. (USAMHI)

Only with death did friendships end, and even then the memories went on. In the foreground, the grave of a soldier drowned in the James River, near Fort Darling. (USAMHI)

With the war done, the comradeships went on, and not all of them between men. So closely did those who fought become that even pets — dogs and birds — and war-horses were beloved. Charlie, horse of the colonel of a Massachusetts regiment, was treasured for years afterward by the men of his regiment. (USAMHI)

In time, though happy with the peace, the men missed each other and began to meet again, this time for conviviality, old times' sake, and not war. Company B of the Thirteenth Massachusetts gathers at Nahant on July 9, 1876. (USAMHI)

The men of Knap's Pennsylvania battery
and two other Keystone regiments enjoy a
reunion on the field at Gettysburg where all
of them bled years before. (USAMHI)

Amid tourists and onlookers, men who survived the hell of Andersonville gather again at Providence Spring, the trickle of water that miraculously appeared during a dry season in the war. (USAMHI)

At "The Weirs" in New Hampshire, members of the Grand Army of the Republic join in reunion. (USAMHI)

As the years went on, the veterans' ranks grew thin, and the reunions of "the boys" took on a look of age and depletion. Here, Company B of the Thirty-fifth Massachusetts meets at Andover in 1885. (USAMHI)

The same year, the more numerous Twenty-third Ohio meets at Lakeside, beneath its tattered banners. (USAMHI)

And the old men came back to the battle-fields where they had spent their youth. These men of several Massachusetts regiments returned to Gettysburg twenty years after the battle, to stand with the monument to the Second Massachusetts. (USAMHI)

The generals joined the returning soldiers, themselves showing the ravages of the war, and time. Maj. Gen. Daniel Sickles lost his leg at Gettysburg. He never tired of returning to the field and seeing old comrades from the glory days. (USAMHI)

Veritable tourist excursions took veterans back to the scenes of their youth. A group of Yankees fill the steamer *Berkshire* more than twenty years after the war, on their way south to North Carolina, to the land where they spent their war service. (USAMHI)

There they could pause and look, and remember what they had done, and those who had not come back. One pensive Northerner stands on the bridge near Kinston, North Carolina, where two decades before there had been his war. (USAMHI)

Old-timers of the Forty-fourth and Forty-fifth Massachusetts look over the onetime site of Fort Washington near Kinston. It, like they, had eroded somewhat over the years. (USAMHI)

Yet there was still some of the gleam of old in their tired eyes, a brilliance that came from remembrance. (USAMHI)

Wherever the armies had gone, the veterans went back years later, as here at Hamilton Crossing, Virginia, where once Stonewall Jackson had battled. (USAMHI)

At Petersburg, in the great hole known ever after as the Crater, the fiery little Confederate general William Mahone stands front and center, leaning on his cane. In the war he had helped repulse Yankee attacks here. (USAMHI)

Fort Stedman, in the Petersburg forti-
fications, was almost overgrown twenty
years later, but still the men came back.
(USAMHI)

Wearing their veterans' badges, they gathered
about their old leaders. In Lexington,
Kentucky, in 1901, old Rebel cavalryman
Joseph Wheeler stands at center surrounded
by comrades from younger days. (KHS)

In addition to all this, the veterans tried to preserve the places that most reminded them of their years of comradeship, the places that held special meaning for them. There were the battlefields, to be sure. But there was also Providence Spring, where a chance appearance of water gave hope to thousands. (USAMHI)

Some of the more dedicated even began major collections of records to preserve the story of what they and their friends had done. Col. John P. Nicholson amassed one of the largest private libraries on the Civil War in existence. (USAMHI)

And the veterans with the money did even more. Here in Boston, for instance, members of the Military Order of the Loyal Legion of the United States erected this armory to preserve the relics of their youth. (USAMHI)

They built a massive library and collected artifacts from the war. (USAMHI)

Nothing was too insignificant to be worthy of preservation, nothing from the war was unimportant. (USAMHI)

And in these volumes they built the greatest collection of war photographs in existence. They still exist today, filling the books shown here with the scenes of young men's triumphs and hardships. (USAMHI)

In the end, their youth was gone. Like these
aged veterans in the Kentucky Confederate
Home, there was little left to them but the
December of their lives. Yet it was for all of
them a season filled with the memories of
what they had done, what they had risked
and won or lost together, touched by fire
with their comrades. (KHS)

Contributors to Volume One

ALBERT CASTEL has long been recognized as one of the leading historians of the Civil War in the West, thanks particularly to his outstanding biographies of Maj. Gen. Sterling Price and the Confederate raider William C. Quantrill. Professor of History at Western Michigan University, Dr. Castel is currently working on a major new history of the Atlanta campaign and the March to the Sea.

CHARLES EAST, formerly Director of the Louisiana State University Press and, later, the University of Georgia Press, is currently a free-lance writer living in Baton Rouge. His interest in Civil War photography, and particularly the work of A. D. Lytle, has already led to an excellent book on the wartime images made in Baton Rouge by Lytle and others.

ADM. ERNEST M. ELLER enjoyed a long and distinguished career in the United States Navy before his retirement. A natural outgrowth of his service is his avid interest in maritime history, as reflected in his works on the Civil War at sea and the Revolutionary War on the Chesapeake. For many years he has been an Advisor to the National Historical Society.

HERMAN HATTAWAY is Professor of History at the University of Missouri at Kansas City, and the coauthor (with Archer Jones) of the recent and widely acclaimed *How the North Won*, a study of Union strategy. In a forthcoming volume, he and his coauthors will deal with "How the South Lost." He is also the author of an award-winning biography of Gen. Stephen D. Lee.

PERRY D. JAMIESON is currently an Air Force historian assigned to the Strategic Air Command, though he is best known for his work on the Civil War, and particularly for his coauthorship of the controversial study of Confederate battle tactics *Attack and Die*.

RICHARD J. SOMMERS, Archivist at the U.S. Army Military History Institute, is one of today's foremost military historians of the Civil War. His award-winning book *Richmond Redeemed*, which deals with a phase of the Petersburg campaign, is a model study.

WILLIAM C. DAVIS, Editor of this work, is the author or editor of eighteen books dealing with the Civil War, including the six-volume *Image of War* photographic series. For many years editor of the magazine *Civil War Times Illustrated*, he now divides his time between writing and magazine management.

WILLIAM A. FRASSANITO, Photographic Consultant for *Touched by Fire*, is the leading Civil War photographic historian of our time, and the author of a brilliant trilogy dealing with the images of Antietam, Gettysburg, and the 1864–65 campaign in Virginia.

Photograph Credits for Volume One

Abbreviations accompanying each image indicate the contributor. Full citations appear below. Very grateful acknowledgment is extended to the individuals and institutions, both public and private, who have so generously allowed the use of their priceless photographs.

ADAH	Alabama Department of Archives and History, Montgomery
CA	Cape Archives, Durban, Republic of South Africa
CHS	Chicago Historical Society
CM	Confederate Museum, New Orleans
DT	Donald Thorpe
FSU	State Photographic Archives, Strozier Library, Florida State University, Tallahassee
HP	Herb Peck, Jr.
IMP	International Museum of Photography, Rochester, N.Y.
JAH	John A. Hess
JM	Justin Martin
JPR	Jan P. Reifenberg
KA	Kean Archives, Philadelphia
KHS	Kentucky Historical Society, Frankfort
LC	Library of Congress, Washington, D.C.
LFH	Lee-Fendall House, Alexandria, Va.
MC	Museum of the Confederacy, Richmond, Va.
MHS	Minnesota Historical Society, Saint Paul
NA	National Archives, Washington, D.C.
NHC	Naval Historical Center, Washington, D.C.
NYHS	New-York Historical Society, New York City
OCHM	Old Court House Museum, Vicksburg, Miss.
PC	Private collection
PHS	Pensacola Historical Society, Pensacola, Fla.
RM	Robert McDonald
RP	Ronn Palm
SC/RSY	Sterling Chandler and Richard S. Young
SHC	Southern Historical Collection, University of North Carolina, Chapel Hill
SSC	Sophia Smith Collection, Smith College, Northampton, Mass.
TU	Tulane University, New Orleans
UR	University of Rochester, Rochester, N.Y.
USAMHI	U.S. Army Military History Institute, Carlisle Barracks, Pa.
VM	Valentine Museum, Richmond, Va.
WA	William Albaugh
WG	William Gladstone
WLI	Washington Light Infantry, Charleston, S.C.
WLM	War Library and Museum, Philadelphia
WRHS	Western Reserve Historical Society, Cleveland

TOUCHED BY FIRE

A National Historical Society
Photographic Portrait of the Civil War,
in Association with CIVIL WAR TIMES

VOLUME TWO

★ ★

William C. Davis EDITOR

William A. Frassanito PHOTOGRAPHIC CONSULTANT

BLACK DOG
& LEVENTHAL
PUBLISHERS
NEW YORK

Introduction to Volume Two

William C. Davis

OF ALL THE HUMAN SENSES, none opens to us so much of wonder and fascination as sight; none can so move our feelings and emotions for good or ill. It could hardly be a surprise, then, that the world went a bit camera-happy when the discovery of photographic processes in the last century opened, to millions around the globe, vistas of scenes unseen, places unvisited, and experiences undreamed. Hardly surprising is it, either, that the first epic human endeavor to occur after the camera's development should become one of the most photographed events in modern times. The camera and the American Civil War were like children of the same generation, linked in a sibling relationship that produced not rivalry but a profound partnership and a moving documentary record of a people who were literally "touched by fire."

The first volume of this work addressed much of that human experience — its impact upon the continent, upon the leaders and the led, the story of the lasting compact of comradeship that the war experience produced, the face of the Confederate soldier, and more. This second volume of *Touched by Fire* continues the story, its purpose the same. This is no definitive history. For the scholars and serious armchair historians, there will perhaps be little that is truly new in the text on the pages that follow. But this is not intended to be a new history of the war.

Rather, *Touched by Fire* attempts in this volume, as in its predecessor, to present some specific themes that run through Civil War history, in ways that most of the public — and not a few historians — will not have considered before. Just what was the nature of the two governments that waged war upon one another? Where were their ideologies divergent, and how did they reflect the aspirations of the peoples who supported them? Some penetrating thoughts in response to those questions appear herein. So many books have been written about the armies and what they did. But how much does the public know of the virtual armies of the unseen and unheralded, those behind-the-lines support services without which no army in any age could move? And what of the role of minorities in this war? After all, the chief catalyst for the conflict was America's most visible minority, the slaves. Yet they were only one of many

ethnic and racial groups who made this terrible experience their war too.

There is much more. The Civil War revolutionized infantry weapons and tactics. Less recognized is what it did to the sciences of defensive fortifications and artillery, two features of conflict most readily identified with warfare. This volume offers some insights into the revolution that occurred in these areas, too, and why. We look at the face of Billy Yank, that indomitable soldier whose resolve lasted through years of defeat and setback before he marched onward to final victory. And we see the terrible cost of the war in the waste it laid on the people and their landscape.

While the text tells much, the photographs, which attract and capture the eye, are what really illuminate this vision. Of the 542 images in this volume, more than half have not been published previously. At that, they represent only the tiniest, almost incalculable, fraction of the total photographic legacy of the war. Alas, the cameras could not be everywhere, and there were many scenes, many experiences of the war, that were simply never captured on negatives. In many cases, so few images survive — sometimes only a single one — that in order to provide any coverage at all, we must rely upon views already published many times over. We are fortunate to have them, though, for like a fine piece of music, they get better with every new "performance."

That we have images like these to present is due to many individuals and institutions. Fortunately, those who came before us, now long dead, had a sense of history. They knew that these fading views carried a memory of a generation and a time that would be everlasting in the consciousness of the American people. These were shadows of the past worth saving, and tens of thousands of them have been saved. It took a few years after the war for government to appreciate their worth, but in time it did. Meanwhile, collectors and antiquarians had already begun the work of preservation, as they continue it today. Would all these images have survived had they not related to a subject that itself remains the most written about and talked about event in our history? Probably, for the vision of the Civil War is often more persuasive than the narratives. Indeed, it is the photographs themselves that have led many of the uninitiated to their first exploration of a topic that has captured them for life.

Without those institutions and collectors, we could not present this or any other volume. They deserve recognition for what they are doing to help people remember — but lists of names in book introductions are little read, and less recollected. That is human nature, so anxious are we to *see* what there is to follow. (Indeed, introductions themselves are little read, and that is all right.) Few collectors maintain these priceless old images in order to achieve recognition. They acquire and save them because they must. It is a calling — a compulsion to see as much as possible for themselves, and to preserve for the rest of us. The surety that they have done this is often thanks enough.

In looking at these remarkable views, in learning the lessons they impart, in remembering what they represent, we thank also those who made them — and those who suffered and sacrificed and triumphed and failed while the images were being made. Seeing these scenes now, as they may only be seen in these pages, we can still feel the flames that touched their lives.

E Pluribus Duo

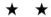

Harold M. Hyman

OUR CIVIL WAR was many wars. Above all else, it was a civil war. History's verdict is that civil wars unleash the worst behavior of individuals and governments and profoundly deteriorate the standards of the warring societies, especially if a conflict continues for a long time, and most especially when racial or religious factors are involved. In the 1850s, during the Taiping Rebellion, Chinese killed probably 20 million other Chinese. Ten years later, Frenchmen so savagely suppressed the Paris Commune uprising as to inspire Georges Clemenceau (who as a journalist had reported from Washington on our Civil War and Reconstruction) to note sadly that in France half the nation was a firing squad for the losing half. From 1917 to 1920, the Russian Revolution created perhaps 10 million civilian casualties. And no reliable casualty estimates exist for the post-World War II civil wars in China, Vietnam, India—the list is long.

America's Civil War became the longest one fought anywhere in the Western world during the period between Napoleon's surrender in 1815 and World War I. It involved the intertwined destinies of whole races. Yet with rare exceptions Union and Confederate armies obeyed "laws" of war that, elsewhere, did not apply in civil wars. Despite the fact that the nineteenth century was the classic time of "men-on-horseback" military dictators seizing power out of civil wars, in our Civil War civilians retained tight control over the bestarred galaxy. When the Civil War ended, the victor did not impose mass executions, exilings, jailings, or property confiscations. Disfranchisements were few and brief. Indeed, our Reconstruction, both before and after Appomattox, was a sustained attempt to increase, not decrease, the electorates of the would-be Confederate states. The major characteristics of the restored Union of states — constitutionalism, federalism, and biracial democracy — were far better based than when the war began.

Our Civil War was surprising in that it occurred at all. In the winter of 1860/61, odds were very heavy against the United States fighting to save itself. Northern timidity in the face of rising demands by Southern whites for favored treatment had begun in 1787. Responsively, the Constitution's framers had substantially overrepresented the Southern states in the House

of Representatives and the electoral college by counting each slave as three-fifths of a person, and had also yielded by specifying as a federal duty the return of fugitive slaves even from nonslave states. Then, in historic "compromises" of 1820, 1850, and 1854, concerning slavery in the national territories (future states), this tradition of giving in to the South received spectacular reemphases.

Despite these political successes, Southerners grew ever-more fearful for their special property rights in humans. After the November 1860 election of Republican candidate Abraham Lincoln to be president, the Deep South's leaders organized their states' secessions from the Union. Lame-duck president James Buchanan could find no relevant constitutional grounds or military resources for halting the outgoing tide. Unopposed state secessions further convinced Southerners that urban and commercial corruptions, non-English (that is, Irish, German, and free Negro) immigrants, and excessively open political democracy had made the nonslave North impotent. Only weeks after Lincoln's inauguration, in April 1861, Confederate president Jefferson Davis ordered the artillery attack that quickly forced the surrender of the tiny garrison on one of the nation's last Atlantic strongholds in the South, Fort Sumter in Charleston.

Was Sumter's surrender the Union's last leaf? Many commentators here and abroad thought that obituaries were in order. No nation that fails to protect its military property in one of its own harbors was likely to outlast even the strains of peace, much less fight a war. Should a war come, however, the Confederacy, it appeared obvious even to amateur strategists, enjoyed large advantages. The East Coast's complex mountain-to-Atlantic rivers were ideal for defense, especially with hordes of docile slave-laborers to dig trenches and erect fortifications. Southerners also saw correctly that the Confederacy needed to win no battles — although it would. Instead, the Confederates, like their Revolutionary fathers before them, had to hold out against a superior foe until they won by default.

Soon after Appomattox yearners after the Lost Cause created a tradition that the Confederacy could never have won, that the Union's industrial, communications, and population advantages foredoomed the South to defeat. The tradition is still impressive, especially if statistics are seen as a primary measure of history. Union states numbered twenty-two or twenty-three, depending on whether West Virginia is counted. Throughout the war years, European immigrants reinforced the Union's 22 million residents. Telegraph, factory, and farm figures were all six to seven times greater in the North than in Secessia, and except along the Maryland-through-Missouri border, the unseceded states were little disturbed by actual combat. Washington possessed foreign recognition, functioning credit and fiscal structures, and existing government institutions.

By contrast, at peak the Confederate states numbered only eleven (plus two "rump" states), had but 9 million residents (of whom more than one-third were black), and saw virtually no immigration. The South had to create its national government institutions since it abandoned those the Union provided. And foreign recognition never came. But, to balance, the South had significant natural resources and industrial-communications facilities. Its agricultural output was magnificent. Slave labor served farms, factories, mines, and, as laborers, the Confederate armies. Because the endless, twisted Atlantic and Gulf coasts and the Mexican border were unblockadable, waves of goods flowed into the South.

Less precise data may be ultimately more significant in assessing civil wars, as the poet W. H. Auden advised when he warned: "Never sit with statisticians nor commit a social science." Agricultural societies lacking great cities are like sponge rubber to invading armies, whose battlefield successes can seem to be meaningless while the defenders' armies remain alive. The Union, not the Confederacy, had to invade and to garrison a region larger than all Europe west of the Rhine; had to win gory campaigns, not single battles; had to recreate the governments of thirteen states and of a multitude of localities — all in the face of overwhelmingly hostile white residents — before it could even approach the war aim of 1861, national reunion.

Adding to the South's advantages was the fact that Southern white society did not suffer the "excesses of democracy" of

two-party politics in Union states. Thinking in these terms, Lincoln used rural imagery. He pictured himself as a (not *the*) driver of a frail wagon — the Union. Ahead, pulling the cart, were three powerful horses in tandem. All moved toward one common goal, reunion, but not at the same speed. In the lead, trying to gallop, was the so-called radical Republican, who wanted reunion plus abolition of slavery. The second horse, the "regular" Republican, was content only to canter, and was less sure about emancipation. Last of the three, the "war" Democrat, wanted reunion only, but might be convinced that emancipation was essential, and yet would only trot ahead. But tied behind the wagon was the antiwar, pro-Southern, Negrophobe Democrat, heels dug in to retard any forward motion. Could the weary, creaking Union-wagon long endure such torsions?

By contrast, the Confederate condition was one of overwhelming white unity favoring a war to retain existing race relationships. The South was composed, politically, of single-party or no-party states. Only prowar Democratic organizations existed, except for a few antique, irrelevant Whig remnants. No Republican organizations polluted any seceded state. To be sure, in scattered border localities in western Virginia, Missouri, Tennessee, and Texas, some antisecession and anti-slavery sentiment coexisted with white-superiority convictions. But until secession and war created the opportunities in the form of "invading" Bluecoats, such sentiment rarely generated politically meaningful organization or strength. In slave states law and custom had combined, long before the Civil War, to locate and stifle dissent, whether through legal procedures or the "hanging tree." Consider that United States senator Andrew Johnson of Tennessee had to flee his state in 1861 in order to escape being assaulted or even lynched, returning to it a year later in the wake of Union troopers as Lincoln's military governor. In short, the South gave off an illusion of massive white unity.

It was no illusion that most Southerners, even including many antisecessionists of 1861, would fight a "foreign" invader in order both to defend their homeland and to preserve white-on-top race relationships. Southerners had a not-so-secret

weapon: northern democracy. Graybacks could surely endure until their battlefield victories, or, at worst, stalemates, fed home-front dissent and outright disloyalty in Lincolnland. Foreign recognition or aid to the Confederacy seemed likely. Combined, these forces would unleash unstoppable pressures for a negotiated peace, especially at election times (an idea behind the South's 1862 and 1863 thrusts into Maryland and Pennsylvania preceding elections there). Hawkish Southern prophets envisioned peace treaties that included permanent protections for slavery and extradition-like fugitive-recapture clauses.

Southerners misjudged much about the society they had left. Reversing history, the majority of nonseceded America did regain faith in its elected leadership, from Lincoln down. This unanticipated revival of faith proved to be the ultimate misjudgment by the South, one that basically affected the Civil War's pace, nature, and outcome. Fundamentally, this misjudgment centered on the ability of the Union's civilian and military leaders to learn quickly from crises. Confederate makeweights failed to anticipate that their Union counterparts could arm themselves quickly with sound perceptions about the elastic limits of government in domestic crises, perceptions derived from the nation's constitutional history and law. And Southern analysts misread the capacity of the nation's leaders and general population, so armed, not only to hold to the war aim of 1861, but to advance to others such as emancipation. The South failed especially to anticipate Lincoln's educability and character, not to mention the possibility that Northerners might, like their Southern countrymen, also be willing to endure the costs of war.

Northerners also misjudged. Their basic misperception concerned the degree of devotion that even antisecession, nonslaveholder Southerners felt for their static, racially hierarchic society. But because free America was not pinned to rigid racial or constitutional visions, but instead felt served by an adaptable Constitution and educable leaders such as Lincoln, Northerners proved to be able to discard their false or irrelevant misjudgments. Two-party politics, so despised in the South, became the major vehicle for educating the Union public about

military and constitutional strategies, and about the risks and hazards attending the abolition of slavery, especially if schemes to colonize freedmen abroad proved to be unworkable, as they eventually did.

These sectional differences became important as the Civil War escalated from the ninety-day militia muster that both Lincoln and Davis initially expected to be the full extent of the war. One year later, the Union — which in 1861 could not stop first seven states, then eleven, from seceding, or protect a single fort — was maneuvering Napoleonic-scale forces against equally huge Confederate armies across a vast arc from northern Virginia to southeast Texas, and southward to the Gulf of Mexico, where the South's major city, New Orleans, fell to Union troops. Warships contested oceanic trade routes while armies and shallow-draft fleets tried to dominate railroad and river systems that allowed strategic mobility and fed the economy. Despite terrible combat casualties in vast stalemate battles, Lincoln, in the midst of 1862's scheduled congressional and state elections, dared to proclaim the emancipation of slaves in still-disloyal states. In 1863, once-lockjawed federal power was conquering Vicksburg and stopping Lee at Gettysburg, reconstructing the governments of whole states and innumerable localities, and recruiting and conscripting whites and blacks (the latter being mostly runaways from slavery) into bluecoated ranks. In 1864, for the first time in the world's history, a warring nation — especially one fighting a civil war — conducted nationwide calendared elections (which Lincoln expected to lose) for a head of government and the majority of legislators, elections in which soldiers voted if their states allowed the practice. Odds are that a negotiated peace involving permanence for the Confederacy and for slavery — the unchanged Confederate war aims since 1861 — would have followed Lincoln's defeat in 1864. By the time Lee surrendered at Appomattox in April 1865, four years after the war began, Union armies had rolled back both secession and slavery to vanishing points.

From Sumter to Appomattox, however, this costly progress was reversible not only by Confederate defenders but also by Northern voters and pro-Southern activists — all of which

suggests that the idea of a successful Confederate rebellion was not foolish. Indeed, the abolitionist radical-Republican vision that Lincoln finally accepted — of Bluecoats crushing both secession and slavery, and of the reconquered states raising their internal governing standards to higher levels of popular participation — long seemed the greater foolishness.

This phenomenon of Union adaptability is the more remarkable in that its government and the Confederacy's were so similar in form. Both were organized federally by written constitutions that more or less precisely assigned certain functions to their respective nations, reserved others to member states, left others for either nation or states to perform, and ignored still others. The two national governments, like those of almost every one of the states, were composed of the familiar three branches — the legislative, executive, and judicial. In both the states qualified national as well as state voters, an additional reflection of the incurable state-centeredness prevailing everywhere in America. Both were political democracies, a condition Secessia defined in white-only and partyless terms.

As for war emergency home-front policies, from first to last both the Union and Confederate national and state governments intruded in seemingly similar ways into formerly untouched and untouchable areas of life. Under delegated commander-in-chief authority, soldiers arrested, tried, and imprisoned allegedly or actually disloyal civilians. Northern Democrats decried the growth of "American Bastilles" and denounced "King Linkum I," especially after the president accepted emancipation as a new Union war aim. Important twentieth-century scholars, reacting to emergency policies of their own time, echoed these criticisms of Lincoln (though rarely of Davis) when describing him as a "constitutional dictator."

Yet Davis also ordered soldiers to arrest civilians. Confederate as well as Union congresses and state legislatures imposed loyalty oaths on officials, then on ever-increasing categories of civilians, including lawyers, teachers, travelers, and contractors (though never, in the South, on slaves or free blacks), and censored newspapers — even, in rare instances, temporarily suspending publication. Both warring sections resorted for the

first time in American history to conscription (though as late as 1865 the Confederacy refused seriously to consider the drafting or arming of free or slave blacks). Both sides licensed coastal trade, blockaded their own ports, printed paper money, and taxed many consumer goods and individuals' incomes; both, possessing what appeared to be essentially similar *forms* of government, when faced with a long, searing civil war, apparently resorted to similar policies.

But the appearance of similarity is deceptive. For, as suggested earlier, even during this long, searing civil war the Union maintained its capacity to grow, to change, to risk even biracial coexistence on terms other than master-slave. By contrast, the Confederacy held statically to its war aim of 1861. This rigidity helped to lead not only to the military verdict of Appomattox but also to constitutional verdicts against slavery and race-based inequalities in the laws of nation and states.

Over a century later, after much experience with and study of wars of many sorts, including civil wars, we recognize how dynamic they can be. Wars, we understand, can start from certain causes, develop derivative yet differing aims, and then lead to still more differing yet still derivative results. Ralph Waldo Emerson called the Civil War a "dynamometer," and "a new glass to see all our old things through." Well and good for the Union that a leading intellectual like Emerson should so advise his audience. But perhaps it was more important that Lincoln, who made a nation his attentive audience, should rediscover in America's Constitution and history adequate supports for rugged wartime policies; that an obscure Ohio "war" Democrat and Union army officer, Durbin Ward, and many more like him, could grow with Lincoln from the reunion-only war aim of 1861 to one of reunion plus abolition in 1865. In short, the war experience taught a generation that the Constitution was not merely a network of negatives.

In essential ways the North was able better than the South to respond to the war's superheated pressures, in part by reason of this widespread attitude about the Constitution as a flexible source of authority as well as restraints. Southern constitutionalists, political leaders, and voters proved to be committed to the static constitutional ideas that in 1860 and 1861 had

justified secession. Therefore, in 1865 as in 1861 the South's war aim was white superiority enshrined in constitutions, laws, and customs. Southern politicians from Jefferson Davis down shared this comforting simplicity of policy position, and many expressed pleasure at the absence of political parties in their states. Secessia's politicians also did not enjoy the benefits offered by fund-raising, patronage-dispensing, criticism-blunting, public-educating, government-lubricating, and policy-formulating services that parties provided in the North. Basic policy alternatives such as arming slaves or seeking reunion could rarely become public questions. Less fundamental changes had few coattails to cling to. In the South, as a result, accountability, responsivity, and adaptation were improbable no matter how desirable or necessary.

Contrast what did not occur in the policy-immobile South with what did take place northward. There, Republicans and "war" Democrats formed coalitions that ultimately sustained Lincoln's antidisloyalty policies, diplomacy, emancipation, conscription, paper-money issues, and wartime reconstructions of occupied rebel states. Congressmen and president approved also monumental so-called nonwar laws (none of which could mean much unless the Bluecoats won). These improved the banking system and lower federal courts, encouraged "homesteaders" to purchase public land cheaply and to establish tax-supported territorial and state universities, and supported private-sector construction of transcontinental railroads. The Congress modernized its internal operations, with the Speaker of the House improving his control over legislative traffic, especially money appropriations. Determined to oversee the swelling numbers of military officers, Congress created the world's first military postal service and America's first joint standing committee, on the Conduct of the War. Commander-in-chief Lincoln quickly established strong, friendly, and intimate links to the committee. It whipsawed upstart generals when he wished not to do so publicly. For its part, the committee monitored war contracts, spoke loudly in matters of military commissions, and increased the president's accountability for all war matters, including the fates of allegedly disloyal civilians who were under arrest and of

freed slaves. Which is to say that traditional logrolling, pork-barrel political-party operations adapted quickly to the war's hectic pace and hot issues.

This adaptation was possible because Northern party organizations linked Washington to every state and locality. Some states' legislatures, like the Congress, enacted "war" measures (including test oath laws especially for licensed professionals), created home-guard military units, and set price limits on staple foodstuffs. And, again like the Congress, almost every Union state reformed itself in "nonwar" terms during the Civil War decade, rectifying inequitable gerrymandered election districts, equalizing tax burdens, democratizing voting qualifications, and eradicating old antiblack clauses from the laws. Further, states and localities established numerous new institutions, ranging from city police, fire, and health departments to state and local boards of public education. In the South, however, to state the matter briefly, neither the Confederate national nor state governments risked what latter-day scholars have described as "modernization."

The diverse populations of the reformed Union states re-elected Lincoln and his party colleagues in 1864, ratified the Thirteenth Amendment a year later, and tried through the rest of the 1860s to convince the defeated Confederates to raise their states' standards to similarly improved levels. That the effort became frustrated and derailed by Southerners' continuing devotion to their race advantages suggests that a century ago the surface similarities of the "two governments" were deeply modified by these underlying factors. The Union reached Appomattox greatly changed from the society that in 1861 had learned the news of Fort Sumter's surrender; the Confederacy reached Appomattox in part because of its determination to remain as unchanged as possible from the society that four years earlier had launched the experiment in rebellion.

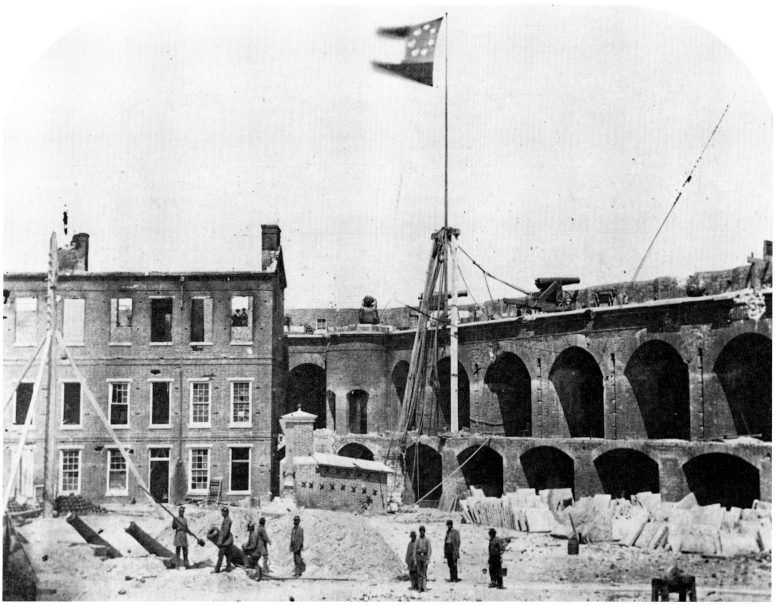

It seemed incomprehensible to Americans then and later that the people of North
and South, brothers, Americans all, could come to blows. Fort Sumter changed that.
As the new Rebel banner flew over the parade ground in F. K. Houston's April 15,
1861, image, there literally were two nations out of one. (USAMHI)

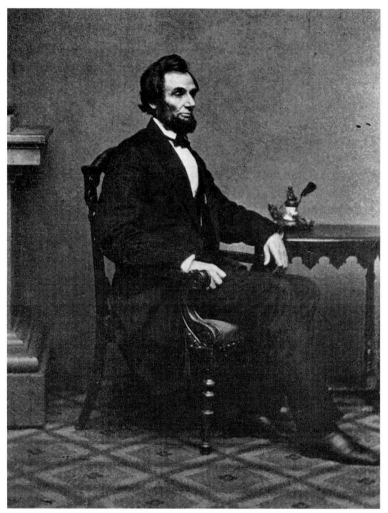

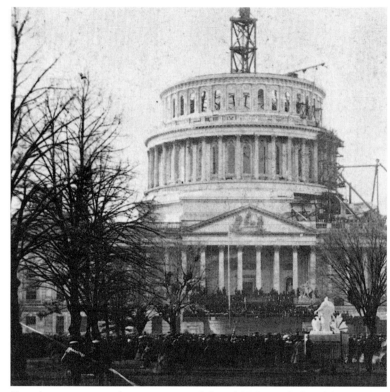

But there was a mighty remnant of the old Union behind him as he took his oath of office: the still unfinished Capitol. This image of the ceremonies was taken by a captain of engineers, Montgomery C. Meigs, who was in charge of the Capitol expansion. Soon he would be quartermaster general of Lincoln's armies. (LC)

At first there were substantial doubts about the ability of the untested new president Lincoln to cope with the crisis — to prevent actual war, much less reunite the divided sections. In Alexander Gardner's February 24, 1861, portrait, all of Lincoln's abilities and future promise remain yet untested. (LO)

Top right: A host of diverse — often discordant — elements were what Lincoln had to use to forge a weapon for victory. Within his own party he had to contend with radicals like Thaddeus Stevens of Pennsylvania, men who took a hard-line stance against the South and pushed for immediate progress on emancipation. (LC)

Bottom left: Leading radical Charles Sumner refused even to consider compromise short of reunification and emancipation. Such doctrinaire elements in the president's party were a constant challenge, and sometime embarrassment, to Lincoln. (KA)

Bottom right: Less rigid in their thinking were men like William Seward, Lincoln's secretary of state. Ambitious for the presidency himself, he was at first jealous of the chief executive, even suggesting that Lincoln should let him run the country. (NA)

Edwin M. Stanton had been attorney general in Buchanan's Democratic administration. But in 1862, still a Democrat, he became perhaps Lincoln's most effective cabinet minister as secretary of war. (KA)

Lincoln also had to depend upon former Democrats who stood behind the war effort and the cause of the Union. Stephen Douglas, his old political foe from Illinois, campaigned against Lincoln for the presidency in 1860, yet stood squarely behind him for the Union in 1861. (LC)

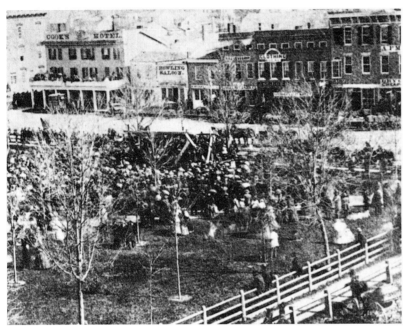

There was little question that the people of
the Union were behind Lincoln. In the days
after Sumter, scenes like this war rally in
Ann Arbor, Michigan, were repeated all
across the country. (MHC)

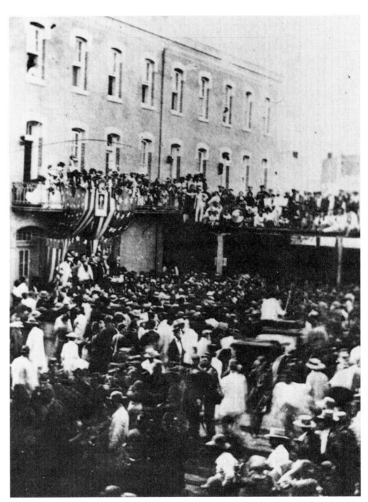

And when the first boys went off to war or
returned home — as here, at the return of
the First Michigan to Detroit on August 7,
1861 — the people poured forth their support.
(BHC)

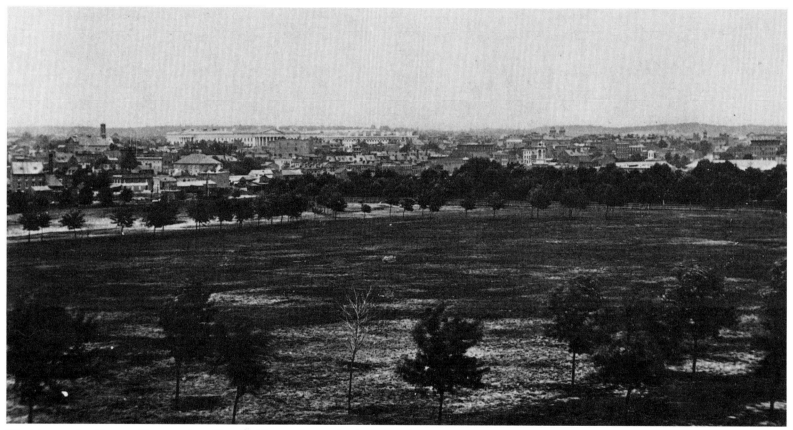

Washington itself was still a city that, like the Union, lay unfinished. Stately
government buildings stood cheek-by-jowl with swamps and shanties. There was still
a sense of uncertainty about where the capital was going as a city and, with its
predominantly Southern heritage, just how loyal it would be to the Union. (USAMHI)

Still there were the symbols of national power, imposing if not quite finished. The Capitol, shown here in April or May of 1865, with Lincoln's mourning crepe still tied to the columns, housed the greatest deliberative body in the hemisphere. Cantankerous, argumentative, occasionally adversarial, the members of Congress were Lincoln's arm's-length allies in the fight for the Union. (NA)

Lincoln's government had a host of weapons to wage its war, not the least of which was its economic superiority. The Customs House in New York City produced enormous revenue to help finance the war effort, and in 1863 it did double duty as a branch of the Treasury. (LC)

The Patent Office, shown in this early prewar image, was the venter for invention and enterprise, much of which came to fruition in the weapons being manufactured for the Union's armies. (LC)

The North's military and naval might, barely marginal at war's outset, grew to be overwhelming. The Confederacy could never put to sea ships like the mighty *Vandalia*, shown at Portsmouth, New Hampshire, in this 1863 image by H. P. Moore. (JAH)

Indeed, almost from the first Lincoln's navy was able to institute a generally effective blockade of all the major Southern ports. This late-April 1861 image by J. D. Edwards shows the Yankee blockading ships (on the horizon) off Fort Pickens, near Pensacola harbor, literally within days of their arrival. (USAMHI)

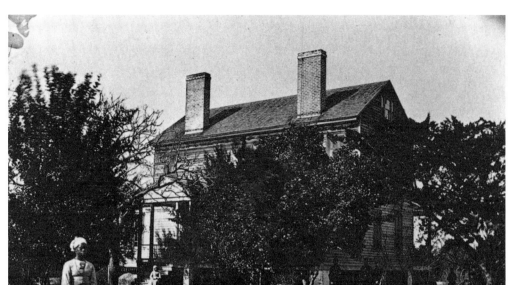

In time, Lincoln would also use the cause of the war—slavery—as one of his weapons. Millions of former slaves, like these outside the Hilton Head, South Carolina, plantation home of Brig. Gen. Thomas Drayton of the Confederate army, would flock to the Union's banners. (USAMHI)

The first step was emancipation. Beneath this tree, ever after called Emancipation Oak, a Federal reads to the assembled blacks Lincoln's January 1, 1863, Emancipation Proclamation. By making freedom, at the right time, one of his goals, Lincoln made the fight for the Union a holy crusade. (FL)

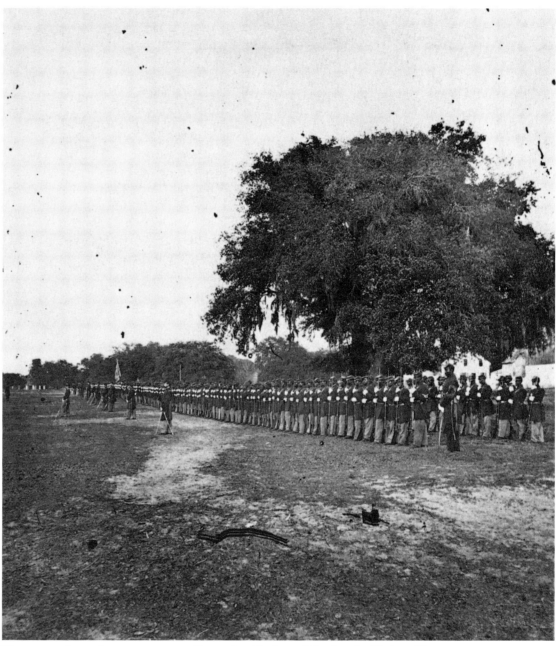

That step taken, the next was actually arming blacks to fight for the Union. That same January 1, the First South Carolina Volunteers pose at Port Royal, South Carolina. They are the first unit of former slaves officially enlisted. (LC)

Yet Lincoln had his enemies within his own camp, and the question of loyal opposition versus outright treason became a thorny one. No one epitomized this more than Clement L. Vallandigham of Ohio. Imprisoned by one general for his antiwar speeches, Vallandigham would eventually be banished from the Union briefly, though he was no traitor. (LC)

Especially when they were in Confederate territory, Lincoln's armies had to guard against the disloyal. Loyalty oaths were a commonplace requirement, and many a farmer, like these two in Virginia, was stopped and questioned when suspected of providing aid to the enemy. (HEHL)

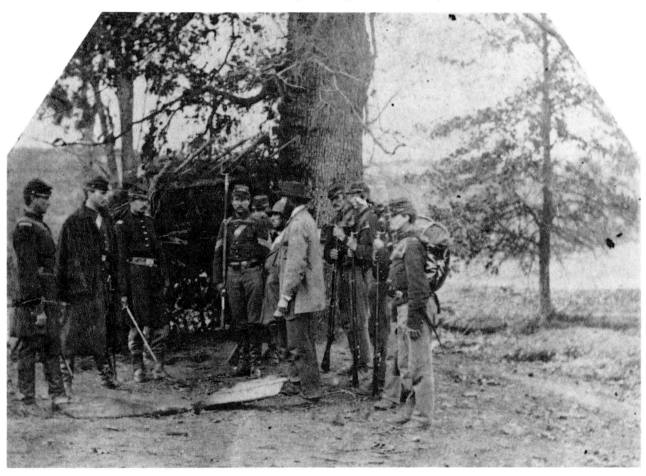

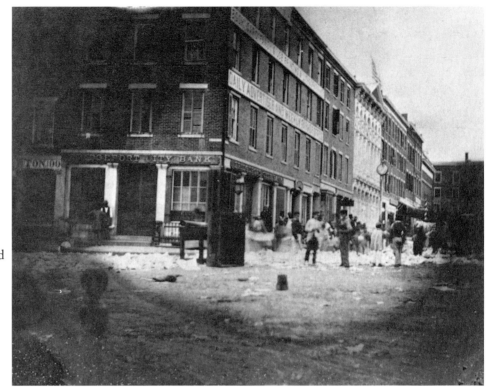

Sometimes Northerners took the law into their own hands when dealing with suspected treason. More than one antiwar newspaper suffered the fate of the *Bridgeport* (Connecticut) *Weekly Farmer*, when angry mobs destroyed their presses. Here, on August 24, 1861, furniture and type have been sent crashing through the windows to the streets, and members of the mob still linger. (BPL)

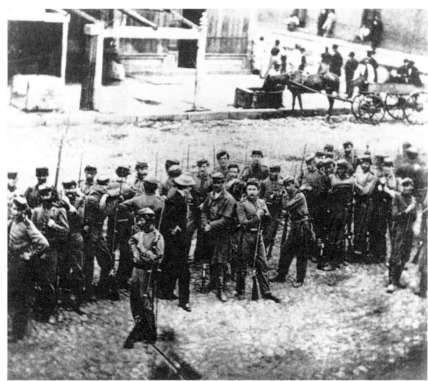

Sometimes unrest broke out in other kinds of civil disturbance, such as the July 1863 draft riots in New York City. Here members of the Seventh New York Militia stand in the city's streets after being called forth to maintain order. (SRF)

What quieted the loyal and disloyal opposition alike in the Union was success. Lincoln's victories came at the right times. Here at Little Round Top at Gettysburg, and elsewhere, his armies won when they had to, sustaining the will of the public to continue the war to victory. (USAMHI)

And thus it was that Washington and that still unfinished Capitol building could host a Grand Review in May 1865 celebrating the victory of the Union. (LC)

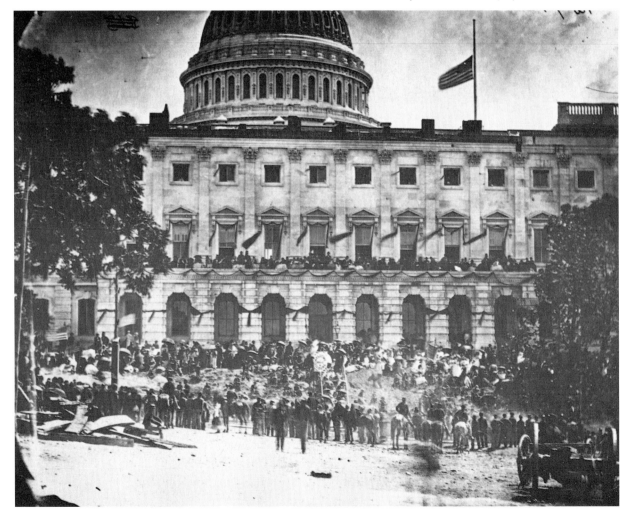

Top right: The weapons of war available to the South were far less extensive. Indeed, when South Carolina voted here in Secession Hall to leave the Union in December 1860, there was no government in place as an alternative. (USAMHI)

Bottom left: Everything had to be created for the new Confederacy, from its new president, Jefferson Davis of Mississippi, to the most mundane things, like post office forms. At the inaugural ceremony here in Montgomery, Alabama, on February 18, 1861, the new chief executive . . . (NA)

Bottom right: . . . Jefferson Davis probably did not yet realize fully just how enormous the task ahead of him would be. (NA)

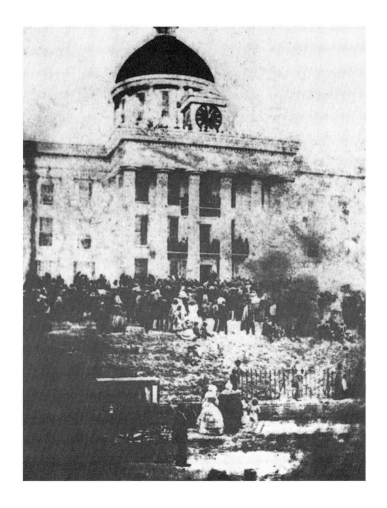

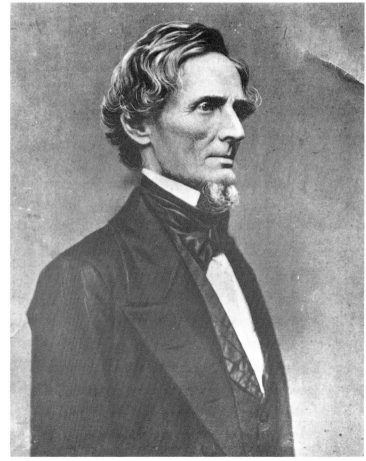

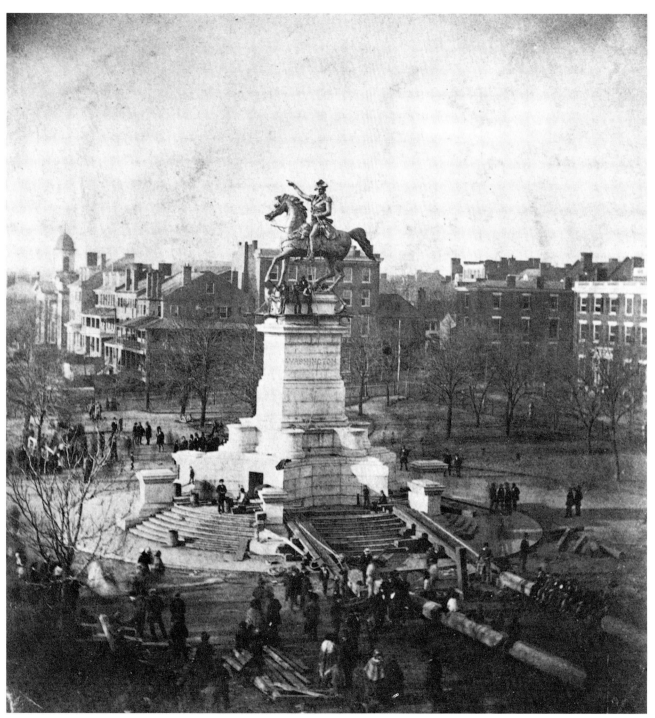

From the outset, the political necessity of having Virginia stand with the South
influenced policy, and in the end resulted in the Confederate capital being moved
here to Richmond. Politically, the move made sense. Militarily, it put the new capital
within 100 miles of Washington, and saddled Davis from the first with a policy that
kept Virginia always uppermost in his mind. (LC)

E PLURIBUS DUO 339

Top right: Davis himself established residence in the old Brockenbrough house, making it the White House of the Confederacy. (USAMHI)

Bottom left: The Confederate House and Senate moved into the old Virginia State House nearby. (USAMHI)

Bottom right: The South did have its share of established governmental systems in place that could be converted to the needs of the new nation, but never nearly enough. The U.S. Customs House in Richmond was symbolic of the financial straits of the Confederacy from the first. Thanks to the blockade, customs duties were only a shadow of what was needed. (LC)

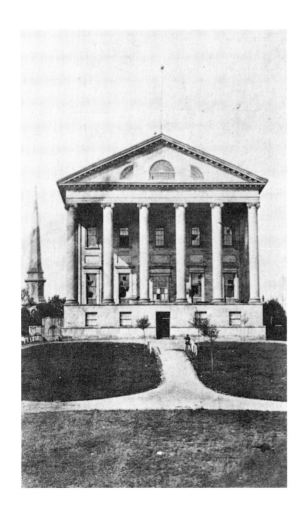

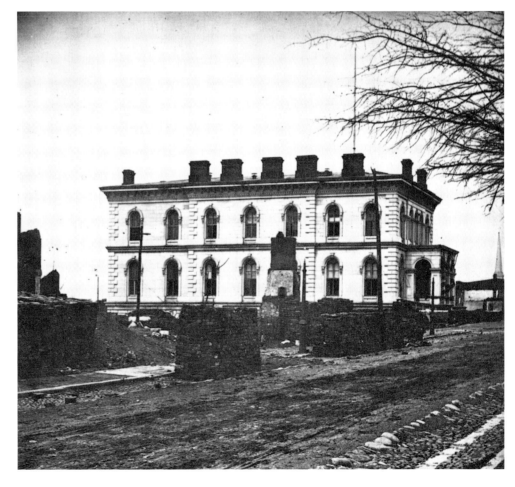

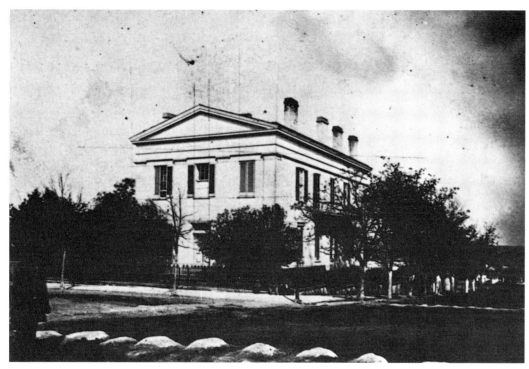

The scarcity of gold and silver made the South's currency wildly inflationary, and her treasuries, like this one in Vicksburg, almost meaningless. Only massive foreign and domestic loans, not real income, kept the government afloat and able to buy the munitions of war. (KA)

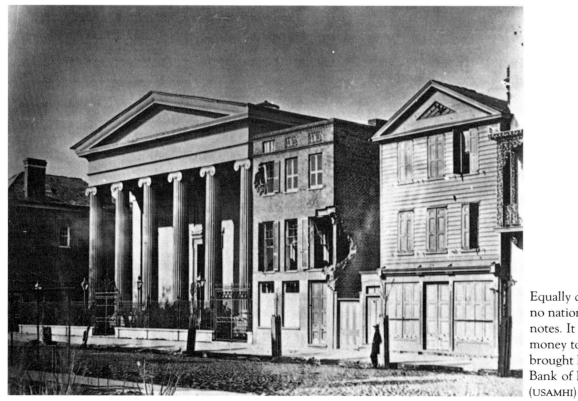

Equally chaotic was the banking system, with no national currency other than promissory notes. It was said that a Confederate took his money to market in a wheelbarrow, and brought his purchases home in a pocket. The Bank of Richmond after the surrender. (USAMHI)

Strangely enough, for a region that had produced so many great statesmen in the past, the South possessed few of them by 1861 (perhaps one of the reasons that the war came when it did). Those few, like John Slidell of Louisiana, were early pressed into service — Slidell as a diplomat to France. (LC)

Like Lincoln, Davis had to face a considerable share of opposition in the Confederacy. There were many like John Minor Botts of Virginia, seated here among his family, who would not forswear their loyalty to the old Union, who withheld their allegiance from the new Confederacy. Not a few, like Botts, went to jail for their beliefs. (LC)

More galling to Davis were those so-called
fire-eaters who helped bring on secession but
who opposed his administration for not
being radical enough. Robert Barnwell Rhett
of South Carolina was one of their leaders,
an almost constant thorn in Davis's side. (LC)

His home, Rhett House, reflected all the
values and aspirations that befitted his class,
but like so many, Rhett never understood
that some of the state rights he loudly
championed would have to yield if the
Confederacy were to succeed. (USAMHI)

Top right: Davis also faced problems with many of his governors. Both of Virginia's war governors, John Letcher and William Smith, lived here in the governor's mansion and cooperated fully with Davis. (USAMHI)

Bottom left: Others proved more jealous of their prerogatives. Zebulon Vance of North Carolina resisted allowing Tarheel soldiers to be commanded by men from other states, and withheld some supplies and arms that were needed elsewhere in the South. (NCDAH)

Bottom right: Most difficult of all, however, was Georgia governor Joseph Brown. He intentionally withheld Georgia troops from the Confederacy because he refused to acknowledge Richmond's right to command his state's resources. (LC)

Even Davis's own vice-president, frail and diminutive Alexander H. Stephens, opposed him through most of the war, and finally in 1865 simply went home to Georgia well before the collapse of the Confederacy. (LAWLM)

As for Davis, he fought on in spite of all the obstacles before him, becoming at times the personal embodiment of his cause. From the start, he and the Confederacy had faced attempting to do too much with too little. When he was captured May 10, 1865, at Irwinville, Georgia, he was placed in this ambulance and taken back to Macon, with an uncertain future ahead of him and the Confederacy. (LC)

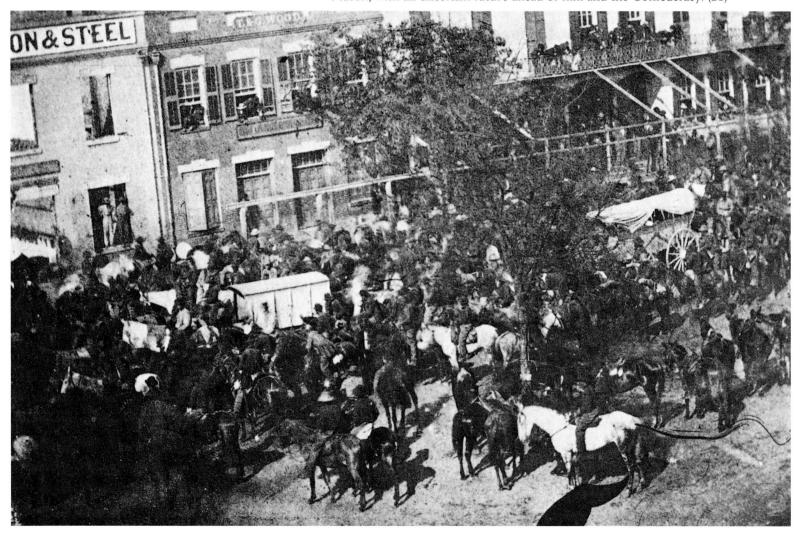

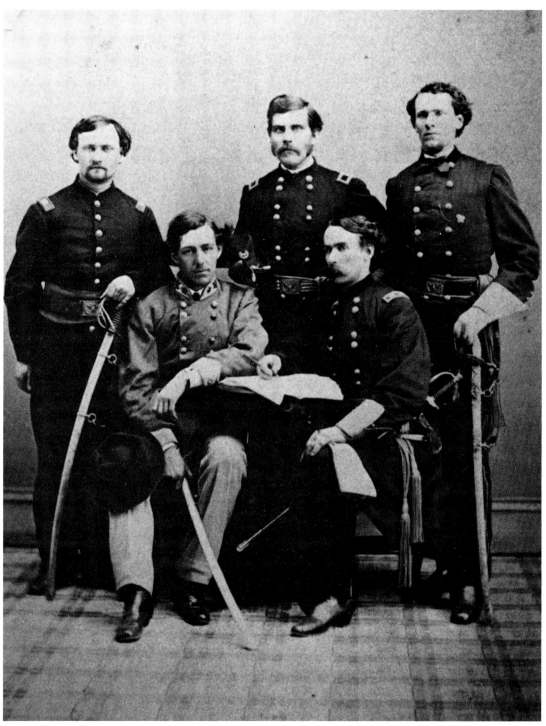

For the men and officers of the fallen South, their armies beaten and crumbling and their government evaporated, there was nothing left but surrender. An unidentified Confederate brigadier meets with Federal general Joseph Hayes in a scene probably posed immediately after Appomattox. (JCF)

They must all, North and South, join hands as, once more, they become what the Union's motto declared, "one out of many." (WAF)

Feeding the Machine

★ ★

Maury Klein

VOLTAIRE once observed that God is always on the side of the biggest battalions. In the American Civil War the world would learn for the first time a whole new definition of biggest battalions. The armies were far larger than anything seen on the continent before and required massive efforts to feed and supply them. North and South alike had not only to produce vast quantities of matériel but also to move them efficiently to the front. To a surprising extent their success or failure in this endeavor shaped the outcome of the war. The North won largely because it had a crushing superiority in resources and created efficient systems for harnessing them; the South lost because it was short of just about everything except courage and never forged systems to utilize effectively the meager resources at its disposal.

It was this new dimension that made the Civil War the first modern war in which numbers, valor, and leadership were no longer enough to assure victory. In the emerging industrial age, the biggest battalions were not at the front but behind the lines: a juggernaut of productivity capable of transforming the face of war itself. From the factories and fields of the North poured forth a seemingly endless flow of food, weapons, ammunition, tools, uniforms, blankets, shoes, wagons, and other supplies. The railroad system moved troops and equipment faster than ever before, while the telegraph moved information even more quickly. Government agencies, swollen in size and number, roused from their slumber of earlier years to grapple with the problems of administering so huge an undertaking. An army might still march on its stomach, but the stomach did not get fed until the paperwork was done.

In this great undertaking the North possessed immense advantages over the South. It had more people and more raw materials, most of the factories, foundries, machinery, tools, railroads, and telegraph lines, as well as the managers, technicians, and skilled workmen to operate them. Unlike the South, the apparatus of government was already in place and manned by experienced bureaucrats. It had ships to import whatever goods or material were needed and a navy to prevent the South from doing the same. Although the South was an agricultural region, the North's farms held an edge in sheer quantity of

output and in diversity. Where cotton was king in the South, the North produced vast amounts of wheat, corn, meat, dairy products, and wool to replace the cotton lost from Southern sources.

Under the new conditions of war, these advantages increased over time. The side with the biggest industrial battalions actually grew stronger as the war progressed. What began as a diffuse, fumbling effort to supply the armies evolved gradually into an efficient engine of productivity harnessed to coordinated systems of organization. The North might lose heart or grow discouraged over its appalling losses, but it would never falter for want of the resources to prosecute the war. By 1864 it had become a mighty storehouse of soldiers and supplies against which the Confederacy could not hope to compete on anything like equal terms.

For the South the reverse held true: as the war progressed it grew steadily weaker through an inability to replenish losses of every kind. Lack of factories, mines, and raw materials made its output skimpy from the start and therefore wholly unequal to replacement needs. Machines wore out for want of new parts, and bent or broken tools stayed in service long after they ought to have been retired, because new ones could not be obtained. The Southern railroad system was run into the ground long before enemy troops made "hairpins" out of its worn and overworked rails. Most of the lines would have needed rebuilding after the war even if Yankee marauders had inflicted no damage on them.

Without a transportation system, the South could not move vitally needed supplies from one region to another. Food for the troops was plentiful even in 1865, but no way could be found to get it to the men. Since most of the war was fought on Southern soil, large chunks of the Confederacy were lost to the ravages of battle, conquest, or despoliation. As the South's domain shrank, so did its already feeble store of resources. The naval blockade reduced the flow of imports from abroad to a mere trickle, and the fall of Vicksburg in 1863 all but eliminated the trans-Mississippi West as a source of supplies. Early in the war Southern troops found themselves in the position of guerrilla fighters obliged to live off arms and equipment scavenged from the enemy on the battlefield.

For all its efforts to organize a government capable of prosecuting the war efficiently, the South's mobilization seldom reached beyond the level of improvisation on a grand scale. It lacked the resources, the managerial talent, the organizational skills, and the social or political philosophy to do anything more. A people wedded to state rights and suffused with an exaggerated sense of individualism were not likely candidates for creating a united front. Victory was possible only through cooperation at every level, yet too many Southern leaders preferred defending their principles in rancorous disputes to solving problems through compromise. Often their intransigence defied the bounds of common sense. This divisiveness aggravated the already serious shortages and lack of productivity that plagued the Confederacy.

None of this was apparent in 1861 except to a select few with cool heads and alert eyes. In the first flush of martial enthusiasm that swept North and South alike, it was widely believed that the war would be a brief affair, won or lost on some decisive battlefield by the valor of a few good men. Once the fiasco at Bull Run shattered this illusion, both sides turned in earnest to the task of mobilizing for a war of indeterminate length and unprecedented scale.

Only then did the shocking disparity in resources between the sections become apparent. The most obvious differences lay in sheer numbers. Some 22 million people lived in the North and only 9 million in the South, of whom about 3.5 million were slaves who would be used as labor but not as soldiers. Immigration flowed almost entirely to the North, adding another 800,000 people to that section during the war years alone. The South produced less than 10 percent of the nation's industrial goods and possessed only 8,783 miles of railroad compared to 22,385 miles for the North. Most of the country's coal, iron ore, copper, gold, silver, salt, and that new wonder, petroleum, were found in the North.

Impressive as these numbers were, they only hint at the true dimensions of Northern superiority. That section also contained most of what might be called the infrastructure of industrial productivity: machinery, machine tools, factories, furnaces, forges, foundries, rolling mills, steam engines, technicians, skilled workmen, managers, and inventors. Conver-

sion to war industries came quickly if not always easily. When the flow of Southern cotton to New England slowed, cotton mills and carpet mills became woolen mills. When workmen joined the army, women and children took their places. Machine shops produced guns, saw factories turned out sabers, and jewelry factories made brass buttons. The government armory at Springfield, Massachusetts, employed three thousand men and produced a thousand rifles a day, while private contractors turned out twice that number.

From New England's mills flowed a swelling stream of uniforms, blankets, shoes, and other items. The sewing machine, barely a decade old in 1860, galvanized wartime production. Men's shirts that once required more than fourteen hours to produce by hand could be done in little over an hour. The new McKay sewing machine enabled one person to sew several hundred pairs of shoes a day. Thanks to the war's demands, ready-made clothing exploded into a major industry. New factories sprang up in cities as if by magic. Philadelphia, the manufacturing center of the North, welcomed 180 new establishments between 1862 and 1864. Chicago emerged as "Porkopolis" — the meat-packing capital of America — during these years and could scarcely keep count of the new agricultural-implement factories, carriage and wagon factories, tanneries, machine shops, foundries, breweries, distilleries, and other industries that opened in the city. Even sleepy New Haven saw six large new factories go up in a single year.

Shipyards in Maine, textile mills in Rhode Island, shovel works in Massachusetts, arms factories in Connecticut, iron furnaces in Pennsylvania, rolling mills in Ohio, locomotive plants in New Jersey, wagon works in Indiana — these and countless others poured out goods in amounts that staggered the imagination. "The war," observed a Massachusetts editor in 1863, "has brought into activity many mechanical employments for which there is little occasion in time of peace." Old industries flourished and new ones sprouted. The army's need for food gave rise to the canned-food industry, including Gail Borden's amazing canned milk. Wartime demands called forth new weapons, new products, new machines, new techniques, and a record flow of new ideas. More patents (over five thousand) were issued in 1864 than in any previous year.

Northern agriculture matched the impressive record of Northern industry and drew upon the same sources of inspiration. A land of small farmers might have been crippled by so many thousands of its citizens marching off to war, but production suffered little if at all from their absence. Reliance on machinery helped keep yields high even when labor was scarce. Although mowers and reapers were still fairly new when the war broke out, their use spread rapidly. In 1864 factories churned out more than seventy thousand mowers, twice the number of 1862; that same year, 1864, Cyrus McCormick alone produced six thousand reapers. Cultivators, horse-rakes, new harrows, corn planters, steam threshers, grain drills, and similar devices were also marketed. Like other war contractors, the manufacturers of farm implements smelled bonanza profits in the wind, and they were right. "A hundred thousand agricultural laborers are gone; how are we to meet the deficiency?" asked a Cincinnati editor. "We have met it," he answered, "chiefly by labor-saving machinery."

And by drawing out more labor. Someone had to drive the mowers and reapers and tend to the hundred other chores of raising crops. Like the factories of New England, Northern farms leaned heavily on the women and children left behind. "I saw the wife of one of our parishioners," wrote a missionary in Kansas, "driving the team in a reaper; her husband is at Vicksburg. With what help she can secure and the assistance of her little children, she is carrying on the farm." Another reported from Iowa that he saw "more women driving teams on the road and saw more at work in the fields than men." A popular song urged men to

> Just take your gun and go:
> For Ruth can drive the oxen, John,
> And I can use the hoe!

Through these devices Northern farms managed to produce enough corn, wheat, oats, and meat to feed Union armies and still sell large surpluses to England, which suffered three consecutive years of crop failures. Hog and cattle output jumped sharply in the North and the number of sheep doubled, enabling wool production to soar from 60 million pounds in 1860 to 140 million pounds in 1865. This increase did much to fill

the gap left by the loss of Southern cotton, although some mills continued to operate on contraband cotton smuggled north. Whatever the fortunes of war, the breadbasket of the Union never ran empty or even lean.

The South strove desperately to match this harnessing of resources. "Mechanical arts and industrial pursuits hitherto practically unknown to our people are already in operation," proclaimed Alabama governor A. B. Moore in October 1861. "The clink of the hammer and the busy hum of the workshop are beginning to be heard through our land. Our manufactures are rapidly increasing." Certainly there was reason for hope. That same year a survey by *Debow's Review* listed dozens of newly established plants in Southern towns for making guns, uniforms, swords, spurs, canteens, steam engines, tent cloth, textiles, rope, leather, candles, plows, stoves, and other products.

Much of this optimism derived from a few showcase facilities that were developed or enlarged during the war. The crown jewel of Southern industry was the Tredegar Iron Works in Richmond, virtually the only factory in the South capable of turning out locomotives or heavy ordnance. At its peak Tredegar employed twenty-five hundred men and operated subsidiary iron furnaces, coal mines, a tannery, a sawmill, and a brick factory. Tredegar not only supplied the Confederacy with munitions and other matériel but also furnished Southern arsenals with essential equipment for their manufacturing. Together with the government-operated Richmond Armory and Arsenal, Tredegar provided about half the ordnance supplied to Confederate armies.

After 1862 Selma, Alabama, emerged as a major site of wartime industries for the South. Using iron ore and coal from nearby mines and machinery run through the blockade from England, the Selma complex included an arsenal, a naval yard, a naval foundry, and facilities for making powder. A major powder works was erected at Augusta, Georgia, and smaller plants for war implements went up in cities throughout the Southeast. The effort was impressive but wholly inadequate to the needs of Southern armies. A major problem for the Confederacy was not merely developing new industry but also

keeping hold of what they had. Nashville was an important industrial site until Union troops captured it in February 1862. The fall of New Orleans that same year cost the South the resources of that city. Every loss of territory crippled the Confederacy's ability to wage war in some way.

The two words that best characterize the Southern war effort are *shortages* and *substitutes*. The Confederacy was short of nearly everything and scrounged frantically after substitutes for what it did not have. Factories lacked iron, lubricating oils, nails, screws, new parts to replace worn ones, even containers and sacks. When existing supplies were used up, replacements were difficult to find and the army always had first claim on what little was produced. Farms suffered no less than factories from shortages. Draft animals suffered heavier casualties than soldiers and were as hard to replace. Horses or mules gone to war could not pull plows. Basic tools and implements, plows, harnesses, saddles, rope, barrels, tubs, and even such simple items as buckets and troughs wore out, and new ones were difficult if not impossible to obtain.

Nothing hurt Southern productivity more than its chronic shortage of skilled labor. The occupation of mechanic was not an honored one in the South; many of the region's best men were Northerners who went home after the firing on Fort Sumter. Wartime aggravated this shortage by increasing the demands on a limited pool of skilled workers and by reducing that pool even further as workers departed to serve in the military. From Charlotte, North Carolina, came a report in May 1864 that "a number of our most important tools are idle a large portion of the time for want of mechanics to work them, and some of these tools, the steam-hammer for instance, are the only tools of their class in the Confederacy." The *Richmond Enquirer* complained bitterly that shoe production in that city had stopped because "of the absence of the operatives at the front. . . . There is an abundance of leather here, and if the shoemakers were not absent, many thousands of pairs of shoes might now be on hand."

Despite dogged Confederate efforts to patch up old equipment and find substitute materials, both factory and farm productivity dwindled steadily because of shortages. Southern

women, too, replaced men called to the front, running plantations or toiling in the fields of smaller farms. Their contributions were heroic but in vain. Lack of labor, tools, and seed, loss of acreage to enemy troops, and even bad weather cut deeply into the region's production of food. Southern fire-eaters who had boasted that cotton was king soon had to eat their words but could not eat the cotton or even sell it once the blockade clamped down. King Cotton changed uniform to King Corn as land was shifted to the planting of provisions, but the switch came too late. By 1864 the South faced the grim and bitter irony of being an agricultural region unable to feed itself, let alone its armies.

From the first, transportation posed a major problem. It was not enough merely to produce the stuff of war. Men, equipment, and supplies had to be sent in vast quantities to the right place at the right time in the right amounts. In the field an army moved not only on its stomach but on its arms and with its wagons, horses, and mules — all of which had to be furnished in great numbers. The scale of war in the industrial age transformed logistical problems into nightmares of complexity that demanded fresh approaches to old problems.

Two technological marvels were at the disposal of both sides: the railroad and the telegraph. Here, too, the North had an overwhelming advantage. Apart from possessing most of the nation's railroad track and telegraph lines, it had the men, the matériel, and the technical expertise to keep both in superb condition throughout the war. Where the South had a collection of railroads, the North had what could reasonably be called a rail system linking all of its major cities and water outlets. Northern rivers extended the utility of the region's railroads; Southern rivers acted as little more than obstacles to rail lines.

Southern lines, built largely to accommodate the cotton trade, tended to run "nowhere except from the fields to the sea." Rival cities vying for trade supremacy discouraged connections between the railroads reaching them. Whole sections of the Confederacy lacked any sort of decent rail connection. Moreover, the main routes across the seaboard and from the Ohio-Mississippi valley to the seaboard were roundabout lines

interrupted by repeated transfers. By contrast Northern rails snaked into every major corner of the region and connected with one another to provide an uninterrupted flow of traffic. Northern railroads were better built, possessed better facilities, and had superior equipment in every respect than Southern ones. The four eastern trunk lines alone had as much rolling stock as all the railroads in Dixie.

After a slow start caused by the venal and shortsighted policies of Secretary of War Simon Cameron, the North utilized its rail superiority with devastating effect. The ability to move troops and supplies rapidly by train all but neutralized the South's geographical advantage of possessing the interior line. As Union armies penetrated deeper into the Confederacy, the use of railroads kept their supply lines open and flowing freely. A talented engineer named Herman Haupt developed techniques of bridge building that replaced burned or missing spans so quickly that one astonished onlooker cried, "The Yankees can build bridges faster than the Rebs can burn them down." Alongside the track a string of poles carried telegraph wires that kept the line of communications open wherever the armies went. Only Sherman, on his march to the sea, found himself unable to wire headquarters.

By contrast the Southern railroads, the lifelines of its war effort, wore down like a game but overmatched boxer. The soft iron rails of that era needed constant replacement; so did ties made of wood that the climate attacked voraciously. New engines or cars, parts or tools for maintenance, grew difficult and then impossible to procure. Unlike their enemy, the Confederates lacked the tools, talent, and technique for repairing damage wrought by Union raiders or advancing armies. The North, it seemed, could not only build railroads faster but also tear them up far more effectively than the South. The Southern army could scavenge weapons from the battlefield but not locomotives or boxcars from a roundhouse or depot.

As the Confederate transportation system staggered and faltered before its final collapse, Southern cities and whole regions suffered severe privation and faced the real threat of starvation. By 1865 the South had been stripped of so much of its wherewithal for war that it was surviving on raw courage

alone. Phil Sheridan's devastation of the Shenandoah Valley cost the Confederacy a major breadbasket at a time when it lacked the means to ship food in quantity any distance. The bitter defense of Richmond had less to do with saving the capital than with preserving Tredegar and the last major railhead left to the South. Without Tredegar and some semblance of a rail line, the South could not hope to prolong the fight. In those final weeks Robert E. Lee's army starved and shivered in rags while huge caches of food, forage, and clothing waited for them in the distance.

For a century Americans have with fine impartiality fought and refought the bloody battles of the Civil War, relishing their every detail, savoring the valor of brave men and the ignominy of incompetents or cowards. In the end, however, victory came for reasons that had little to do with glory or valor. The North won a war of attrition. There was nothing noble or glamorous about it, and precious little that could be passed down as the stirring tales and great deeds of heroes. But that was the way with this new version of the biggest battalions, in which clerks and quartermasters, engineers and mechanics, managers and bureaucrats fought in their own manner as hard as soldiers. They did not wear uniforms or march to the martial airs of bands or gather around campfires or thrill to the smoke and din of battle. All they did was win.

Top left: Poor as the South was in industry at war's outset, that condition was made even worse by the fact that so much of the region's industrial capacity was concentrated in relatively few areas — particularly Richmond, Virginia. Manchester, across the James River from Richmond, boasted several factories. (LC)

Top right: Like Haxall & Crenshaw's establishment, they were chiefly flour mills, dependent upon the river both for water power and for transportation of raw materials via the James River Canal. One of its locks is just visible in the foreground. (LC)

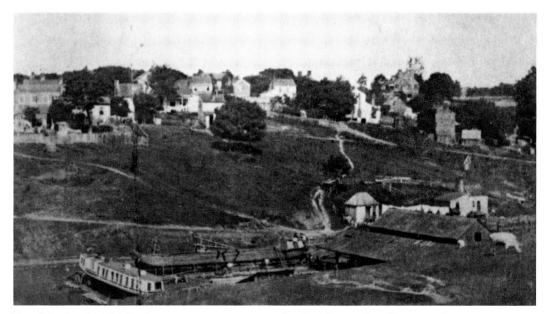

For shipping itself, whether in peace or wartime, the South was also ill prepared, with only a handful of shipyards — such as the one here, also in Richmond. Philadelphia photographers Levy & Cohen made this image in April 1865, showing two canal boats still under construction. (LCP)

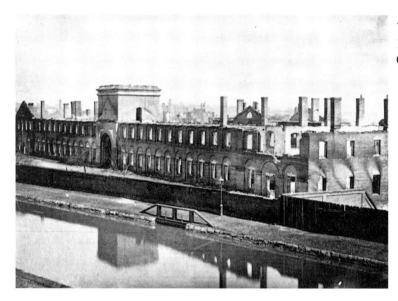

The Virginia State Arsenal, in ruins in this 1865 image, also made Richmond a center of Confederate arms manufacture, . . . (LC)

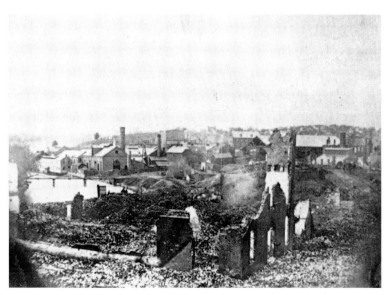

. . . just as the Tredegar Iron Works, the Confederacy's only major foundry capable of casting cannons and ship's armor, helped make the city an object of Federal desire. Capturing Richmond would put an end to a major share of the South's industrial war effort. (VM)

From the arsenal and Tredegar poured a steady stream of guns, solid shot, shell, ordnance, and ammunition of every description. (LC)

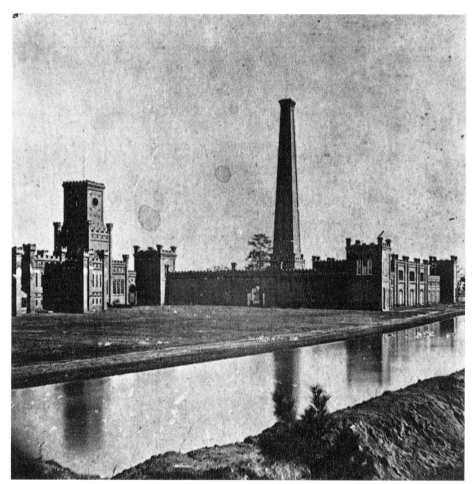

Manufacture for the Confederate armies did take place elsewhere, thanks in large part to the ingenuity of men like Col. George Washington Rains. It was he who designed and operated . . . (ARCM)

. . . the Augusta (Georgia) Powder Works. Despite hardship and shortage, its output of high-grade powder for Rebel armies was prodigious, a credit to what hard work and innovation could accomplish. (LC)

But some of the South's manufacturing was scattered in little cities and towns like Macon, Georgia, far enough from danger to protect it from strong Federal threat, but at the same time too small in output to be really significant in meeting Confederate needs. (GDAH)

Schofield's Iron Works in Macon was just two years old when war broke out. (HP)

Still, its small steam engine . . . (HP)

. . . and its larger one were turned to Rebel ordnance needs when the fighting came. (HP)

Beyond the heavy manufacturing, much of what was produced in the South came from the hands of its women, whose fingers and needles had to provide the clothing, flags, and bandages that the factories could not, and whose labor had to till the fields of the men who were away in uniform. A Timothy O'Sullivan image of Southern women on the Cedar Mountain, Virginia, battlefield in 1862. (LC)

The South was still a horse-and-buggy region — or, as here, an ox-and-cart one. Cameramen Armistead & White of Corinth, Mississippi, photographed this Southern civilian hauling slab wood in Federally occupied Corinth. (CHS)

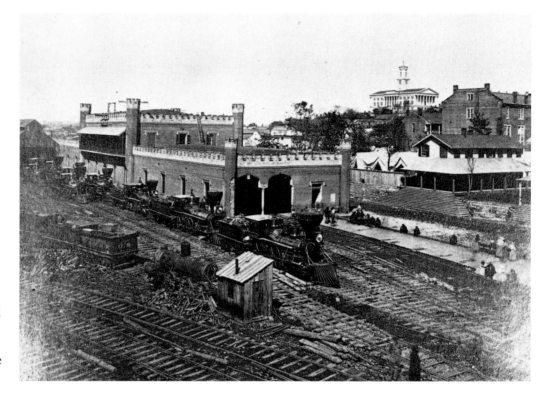

It was an even greater misfortune for the Confederacy that so much of its industrial capability lay directly in the path of the Yankee armies. Southern railroads, inferior in quality and mileage at the outset, suffered further setbacks with the fall of Nashville. The Chattanooga depot appears in the foreground, with the Tennessee State House in the distance. (LC)

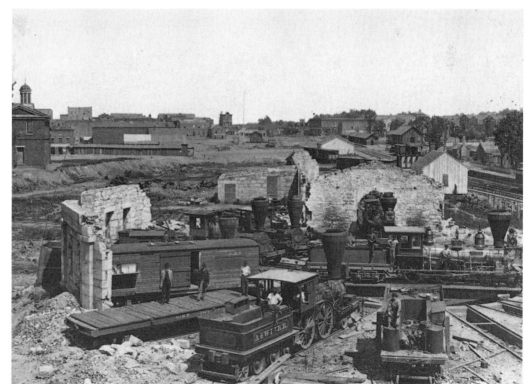

An even greater blow came with the fall of Atlanta, the Confederacy's major rail interchange. Here George Barnard photographed the ruins of the roundhouse used by the Georgia Railroad and by the Atlanta & West Point Railroad. The loss of its already worn rolling stock, and the cutting of its rail lines, made it increasingly impossible for the South to get its meager produce and manufactures to the armies that needed them. (NA)

This tiny little four-wheeled fire engine, photographed in Richmond at war's end, almost symbolizes the crushing inability of the Confederacy's resources to extinguish the Northern conflagration that ravaged the South. (LC)

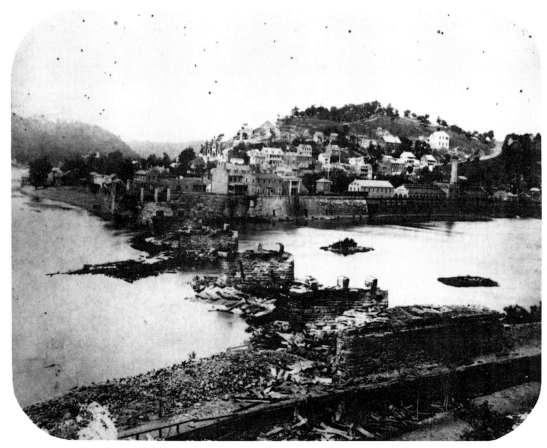

By contrast, even though unprepared for war when it came, the North had all the pieces in place to wage a victorious effort. Its factories were spread all over the nation, as here at the Harpers Ferry Armory, just across the river at right. (LC)

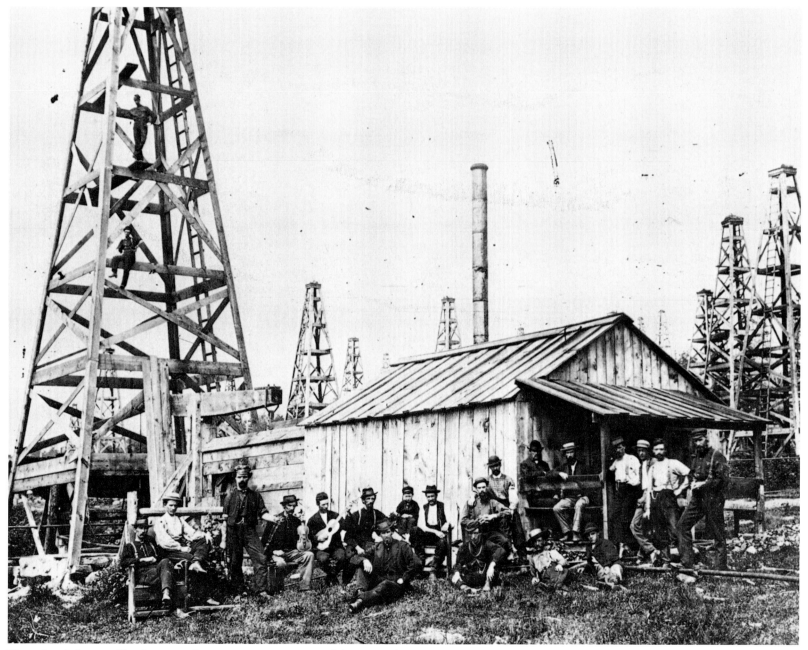

The oil to lubricate Northern machinery was coming out of the ground in
Pennsylvania, with a whole new industry burgeoning just as the war commenced. (DWM)

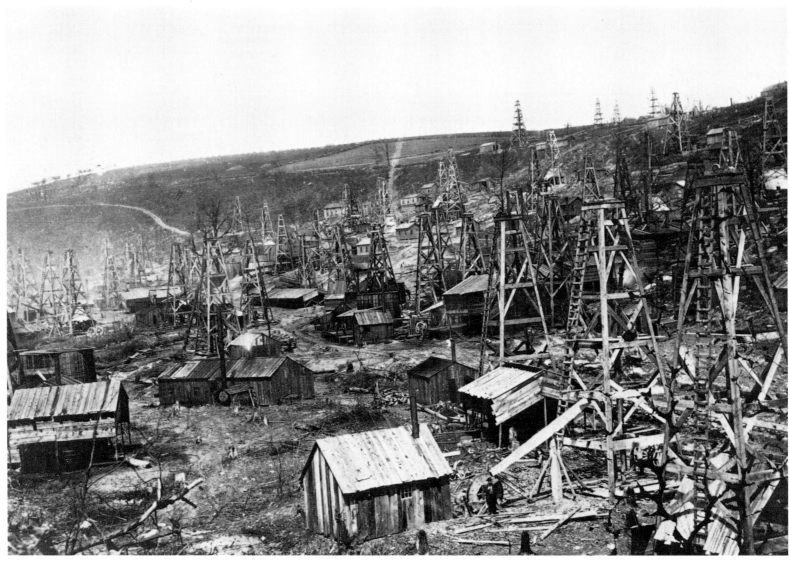

New fortunes were about to be made, even as the Union was caught up in the greatest test it ever faced. (DWM)

And to keep the furnaces supplied with iron ore, mines from Michigan to New England poured forth a constant flow of mineral. Out of earth like this in the Jackson Mine in northern Michigan came rifles and buttons, cannons, stirrups, and every manner of hardware that mind could conceive or soldier could need. (MDSSA)

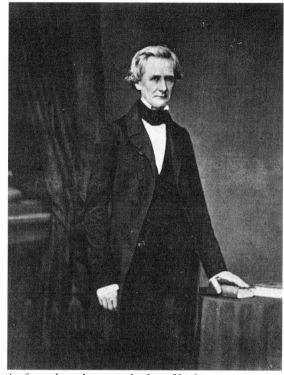

At first, though, even the best Yankee potential was no better than the men responsible for directing the war effort, and Simon Cameron of Pennsylvania, Lincoln's first secretary of war, was not the man for the job. Only with his departure did the mobilizing and marshaling of the Northern resources and organization begin to tell. (USAMHI)

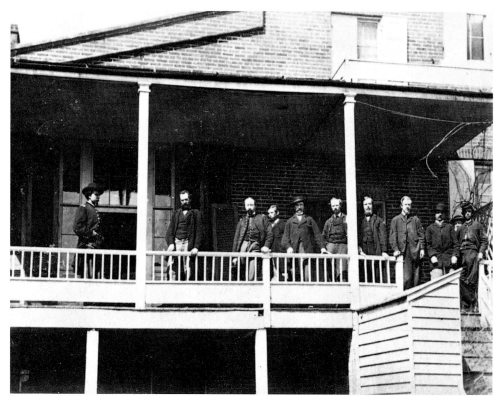

In communications, so vital in this first really mobile and virtually continental war, Washington enjoyed preeminence from the outset. From Signal Corps headquarters here in Washington, and from several other places, a constant flow of information was available daily from the far-flung Union armies. (USAMHI)

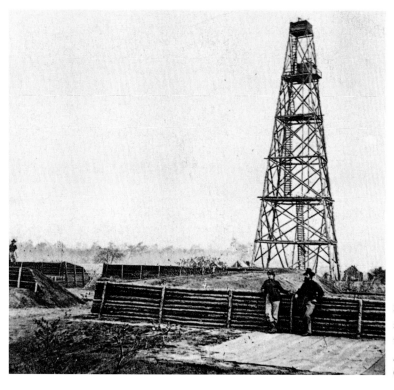

Some of that information was gathered right at the front by men atop signal observation towers like this one on Cobb's Hill on the Appomattox River, outside Petersburg. (USAMHI)

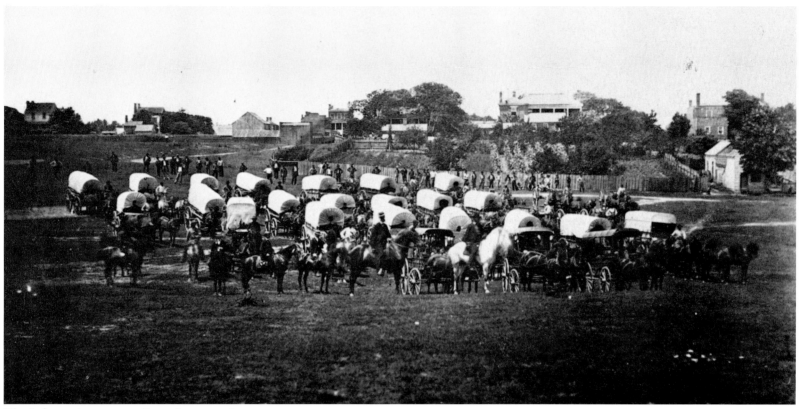

The information, once collected, was sped back to the rear, no matter where the Yankee armies went, thanks to the work of the Military Telegraph Corps. Many of its men and wagons pose here outside Richmond in June 1865, their task finished. (USAMHI)

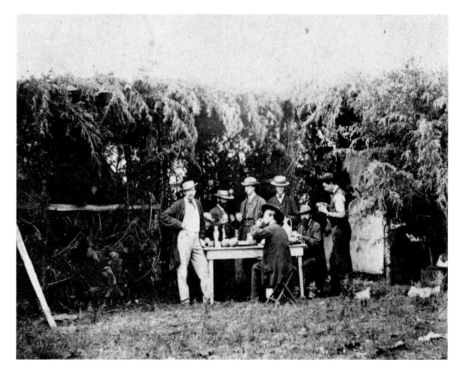

They established their camps right at the front and stayed with the armies. Most of the time telegraphers like these at Bealton, Virginia, in August 1863, had more to do than lounge and feast. (USAMHI)

Their lines stretched everywhere. Here the wire comes down out of the wood at the right, near Lookout Mountain, not far from Chattanooga. (USAMHI)

In Virginia, where the wire is supported by a hastily erected pole, staff officers gather at a church to discuss the latest information. (USAMHI)

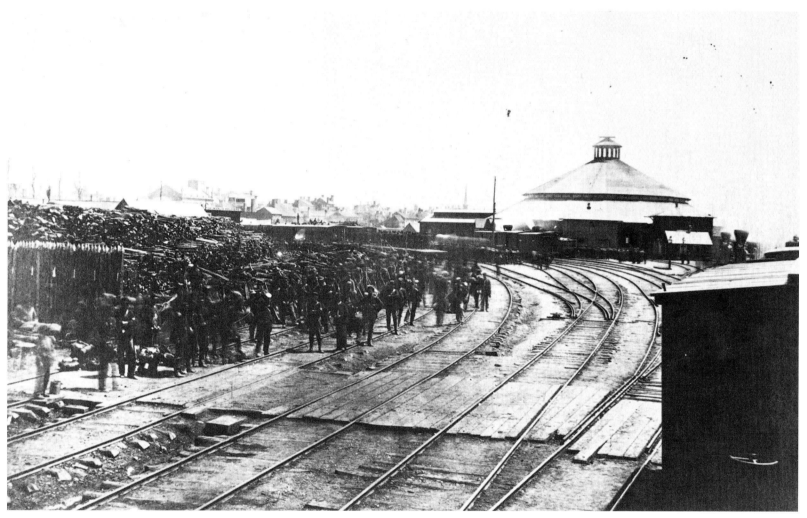

The Union stood just as unchallenged in its transportation capabilities. The great roundhouse and depot at Alexandria, Virginia, across the Potomac from Washington, was one of scores of major rail installations. In this image by Capt. A. J. Russell, the Union's only official army photographer, hundreds of soldiers stand in the distance, perhaps awaiting transportation, while rolling stock and firewood everywhere attest to the Union's rail strength. (USAMHI)

Even when the Confederates managed to reach and tear up sections of Yankee track, the interruptions in rail traffic were brief. Here workers repair a part of the Orange & Alexandria Railroad near Catlett's Station, Virginia. (USAMHI)

Ingenious railroadmen devised speedy ways to restore damaged track, like this brace supporting a broken rail. It was much quicker than laying new track. (NA)

The tracks were a lifeline for the Union war effort, and nothing received greater care and tending. (USAMHI)

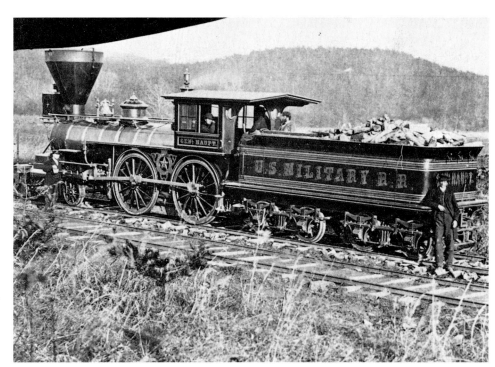

New rolling stock and engines moved from the Atlantic to the Mississippi — among them this engine, a tribute to Gen. Herman Haupt, chief of construction of the U.S. Military Railroad, the man responsible for many of the wonders achieved. (USAMHI)

Honored, too, was Col. Daniel C. McCallum, director of the Union's military railroads. Despite this tender's illustration, McCallum's rank as a general was only informal. (USAMHI)

As they moved into Confederate territory, McCallum's and Haupt's legions quickly appropriated remaining Rebel rails. J. D. Heywood, photographer of New Bern, made this image of a "conductor's car" on the nearby Atlantic & North Carolina Railroad. But it was an engine of the United States Military Railroad that pulled it now. (USAMHI)

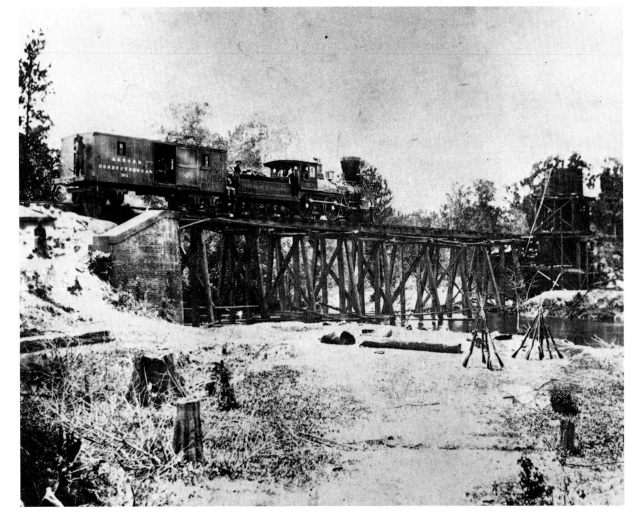

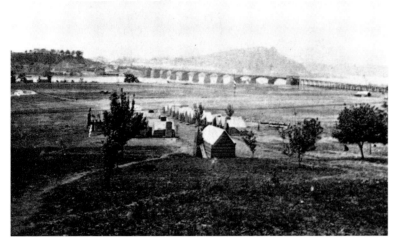

The feats Haupt's bridge builders could achieve staggered the imagination. Here at Chattanooga, the conquering Federals had found only the remaining stone piers of a burned bridge across the Tennessee River. The men who lived in the camp in the foreground rebuilt it in record time. (USAMHI)

They could build a simple trestle to carry newly laid line across a gully. (USAMHI)

Or they could rebuild a destroyed six-hundred-foot bridge, like this one over the Etowah in Georgia constructed during Sherman's Atlanta campaign. (USAMHI)

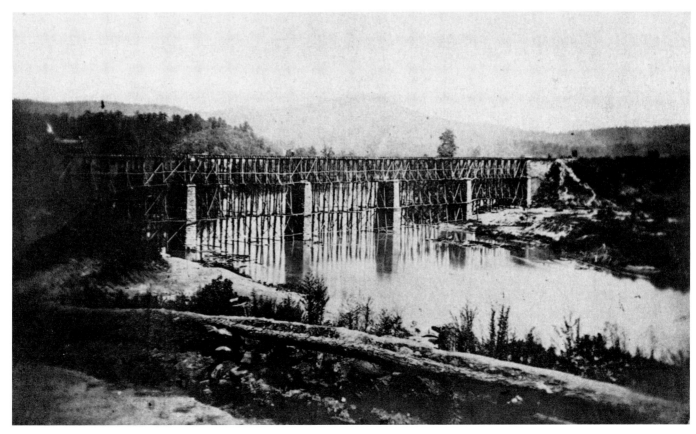

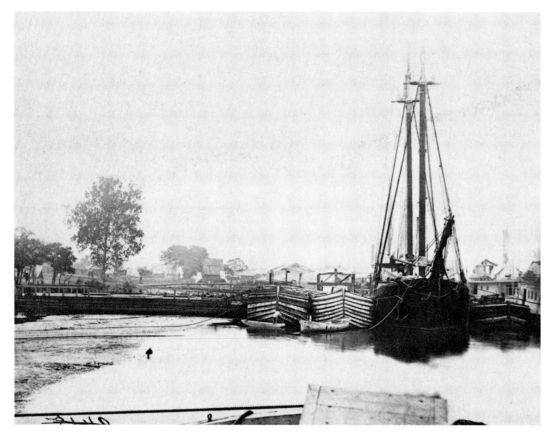

The story was the same with shipping. Wherever Lincoln's armies went, they commanded the rivers and the seas, and used them to keep a steady flow of supplies coming to Union quartermasters. Supply bases like this one at White House Landing on Virginia's Pamunkey River sprouted the moment soldier and sailor could forge a link between each other. (USAMHI)

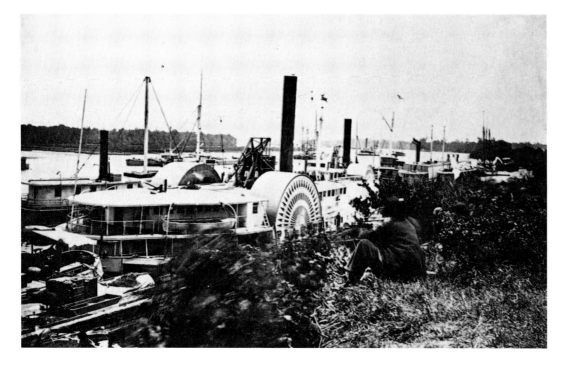

Once forged, that link was strengthened with unending traffic. Here the Pamunkey teems with supply and transport vessels in 1864. (USAMHI)

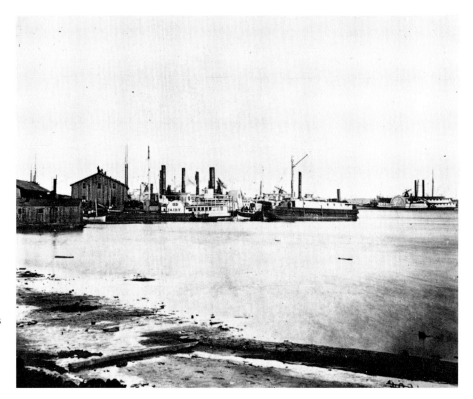

The year before, the Army of the Potomac's supply base had been here at Aquia Creek Landing, where every kind of vessel was pressed into service, from tugboats to scows to river packets. (USAMHI)

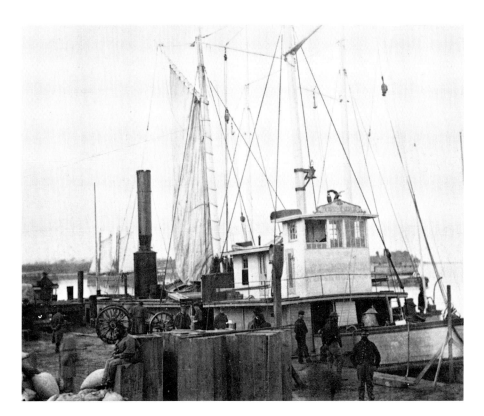

Steam vessels augmented with sails even plied the rivers. (USAMHI)

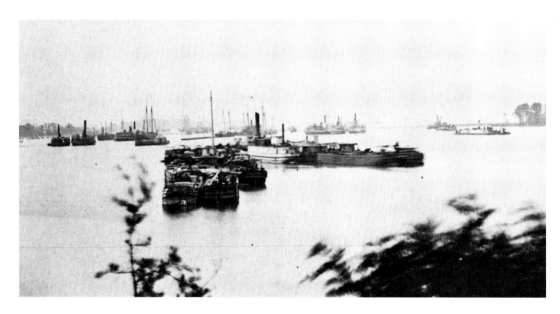

Whatever their source of power, the ships brought with them an endless line of barges and other small craft, each one crammed with munitions or food, or both. Here the James River in 1864 teems with traffic of every description. At far right, the captured Confederate ironclad *Atlanta*, with its distinctive sloping sides, patrols the stream. (USAMHI)

Sailing vessels like these schooners even helped when at anchor — as here, where they provide stability for a long pontoon bridge over the James at Weyanoke Point. (USAMHI)

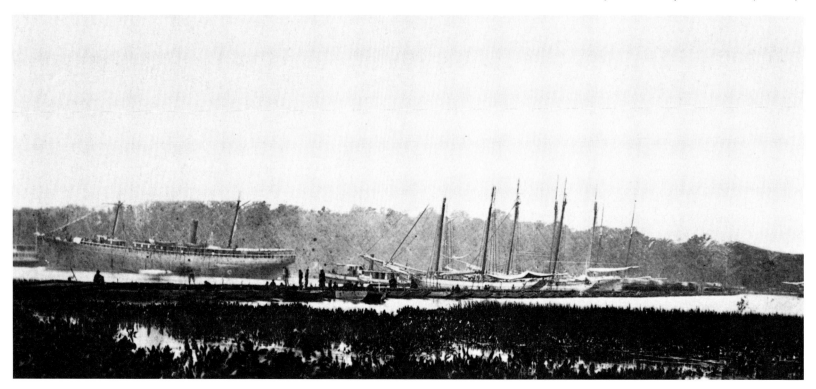

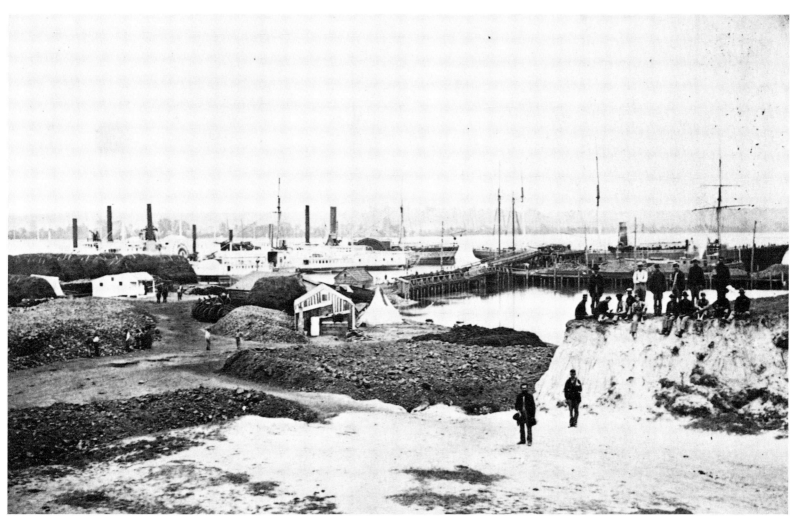

Powering most of these Yankee ships was coal, consumed in unfathomable quantities, and shipped to several major supply bases like the government coal wharf here at Alexandria. The produce of Pennsylvania's coalfields sent warships and supplies everywhere that water could take them. (USAMHI)

The men themselves, soldiers numbering in the tens of thousands, went to war aboard great transports like the *Thorne* (at left) and the *Prometheus*, photographed here on June 28, 1864. (USAMHI)

Here in the same slip, on June 16, had berthed *El Cid*. In the constant traffic, ships did not stay put for long. (USAMHI)

The greatest water-fed supply base of all, however, was Grant's at City Point, so vital in his months-long siege of Petersburg. More men, matériel, munitions, and foodstuffs passed through here than through any previous supply base in military history. (USAMHI)

Responsible for getting the right things to the right people at the right place were the army quartermasters, based in Washington, with offices spread all over the country, as here in Alexandria. (USAMHI)

From those main offices, the supplies went to the quartermaster's offices with the armies. The quartermaster's department of the Army of the Potomac at Aquia Creek Landing, shown here in February 1863, controlled the flow of matériel to Gen. Joseph Hooker as he prepared for his Chancellorsville campaign in May. (USAMHI)

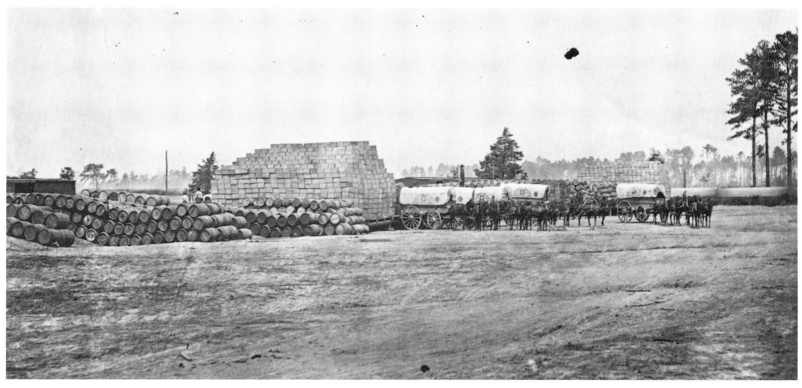

The quartermasters could build virtual mountains. Commissary wagons of the Federal V Corps receive boxes and barrels of bread and pickled meat brought to them by rail from the supply base. (LC)

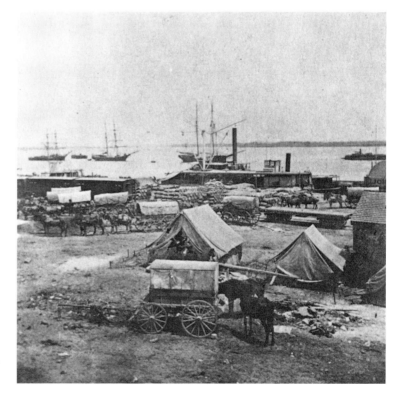

Emptied of their loads, the boxcars and flatcars returned to the base for another burden in a ceaseless dance between supply base and soldiers. (USAMHI)

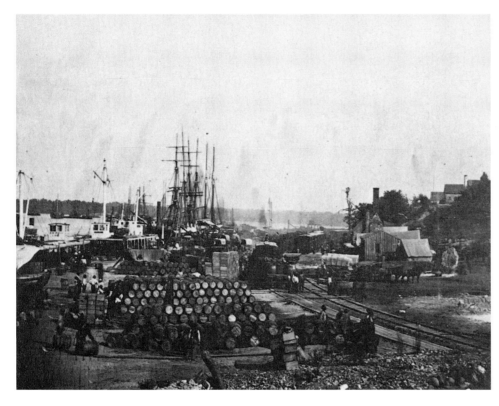

At bases like City Point there was little or no sleep, it seemed. The ships and trains, wagons, boxcars, barrels, and crates moved night and day. In July 1864, when this image was made, Grant was just beginning the enormous buildup that would choke Petersburg in a ten-month siege. (USAMHI)

Any building with sufficient space to be useful was pressed into service to house commissary stores, like this one at Aiken's Landing on the James, shown in January 1865. (USAMHI)

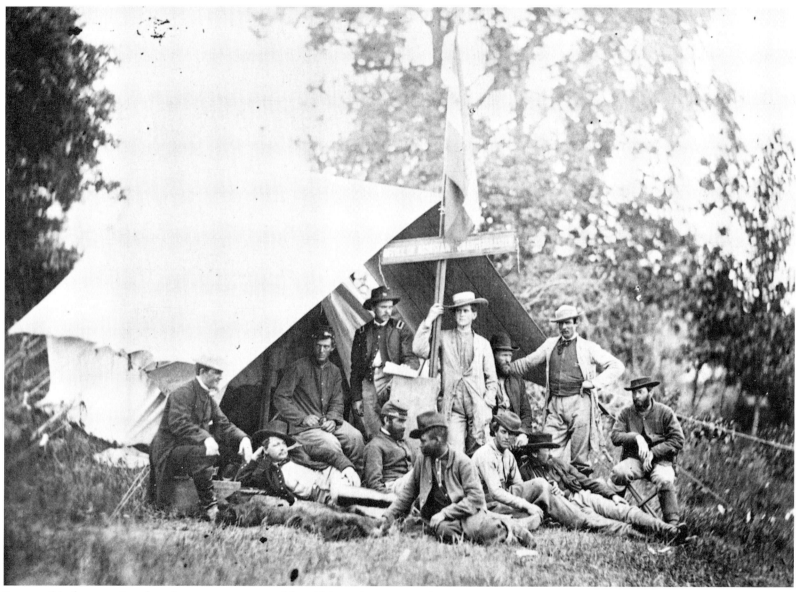

Responsible for ensuring that the system ran smoothly within each army was the office of the assistant quartermaster. Hooker's appears here at Fairfax Court House, Virginia, in June 1863. (USAMHI)

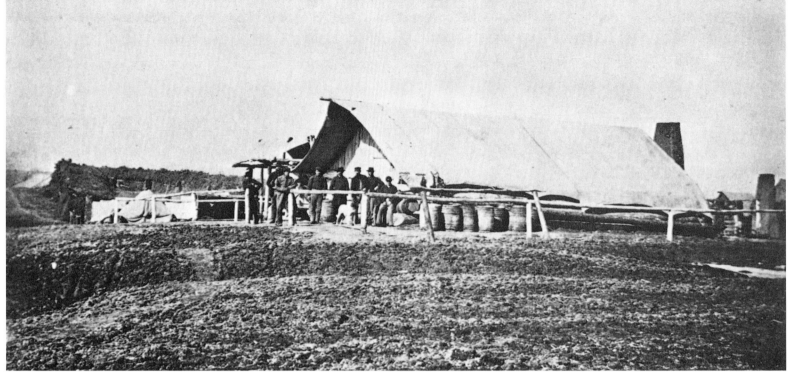

The supplies flowed from that office to a host of smaller depots. The artillery brigade of the VI Corps, Army of the Potomac, had its own commissary storehouse. (USAMHI)

Beef cattle moved in herds wherever the men went, and if men went where animals could not follow, the beeves were slaughtered and their meat "pickled" and packed in barrels for shipment. The process had its flaws, leading the soldiers to refer to the smelly stuff in the barrels as "blue beef." (USAMHI)

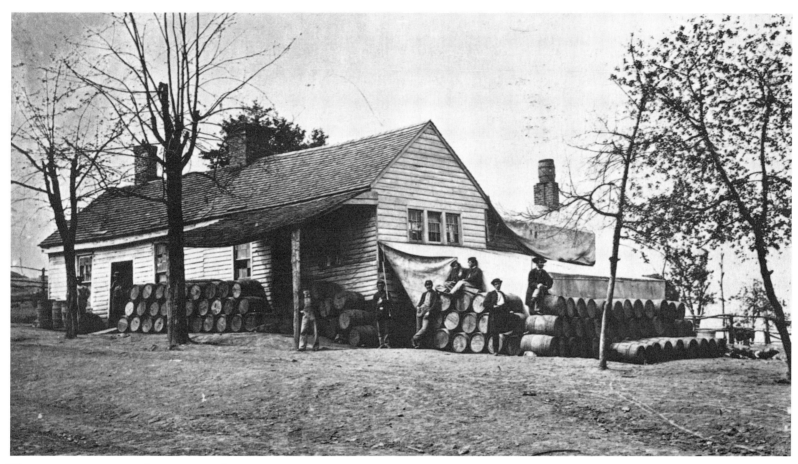

There were commissary depots out in Georgia with Sherman, on Rocky Face Ridge. (USAMHI)

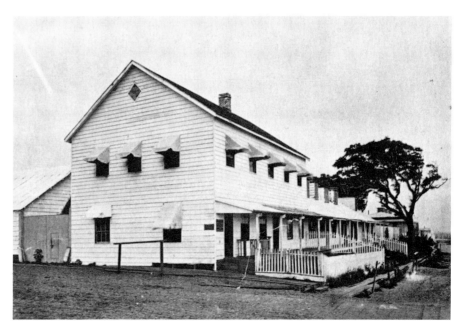

And there were more lush commissary offices on Hilton Head Island, South Carolina, shown here in September 1864 by the camera of Samuel Cooley. (USAMHI)

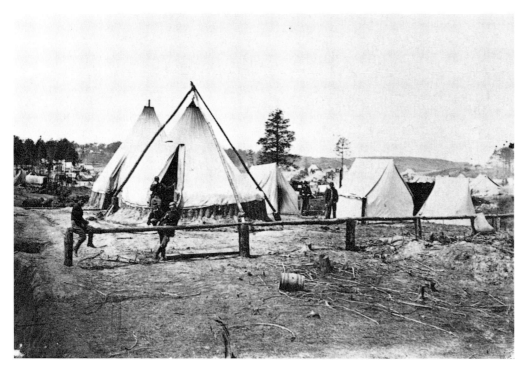

There was a modest, tented depot at Stoneman's Station, in Virginia . . . (USAMHI)

. . . and a major base at Brandy Station near the Rappahannock, photographed in 1863 by the Bostwick Brothers. (VM)

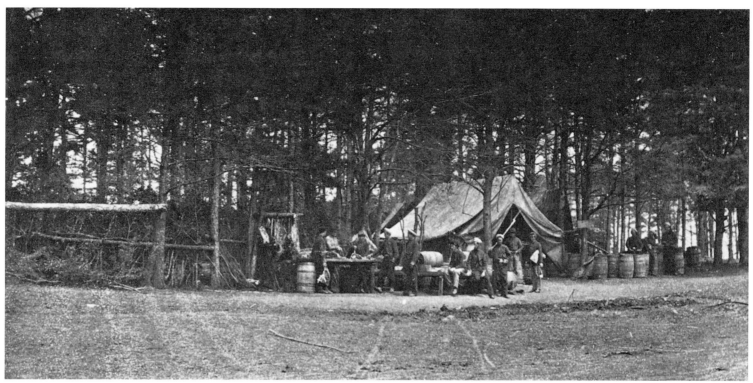

Wherever the supply bases and commissary depots were located, they all led to this: the butchers cutting the meat and soldiers doling out the bread and rations to the men in the field. Considering its time and place, the whole system worked magnificently, playing no small part in the defeat of the Confederacy. A commissary depot with the Army of the Potomac in April 1864. (LC)

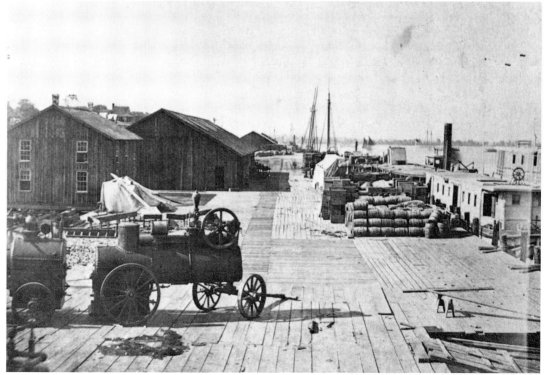

Whatever could be used to help win a war, the Yankee warmakers in Washington shipped to their armies. A. J. Russell's image of the City Point depot and quartermaster's buildings barely hints at the variety. (USAMHI)

Ordnance storehouses and armorer's shops like these on Hilton Head supplied and maintained the cannons that reduced Rebel forts into submission. (USAMHI)

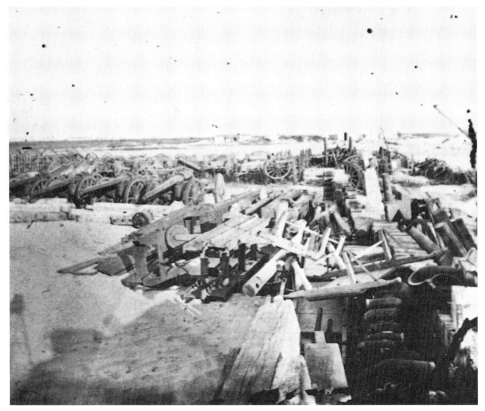

Ordnance yards like this one on Hilton Head stored uncountable cannons and carriages, parts of guns, ammunition, and more. (USAMHI)

Samuel Cooley's camera caught much of the picture of Union might on Hilton Head, not by photographing Yankee soldiers, but by focusing upon what was sent for them to use. (USAMHI)

Lincoln's cavalrymen were supplied the best horses that his Cavalry Bureau could find as it tread a difficult path between dishonest contractors who sold unsound mounts and corrupt officials in the bureau itself who tried to profit at the troopers' expense. These government stables in Chattanooga gave the Union's steeds the best care that horses at war could hope to receive. (USAMHI)

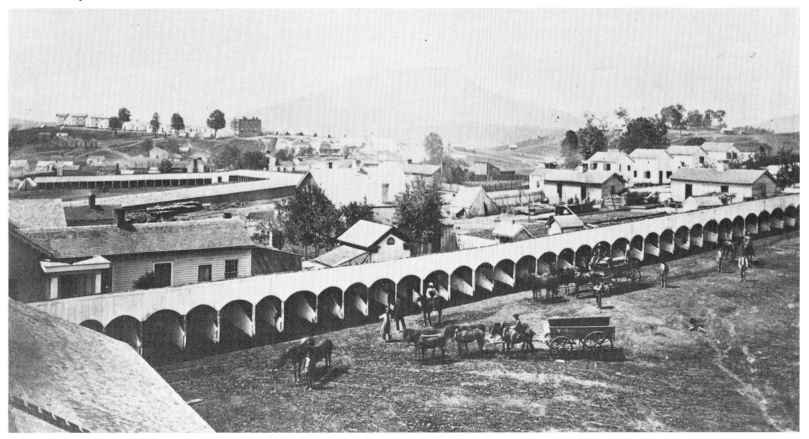

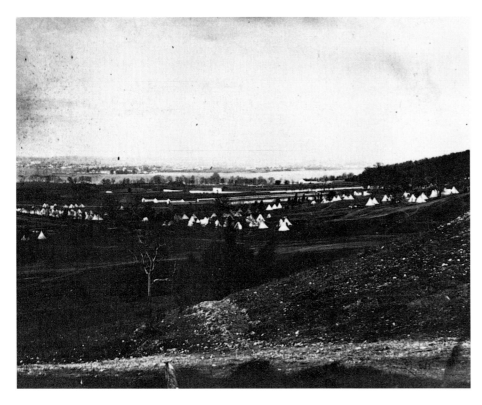

Here at Giesboro Point on the Potomac, with Washington in the background, stood the largest cavalry depot in the nation. (USAMHI)

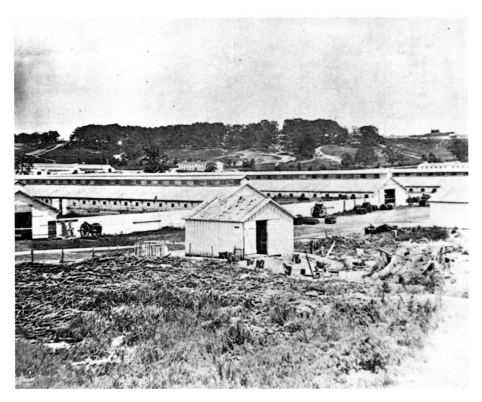

Its stables sent thousands of mounts out to the cavalrymen in the field. (USAMHI)

A modern army had to be able to maintain itself when it put into the field, and the ever-industrious Yankees brought their own forges and repair facilities with them, as here at City Point. (USAMHI)

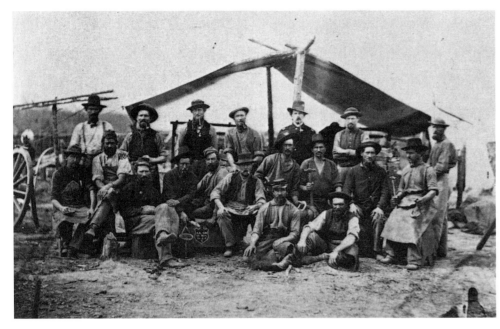

These mechanics attached to the First Division of the IX Corps were prepared to repair whatever needed mending. (USAMHI)

Mostly they worked to keep the army vehicles rolling. At government repair shops like these on the Franklin Pike, outside Nashville, worn-out wagons, broken wheels, and more awaited their turn under the hammers of men who forged victory with tools other than rifle and bayonet. (USAMHI)

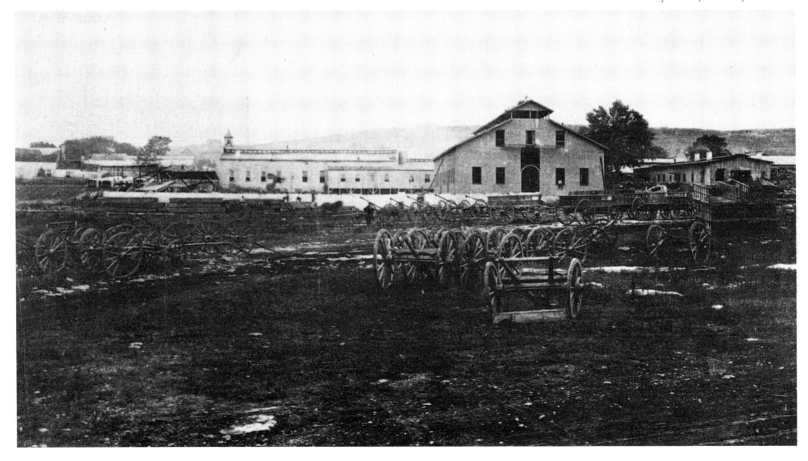

Yankee ingenuity extended even to "making" water. Here at Beaufort, South
Carolina, a saltwater condenser next to the coal dock separated salt from seawater.
The result was relatively pure water, and salt vital for preserving meat. (USAMHI)

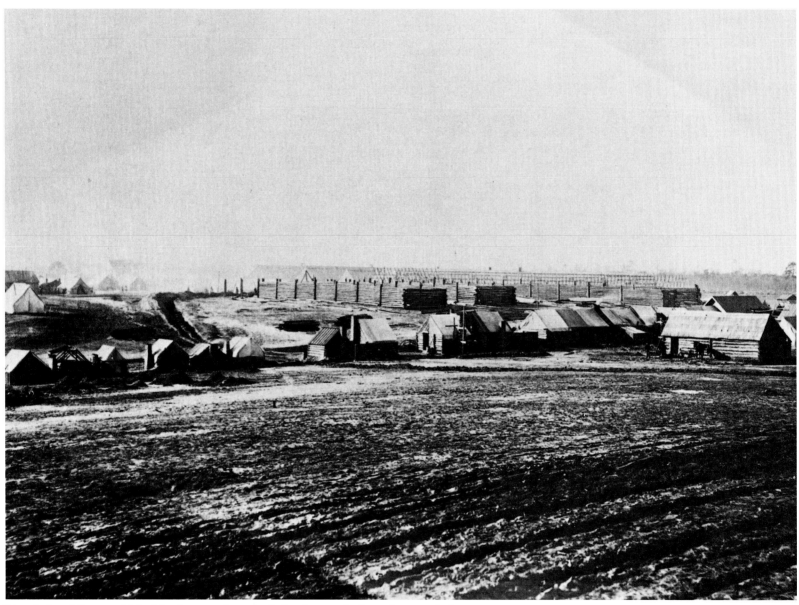

Lincoln's soldiers could build whatever they needed, when and where they needed it. When they required a hospital, they built one, like this mammoth general hospital going up near Bermuda Hundred, Virginia, in 1864. (USAMHI)

As many amenities of home life as possible were provided. Mail from loved ones, so important in maintaining morale, came right to the front, thanks to the military post office. This outpost at Brandy Station, Virginia, photographed in April 1864, often could have a letter in a soldier's hands less than a week after it was mailed from home. (USAMHI)

The men who kept the armies going worked out of tents and sheds when they had to, and occupied better quarters when they could. No sooner did Confederates evacuate a city or town than the bureaus that supplied the Yankee armies moved in. The post office in Petersburg was quickly turned into a quartermaster's office within days after Lee's army departed. The Union juggernaut, so well fed, so well prepared, so well supplied, seemed unstoppable. (USAMHI)

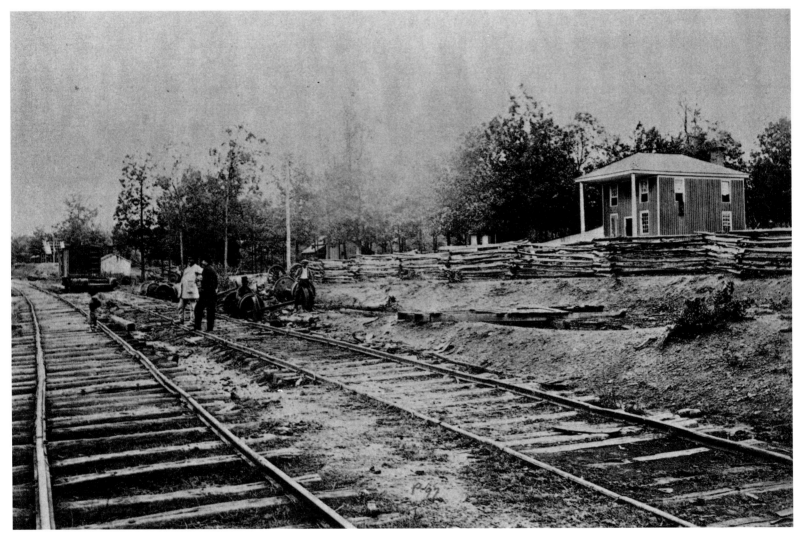

For the Confederacy, alas, it was nothing but the opposite—as symbolized so well by this modest little place, Appomattox Station, Virginia. Lee and his army, abandoning Petersburg, desperately needed more supplies if they were to have a hope of continuing in the field. They were to find them here. But Union interference, dilapidated Rebel railroads, and shortages in supplies all conspired against Lee. When he reached this place, there was nothing awaiting him. The general still had an army, but with nothing left to feed that once magnificent machine, there was no place it could go, nothing it could do. (LC)

Camp Nelson

Mr. Lincoln's Microcosm

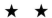

A portfolio of a Yankee installation in occupied
Kentucky that reflected the myriad undertakings that
kept the Union armies ascendant in the field

Boone's Knob on the Kentucky River overlooked parts of the area that Lincoln's soldiers turned into only one of scores of behind-the-lines installations designed to sustain the war effort; hold, occupy, and maintain the peace in a portion of the reclaimed South; and exist as much by self-sustenance as possible. (NA)

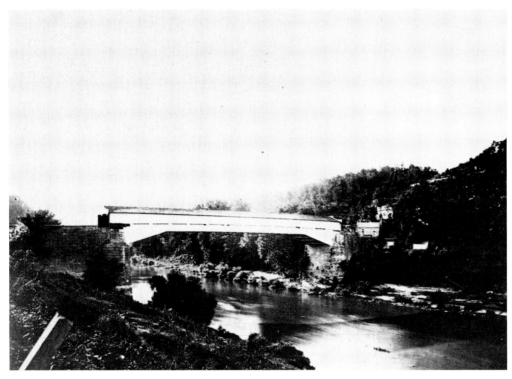

It was a scenic area, far removed from the war front, and virtually unvisited by the conflict after 1862. The anonymous photographer who made these images could indulge himself in a bit of scenery like the Hickman Bridge over the Kentucky not far from Camp Nelson. (NA)

But it was the camp itself that attracted his chief interest. For the officers in command, the post headquarters was a far cry from the kinds of headquarters inhabited by most of the generals in the field. Grant and Lee lived most of the war in tents. The commander here had a roof—and a cupola—over his head, porches for the sultry summer evenings, and a small pond surrounded by a white gravel walk. (NA)

Top left: There was always fresh water, thanks to the nearby Kentucky. Water pipes ran up the bluff from the river. (NA)

Top right: Steam-powered pumps in the engine house sent tons of water up the steep hillside to . . . (NA)

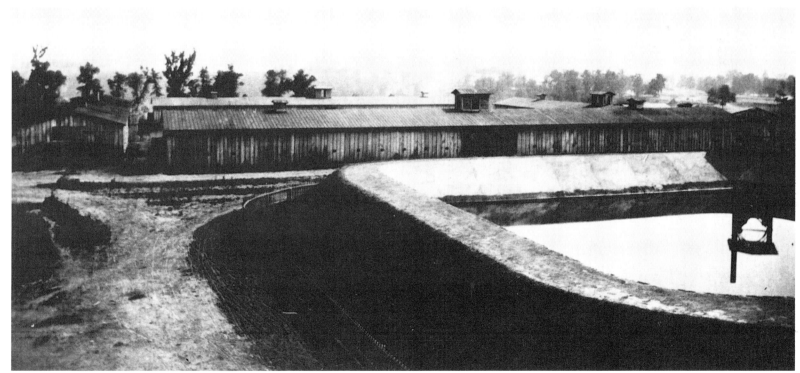

. . . the camp reservoir on top. (NA)

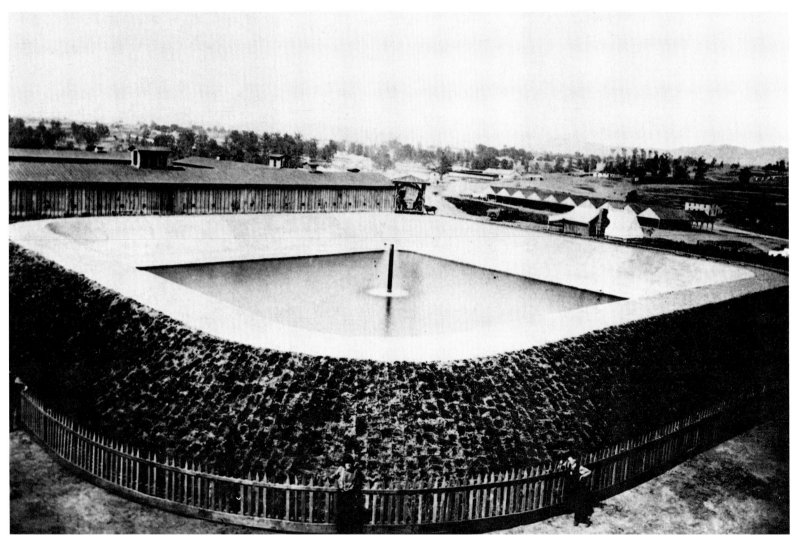

The water was aerated in a primitive way, and officers could enjoy the view from the little gazebo inside the reservoir's picket-fence enclosure. (NA)

Not far away stood the Ordnance Office, constant reminder that this peaceful post was a part of a war. (NA)

If that were not enough, the array of cannons at the Ordnance Depot recalled well enough why everyone was here. Yet it is an odd mix of pieces in the yard—a couple of napoleons, a couple of ordnance rifles, and, second from the left, an old prewar smoothbore gun with handles, probably a veteran of the Mexican War. Equipping Camp Nelson with the most up-to-date ordnance was obviously not a high priority. (NA)

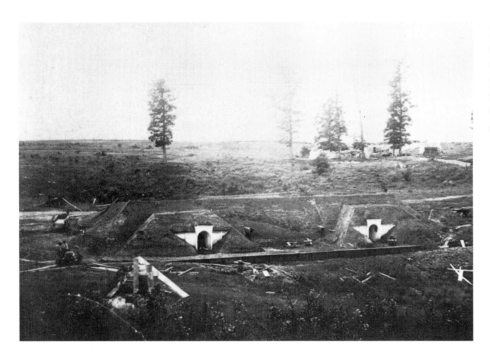

But regardless of the vintage of its artillery, the guns had to have ammunition, and that called for a magazine for safe storage of powder and shell. Few field installations could boast of so fine a magazine, complete with wooden conduits emerging from the earth to provide interior ventilation. (NA)

Armaments were incidental to Camp Nelson's greater purpose: construction and maintenance of the vehicles that were so vital to the armies. The engineers required lived in these quarters. (NA)

And these are the shops where the engineers and mechanics worked. Every imaginable sort of activity is going on here. Planking for the wagons abounds. Iron stock, either for hoops for the wagon tops or perhaps to be turned into wheel "tires," stands stacked in abundance. (NA)

Farriers bend over horses' hooves; blacksmiths toil at anvils, shaping the shoes. (NA)

Horses awaiting their turn stand before the workshops. (NA)

Nearby, the forage shops collected and prepared the grain and grass necessary to feed the hundreds of animals necessary for the camp's officers and vehicles. (NA)

The blacksmiths' shop did what was needed to bend iron to the needs of men. Everything of metal required to build one of the ambulances at left could be produced in this shop. (NA)

Not far away, the carpenters' shop could do the same for the wooden needs of wagons and soldiers alike. Its artisans pose proudly with the tools of their trade. (NA)

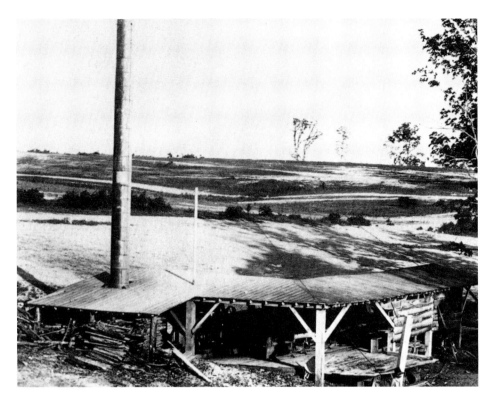

The carpenters could do what they did at Camp Nelson thanks largely to having their own steam-powered sawmill, which helped turn hundreds of trees into wagon boxes, carriage wheels, barracks, and more. (NA)

The machine shop, also steam-powered, could further refine the mill's raw planks, or machine with more precision the smithy's forged iron. (NA)

The wagon yard, not far off, was where the newly built or repaired vehicles were assembled and stored. (NA)

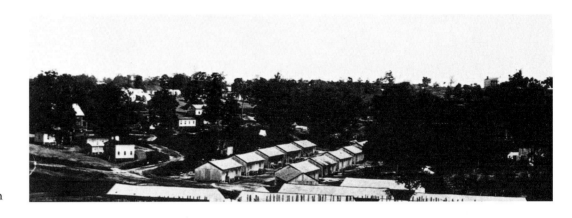

The ambulance yard was kept separate, with the ambulances parked in rows, some of them not yet finished. (NA)

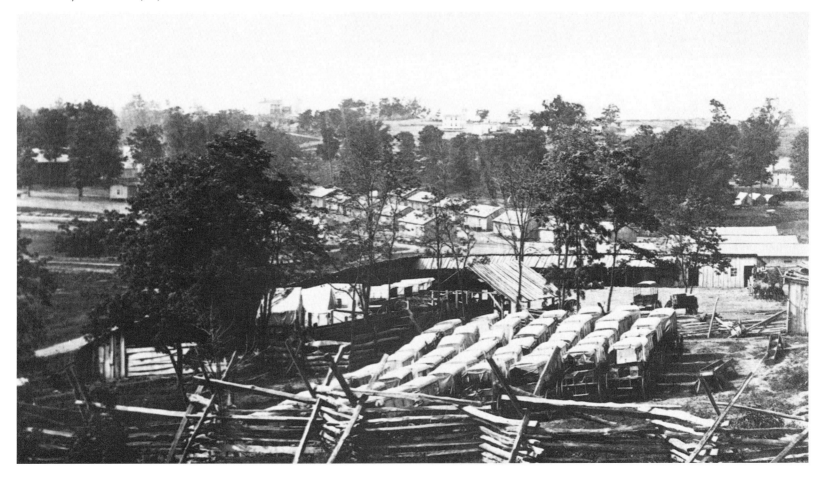

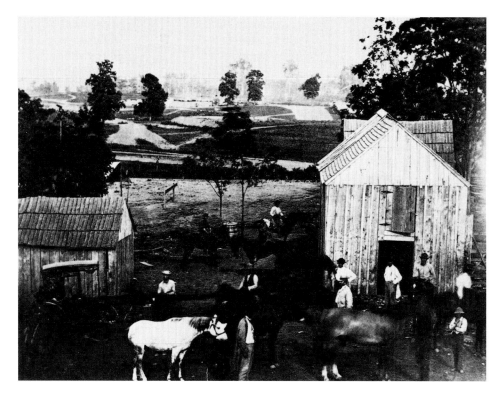

The inspection yard stood near some earthworks that never had to hear the sound of battle. Here government inspectors examined the horses being purchased by agents for use as cavalry mounts. (NA)

Those that passed the inspection, along with the hundreds of mules purchased for wagon teams, were penned here before shoeing and training. (NA)

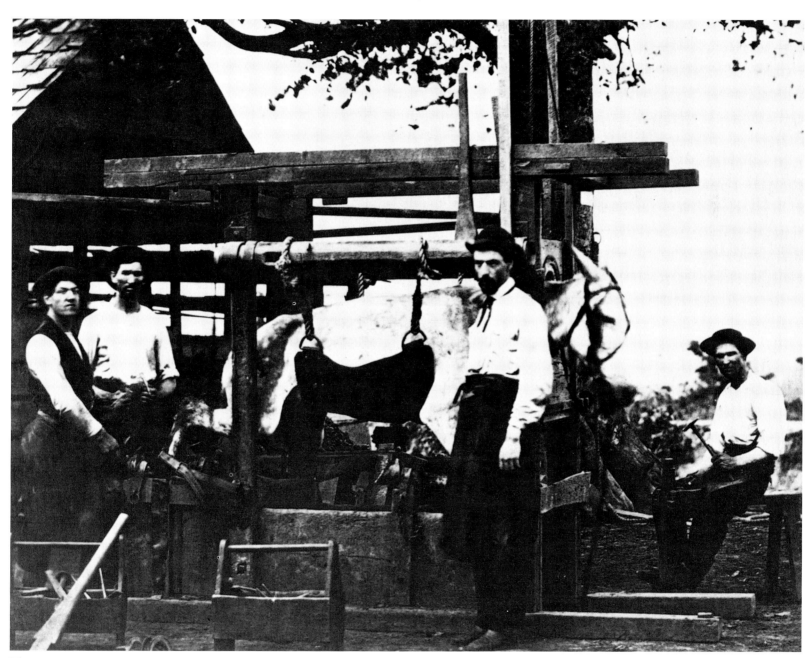

Their next stop was the mule chute. Its crude but effective apparatus was designed to keep a mule upright and off its feet so that all four hooves could be shod at once, reducing the time required for the operation by almost three-fourths. (NA)

All those animals required stables. The officers had a stable all their own for their mounts. (NA)

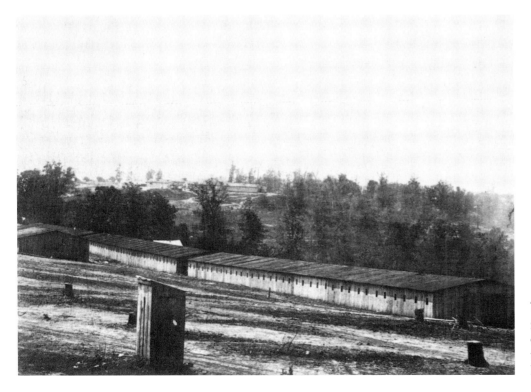

The enlisted men in the cavalry units garrisoned in or near the camp had their own separate stables. Cavalry mounts with the armies in the field enjoyed nothing at all like this luxury. (NA)

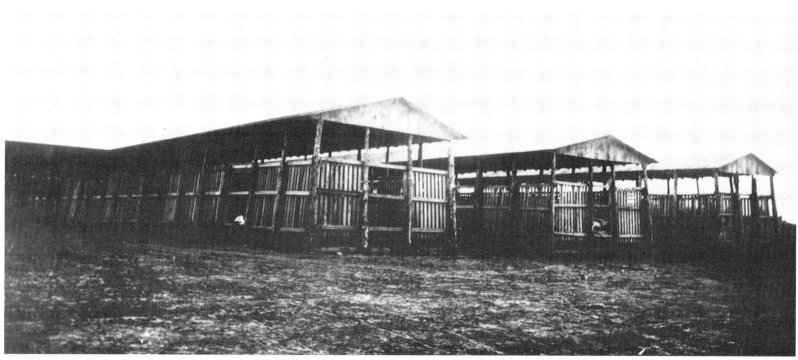

Grain sheds kept stored in the proper conditions the tons of sacked oats and corn needed to sustain the animals. (NA)

The sides of the large shed at center almost seem to bulge outward from its heavy burden, and it does appear that a good bit of grain lies scattered about the yard outside. (NA)

Of course, Camp Nelson had to have a garrison. Units varied through the war but, appropriately enough in this conflict, some of the soldiers were black troops, such as those shown here before their barracks. (NA)

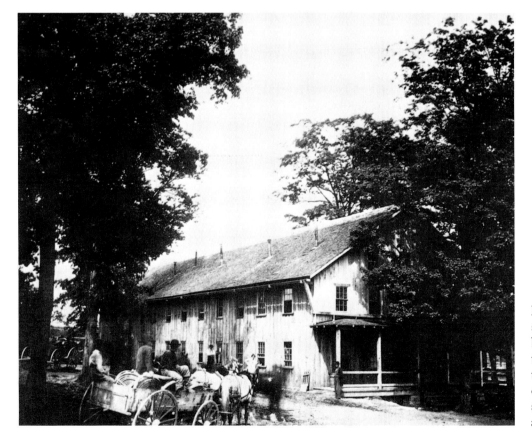

Having a garrison required all of the usual support services beyond the special functions being served at Camp Nelson. The office of the quartermaster and commissary saw to it that the men were fed and clothed. The canvas hoses in the wagon in the foreground suggest that protection against fire was another concern. (NA)

"Q.M. Stores Warehouse No. 1," in the foreground, and its nearby counterparts saw a constant traffic of supplies coming in and going out. (NA)

The men had to eat from those stores, and that called for mess houses like these used by civilian employees and artisans working in the camp. (NA)

No army could get by without bread. Camp Nelson made its own in the "U.S. Bakery," where the empty barrels at left attested to the quantity of flour and other ingredients used. (NA)

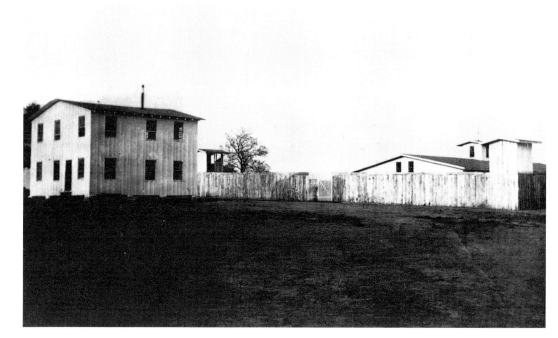

Since everywhere that men gathered in large numbers there were bound to be the unruly, a provost marshal's office was needed. It stands at left, and to the right, more sinister, stands the stockade for those who stepped beyond the military law. (NA)

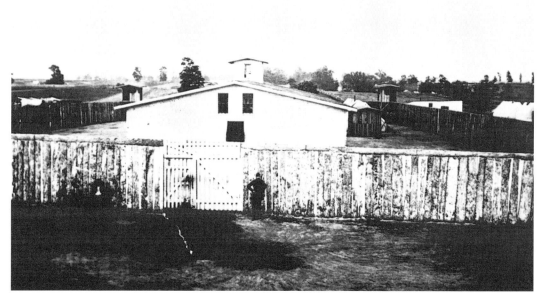

Inside that stockade stood the military prison—sturdily built, with as few windows as possible and surrounded by guard towers at every corner of the palisade. Alas, not every Billy Yank was a hero. (NA)

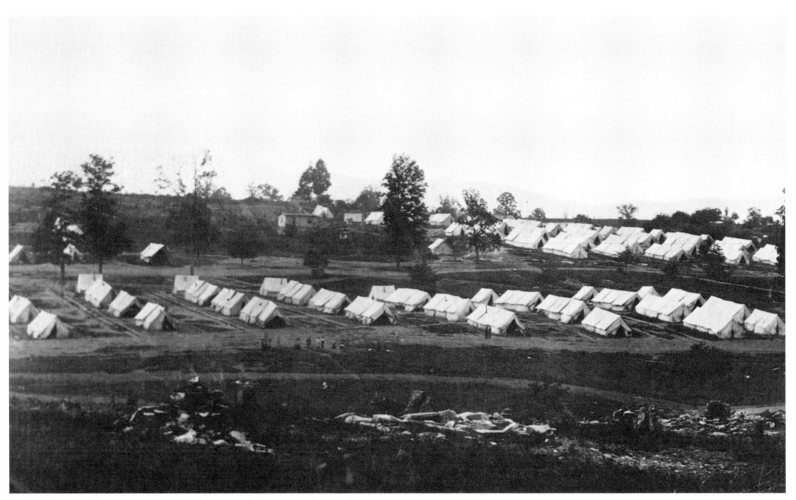

And wherever the armies went, sickness and disease followed. It was an age ignorant
of sanitation, an age when men had never been exposed to large groups of people
before. Camp Nelson's convalescent camp was a small city of tents filled with men
on the mend. (NA)

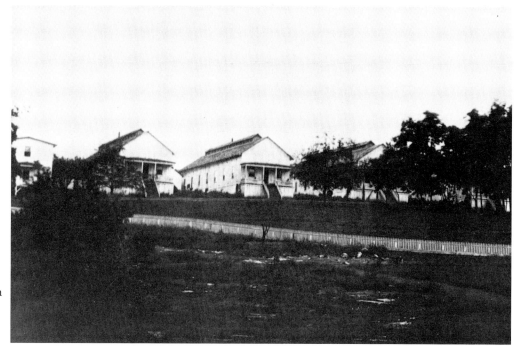

The more serious cases, including those with wounds from some of the western battlefields, inhabited the sturdier confines of the general hospital. (NA)

A special section was designated the "Eruptive Hospital," for those suffering with rashes and other skin maladies. (NA)

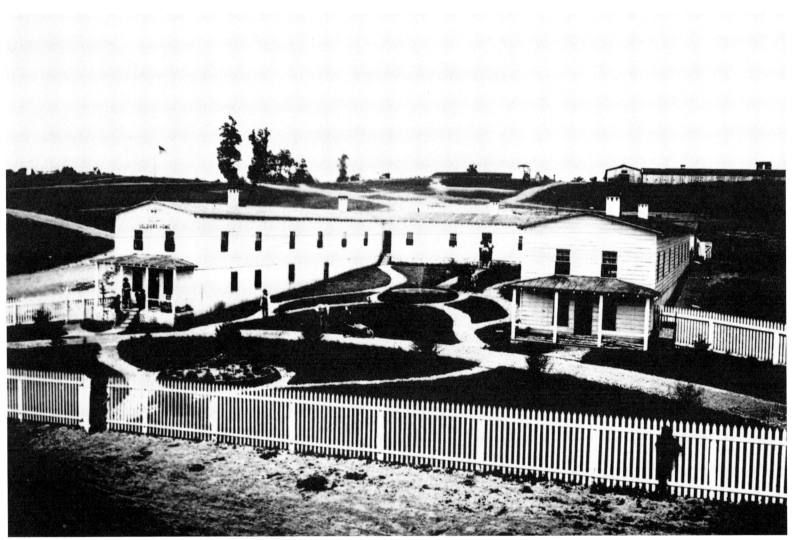

And for those whose active service was at an end, the invalid and infirm, Lincoln's Camp Nelson even provided the Soldiers' Home, "to care for him who shall have borne the battle." Camp Nelson was only one of many of its kind, yet it contained in small compass all the elements of the organization, the system, the industry and enterprise, that made the war machine of the Union invincible in the end. (NA)

Fire and Stone

★ ★

Robert K. Krick

Since an artillery piece fired the opening round of the Civil War in the direction of a fort, it is hardly surprising that so much of the war effort went into using artillery, on the one hand, and protecting against it with fortifications, on the other. That first shot in the early morning hours of April 12, 1861, was the signal for a concentrated bombardment of Fort Sumter in Charleston harbor. When the fort surrendered a day and a half later, it had been the target of about four thousand shot and shell. The delirious conquerors viewed the result as a stunning victory that validated the prowess of Southern arms. Few of the military men who witnessed the affair viewed it as a symptom of the changes afoot in both artillery and fortifications.

For decades before the war, the United States had been at work on a system of masonry fortifications that left the coastline speckled with forts of several standard patterns. Many army officers spent their antebellum careers building those forts; the rest spent their time manning them. R. E. Lee's service in the old army, for instance, included stints at work on construction of or improvements to Fort Pulaski near Savannah, Fort Carroll in Baltimore harbor, Fort Monroe in Virginia, and Fort Hamilton in New York harbor.

While fixed fortifications got their due in the 1850s, little attention was paid to the notion that field fortifications might become essential considerations in the next war. The Civil War was just about precisely half over before infantry began to entrench in earnest. By 1864, ad hoc protective works were thrown up routinely with or without guidance from engineer officers.

To some extent, field fortifications were designed for protection against artillery fire, and the fixed fortifications had such protection as their primary goal. The artillery delivering fire against Civil War targets was in the midst of a revolution in equipment, tactics, and ammunition. Artillery offered perhaps a greater variety of weapons specifically designed for specific purposes than any other category of weapons in the war.

Field artillery in the Mexican War and into the 1850s had consisted in large part of bronze 6-pounder and 12-pounder guns, and of lightweight bronze howitzers. The guns were too

heavy to be adequately mobile, and the howitzers were short on range and power. A fresh design sponsored by Emperor Louis-Napoléon of France first was cast in America in 1857. The new 12-pounder bronze weapon weighed almost one-third less than the 12-pounder gun, and could do most of the things for which both guns and howitzers had been required in the past. Although there were fewer than a half-dozen of the "napoleon" on hand in 1861, it quickly became the favorite of Civil War artillerists on both sides. The napoleon could operate at as long a range as the heavy old 12-pounder gun, and was much more adept at firing shell and canister. Late in 1862, Lee was pleading with Richmond (at the instance of Stonewall Jackson) for napoleons, offering 6-pounders and old 12-pounders to be melted down for the metal if necessary. By the end of the war, there were about eighteen hundred napoleons in service.

An even more pivotal change in artillery also was in motion in the 1850s. The immense increase in range and accuracy that rifling granted to sporting weapons was something artillerists long had envied. Neither artillery nor military small arms, however, had been able to take advantage of rifling until just before the Civil War. The rifled sporting weapons had only marginal military application because they were cumbersome to load, requiring that a tight-fitting patch around the ball be hammered home to the base of the barrel. Only in that manner could the charge fit tightly enough to take the spin imparted by the spiral grooves of the rifling.

The advent of rifled muskets and of rifled artillery resulted in each case not from the design of new weapons, but rather from the design of new ammunition that could be loaded easily but still fit tightly on firing and thus pick up the rifling spin. It was just before 1860 when the first rifled artillery projectiles appeared in America. Some rounds were designed that required a precise fitting of studs on the sides of the projectile into the grooves of the rifle. Inevitably this system resulted in very careful — and therefore very slow — loading; it also required exquisitely careful manufacture and handwork.

The rifled artillery projectiles that revolutionized artillery practice were those that expanded into the rifled grooves only at the moment of firing, and therefore went into the gun loosely and yet fit tightly on the way out. The expansion at firing did not involve the entire projectile, of course. A band or cup of soft metal such as lead or brass or copper was affixed to the round in such a way that the gases from the propellant charge pushed the soft metal out into the rifling. Imaginative designs proliferated amongst ordnance dabblers on both sides. The Confederates actually tried a projectile with wings attached, so that it would spin in flight even after being fired from a smoothbore.

Charles T. James was one of the men at work on rifled artillery. He contrived a method for converting bronze smoothbore guns to rifles by boring narrow, deep grooves into them. Guns so fixed became known as James rifles. Because bronze is a soft metal, the rifling in the James pieces didn't stand up well, and iron quickly became the metal of choice in rifles. Robert P. Parrott patented in 1861 a design for a rifle made of cast iron, with a wrought-iron band shrunk around the breech for reinforcement at the point of greatest pressure. The resulting 10-pounder and 20-pounder Parrotts were mainstays of artillerists on the battlefields of the Civil War. Their familiar forms dot those fields to this day, readily distinguishable by the reinforcement ring around the breech.

The 10-pounder Parrott was overshadowed in large measure as the war progressed by an even better piece. The 3-inch ordnance rifle was made of tough wrought iron and performed admirably in the field. A young Virginia artillerist, Ned Moore, came up against this "most accurate shooter" for the first time at Cedar Mountain in August 1862, and remarked upon the "singular noise" made by its shells: "quite like the shrill note of a tree-frog on a big scale." Those shrill shells went where they were aimed with a precision that gratified their employers. The longer range and greater accuracy of rifled pieces were obvious advantages. For close work, though, the napoleon fired more metal from a larger bore; and when canister was the specific, rifles were not as useful. As a result, a well-run artillery battalion included some rifles and some napoleons.

The men who led this new field artillery on both sides of the lines included a host of youngsters whose bravery made them legendary. Capt. Hubert Dilger, who went by the catchy nick-

name Leatherbreeches, made an immortal name for himself at Chancellorsville as he stood undaunted against Stonewall Jackson's mighty flank attack. Dilger was reported to have fallen back down the Orange Turnpike only by means of the recoil of his pieces, on a day when most of his comrades were fleeing incontinently. At Gettysburg, Charles E. Hazlett was mortally wounded while working his guns on Little Round Top with all eyes upon him, and Alonzo H. Cushing died in epic dramatic circumstances at the focus of Maj. Gen. George E. Pickett's charge.

Willie Pegram constantly fought his Confederate guns from positions beyond friendly infantry lines. His bespectacled face was shining "with the fire of battle" on Hazel Grove at Chancellorsville as he called across the guns to a comrade: "A glorious day, Colonel, a glorious day." None of the war's artillerists glowed with a special fire any more brightly than did John Pelham of Alabama — "the gallant" Pelham, Lee called him after Fredericksburg. Pelham was only a major when he died before the war was half over, and he was only twenty-four years old, but something about him appeals strongly across the years. A sizable and zealous Pelham society thrives a century and a quarter later.

Men of higher rank in artillery service had a profound effect on the war. Gen. Henry J. Hunt, for instance, was arguably one of the most important men in the Army of the Potomac, which he served as artillery chief for much of the war. His admirable skills in organization and operations made that army's long arm wonderfully efficient. By exiling Hunt to rear areas during the Chancellorsville campaign, Joe Hooker went far toward losing that battle. The opposing Army of Northern Virginia, by contrast, had Gen. William Nelson Pendleton, a querulous, stodgy, and ineffective fellow, as nominal head of its artillery.

Not all of the dire disadvantages that beset Southern artillerists are well recognized. Shortages of material and of industrial capacity in the South do get well-deserved attention. Desperate efforts to increase such output found mixed success at best. Catherine Furnace, which became a landmark on the Chancellorsville battlefield, illustrates the problem well. The furnace had failed economically in the 1840s after a decade of weak output — the victim of poor-grade bog ore. The Confederacy started Catherine Furnace anew but it never made even so simple a product as artillery solid shot, yielding only pig iron to send to Richmond's overworked manufactories.

Less familiar is the tale of woeful results achieved by Confederate artillery ammunition. Despite the best efforts of the country's ordnance wizard, Josiah Gorgas, Confederate explosive shells just did not go off with any reliability. Imaginative ersatz devices intended to ensure ignition often failed. A Confederate artillerist who fought through the finest artillery performance of the Army of Northern Virginia at Chancellorsville reported in the aftermath:

I found our fuses were very defective, although it was reported to me that we were using the fuse-igniter. I estimated that one of our shell out of fifteen exploded. . . . I was compelled to watch closely the effect of all the projectiles, as if we were using entirely solid shot.

Confederate rifled rounds were particularly defective, tumbling in flight and failing to explode or else exploding prematurely. E. P. Alexander, who was among the very finest of Confederate artillerymen, refused to use any rifled guns except in one single battery of the six in his battalion. In evaluating the problem of premature explosions, Alexander explained that the army's tactics were damaged by the basic inability to fire over advancing friendly troops. Southern infantry knew "by sad experience" of the danger in such a practice, and Alexander claimed that he had "known of their threatening to fire back at our guns if we opened over their heads." Solid shot could be used safely for the purpose, but that was the least effective sort of round. Furthermore, the infantry wouldn't know the difference and "would be demoralized & angry all the same."

One artillery advantage that the South realized was organizational. Since time immemorial, batteries had been assigned to brigades until the two became almost an integral unit. This left an infantry officer with considerable power over the artillery captain. Efficient use of the artillery too often gave way to considerations of unit pride, and to the vagaries affecting brigade locations. During the winter of 1862/63, the Army of Northern Virginia scrapped this inept system and instituted a

battalion organization based on groupings of four to six batteries. Two field officers and a staff hierarchy went with each battalion. E. P. Alexander, who had been a central figure in crafting the new arrangement, was so delighted with his battalion that he at first refused to be considered for an opportunity as brigadier general of infantry, saying that his battalion was as "independent & as conspicuous as a Division of Infantry." Most of Alexander's comrades doubtless would have cheerfully subscribed to his notion that six hundred artillerymen and their guns were more than the equivalent of eight thousand infantrymen. The Union artillery copied the battalion idea before long, and eventually most of the armies of Europe did too.

By 1865, there were field fortifications everywhere a handful of soldiers had gathered. Early in the war, however, no one thought to throw some earth or some wood between themselves and the long-range rifled arms that were aimed their way. Many of the men, in fact, were derisive of such cowardly measures. When R. E. Lee assumed command of the army he would make famous, one of his first initiatives was to fortify the Confederate lines around Richmond as a means to free manpower for offensive action. The response of his army was strongly negative. Lee was "The King of Spades," it was said, and must be short on the daring and aggressiveness that the South needed.

An observant veteran soldier from South Carolina reported that until December 13, 1862, his unit had never built any protective works. That night, after the Battle of Fredericksburg was actually over, "the brigade felled a few trees and formed a rude breastwork — the first thing of the kind we ever lay behind." When campaigning opened again the next spring, the same young man found himself behind the same "rude breastwork." This time he noticed among his comrades "the first well-defined inclination for protection in battle." On that day, the war was already three weeks more than half over.

Visitors to the scenes of Civil War action often use the earthworks as benchmarks to discern what happened. As surviving traces of what soldiers themselves did long ago, the earthworks also are touchstones — points of departure for our imaginations. Photographs of the works as they stood in the 1860s show complex, sometimes massive defenses. The same works today often are far less sizable. The reason in most cases is that the men using them for protection employed logs and other wood for the main mass of their work. That wood fiber is long gone today, but the earthen mounds remain as mute reminders of the men who fought behind and around them.

Field fortifications also have changed from their original appearance because they suffered rapid alterations every time they changed hands. There was, of course, a front and a back side to each fortification. If one army abandoned a line, or was driven from it, the new owners hurried to fill in one side of the work and scoop out the other. Modern visitors to old battlefields who become confused can take solace in the account of a young Virginian from Orange County. George Q. Peyton had fought near the "Bloody Angle" at Spotsylvania behind earthworks that were among the most complex (and perhaps the most famous) field fortifications built during the war. A week after the famous day at the Bloody Angle, Pvt. Peyton wrote in his diary that his regiment "occupied our old line of works near where we fought. . . . The Yanks had filled up the ditches and turned the works around so I hardly knew them."

Formal fixed fortifications were proving less and less imposing at the same time that field fortifications were growing in use and importance. During February 1862, Confederates suffered the loss of control of both the Cumberland and Tennessee rivers when Forts Henry and Donelson could not stand up to Gen. U. S. Grant. Not long thereafter, at the same Fort Pulaski in Georgia that R. E. Lee had helped to build as a youthful lieutenant, Northern weapons signaled a new day in warfare. On April 10 and 11, 1862, some of the gigantic new siege rifles, under Gen. Q. A. Gillmore, shattered the brick walls of the fort with amazing ease and in rather short time. It was apparent that big rifles could batter down masonry walls from a far greater distance than the designers of those walls had imagined possible.

Two masonry fortifications protecting the approaches to

New Orleans also fell in April 1862 — Fort Jackson and Fort Saint Philip. When they succumbed to Federal firepower and seapower, the South's largest city followed suit promptly. Forts Gaines and Morgan and Powell were similarly impotent in protecting Mobile in 1864. The arsenals of the North were stocking weapons unlike anything used in earlier wars: 200-pounder Parrotts; 300-pounder Parrotts; 13-inch mortars; 8-inch, 10-inch, and 15-inch Rodman smoothbores; even 20-inch Rodmans, the biggest guns ever cast in the country, albeit guns that never were used. It was apparent that fortifications would have to change in keeping with the changes in what was being thrown at them.

Forts built of earth proved to be an interesting and often successful expedient. Their earthen walls absorbed the same mammoth bolts that crumbled masonry walls. Fort Sumter itself illustrated the case to some extent when it was the focus of a mighty Federal attack in 1863. Its masonry walls quickly were reduced to a pile of rubble bearing little resemblance to the fort of 1861. The rubble pile became virtually a pile of dirt, however, and was almost impervious to further harm. Confederate Battery Wagner, across the harbor from Sumter, was built mostly of Carolina sand and fell only after desperate, close infantry action.

The Confederates held a critical strong point on the James River below Richmond at Drewry's Bluff through the war. The fort atop that bluff had earthen walls, and also was blessed with a panoramic view down the river. Confederate artillery atop the bluff drove back Union gunboats on the river in May 1862 at a time when there was uncertainty whether Richmond could be held. Two years later another battle at Drewry's Bluff resulted in another Confederate victory, this time predominantly as a result of infantry action.

A splendid example of the new earthen fortification at work came at Knoxville, Tennessee, during James Longstreet's bungled attack on the Federals there in November of 1863. A small earthwork near the city was named Fort Sanders, in honor of a Northern officer killed earlier that month. After much equivocation, Longstreet determined to launch an infantry assault on the fort after artillery preparation. Confederate rifled artillery firing at Fort Sanders (with the usual ineffective ammunition) failed to make any impression. The tiny group of Northerners in the fort then beat back a large contingent of proud infantry veterans of the Army of Northern Virginia with consummate ease on November 29. The Southerners engaged lost not only a painfully large number of soldiers but also considerable poise, because the reverse set off an attack of biliousness in Longstreet that resulted in charges against his ranking subordinate. Fort Sanders did the Confederacy much harm.

As Confederate access to the world shriveled late in the war, the last gateway for blockade-runners was Wilmington, North Carolina. A fortification of earth and sand named Fort Fisher held that portal open. Thunderous, rolling bombardments failed to shake the place; only maneuverable infantry would be able to isolate and neutralize the fort. A vast Federal expedition mounted in December 1864 failed to take Fort Fisher, but a renewed effort the next month captured the stronghold on January 15, 1865.

By the time of the Fort Fisher expeditions, the war in Virginia had long since settled into virtual siege operations around Petersburg. What had started as field fortifications when units went to ground in the summer of 1864 had turned into endless miles of mighty works, defended by abatis and chevaux-de-frise and traverses and all the other implements of the entrenchers' art. Infantry lines were dotted with artillery redoubts and with strong earthen forts. These forts often were named for the commander in the area, or for a recently dead hero. The soldiers sometimes gave the forts vivid names, such as the aptly labeled Fort Hell near Petersburg. Lee's last offensive gesture during the war in Virginia came against one such work, Fort Stedman. A stealthy attack on the morning of March 25 won temporary success but degenerated into demoralizing defeat. Within a week, Lee was away from the miles of forts and fortifications around Petersburg and racing in vain for Lynchburg until he was brought up short at Appomattox Court House.

Four years of war had worked nothing less than a revolution

in fortification and artillery. Napoleons and 3-inch ordnance rifles and 20-pounder Parrott rifles had supplanted a series of far less efficient pieces. Mammoth siege weapons had demonstrated the impotence of masonry forts. Artillery battalions had destroyed the parochial notion that batteries and brigades made a team. Soldiers under fire had resolved the need for protection by refining a system of field fortifications. And the North had won its war, not least because of its skillful exploitation of the mechanical and industrial capacity that made its artillery a force on land and sea.

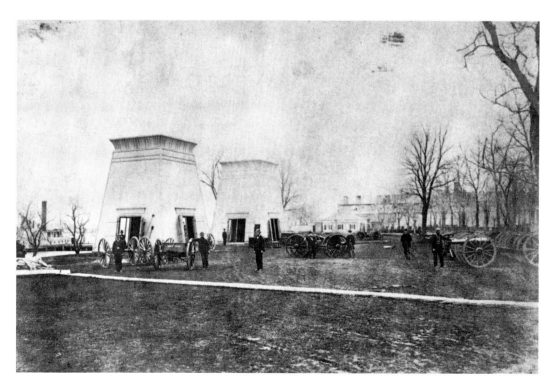

In a scene repeated innumerable times on both sides in the war, members of a battery division from the Army of the Potomac, in this case one with some sixteen or more cannons, draw themselves into line for the photographer outside their winter quarters. While no accurate tally exists, it is probable that men like these manned more than five thousand artillery pieces of varying kinds in this war. (USAMHI)

Headquarters of the mighty Union artillery effort was the Washington Arsenal, where every day a seemingly endless array of weapons awaited shipment to Lincoln's far-flung armies. (LC)

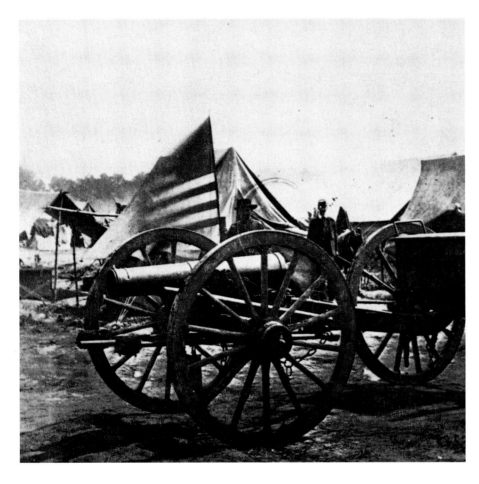

Across the lines, their Confederate foes had to depend largely upon what they could buy, take from the Yankees, sneak through the blockade, or manufacture. As a result, much of Rebel gunnery involved more outdated pieces, like this captured 12-pounder field howitzer shown in 1862. (USAMHI)

The Union, too, had its share of outmoded weapons, like these 12-pounder mountain howitzers shown in Fayetteville, Arkansas, probably in the hands of men of the Third Kansas Light Artillery. (WCHS)

Men everywhere went to fight with what they had, like these youngsters still awaiting their uniforms, but with an old field piece to take off to war. (JAH)

The workhorse cannon of the war would be the napoleon field piece, like these two in the foreground being served by men of Company F of the Third Massachusetts Heavy Artillery. Photographer W. M. Smith made this image at Fort Stevens, in the defenses of Washington, in August 1865, with the war done, and when the men had time to polish their cannons brightly. (LC)

Confederates often cast their own napoleons, like these pieces captured from them on Missionary Ridge in November 1863, and here photographed in Chattanooga. (NA)

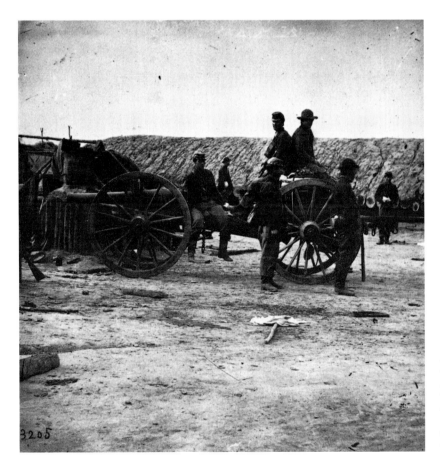

More accurate and with greater range, the 3-inch ordnance rifle was also popular in both armies. This piece was used by the Rebels until captured with Petersburg in April 1865. Its captors pose jauntily upon the now forever-silent cannon. (LC)

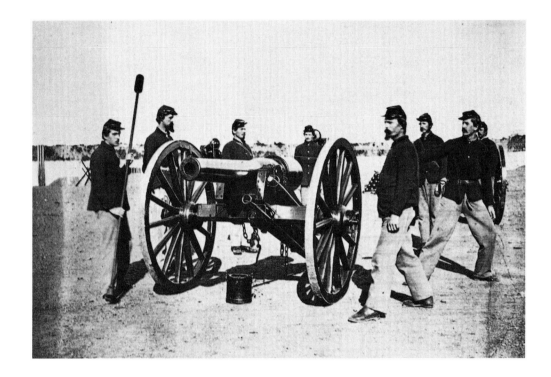

Still more deadly, and manufactured in a seemingly endless variety of sizes, was the Parrott rifle, marked by its distinctive reinforcing band around the breech. This 3.67-inch Parrott field piece was a favorite throughout the Union army. (LC)

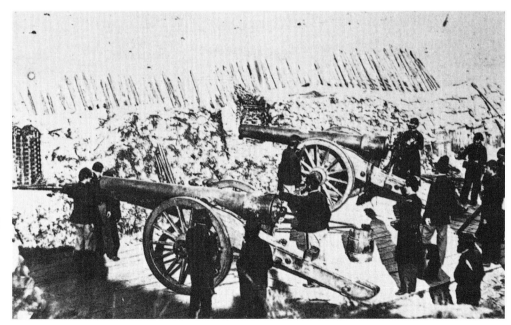

More intimidating was the 30-pounder, like this brace of Parrotts in Fort Putnam, among the Federal works surrounding Charleston. Their power, especially against masonry fortifications, was awesome. Yankee cameramen Haas & Peale made the Parrotts around Charleston the most photographed of the war. (USAMHI)

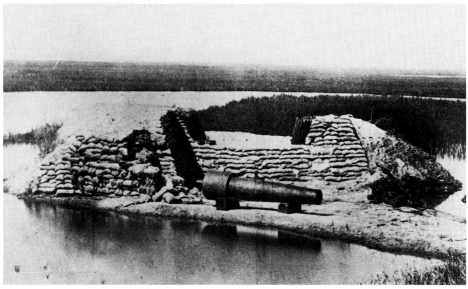

Top left: Fort Putnam had even larger guns, like these massive 100-pounder Parrotts, shown in 1865 with their shells. (LC)

Top right: And nearby in Battery Hays, one of the batteries that severely reduced Fort Sumter, Haas & Peale found this huge 200-pounder. Even larger types were cast. (NYHS)

Among the larger guns, the variety seemed endless, particularly in the case of those intended for seacoast defense. Here a 32-pounder seacoast gun does duty in one of Washington's many forts. (USAMHI)

Two more large siege guns stand in Richmond after the city's fall in 1865. At left is a 32-pounder Navy smoothbore, and next to it, a 6.4-inch rifle. Behind them a host of other captured Confederate field pieces and siege guns await shipment north. (LC)

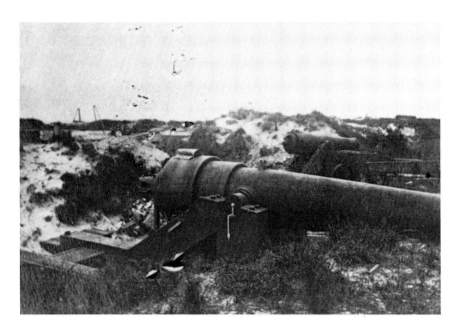

The Confederates made some of their own distinctive big guns, like this 7-inch, double-banded Brooke rifle in Mobile's Fort Morgan. The bands reinforcing the breech allowed for heavier powder charges. (NA)

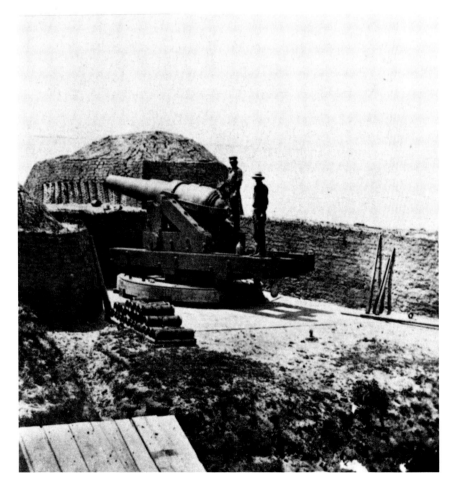

In Battery Marion at Charleston's Fort Moultrie, a triple-banded 7-inch Brooke helped to protect the Confederacy's vital South Carolina harbor. (USAMHI)

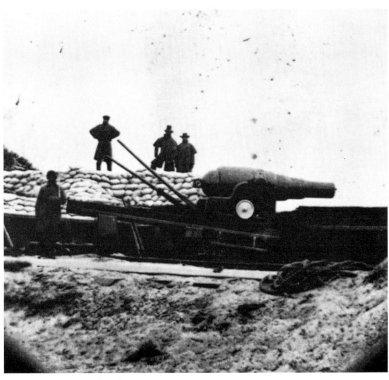

Some of the South's larger weapons were purchased abroad, like this 150-pounder Armstrong gun in Fort Fisher, near Wilmington, North Carolina. (USAMHI)

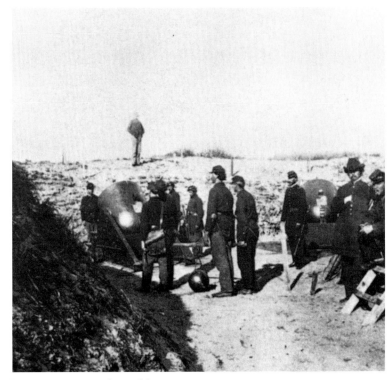

Less gripping on the public imagination were the ponderous mortars used for battering fortresses and cities. Batteries like these helped reduce Confederate works around Charleston. (USAMHI)

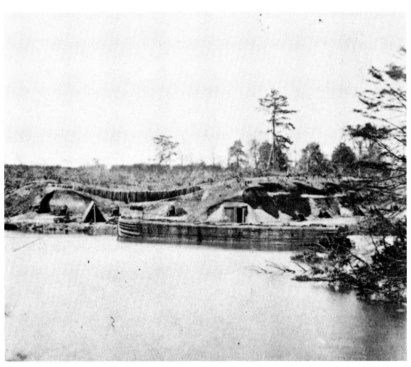

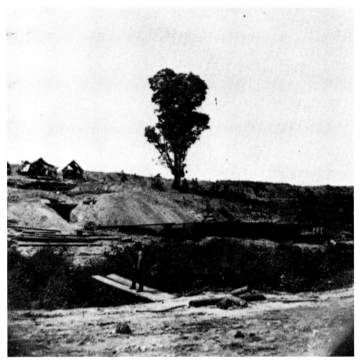

A massive Yankee water battery at Gloucester Point, Virginia, near Yorktown, mounted fifteen mortars that pounded Confederate positions in 1862. Eight of them show here. Their gunners could not even see their targets, having to depend upon word from "spotters" to learn if their aim was true. (USAMHI)

No single cannon of the war became better known than this 13-inch mortar mounted on a flatbed rail car. Called "Dictator," it was only one of many of its size, but this one happened to interest a photographer, who repeatedly captured its image — as here, near Petersburg, Virginia, on September 1, 1864. The photographer, Timothy O'Sullivan, made the gun famous. (USAMHI)

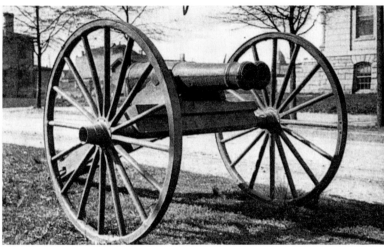

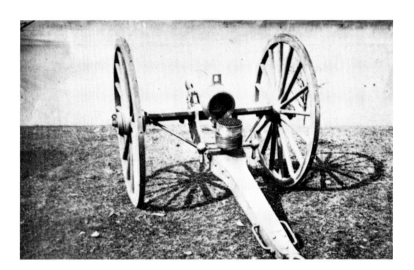

Top left: Ingenuity did not end with the big guns. Scores of new designs were tried. A few worked; most did not. One that failed was the Confederate double-barreled cannon made in Georgia. (CWTIC)

Top right: Another failure was this volley gun, designed to send dozens of bullets at an enemy in a single firing. (NA)

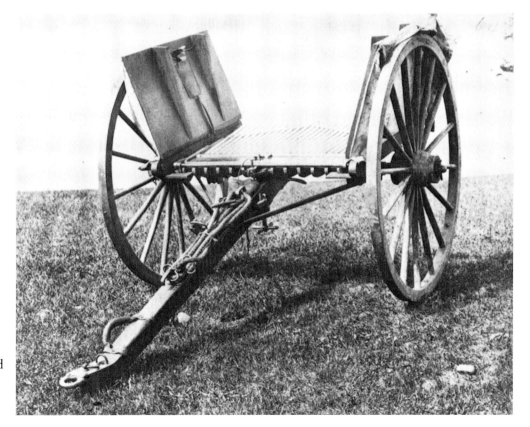

One that did work, though its use was limited to one battery, was the Requia volley gun, whose multiple barrels could send forth a wall of lead several feet wide. (NA)

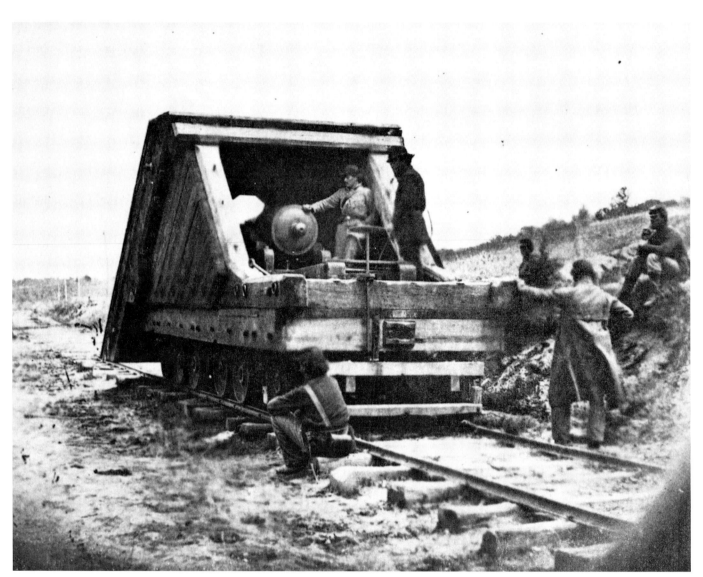

Sometimes ingenuity combined size with mobility, as with this banded siege gun
mounted on a fortified flatcar. It could be moved quickly anywhere there were rails.
(USAMHI)

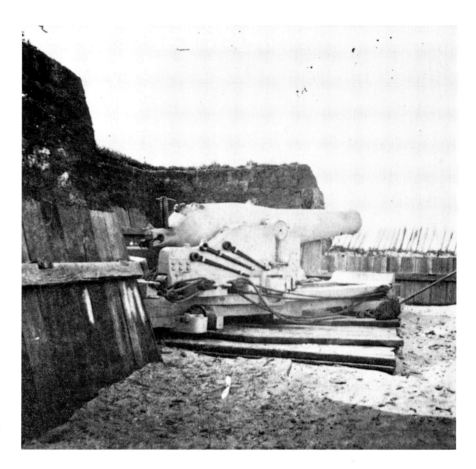

The really huge guns were reserved for defending seacoast forts from ship-borne attack. A massive 9-inch Dahlgren gun peers out to sea. (USAMHI)

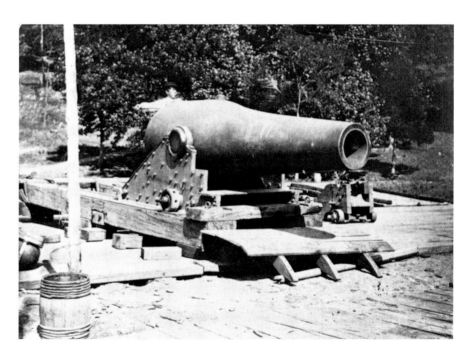

An even larger 15-inch Dahlgren sits ready in the Washington defenses in August 1864. A small man could fit into its bore. (USAMHI)

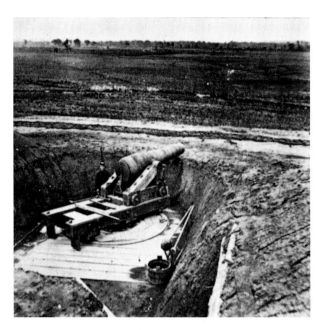

Biggest of all the guns were the massive Rodman columbiads. A modest 10-inch Confederate Rodman copy sits in its emplacement near the James River. (USAMHI)

Another, Yankee, Rodman stares silently from the parapet of New York City's Fort Columbus in 1865. The largest gun of the war was a 20-inch Rodman that was never fired in anger. (NA)

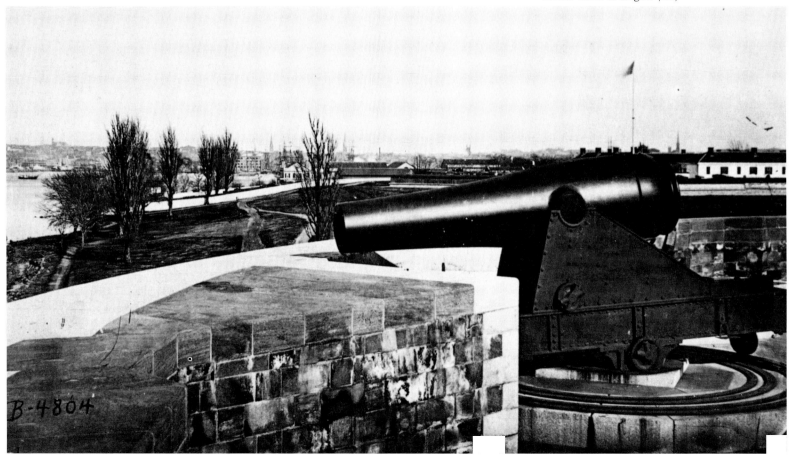

While the artillery of the Civil War represented much that was new, it also put an end to much of the old in the science of fortifications. The old Union had rimmed its seacoasts with masonry fortifications like Fort Monroe, off Virginia's Hampton Roads. (NA)

Conceived and built in a time when there was less powerful artillery to contend with, these massive brick or stone edifices, like Fort Jefferson in the Dry Tortugas off Florida, were already obsolete in 1861. (USAMHI)

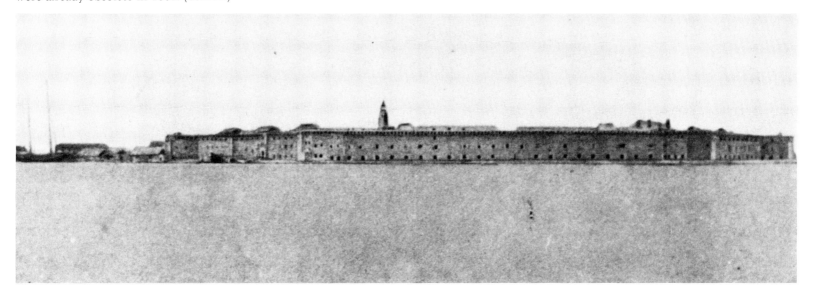

Some of the fortresses, like Fort Sumter—and Fort Jefferson, shown here—were still under construction when the war began. (LC)

Yet North and South alike rushed to maintain or seize possession of them when the call to arms came. Neither expected the effect that newly developed heavy-caliber guns and exploding shells would have. Fort Sumter, photographed by Charleston cameramen Osborn & Durbec on April 17, 1861, three days after its fall, shows on its land side only a little of the damage done. (LC)

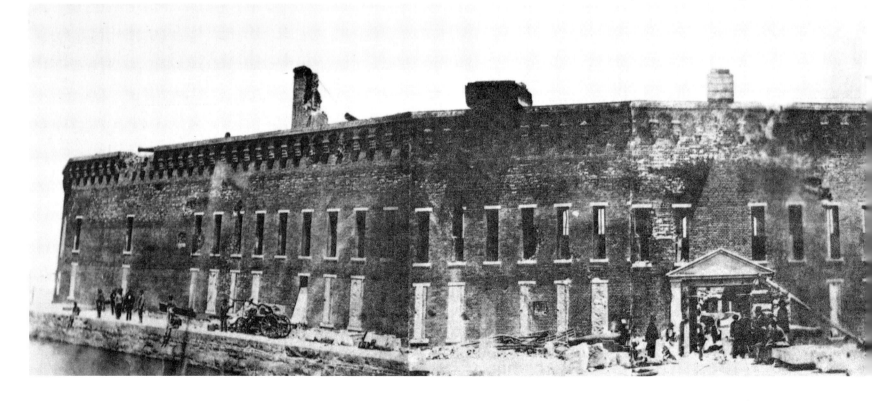

Fire from Rebel batteries on Morris Island severely battered the southwest angle of the fort. (TU)

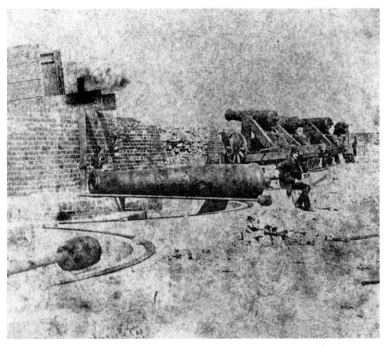

This faded, previously unpublished Osborn & Durbec image shows the terreplein on the western face of the fort, well mauled by the Charleston batteries. (TU)

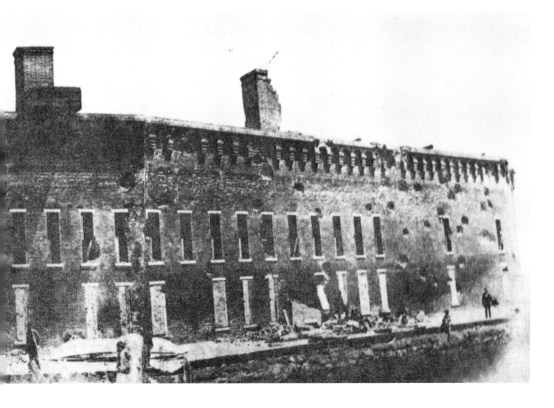

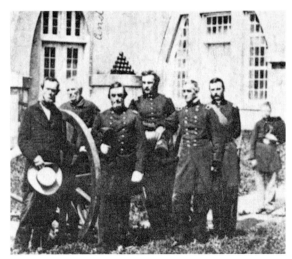

The fort's commander, Maj. Robert Anderson, had no choice but to surrender his beleaguered garrison. Shown here sometime later, standing fifth from the left, as a brigadier general, he poses inside a Northern seacoast fort that has obviously never felt the sting of Confederate cannons. (JAH)

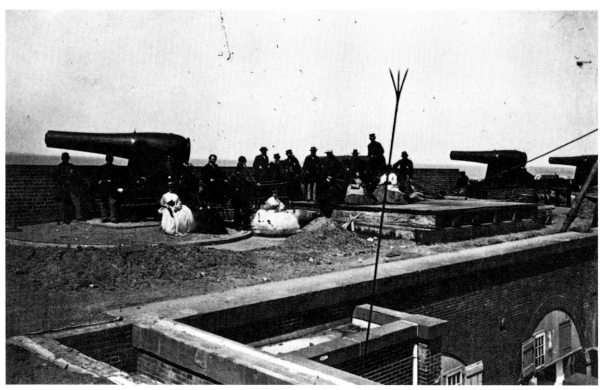

Fort Pulaski, protecting Savannah, was another seemingly impregnable bastion. Its thick walls and ominous columbiads, shown here in 1863, presented a formidable face to any attacker. The Confederates seized the fort in January 1861 when an ill-prepared Washington had left it in the hands of a single sergeant! (USAMHI)

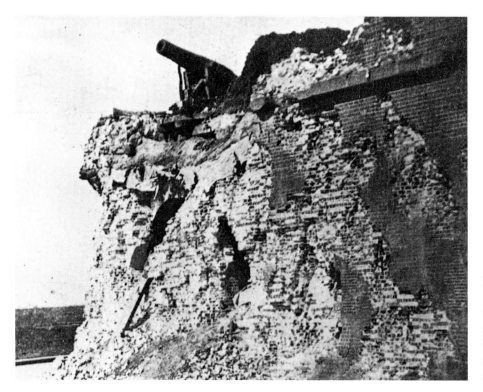

Fifteen months later, on April 10 and 11, 1862, when the Federals came back to reclaim it, Yankee siege guns took just two days to pound these two massive holes through its walls, making it untenable. The fort surrendered, and the days of masonry fortifications were clearly over. (NA)

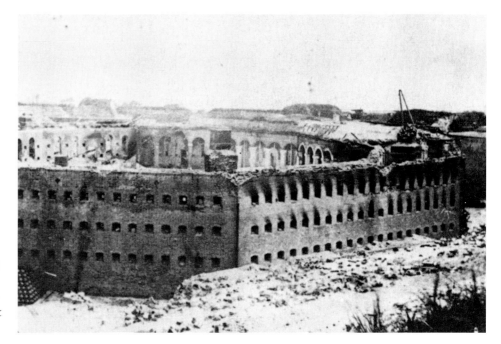

If further proof were needed, it came at Fort Morgan, on Mobile Bay. Built to prevent an enemy from entering the harbor, it could do nothing as a Union fleet steamed right past it on August 5, 1864. (NA)

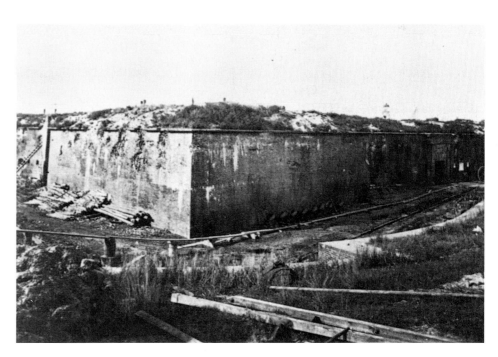

That allowed the Federals to land troops to invest the fort, and after a brief siege, it, too, fell to their hands. (NA)

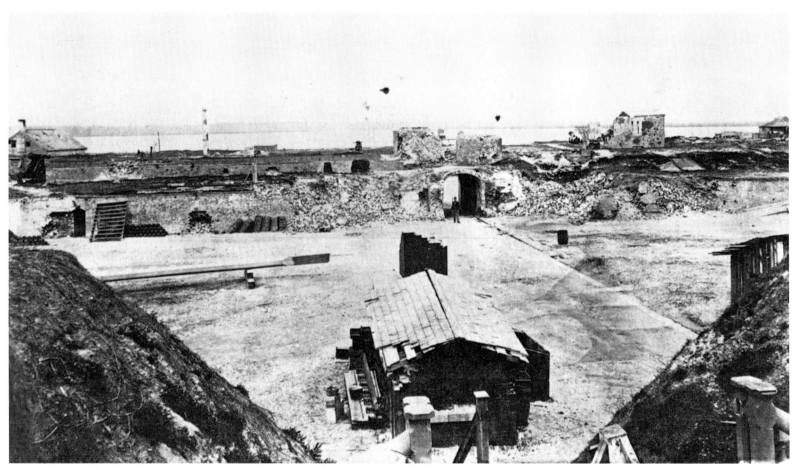

But no forts in the South came even close to the massive damage received by those at Charleston, South Carolina. Fort Moultrie on Sullivans Island was blasted repeatedly. (USAMHI)

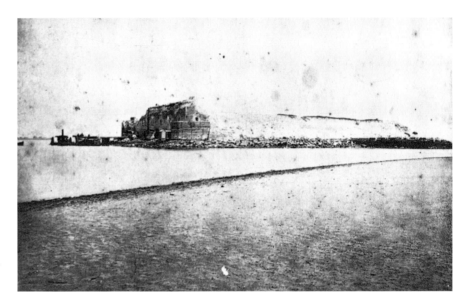

And Fort Sumter was left a shapeless pile of rubble by late 1864. (TU)

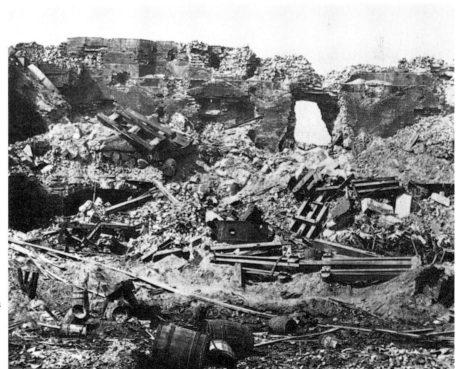

Confederate photographer George S. Cook took his camera inside the besieged fortress in 1864 to record its chaotic interior, with gun carriages blown from the now demolished terreplein, holes in the walls, and devastation everywhere. (USAMHI)

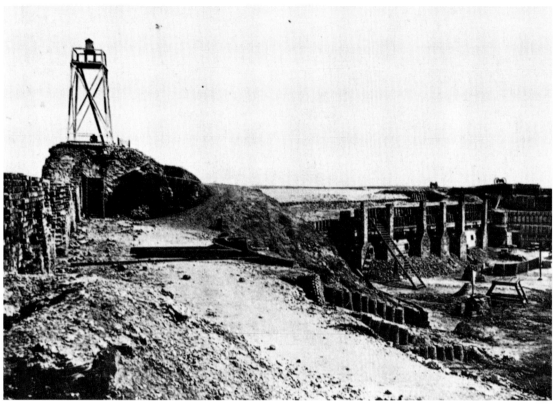

After its final fall in 1865, Sumter bore no resemblance at all to the imposing fortress of 1861. (USAMHI)

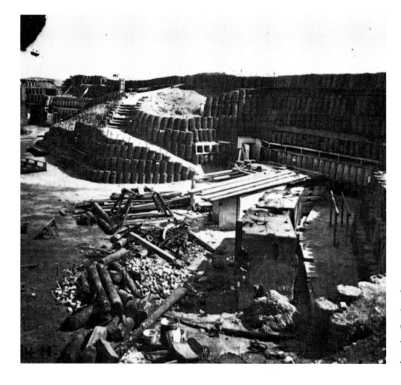

This image, made about April 14, 1865, the fourth anniversary of the fort's fall to the Confederates, shows more eloquently than words how little was left of the bastion Anderson tried so nobly to defend. (LC)

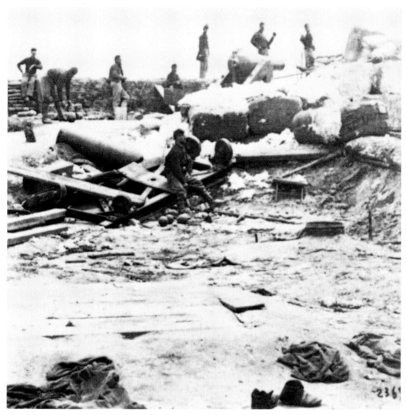

Top left: Other, less formal, more adaptable defenses against enemy artillery and bullets evolved quickly as the war progressed, and often they were more effective than walls of stone and mortar. Ironically, Confederates even used cotton at times. In 1862, erecting defenses at Yorktown, Rebels incorporated cotton bales into their fortifications. (USAMHI)

Top right: The previous fall, out at Lexington, Missouri, Confederates led by Gen. Sterling Price created probably the war's only mobile fortress when they erected a wall of hemp bales and slowly pushed it ahead of them as they advanced and finally took the town. A previously unpublished portrait of Price taken sometime after March 1862. (ADAH)

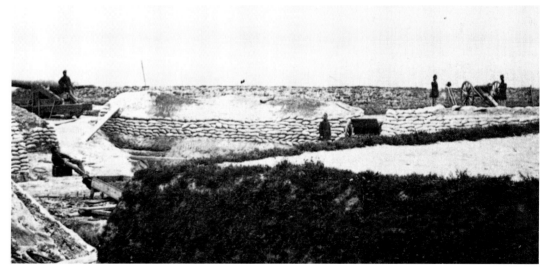

Bottom right: Very quickly the Rebels learned to protect their rivers with earthworks like these at Yorktown, and quickly, too, they learned that dirt and sandbags were far more effective against shot and shell than were brick and stone. (USAMHI)

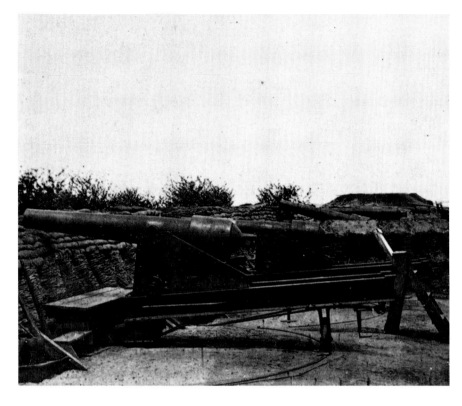

The Rebels soon had the York River almost lined with earth-protected batteries like this one mounting several Parrott rifles. (USAMHI)

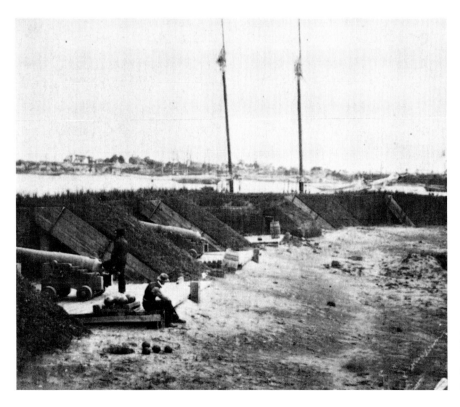

Battery 4 off Yorktown was another example. This one even sprouted grass, which had the added benefit of somewhat camouflaging its emplacements. (USAMHI)

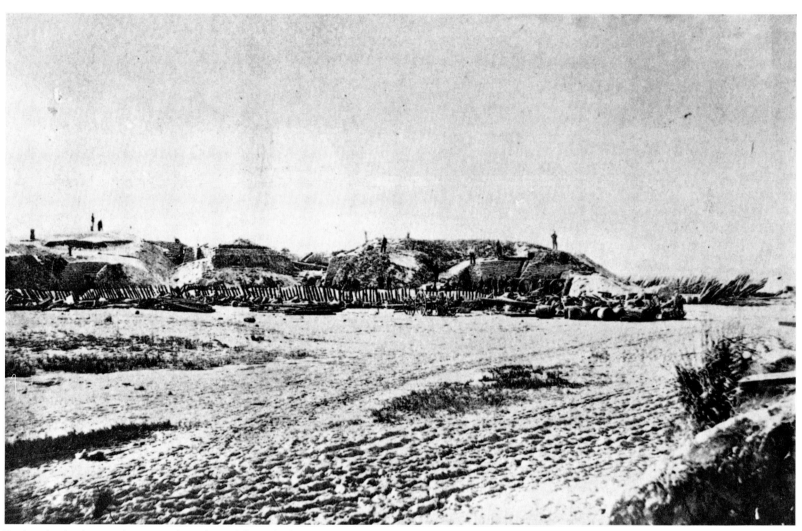

Both sides built even larger earth-and-sand forts farther to the south. Fort Putnam on Morris Island was originally built as Battery Gregg by the Confederates, then was captured and strengthened by the Yankees. Haas & Peale photographed it in 1863. (USAMHI)

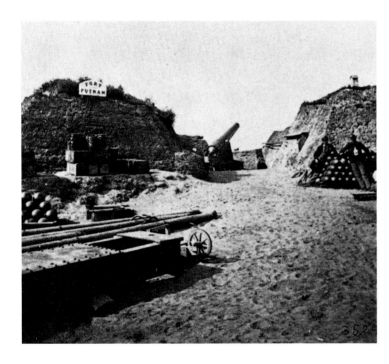

Walls of earth could be built thicker, stronger, and quicker by far than anything previously seen in American warfare. (USAMHI)

Shells that, upon exploding, might send hundreds of dangerous fragments of brick flying about in a regular fort like Sumter, here just harmlessly buried themselves in the sand or kicked up clouds of annoying but hardly dangerous debris. (AIG)

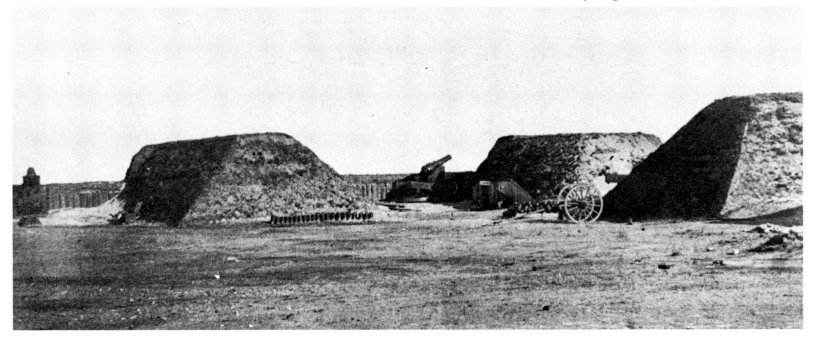

Of course, such new kinds of forts called for very different amenities for their defenders. Soldiers' quarters were not the safe and comfortable casemates or barracks of a Pulaski, but simply tents. (USAMHI)

It was no different for the officers. (USAMHI)

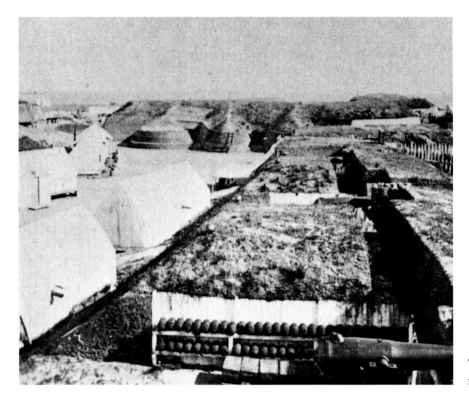

The interior was strictly utilitarian, and the men lived close to their guns. (USAMHI)

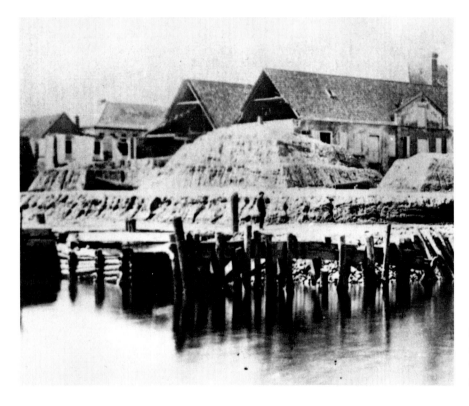

Such earthwork forts could even appear in cities. At Vanderhoff's Wharf in Charleston, this earthen battery appeared right on the edge of the city, along the Cooper River. (NYHS)

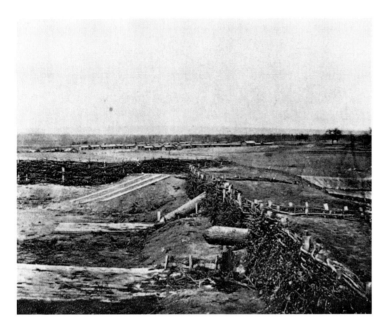

The least permanent fortifications in this war were those thrown up hastily on the battlefield, and at first neither side used them. Indeed, perhaps the first fieldworks of the war were these built by Confederates to protect Centreville, Virginia, during the winter of 1861/62. They were armed in places with "quaker guns" — nothing more than logs, which from a distance looked like cannons pointing out from the embrasures. (USAMHI)

The first major battle use of field fortifications came at Fredericksburg in December 1862. Sitting behind earthen works like these, Rebels peered across the Rappahannock as the Federals crossed the river and fruitlessly attacked the well-protected defenders. (NA)

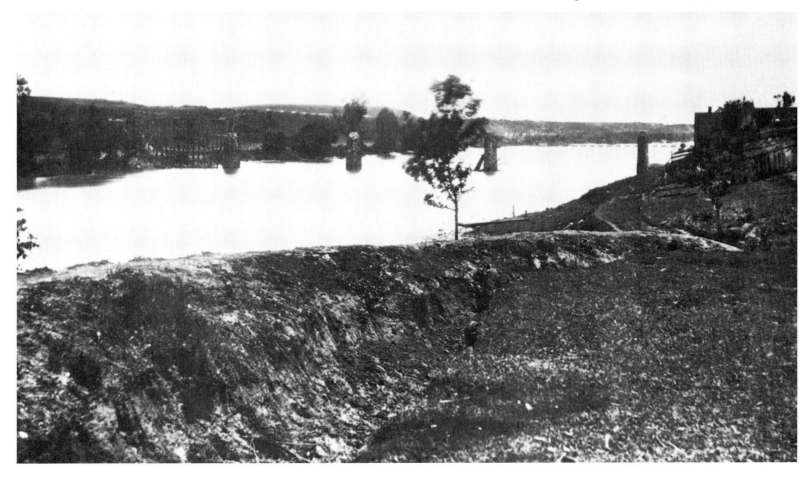

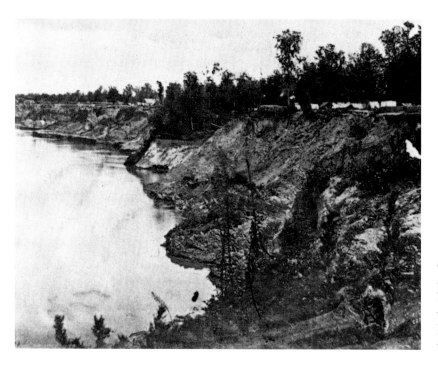

Out west Confederates used such works to even better advantage as they protected the bluffs along the Mississippi. Their earthworks lined the high banks at Port Hudson, Louisiana, the last major bastion on the river to fall to the Yankees. (NA)

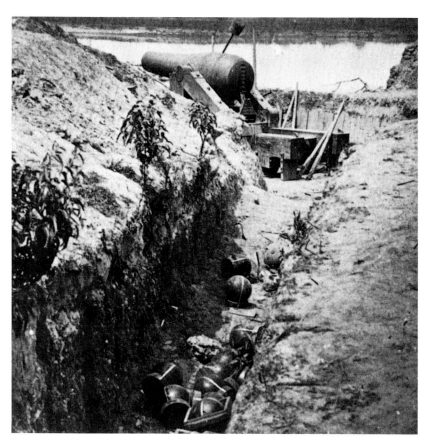

While there was always a sense of disorder about these less formal fortresses, there was no contesting their power to resist an enemy. Even Port Hudson fell only when surrounded and starved into submission. Its walls were never breached. (NA)

Perhaps the most extensive, and one of the most formidable, of the Confederate earthworks was Fort Fisher, off Wilmington, North Carolina. Shown here in an 1865 image by Timothy O'Sullivan, it never succumbed to bombardment but, like most others of its kind, collapsed when its garrison was out of guns and outnumbered three-to-one. (CHS)

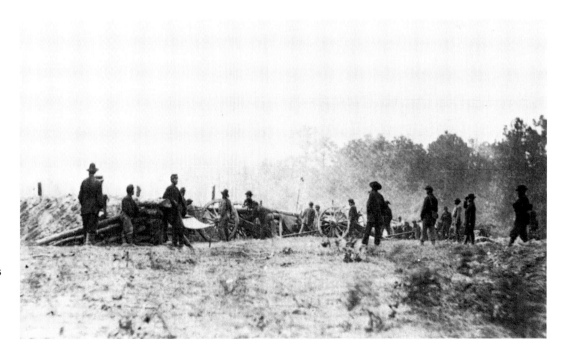

By 1864 men of both sides were expert in erecting defenses for their most immediate needs of protection. In only a few hours, logs and earth could be turned into works like these Northern fortifications now being used by two Federal batteries outside Petersburg. (USAMHI)

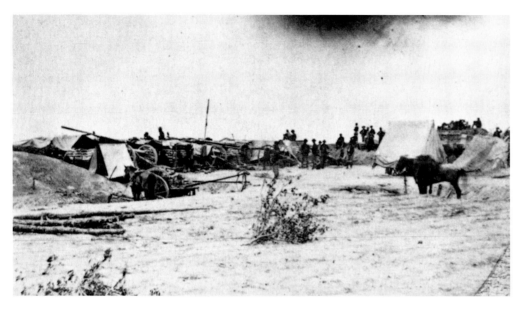

When more time was available, the earth could be bagged and packed more carefully. A June 20, 1864, image of the First New York Artillery in just-captured Rebel works at Petersburg. (USAMHI)

The more time allowed, the more extensive the works could become. Haas & Peale's 1863 image shows the first parallel in what would be a series of earthworks the Federals used to push their lines gradually forward on Morris Island. Using one line as a base, engineers could send trenches running forward, then connect them laterally to create a new line a few yards closer to the enemy. (USAMHI)

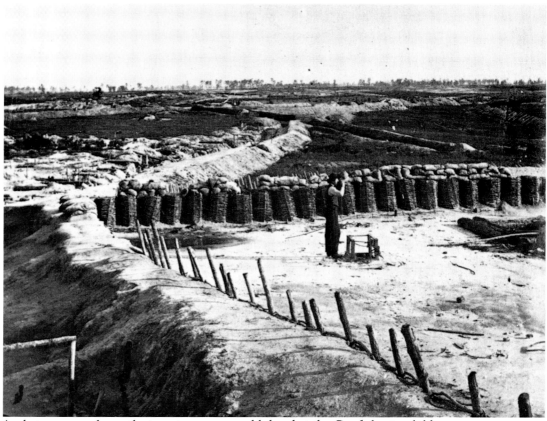

And given several months in a siege, men could do what the Confederates did here around Petersburg—create a virtual maze of forts and earthworks. (LC)

The Federals besieging them had just as much time, and their works—neater, to be sure—stretched as far as the eye could see. (USAMHI)

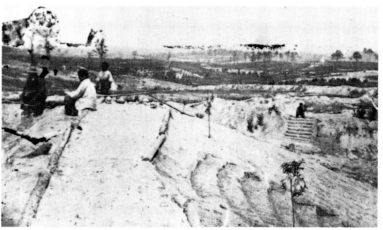

Looking toward the horizon from the captured Rebel works after April 1865, one could see line after line of successive works—testimony to the ingenuity of the engineers, and the endless toil of the soldiers. (USAMHI)

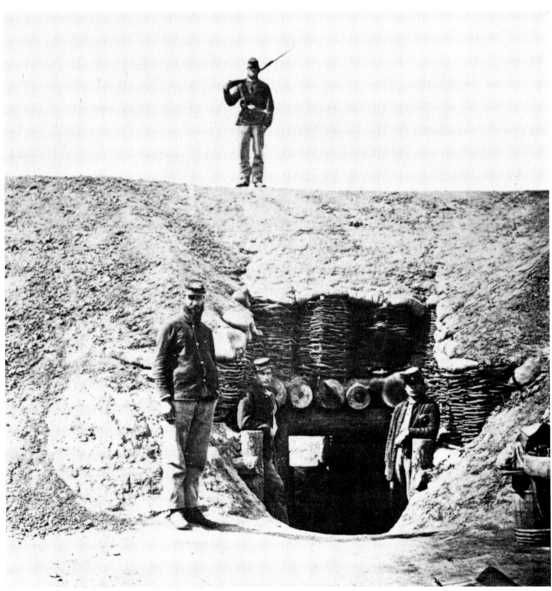

Bombproofs and subterranean passages often connected one fort with another, while powder magazines like this one were buried beneath ten feet or more of sandbags and "gabions," wicker baskets filled with earth. (USAMHI)

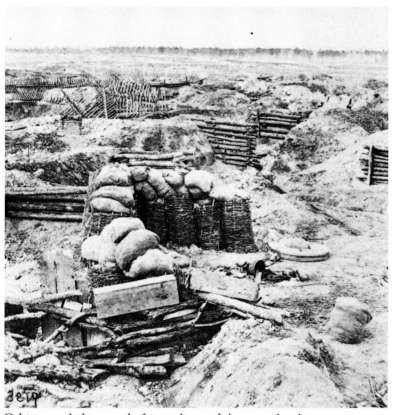

Gabions and chevaux-de-frise — lines of sharpened stakes — protected the Confederate Fort Mahone, which its opponents soon dubbed Fort Damnation. It appears here on April 3, 1865, the day after the Petersburg works fell. (USAMHI)

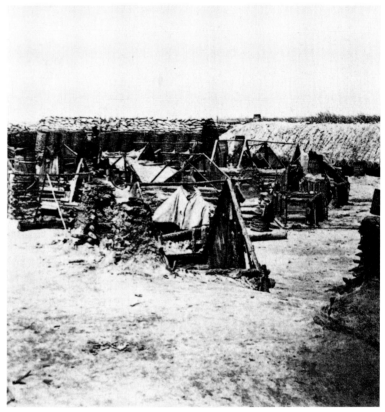

The Yankee forts at Petersburg looked much the same, as here at Fort Rice. The shelter tents that had provided roofs for the winter huts have already been removed from the ridge poles of the soldiers' quarters, showing just how impermanent these works were meant to be. This image was also made very shortly after Petersburg fell, and already the Yankees have abandoned their works. (USAMHI)

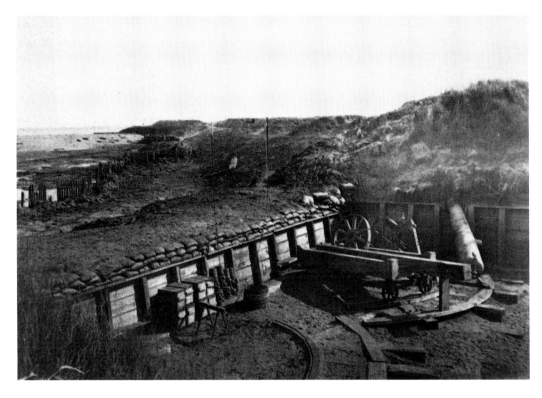

The Confederates were beaten and on the run everywhere, and even their dauntless fortifications — crude yet effective new weapons for defense in a landscape of war now forever changed — could not stand indefinitely. Everywhere they fell. Often the Rebels themselves destroyed their magazines and dismounted their guns as they fled. (LC)

Sometimes their guns lay where they had exploded after heavy use. (USAMHI)

Sometimes no one would remember whether it was friend or foe who destroyed their now silent cannons. (USAMHI)

With the fall of the Confederacy, its artillery was gathered, as here at Richmond, and sent north, prizes to the victors. (USAMHI)

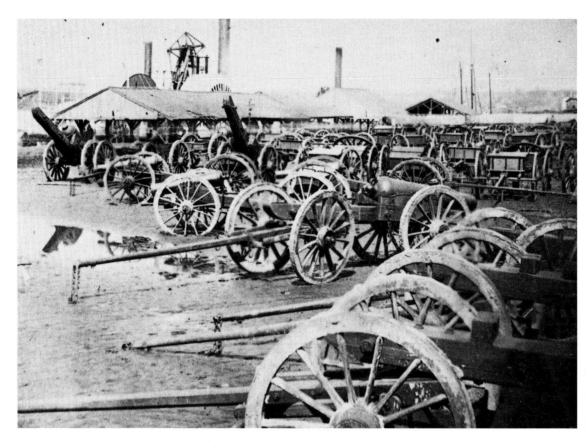

The guns, their limbers and
ammunition chests, clogged the
wharves as they awaited shipment.
(USAMHI)

In row upon row their wheels stood almost
at attention for the final time. (USAMHI)

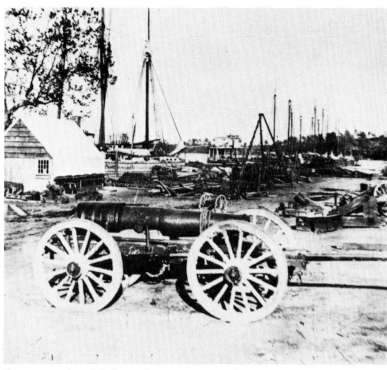

Once proud and defiant, they were trussed
and bound, awaiting their final destinies
as trophies, museum pieces, or fodder for the
final indignity of the foundry's melting pot.
(USAMHI)

Like the swords of old, they were battered
and broken, about to be beaten into
plowshares. (USAMHI)

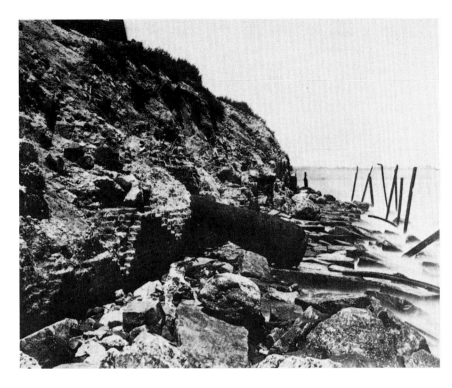

Like this half-buried columbiad in George N. Barnard's image of Sumter in 1866, they and the forts they had protected were about to disappear from a scene where once they had been terrible. (CWTIC)

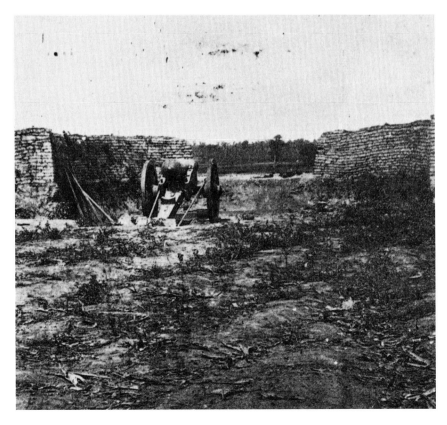

Their man-made thunder, which had echoed around the world and down through the decades, was never to be heard again. (USAMHI)

Billy Yank

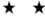

A portfolio of the Union
fighting man in camp and field

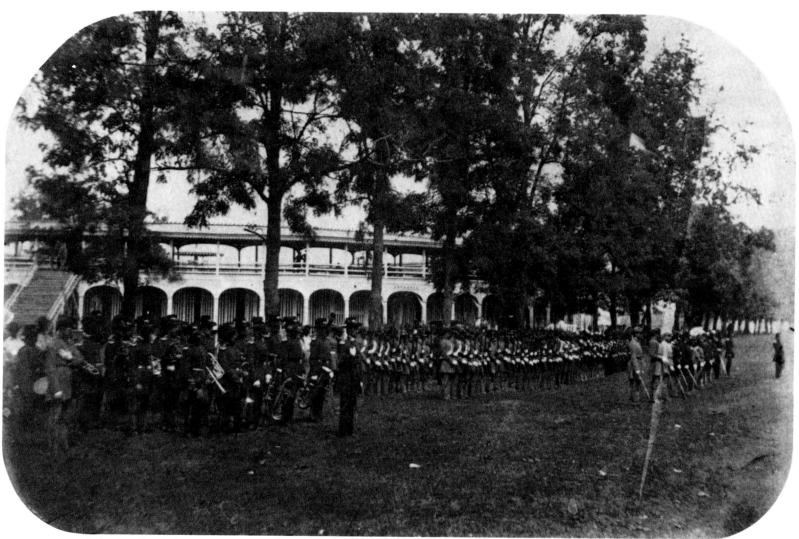

Like his Confederate counterpart, he was ill-prepared for war. With few exceptions, the only military service he knew—if any—was in a local or state militia outfit, and that was mostly Sunday parade soldiering. Many of these men of the Kentucky State Guard, on parade in Louisville in August 1860, would find their way into the Union blue the next year. But none of them had any idea of what awaited them when America went to war. (KHS)

Top left: Before 1861, there had been busby-wearing militiamen like the Lowell Light Infantry. (JAH)

Top right: National Lancers who looked like something from the time of Napoleon. (JAH)

Militiamen with feathers and epaulets. (JAH)

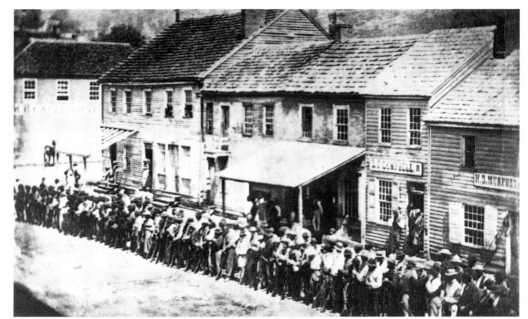

But in 1861 the call was answered by tens of thousands who knew nothing of such soldiering. They were farm boys, mechanics, clerks, sons of noble fathers and the offspring of fathers undistinguished, all bound by a common cause: youth, adventure, and the Union. Recruits gather at the corner of High and Walnut streets in Morgantown, Virginia, soon to be West Virginia. (WVU)

Regiments were raised quickly, and well before many were ready they were sent off to the war, among them the Sixty-ninth New York. It took its first and only blooding in its three months' service at Bull Run. Here, six days later, it returns to New York and a parade down Broadway—with forty-five of its men left dead on the fields of Virginia. It was a rude first lesson in warfare. (FL)

Inspired perhaps by its sobriquet, the Montezuma Regiment, the Thirty-first New York, also present at First Bull Run, affected a decidedly ornate uniform in the war's early days. With little consistency at first, regiments arrived in Washington clad in all colors and with every manner of feather and festoon, as befitted boys going off to a lark in a summer's war. (JAH)

Still, in the early weeks of the war, with Washington threatened by Confederates only a few miles off in Virginia, the arrival of each new regiment from the north was cause for celebration. The Seventy-first New York State Militia posed proudly at the Navy Yard, forming a hollow square, their bayonets at the ready. Neither the bayonet nor the hollow square would see much effective use in the war ahead of them. (AIG)

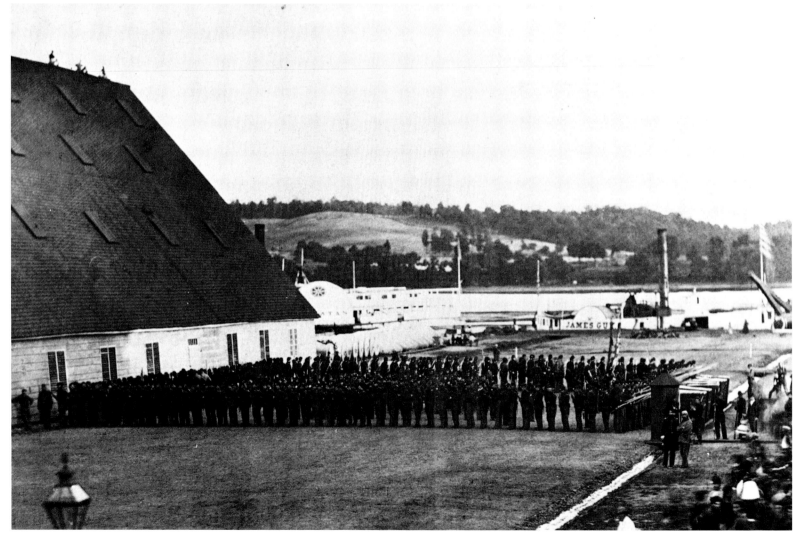

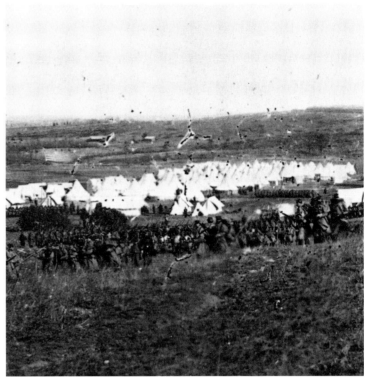

Their camps spread everywhere, like these winter quarters of the Thirty-first Pennsylvania, performing their drill in their greatcoats on a Virginia hillside. (USAMHI)

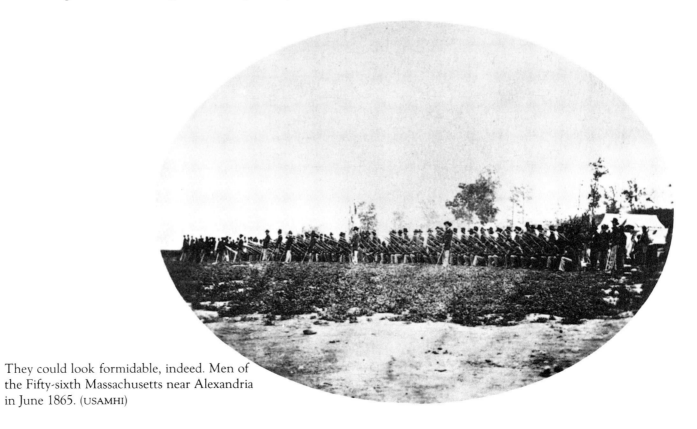

They could look formidable, indeed. Men of the Fifty-sixth Massachusetts near Alexandria in June 1865. (USAMHI)

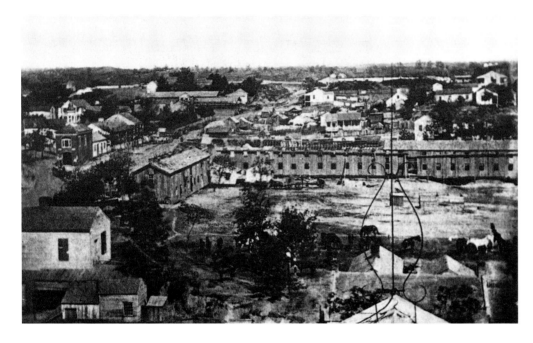

Out with the western armies, the boys were little different. Whether here in the barracks of the 124th Illinois at Vicksburg . . . (USAMHI)

. . . or here, photographed by French & Company in the barracks of the Fifty-second U.S. Colored Infantry at Vicksburg, Billy Yank was Billy Yank. (KA)

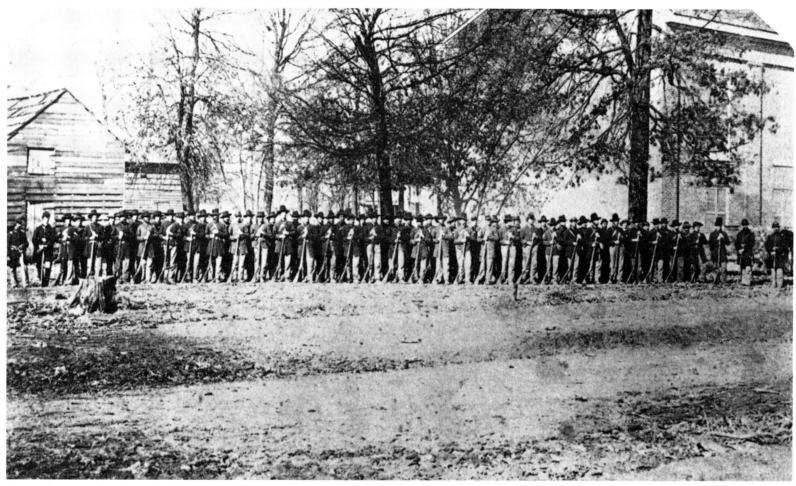

He was looser in his dress than his eastern brethren. Like the Forty-seventh Illinois here in Mississippi, he preferred a slouch hat to the more military short-billed kepi worn in the Army of the Potomac. (WMA)

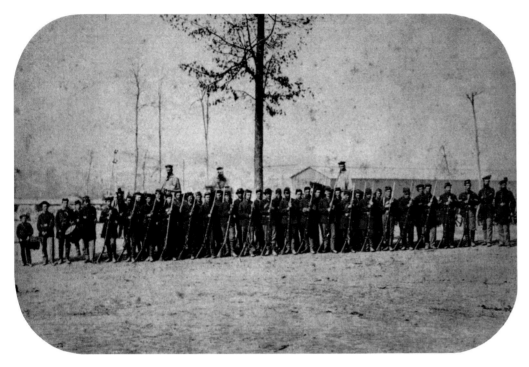

Among Company D of the Twenty-second Ohio, shown here at Corinth, Mississippi, there is every variety of headgear, from kepis to slouch hats, and even what appear to be Scottish tams. (RFC)

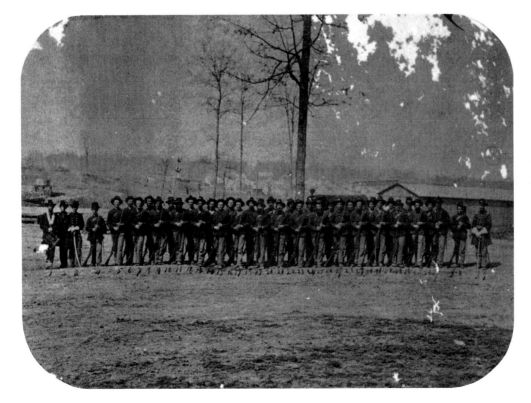

Even though these unidentified Yanks at Corinth are far more consistent in their costume, still they have the somewhat unkempt look of the Westerner. (RFC)

And the Billy Yank from the West tended to look a bit leaner, more rawboned, more like his Confederate foes. Unidentified Billy Yanks at Vicksburg. (RFC)

But like his brothers with the Army of the Potomac, he sprawled out all across the South as the armies advanced into the Confederacy. Here at the Knoxville Deaf and Dumb Asylum, Billy Yanks sit on the lawn awaiting a celebration on the platform erected on the steps beneath the garland-festooned columns. (KKCP)

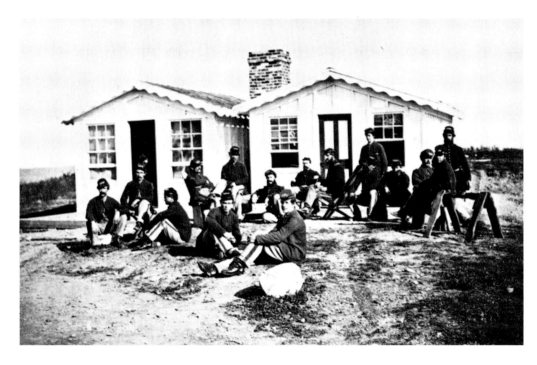

His specialty, as with soldiers of all armies, at all times, was relaxation. When ninety percent of a soldier's time was spent finding ways to fill free hours, he could become expert. (USAMHI)

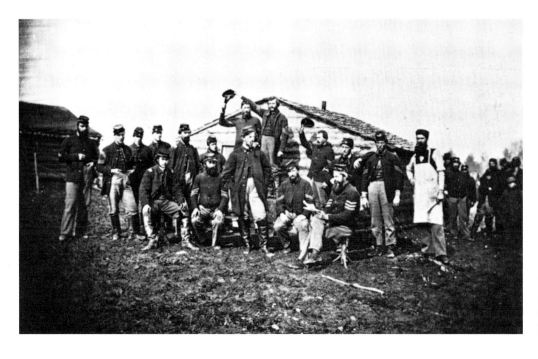

Wherever he went, there was always time to sit, light a pipe, read a letter, pose for the camera, build a winter hut, or fashion a rude bench. (USAMHI)

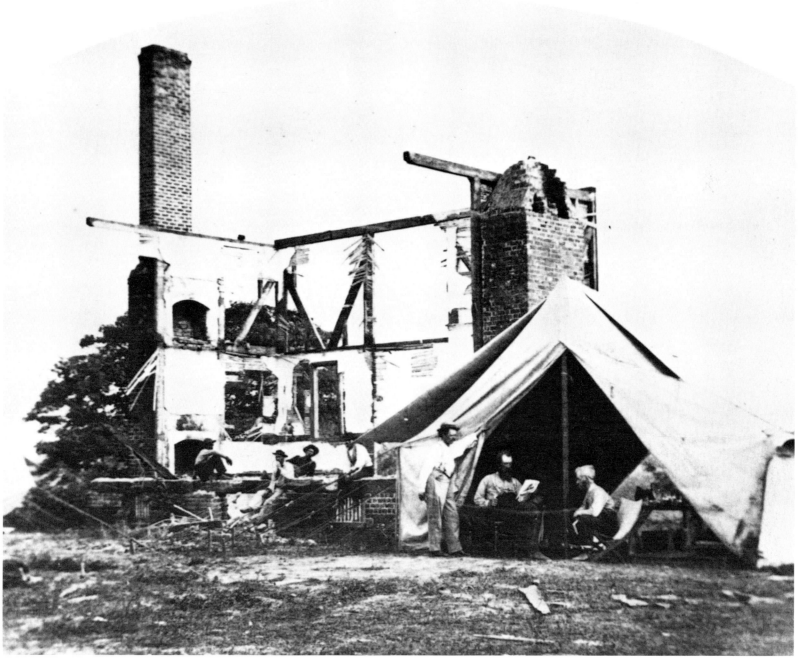

In the shadow of war's destruction, he pitched his tent. (USAMHI)

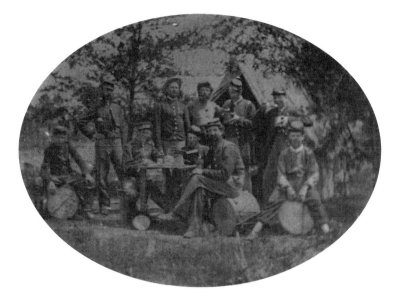

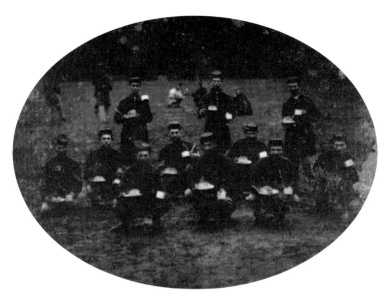

Eating, at home a mundane experience, now became an end in itself — a variation, however brief, in the endless monotony of the field. With bread on the table, some of these boys joyfully shovel heaping spoonfuls of food out of their mess tins and into their mouths. (JAH)

Eleven unknown Yanks pose with their mess plates and cups and a hearty bread ration. (JAH)

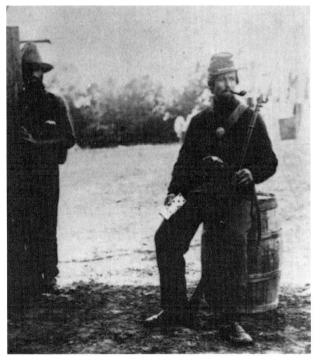

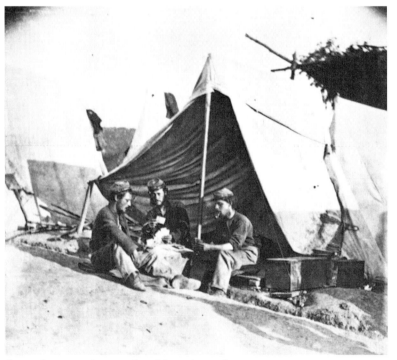

Gambling was a favorite pastime, and a sociable one — though not for this fellow with cards in his hand and no one else in the game. (JAH)

A good pipe and a couple of friends made a game of poker a pleasant distraction. (USAMHI)

These three sergeants are playing an unidentifiable game. While the two Yanks on either side display hands full of face cards, the fellow in the middle appears pretty confident with his ace of spades showing. (JAH)

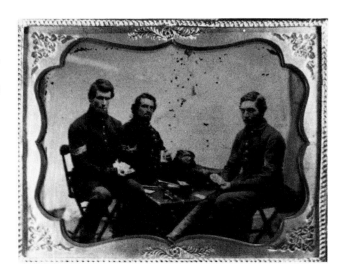

Showing a hand of cards, good or bad, was a favorite pose for Billy Yank, though it is unlikely that he played in full uniform, knife in his belt, jacket buttoned to the collar, especially in the heat of Hilton Head where these boys of the Third New Hampshire posed in 1862. The camera was still a sufficiently new experience for Billy Yank that he could rarely resist spoiling a "candid" image by overdressing. (USAMHI)

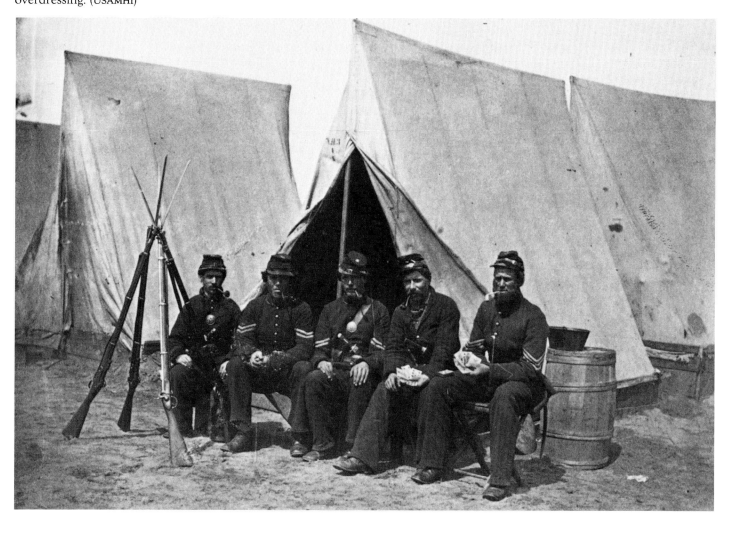

Relaxation, in all its forms, occupied more of Billy Yank's time in a single month than all the time spent in battle during the entire war. Boredom sometimes became a greater enemy than the Rebels. (TF)

Many found solace in liquor, and every camp had its sutlers anxious to ply their wares from their tents and makeshift bars. (JAH)

Top left: But mostly they simply talked, refought their old battles . . . (JAH)

Top right: . . . frolicked when they could . . . (JAH)

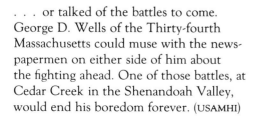

. . . or talked of the battles to come. George D. Wells of the Thirty-fourth Massachusetts could muse with the newspapermen on either side of him about the fighting ahead. One of those battles, at Cedar Creek in the Shenandoah Valley, would end his boredom forever. (USAMHI)

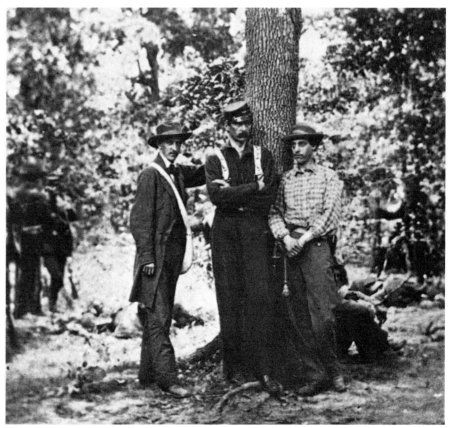

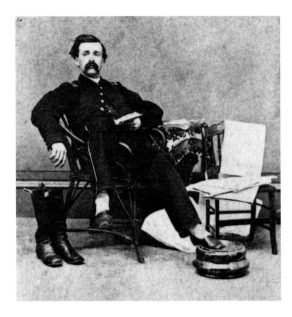

As much as anything, however, the men in blue loved to pose for the cyclops eye of the camera. A sort of formal nonchalance surrounds this officer eschewing his boots for carpet slippers. (JAH)

Whether in the formal studios of Washington and New York or at the tent-darkrooms of the artists with the armies like the cameraman here in South Carolina advertising his "Dagtyps," Billy Yank was ever willing to sit and pose. (USAMHI)

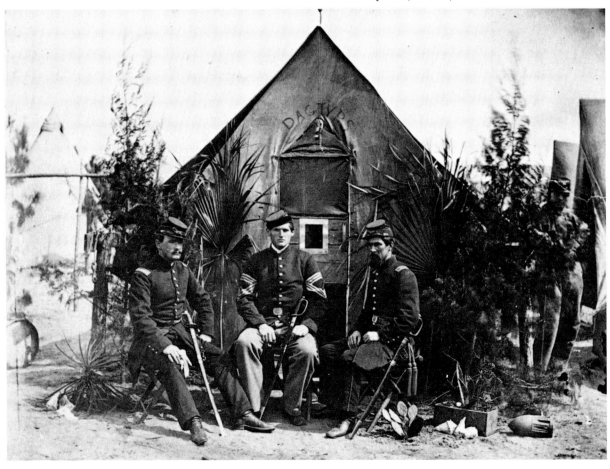

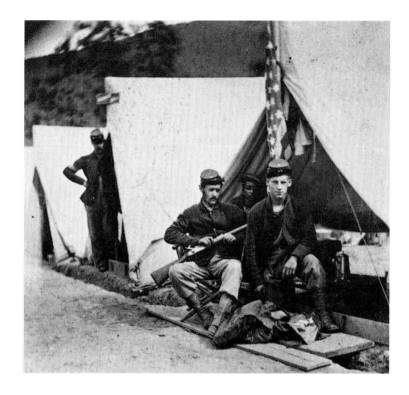

Top left: In winter quarters, Company K of the First New York Cavalry allows the camera to capture it in a formal flag raising in February 1862. (RFC)

Top right: But the best pose of all was with a comrade, perhaps with a knapsack open, like this lad of the Twenty-second New York at Harpers Ferry in 1862, . . . (USAMHI)

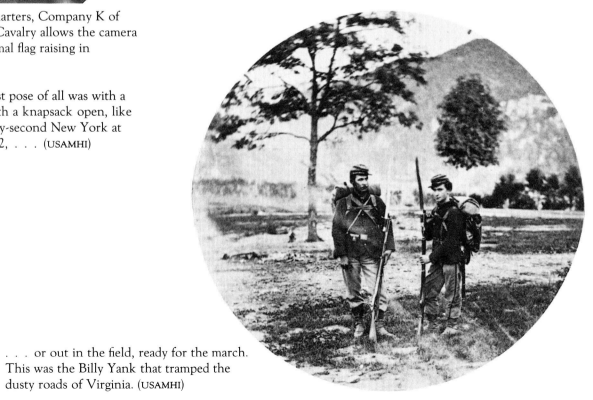

. . . or out in the field, ready for the march. This was the Billy Yank that tramped the dusty roads of Virginia. (USAMHI)

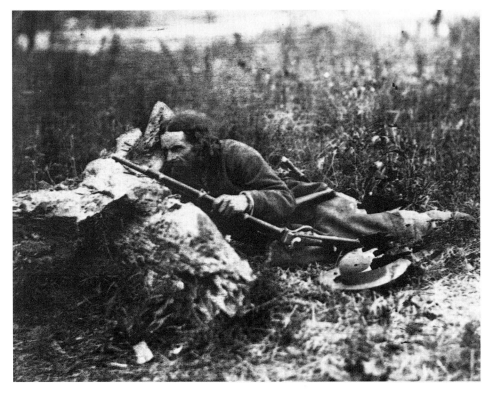

A few of them were older fellows, like old Pvt. Truman Head of the First United States Sharpshooters, who was better known as California Joe. A noted marksman from the West, he is said to have made a will at the war's start, leaving $50,000 for the care of disabled Billy Yanks in case of his death in the war. "Entirely free from brag and bluster," wrote a comrade, Head "was one of those splendid characters that made him a hero in spite of himself." The same might have been said of Billy Yank in all his guises. (VHS)

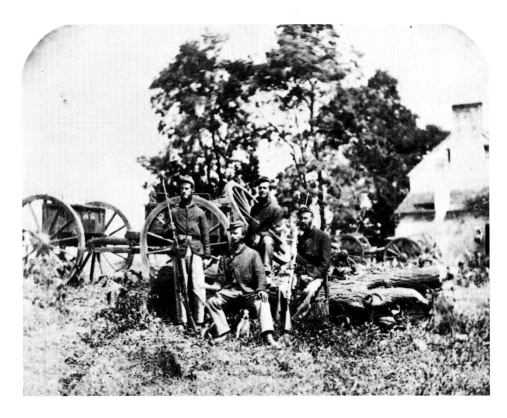

But mostly they were young, like their puppy mascot, and sprouting their first beards. (USAMHI)

They performed all kinds of duties. Some, like Mike Crowley of the Twelfth Massachusetts, were teamsters, caring for the mules . . . (USAMHI)

. . . and driving the wagons and carts that carried water and the soldiers' impedimenta. (USAMHI)

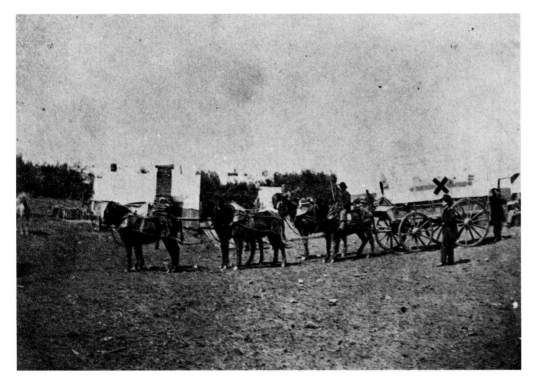

With the soldier's way of turning the mundane into a contest to lend it a little excitement, the drivers even raced their teams. Here the "crack team" of the VI Corps' First Division, near Virginia's Hazel River in 1864. (USAMHI)

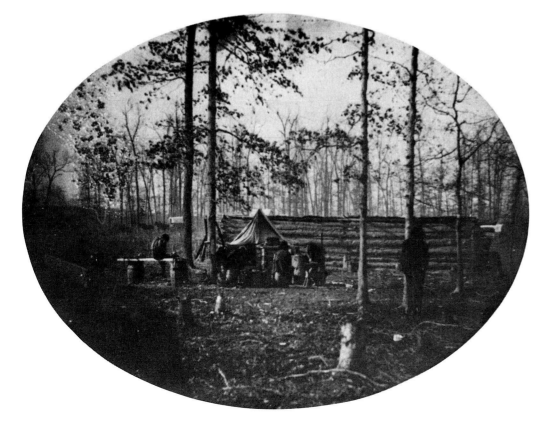

Many plied their civilian trades as blacksmiths, striking at the enemy with blows upon the anvil. (TPS)

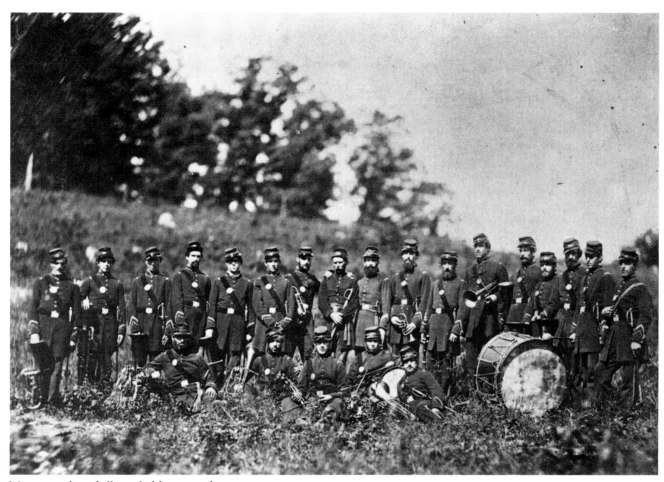

Most popular of all, probably, were the musicians with their drums and horns. They could turn a boring evening in camp into a songfest. (USAMHI)

Billy Yank would remember his war songs for the rest of his life, and many would live forever. "John Brown's Body" was first performed by a military band in May 1861 under the direction of bandmaster W. J. Martland. Its tune would soon be adopted for the "Battle Hymn of the Republic." (USAMHI)

No one was more resplendent than a military drum major. (JAH)

He could look and dress like what the innocent prewar boys thought a soldier ought to appear. (JAH)

Top left: The twitter of the fife was never forgotten, nor the sight of the fifer in his musician's frock coat. (JAH)

Top right: Neither was the sound of the rotary valve horn, . . . (JAH)

. . . especially if it was a booming giant like this one. Music meant a lot to Billy Yank. (JAH)

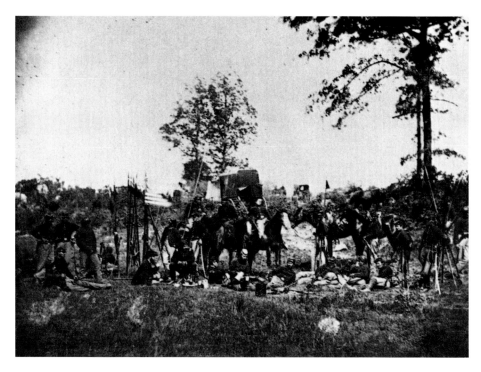

There were a number of specialized units — like the Sixth Pennsylvania Cavalry, better known as Rush's Lancers, thanks to their being armed in part with the outmoded cavalry lances seen here sticking out of the ground. The men were happy to eschew the lance in favor of more practical arms. (USAMHI)

By far the most popular kind of unit in the North was the zouave regiment, its gay uniforms patterned after the French. This unidentified company of zouaves poses for a photographer in Rochester, New York, early in the war while a crowd gathers to admire their turbans and colorful clothing. (WCD)

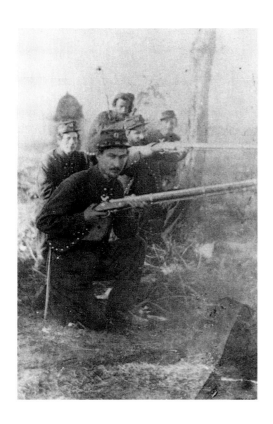

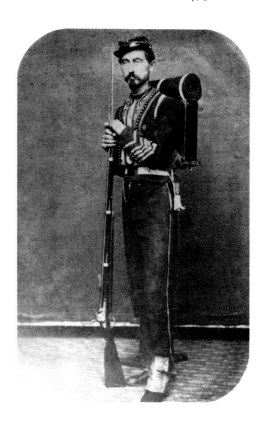

Top left: Some of the zouaves were modest in style, like the Ninety-fifth Pennsylvania, Goslin's Zouaves. (RP)

Top right: Others were a bit more ornate, like this unidentified zouave. (JAH)

Bottom left: Their jackets were seemingly infinite in variety, their pants often baggy . . . (JAH)

Bottom right: . . . and frequently straight, like those of the Forty-sixth Indiana. Zouaves in the western armies were fewer, and more restrained in their attire, with little to set the Forty-sixth apart as zouaves but the jackets. (HLY)

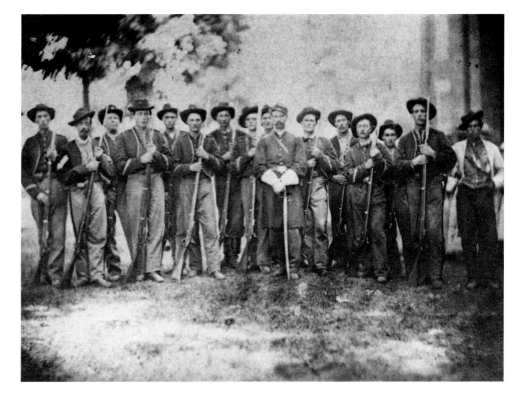

Top left: Burnside's Rhode Island Zouaves were among the earliest in the service, and one of the most colorful. (JAH)

Top right: The headgear could be marvelous, if hardly utilitarian. (JAH)

A near relation to the zouave was the chasseur, such as this one from the Eighty-third Pennsylvania. Ostensibly trained for very rapid movement, the chasseur in this war was an infantryman like everyone else. (JAH)

Top left: Another chasseur — this one holding a Volcanic pistol, an early progenitor of the Henry and Winchester rifles. (JAH)

Top right: But most Billy Yanks looked like this corporal ready for the field, all his equipment in place, rifle at his side. (JAH)

The lads liked to sit for the camera and display their weapons. Half of soldiering, some thought, was striking the right martial attitude. This boy holds a sharpshooter's rifle with telescopic sight mounted on its side. Such weapons were rare, and were used almost exclusively in special units. (JAH)

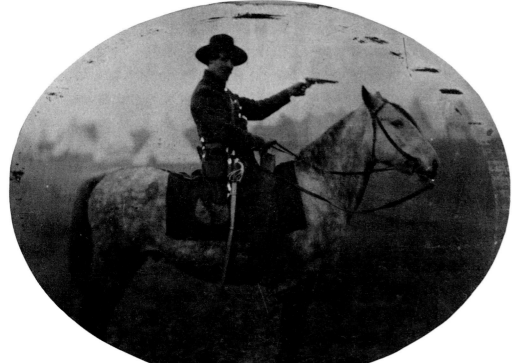

Top left: Most Yanks, like this "Bucktail" from a Pennsylvania regiment, used a standard Springfield or Enfield rifle. (JAH)

Top right: Quite possibly this fellow is a sharpshooter himself, since he holds a Sharps rifle with special double-set triggers used by marksmen. (JAH)

The cavalrymen were no different from their counterparts on foot. When they could, they sat astride their mounts for the camera, like this trooper with his .44-caliber Colt model 1860 revolver pointed, it is to be hoped, toward the foe. (JAH)

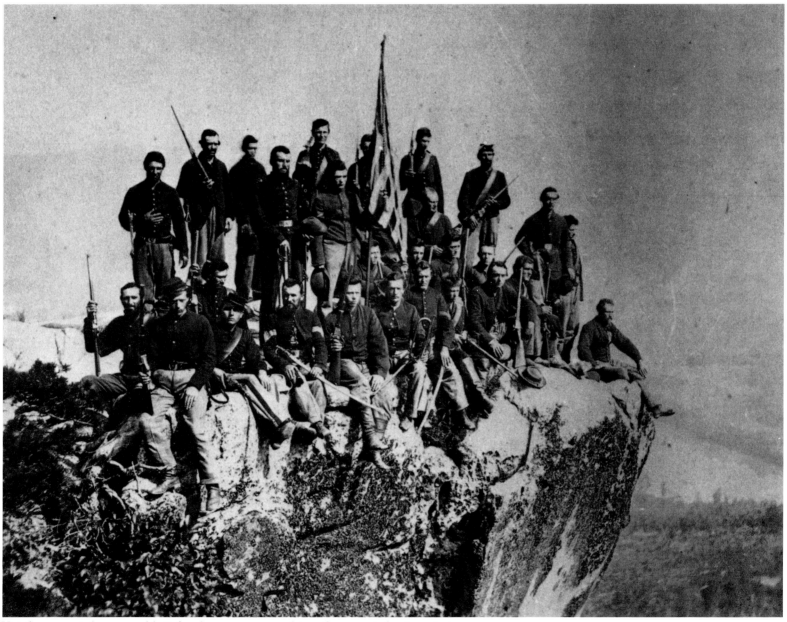

Yet the mounted men could sit for the camera atop things far more lofty than their horses. Men of this unidentified Yankee outfit perch on Point Lookout on Tennessee's Lookout Mountain, clutching their Spencer carbines and their sabers, hats, and flag. (RFC)

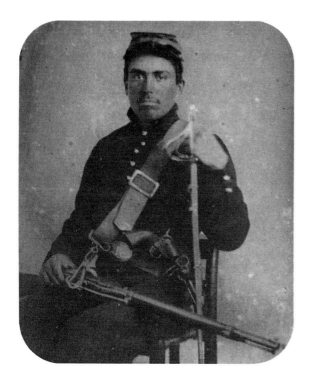

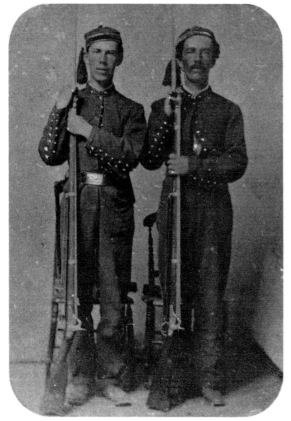

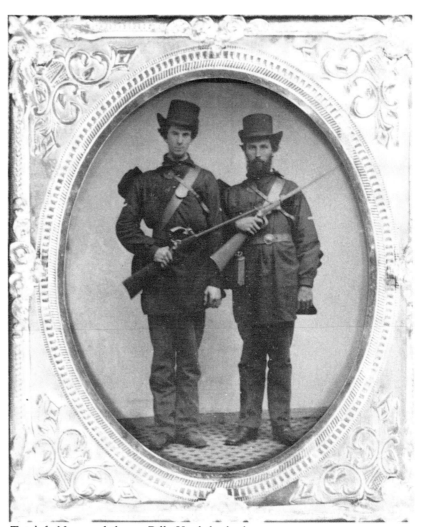

Top left: Now and then a Billy Yank looked like a host in himself, with his Colt, his saber, and even a rare Hall saddle carbine in his lap. That was a lot of hardware to take to war. (JAH)

Top right: They posed with their comrades and tentmates, like these two Rhode Islanders in Burnside blouses and holding Burnside carbines. (JAH)

The zouaves did it. (JAH)

Cavalrymen did it — the one at right leaning
on an early model Henry repeating rifle. (JAH)

Bandsmen did it, horns at their sides as if
they were weapons at the ready. (JAH)

They sat for the camera. (JAH)

Even ate for the camera, crunching on their
hardtack — so-called army bread. (JAH)

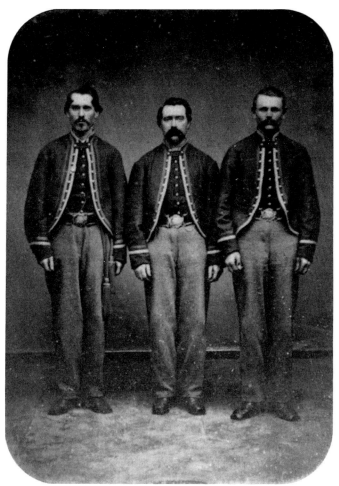

They posed in threes, like these New York
Fire Zouaves. (JAH)

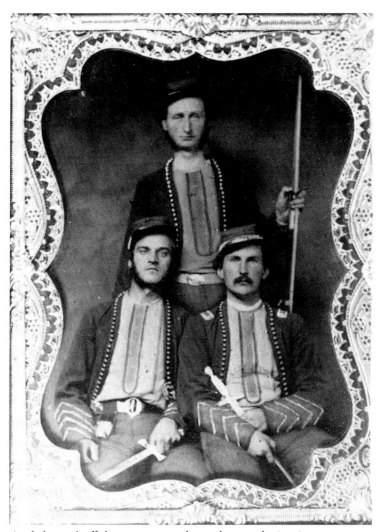

And showed off their ceremonial parade swords. (JAH)

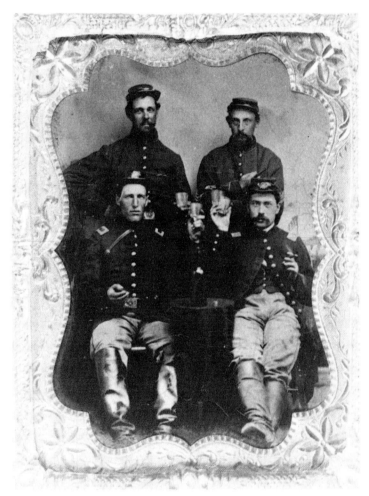

Crossing barriers of rank, officers and
enlisted men posed together and, if this image
may be believed, shared a bottle and cigars
now and then. (JAH)

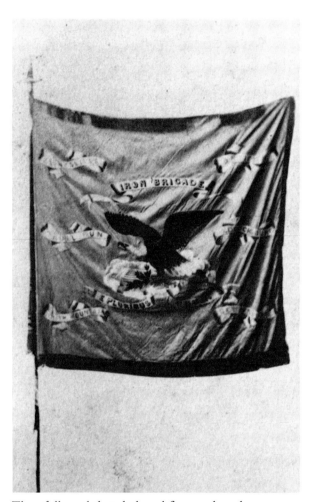

They followed their beloved flags and made
their colors renowned — none more so than
those of the Iron Brigade, its battle credits
for the battles of Gainesville, Second
Bull Run, South Mountain, Antietam,
Fredericksburg, and Gettysburg proudly
displayed. (JAH)

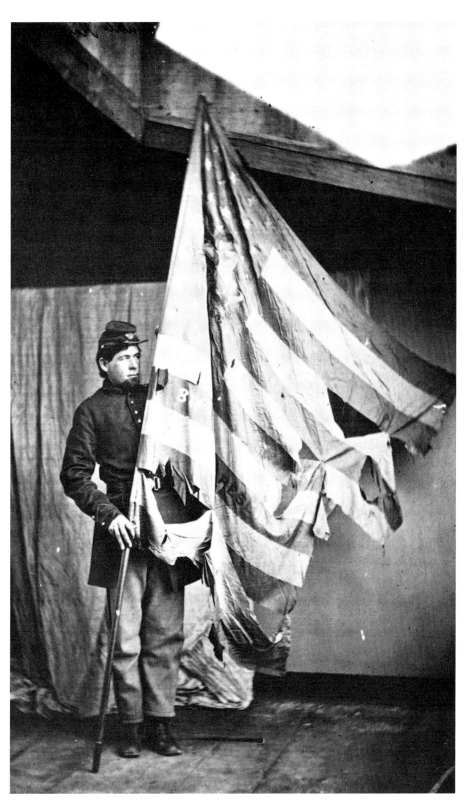

Often their banners showed not only where
the flags had been, but that the journey had
not been an easy one. The colors of the
Eighth Pennsylvania Reserves. (USAMHI)

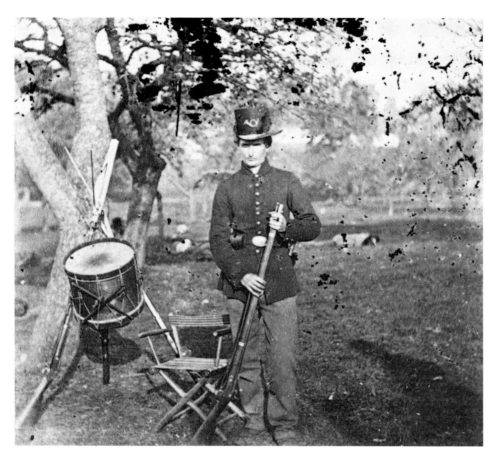

It was not an easy journey for Billy Yank, either, but he faced it squarely, resolutely. (USAMHI)

Bottom left: He risked death from the plains of Manassas to the heights of Lookout Mountain. (JAH)

Bottom right: He did it for fun, for adventure, for love of country and of those left at home, whose photographs he carried with him — or simply because he was drafted and had no choice. (JAH)

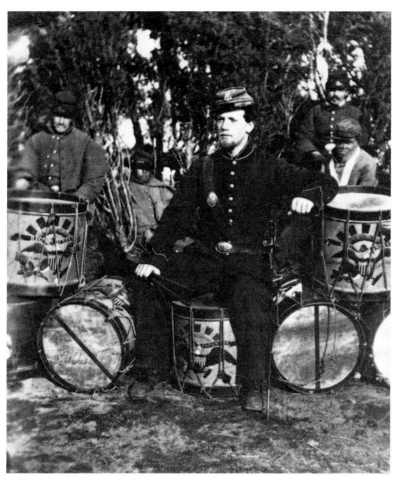

Whatever his reasons, he did the job he was
given. (JAH)

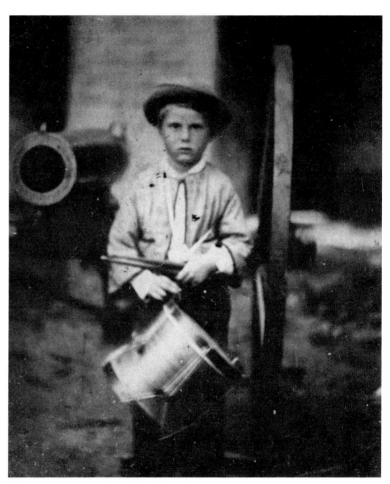

He went to war a beardless boy, full of
innocence and wonder. (JAH)

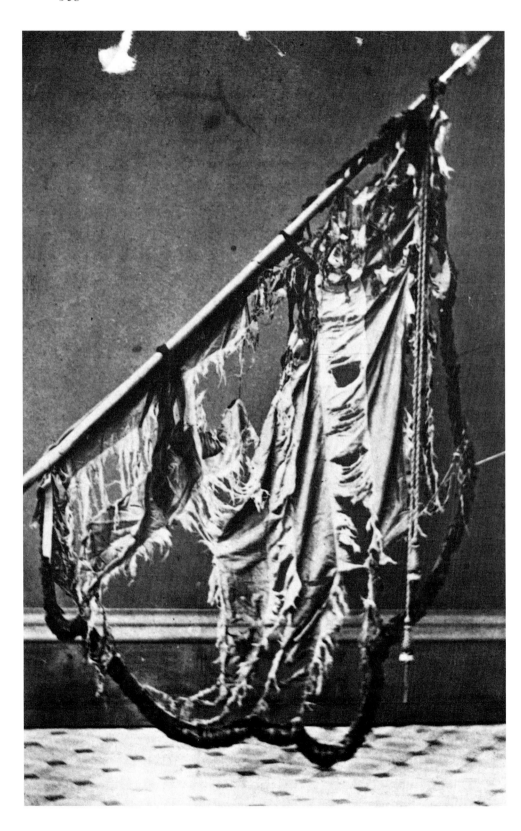

And came home bloodied, scarred — like the colors of the Thirty-third New Jersey — no longer innocent, but ennobled. (TO)

Everyone's War

★ ★

Emory M. Thomas

THE WAR commenced for Billy Yank as a simple conflict about union. Abraham Lincoln called out 75,000 militia troops to confront "combinations too powerful to be suppressed by the ordinary course of judicial proceedings, or by the powers vested in the [U.S.] marshals by law." Jefferson Davis responded by calling for 100,000 men and asserting, "All we want is to be let alone." The American Civil War did not continue so relatively uncomplicated. In four bloody years the war touched countless lives, and the scope of war itself approached totality.

Directly involved in the war were many more people than those 175,000 citizen-soldiers mobilized by Lincoln and Davis in April 1861. And of those involved there were many who were not native-born white American men. Drawn into the conflict were Indians, Mexican-Americans, European immigrants, Afro-Americans, and women. Understanding the enormous impact of the war requires an appreciation of the involvement of these "minorities" and an understanding of the degrees to which the experience of wartime transformed their lives and place in American society.

That society had long made an outcast of the Indian, yet almost from the beginning, the war between rival societies of white Americans also divided red Americans. The principal concentration of Indians close to the conflict inhabited the Indian Territory (the present state of Oklahoma). Known as the Five Civilized Tribes, some of these Indians were slaveholders and so felt some sympathy for the Confederacy, and many associated the Union with the policies by which they had lost their land and with the unkept promises that littered their relations with whites.

Of course Southern whites had also contributed to the Indians' plight, but in 1861 Confederates actively pursued an alliance with the Five Civilized Tribes and seemed to offer some change in what the Indians considered an oppressive status quo. Brig. Gen. Albert Pike, the Confederate commissioned for the task, concluded several treaties with various groups of Indians during the summer of 1861. The Confederacy pledged that Indians would not "hence forward . . . be in any wise troubled or molested by any power or people, State or person whatever."

Cherokee leader Stand Watie proved to be one of the most enthusiastic Confederate Indians. Watie also had signed the treaty that launched the "trail of tears" from Georgia to the Territory, however, and so his support for the Confederacy made him suspect among his people. John Ross, another Cherokee, led an Indian faction committed to remain loyal to the United States. Ross's followers, roughly half the inhabitants of the Indian Territory, tended to be full-blooded Indians; Watie's Confederates were most often of mixed blood.

As long as the United States Army remained preoccupied with missions outside the Territory, Pike and the Confederacy exerted considerable influence among the Indians. Stand Watie recruited three regiments of Indians for the Southern army and Pike led them into action in the Battle of Pea Ridge on March 7, 1862. The Indians, however, saw no good reason to remain on open ground while Federal artillery fired at them; so they took to the woods, where they might fight in a fashion more becoming common sense. After this experience Stand Watie's regiments returned to the Territory and fought an Indian version of the Civil War against pro-Union Indians there.

When the Federals finally sent cavalry units into the Indian Territory, the Confederates proved unable to uphold their pledge to keep their Indian allies from being "troubled or molested." Pike's urgent appeals to Richmond went unanswered, and in November 1862 he resigned. Fighting continued sporadically, though, between the supporters of Watie and Ross. For his efforts Watie became a Confederate brigadier general, and in June 1865 he became the last Southern general to surrender.

The Indians never exerted a truly significant impact upon the war, and neither did the other largely native-American group who served. In a strictly literal sense, all people born in Texas before the revolution in 1836 were Mexican-Americans. And the same logic applied more readily to residents of what became the Mexican Cession in 1848 following the Mexican War. Most Texans, however, had considered themselves "temporary" Mexicans at best, and in Confederate Texas friction continued between Anglos and genuine Mexican-Americans. Elsewhere, in New Mexico, Arizona, and California, Mexican-Americans divided between North and South. Landowners who practiced peonage tended to identify with the Confederacy. New Mexican Miguel Antonio Otero, Sr., plotted briefly to form a separate Pacific confederacy while North and South warred in the East. Both Confederate and Union armies had Mexican-American volunteers and conscripted troops.

Prominent among Mexican-American participants in the Civil War was Salvador Vallejo, who led a Union cavalry battalion of Californians that patrolled the Mexican border and fought Apaches. On the Confederate side Juan Quintero became a valuable diplomat. He secured friendly trade relations with Governor Santiago Vidaurri of Nuevo León and oversaw the passage of war supplies into Texas from Matamoros and northern Mexico in exchange for Confederate cotton.

Far more numerous than Mexican-American and Indian participants in the war were European-born immigrants to North America. Although the roots of the sectional quarrel lay deep within the early life of the American republic and the very name American Civil War implied a struggle between native-born rivals, the country had ever been a nation of immigrants. Thus it should not be surprising that immigrants played a significant part in the conflict.

Approximately 24 percent (five hundred thousand) of the men who served in the Union army and navy were born outside the United States. Even though this means that nearly one of every four soldiers and sailors was an immigrant, foreign-born Americans still were underrepresented as a proportion of the military-age male population. Englishmen and German-born Protestants tended to enlist in numbers larger than their proportion of the population. But Irish- and German-Catholic immigrants seemed generally less eager to volunteer — perhaps because they tended to identify with the Democratic party and associated the war with Republicans. Also, aliens who were not yet citizens and those who arrived to fulfill labor contracts were not liable for the draft. Whatever the cause, the Confederate-proclaimed myth of a Union army composed almost entirely of "foreign hirelings" is precisely that — a myth.

Best estimates of foreign-born Confederate soldiers and sailors conclude that somewhere between 9 and 10 percent of men in the Southern military were immigrants. Yet immi-

grant men in the South were only 7.5 percent of the total military-age male population. So foreign-born soldiers and sailors were overrepresented in the Confederate military, and assertions that Southern soldiers were all pure, native-born Americans are as false as those that depict Federal armies as foreign hordes.

The contribution of immigrants to the war was indeed significant. During most of the war period, half of the six members of the Confederate cabinet were foreign-born (Judah Benjamin, Christopher Memminger, and Stephen Mallory). And when William Browne was interim secretary of state, two-thirds of the Southern cabinet were immigrants. On the Union side, the navy certainly appreciated the technological innovations of two Swedish natives: Adm. John A. Dahlgren devised the gun named for him that was used widely on Union warships; and John Ericsson developed the *Monitor*, which altered forever naval design and strategy and became the prototype for Federal ironclad vessels. Again on the Confederate side, Dublin-born John Mallet designed vital machinery to make Southern artillery. And Swiss-Southerner Henry Hotze became the Confederacy's foremost propagandist in London. Hotze's newspaper the *Index* printed usually reliable news of the American war and reasoned editorials slanted toward the Confederate cause.

Among those half-million foreign-born troops in the Federal army were six major generals, including Hungarian cavalryman Julius Stahel, who won a Medal of Honor. Twenty brigadier generals were immigrants — born in Germany, Ireland, France, Russia, Hungary, Poland, and Spain. And one of the most renowned Union units was the Irish Brigade from New York.

Of foreign-born Confederate soldiers, two became major generals: French native Camille A. J. M. de Polignac and Irishman Patrick R. Cleburne, the Stonewall of the West. Indeed, it is a safe bet that had it not been for army politics, Cleburne would have become at least a lieutenant general. One Louisiana regiment reportedly counted members from thirty-seven foreign states.

Neither side ever attempted to employ mercenary troops from abroad as the British had done during the Revolution. Nor did European nations intervene in the conflict as many expected. Nevertheless, the American war was a decidedly cosmopolitan affair.

Blacks, like everyone else on the continent, had once been immigrants. But by 1860 the overwhelming majority of them were native-born. The Negro presence and the South's "peculiar institution" that rendered over 3 million Afro-Americans slaves had much to do with the sectional conflict that provoked secession and war. And after Lincoln's Emancipation Proclamation, what had been nominally a war for Union became more clearly also a war against slavery.

One story, perhaps apocryphal, recounts the counsel of an aged black man when younger blacks asked him what they should do about the conflict. Think about this war, the old man said, as a fight between two dogs over a bone. North and South are the dogs, and we are the bone. Did you ever see a dogfight in which the bone took part? Despite the wisdom of the old man's advice, though, Negroes were much involved in the Civil War from its outset.

Although neither side accepted black men as soldiers in 1861, the Federal navy had black sailors from the beginning. Eventually several thousand black men served on Northern vessels. Most prominent was Robert Smalls, who captured the Confederate steamer *Planter* in Charleston harbor and sailed her out to the Federal blockading squadron. Thereafter Smalls served the United States as a pilot for Union warships.

Black men marched off to war with Confederates, too, although they were supposed to be noncombatants. Many Southern officers and some enlisted men took black body servants with them into camp and combat. These men usually performed camp chores for their masters; but in emergency circumstances they were known to take up arms in battle and fight as well. More important to the Southern war effort were the military laborers who toiled within the Confederate military. They dug trenches and fashioned field fortifications, cooked for the troops, and drove wagons and moved supplies to war fronts.

Behind Southern lines black labor was also crucial. The slaves who continued to work on farms and plantations permitted white men to leave those farms and plantations to join

Southern armies without leaving fallow fields. Blacks also worked extensively in the war industries that kept Confederate troops armed and supplied. For example, in the naval ordnance works in Selma, Alabama, 310 of 400 workers were black. And in military hospitals, often more than half of the male nurses were black men.

When Abraham Lincoln delivered the formal, final version of his Emancipation Proclamation on January 1, 1863, he authorized recruitment of black troops in Union armies. Ultimately, an estimated 186,000 black men, 9 percent of the total number of Federal soldiers, literally fought for the cause that freed them.

In several ways, however, the United States tried to make black troops "second-class soldiers." Until late in the war, black men only earned $10.00 per month for their service; the lowest pay for whites was $13.00, plus a $3.50 clothing allowance. Fewer than 100 black men were commissioned combat officers, and none held a rank higher than major. Moreover, the Washington government for a long time resisted committing black regiments to combat and instead used black units for garrison and labor duties. As a result combat deaths among blacks occurred at a rate of about 1.5 percent, compared to 6 percent for whites. The black death rate from disease, however, was 19 percent, nearly double the white rate — facts that reflect the blacks' static service in less than healthy locales.

One reason the Federal War Department shrank from sending black troops into battle was the fear of Southern reprisals against former slaves. In fact the Confederates did threaten to enslave or execute black prisoners, but generally did not carry out such threats. Yet in some cases — most infamously at Fort Pillow, Tennessee, in April 1864, and Saltville, Virginia, that October — Confederates did kill a very high percentage of black Federals, many of whom were already wounded or had surrendered.

When black troops did do battle against the Confederates, they generally acquitted themselves quite well. In Louisiana, at Port Hudson in May 1863 and Milliken's Bend in June, during the campaign for Vicksburg, black regiments earned respect and praise from their white comrades. And had a black division charged first into the Crater at Petersburg in July 1864, as

originally planned, that action might not have been such a bloody Federal fiasco.

As Confederate fortunes and available manpower declined, some Southerners began to favor using black troops. Gen. Patrick Cleburne proposed in writing to the officer corps of the Army of Tennessee in January 1864 that the Confederacy arm and free massive numbers of black men to save the Southern cause. Although Jefferson Davis suppressed Cleburne's paper and the debate that attended it, the idea reappeared during the summer and fall of 1864. Finally Davis asked his congress for an act to arm Southern slaves and free them upon completion of faithful service. The Confederate Congress, after considerable debate throughout the South, authorized black enlistments in mid-March of 1865.

Although a company of black men in gray did drill on Capitol Square in Richmond during the last of March, the Confederate decision to make black men comrades-in-arms came much too late to affect the outcome of the war. Yet on both sides the actions and involvement of Afro-Americans were vital.

By far the largest minority in the United States in 1860, however, were the women — some 48.8 percent of the population. A few women on each side disguised themselves as men and took part in combat. But even though, with a very few exceptions, men did the fighting, women were much involved in the war, both directly and indirectly.

Women served both Union and Confederate armies as spies, and although spying is by nature an extremely secretive activity, some female spies achieved celebrity status for their exploits. Rose O'Neal Greenhow used her social connections in Washington to learn Federal plans for what became the First Manassas campaign and transmitted this intelligence to Confederate general P. G. T. Beauregard. This coup cost Greenhow several months in prison, where she was kept until the spring of 1862, when the Federals sent her south to a heroine's welcome. In the Confederate capital, Elizabeth Van Lew was "Crazy Bet" to her neighbors. But beneath her facade as an eccentric spinster, Van Lew was a Federal spy who organized a circle of Unionists and sent coded messages to Federal gen-

erals. Another celebrated Southern spy was Belle Boyd, who escaped arrest to carry vital intelligence to Stonewall Jackson during his Valley campaign. For the Union, Emma E. Edmonds once posed as a black laborer and often disguised herself as a male soldier during the course of numerous daring missions.

On a less elevated plane, wartime generated increased opportunities for some women to practice a much older profession. Extraordinary rates of venereal disease in both armies attest the prevalence of prostitutes and camp followers, who undeniably played a role in meeting some basic needs of the soldiers.

American women began entering, too, what was for them a new profession during the war: they overcame male objections and outright hostility and became nurses. In the North, 3,200 women nursed wounded and diseased soldiers; they constituted about one-fourth of the total number of the Union's nurses. In the South, women quite often responded to medical emergencies with volunteer efforts. But Confederate military hospitals also employed female nurses as official staff members. Mary Walker held a Federal appointment as a surgeon, and Sally Tompkins received a Confederate captain's commission to command a military hospital in Richmond.

Throughout the Union, women responded to the needs of soldiers through the Sanitary Commission. They raised money, purchased or donated food, clothing, and medicine, and distributed these items to the troops. In addition Sanitary Commission volunteers worked with army officers to elevate standards of hygiene and food preparation in military camps. Women in the North also worked through the Christian Commission, an extension of the YMCA, to distribute evangelical tracts and to offer food, care, blankets, and clothing to the troops.

Southern women also formed and assisted volunteer organizations to care for Confederate soldiers. But because the war was often nearby, the women of the Confederacy responded more directly and less institutionally to the needs of the troops. When Confederate units marched through Southern cities and towns, for example, they invariably met sympathetic females who greeted the men with smiles, flowers, and food.

The individual efforts of some wartime women were especially notable. Dorothea Dix served the Union as superintendent of female nurses. She attempted to insure professionalism among her charges by insisting that all of them be over thirty years old and "plain in appearance." Confederate nurse Phoebe Pember gained authority in her ward by seizing the key to the whiskey barrel to control access to the "medicinal spirits." Clara Barton's work with relief agencies during the war enabled her to found the American Red Cross in later years.

Women who remained in their homes, too, quite often felt the impact of the war. For when men went off to fight, the women they left at home of necessity managed the farms, sometimes ran the shops, and usually assumed roles as head of the household. Thus in ways private and subtle, as well as public and obvious, women took part in the war experience.

By 1865 the Civil War had touched individuals and groups of people who seemed immune in 1861. And in turn the total war that Americans fought expanded to encompass issues and aims much larger than the simple question of whether some Southern states could or should secede from the Union. Both in terms of participation and impact, it was everyone's war — a thoroughly national trauma.

It is highly fitting that in a civil war between Americans, the only true native Americans were themselves involved, and just as divided as their white neighbors. Indians fought, often for reasons entirely their own, on both sides. Col. John Drew commanded a regiment of Cherokee Mounted Rifles out west for the Confederacy. (SI)

Richmond sent Brig. Gen. Albert Pike to enlist for the Confederacy the support of the so-called Five Civilized Tribes. He was only partly successful. (NA)

Longtime neighbors — and usually enemies — of the Indians were the Mexican-Americans living along the border. Many served in both armies, and those with the Union frequently operated out of Brownsville, Texas, on the Rio Grande. (USAMHI)

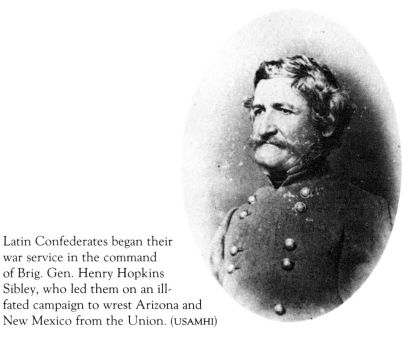

Latin Confederates began their war service in the command of Brig. Gen. Henry Hopkins Sibley, who led them on an ill-fated campaign to wrest Arizona and New Mexico from the Union. (USAMHI)

The Thirty-third Texas Cavalry numbered several Mexican-Americans among its officers, including Refugio Benavides, at left; Atanacio Vidaurri, next to him; and Cristobal Benavides, second from the right. (UAL)

Far more numerous among the soldiers were the Germans, the largest non-English-speaking group to enter the war. Fighting chiefly for the Union, they followed their own beloved leaders — men like Gen. Franz Sigel, who, though a miserable leader, could inspire thousands to enlist. (USAMHI)

Lincoln gave military appointments to many influential immigrants, chiefly in order to use their popularity to encourage enlistments. Carl Schurz, a Prussian revolutionary who fled Europe for America, became a major general and — at times — a trusted ally of the president. (NA)

The Irish, North and South, flocked to their nations' banners in great numbers. Few generals in the Confederate army won a more brilliant reputation than Irish-born Patrick R. Cleburne, sometimes called the Stonewall of the West. He gave his life for the cause at Franklin, Tennessee, in 1864. A previously unpublished portrait. (ADAH)

Across the lines was Brig. Gen. Thomas W. Sweeny, born only a few miles from Cleburne, and pitted against him occasionally in the Atlanta campaign. Something of a professional revolutionary, he tried after the war to foment a revolt against the British in Canada. (NA)

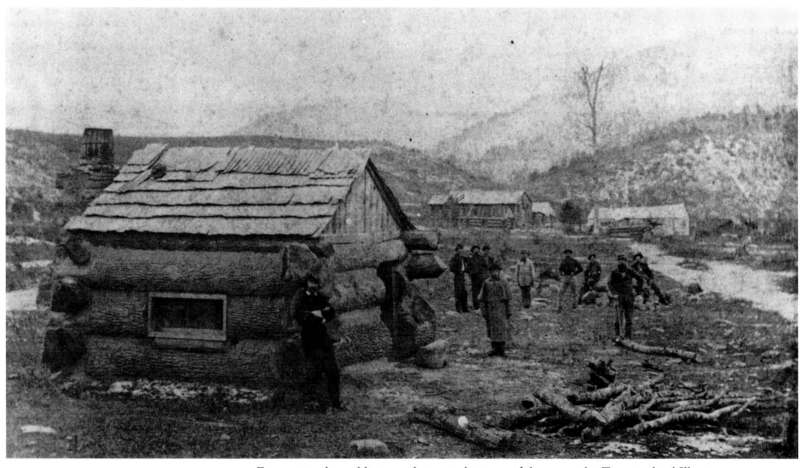

Few units achieved lasting sobriquets, but one of them was the Twenty-third Illinois, which became known to posterity as the Irish Brigade of the West. So potent was the Irish connection that the nickname stuck even though many of its members were not sons of Erin. In 1862 the Irish Brigade wintered at New Creek, in western Virginia. Shown here is their headquarters, "the Den," and standing in front of it, arms folded, is probably their commander, Col. James A. Mulligan. (CHS)

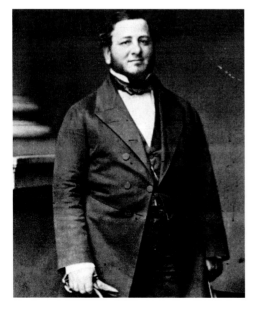

Jews participated in all strata of the war effort, yet ironically it was in the Confederacy, a region notorious for its xenophobia, that a Jew rose the highest. Judah P. Benjamin, a Sephardic Jew born in the West Indies, held three different cabinet posts, most notably secretary of state. (NA)

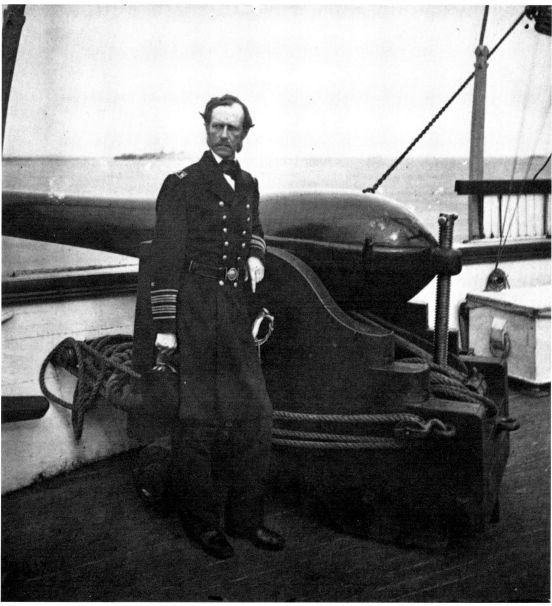

Adm. John A. Dahlgren, son of a Swedish diplomat to the United States, rose to command the Union's South Atlantic Blockading Squadron, playing a large part in the siege of Charleston and the development of naval weapons. He poses here with the naval deck gun that bears his name. In the distance over his shoulder appear what may be the rubble remains of Fort Sumter. (LC)

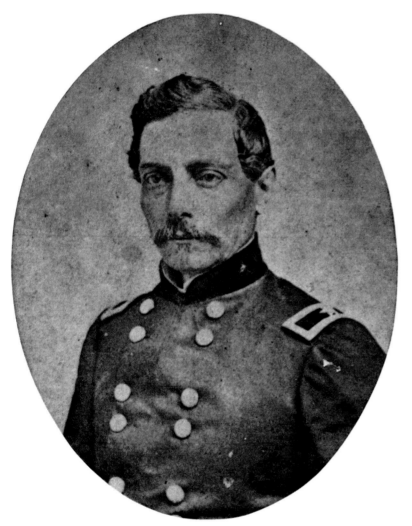

Though not foreign-born, Confederate general P. G. T. Beauregard came of French extraction, and rose early in the war to become a Southern hero, and the fifth-highest-ranking officer in the Confederacy. (SHC)

Another Frenchman, this one from Millemont, Seine-et-Oise, was Camille Armand Jules Marie, the Prince de Polignac. Beginning the war on Beauregard's staff, he rose to divisional command. When he died in 1913, he was the last surviving Confederate major general. An unpublished portrait until now. (ADAH)

The Thirty-ninth New York, better known as the Garibaldi Guard, affected not only a resplendent European uniform but also chiefly European officers. Col. Frederick G. D'Utassy commanded. (AIG)

Lt. Col. Alexander Ripetti served with him. (USAMHI)

But largest of all the minorities involved in this war were the people it was all about, the blacks. At first little or no role was expected for them. Pilot Robert Smalls had to make a place in the struggle for himself when . . . (USAMHI)

. . . on May 13, 1862, he seized the steamer *Planter* and sailed her out of Charleston to the hands of the blockading fleet. (NHC)

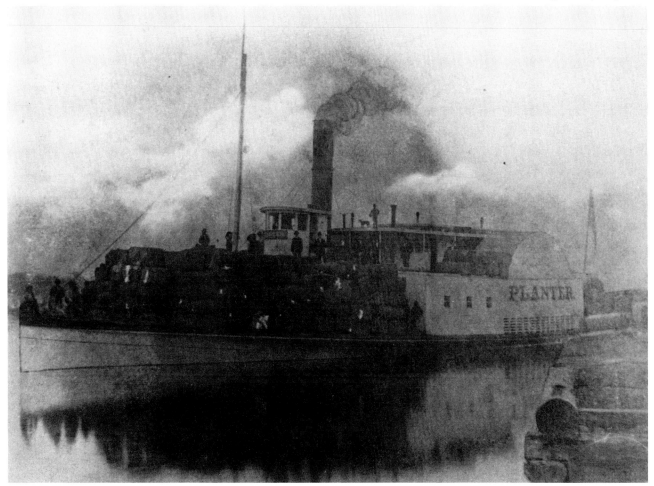

The only part in the war expected for Southern Negroes was as servants and laborers. Jake Alker spent almost all the war as President Jefferson Davis's manservant. (USAMHI)

When Kentuckian John C. Breckinridge, shown here in 1865 after escaping Federal pursuers, went to war to become a Confederate major general, . . . (WCD)

. . . Tom Ferguson went to war with him as valet. He helped the general make his escape at war's end, and as friends, rather than master and servant, they remained loyal to each other after the conflict ended. (LH)

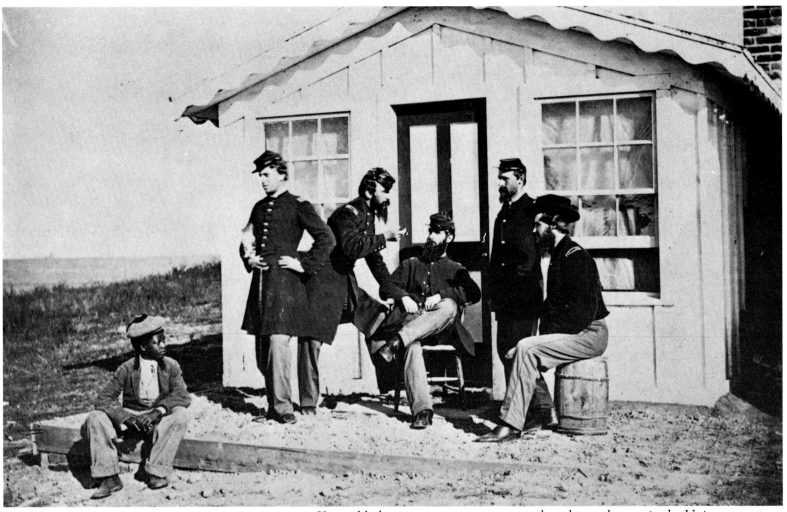

Young blacks went to war as servants—though not slaves—in the Union army, too. Few officers' messes failed to have at least one "boy" to tease and keep house. (USAMHI)

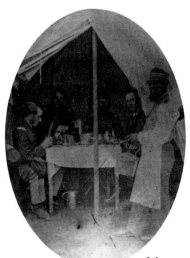

Many served as cooks and waiters. (JAH)

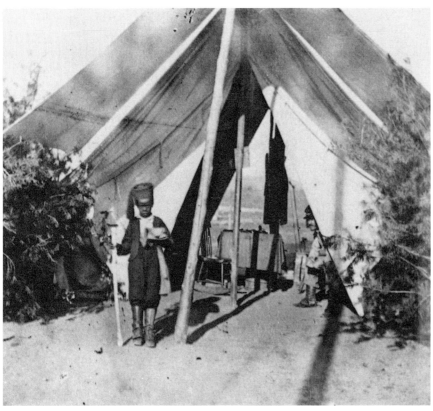

Some were barely big enough to serve as anything. (USAMHI)

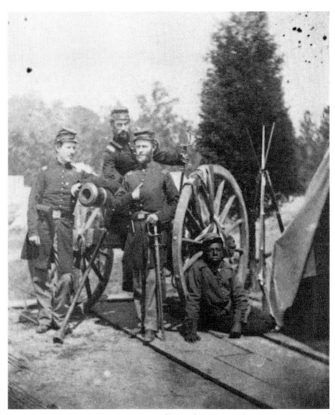

Often they were given cast-off uniforms and allowed to socialize with the men and officers, perhaps earning a few dollars performing odd jobs. (RFC)

A few became regimental mascots, along with dogs and roosters, like these "pets" of the Forty-first Illinois. (TO)

Many able-bodied black men stayed with the armies as paid laborers, digging earthworks, doing the washing, or, as here, helping to clear land and build winter huts. (USAMHI)

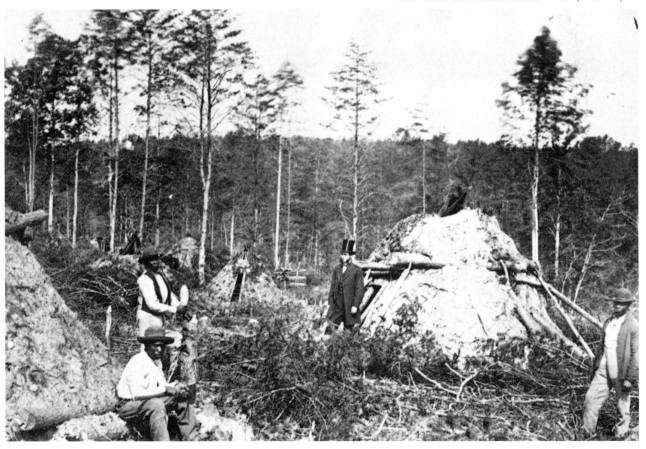

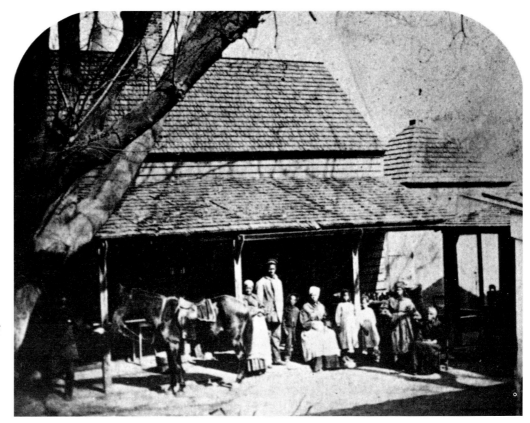

For the majority of blacks, the war was an unsettling experience as literally hundreds of thousands of them were uprooted. The refugees and escaped slaves flocked to the armies of the Union wherever they went. These former slaves gathered in New Bern, North Carolina. (USAMHI)

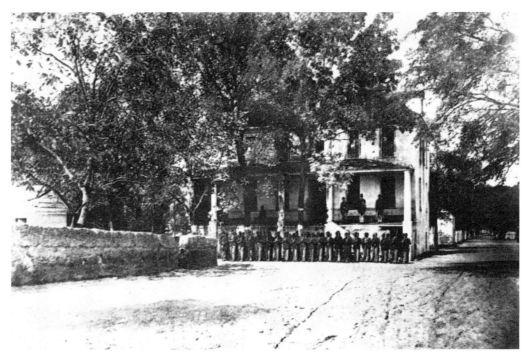

Once the Union government would sanction it, thousands of black men enlisted to fight against the Confederacy, compiling an excellent record despite the handicaps under which they labored. Samuel Cooley photographed this troop of Negro infantrymen in front of the guardhouse at Beaufort, South Carolina, in November 1864. Their officer, standing at far left, is white. (USAMHI)

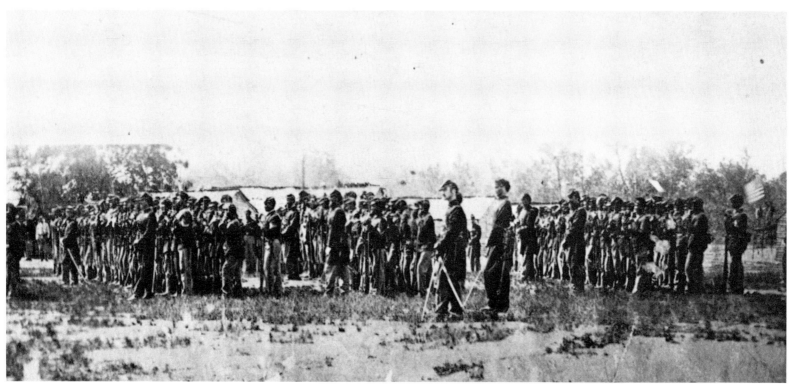

The First United States Colored Infantry, which saw repeated battle in 1864 and 1865, lost more than seventy in killed and mortally wounded as it became as much a veteran outfit as any white regiment. They stand here at Petersburg in the fall of 1864. (USAMHI)

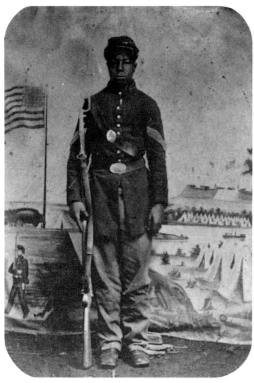

With only one or two exceptions, no black soldiers rose above this man's rank of sergeant. (JAH)

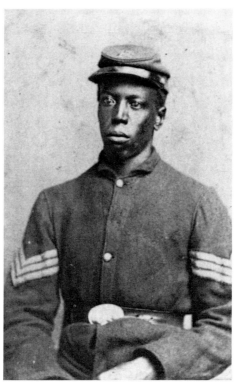

This sergeant served in the Sixty-second U.S. Colored Infantry in Texas. (JAH)

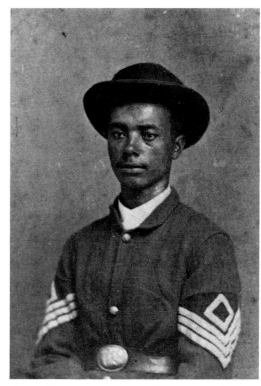

One of his compatriots in the same regiment. Their unit fought in the actions at Palmito Ranch and White's Ranch, May 12–13, 1865, in Texas. These are generally recognized as being the last engagements of the war. (JAH)

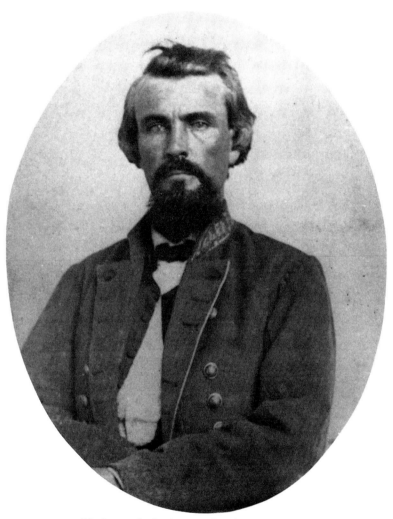

Blacks paid a high price for their participation in the war, especially when facing the hatred of aroused Confederate soldiers. While most wounded and captured black soldiers were treated humanely, occasionally Rebel passions went beyond control. At Fort Pillow, Tennessee, in 1864, scores of wounded and surrendered black soldiers were shot down by cavalrymen led by Gen. Nathan Bedford Forrest. Forrest, shown here in a heretofore unpublished portrait, neither ordered nor condoned the massacre. (ADAH)

Amazingly, as many as two hundred or more women actually managed to pose as soldiers and spend some portion of the war in the field. If she — and her photographer — can be believed, Francis Clalin of Maine became . . . (JAH)

. . . a private in the Thirteenth Maine Cavalry regiment. (JAH)

Women posing as men were generally found out, for there was little place for modesty or privacy in an army. (JAH)

One female corporal was discovered when "he" went into the hospital, and emerged a few days later . . . with a baby. (JAH)

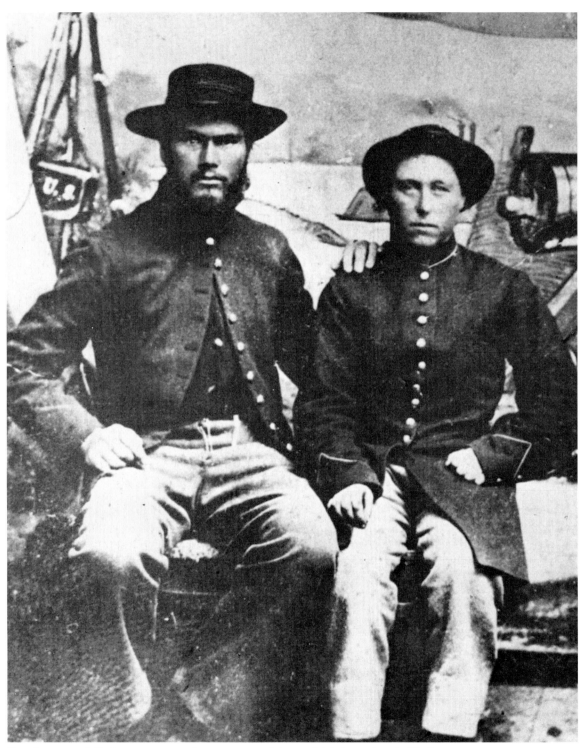

Best known of all the poseurs, and most successful, was Irish-born Jennie Hodgers, shown here at right. She enlisted in the Ninety-fifth Illinois as Albert Cashier, and kept up the sham until 1911 before being discovered. Cashier was a good soldier. (SHW)

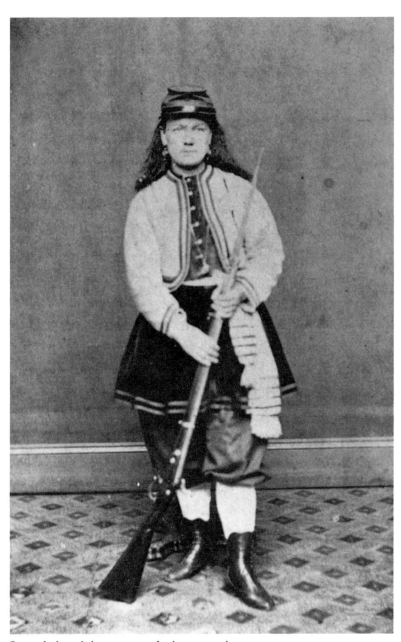

Some ladies did not try to fool anyone, but played their part as vivandières, or simply as "mascots" marching with the regiments when home on parade. (JAH)

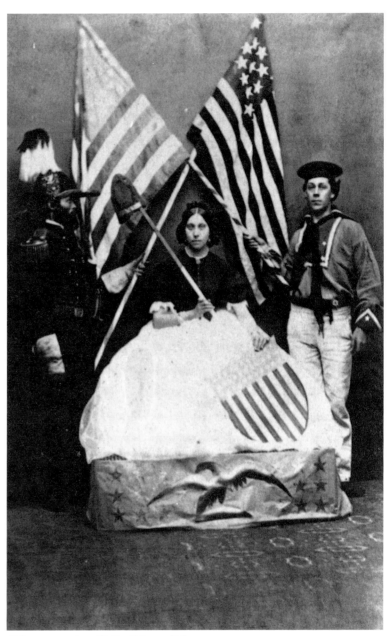

Others posed as "Miss Liberty" for photographs used to stir patriotism and raise money for soldier relief. (JAH)

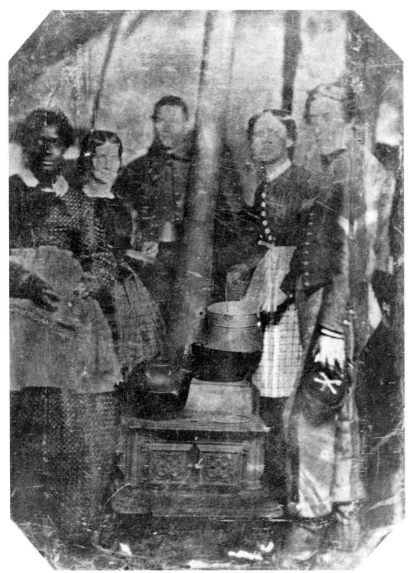

North and South, women made their greatest
contribution to the war as nurses. Like these
ladies at a stove in a hospital tent at City
Point, Virginia, they cooked for and other-
wise tended the men who had fallen to
bullets and disease. (NSHS)

Few of their names are remembered. Harriet
Duane was an exception. (USAMHI)

Fewer still were very glamorous, thanks to an edict that nurses ought to be plain, so as not to arouse the soldiers. (USAMHI)

They wrote letters for the wounded and the ill. (USAMHI)

They poured and administered the medicines.
(USAMHI)

In the Confederacy, one of them, Sally
Tompkins, even became the only woman in
the war to hold a military commission. Capt.
Tompkins commanded the Robertson
Hospital in Richmond. (VM)

With the thousands of freedmen gathering around the armies, . . . (USAMHI)

. . . many women went south to act as teachers, bringing education — and a dose of New England religion — to the newly free blacks. (USAMHI)

With the organization of humanitarian groups like the U.S. Sanitary Commission, women found a structured way in which to work for the war effort at home. They raised funds to buy supplies, books, and hire special care for the men in the field, and sent the aid to be administered through agents with the armies. Sanitary Commission headquarters in Richmond at war's end. (USAMHI)

Many of the nurses who followed the armies were hired by the Sanitary Commission, and were themselves members of the group. (USAMHI)

These ladies organized the great New York Sanitary Fair in 1864 as a fund-raising enterprise that proved more than successful. It collected over $1 million for soldier relief. (WRHS)

While the Sanitary Commission tended to the soldiers' physical health, the U.S. Christian Commission sought to care for their spiritual needs, providing thousands of Bibles to the troops from the organization's headquarters in Washington. (USAMHI)

Staffed largely by women, the Christian Commission also employed nurses and maintained offices close to the armies, like this one in Richmond. (USAMHI)

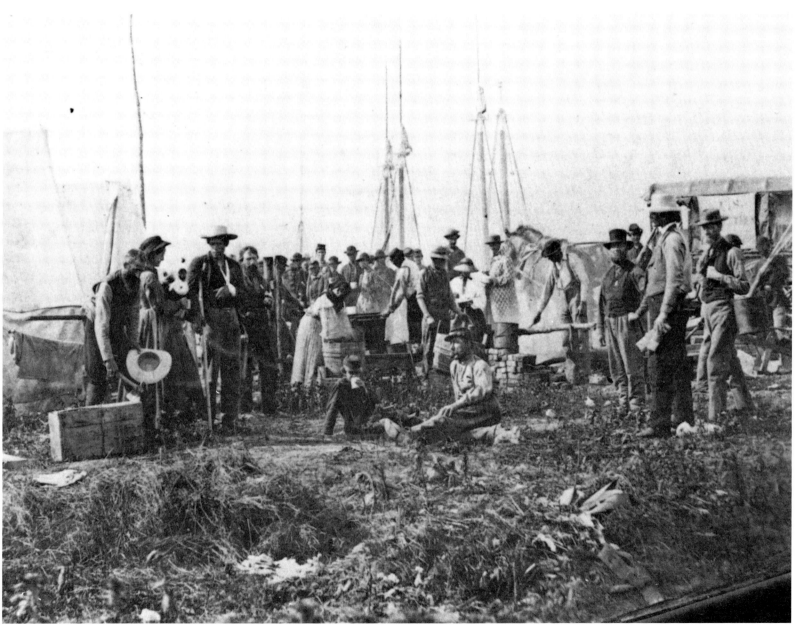

Here at White House Landing, Christian Commission ladies serve coffee to the wounded, cook and wash for them, and serve their other needs, aided by male members of the commission. (NLM)

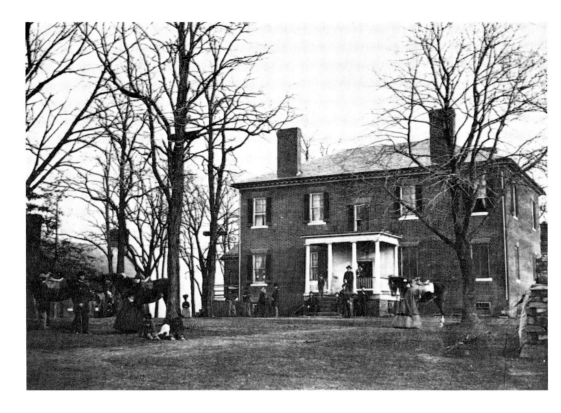

And whenever they could, loyal and loving wives joined their men in winter quarters to comfort them in ways no nurse or humanitarian could. (USAMHI)

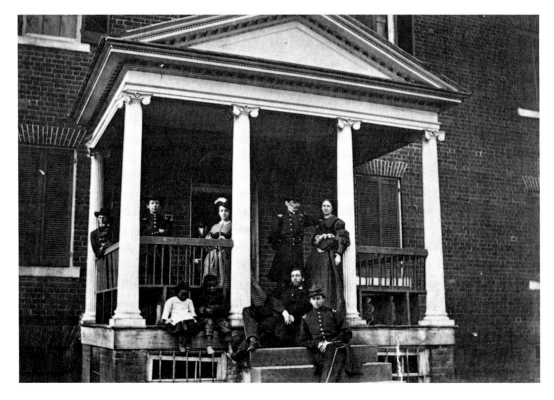

Most often they were the wives of officers who came to spend the idle months with their husbands. (USAMHI)

Regardless of whom they were married to, however, the ladies in camp brought cheer and comfort to all the men, reading to them, helping them with their letters home, and mostly just bringing them a little of the female companionship from home that they were denied. (USAMHI)

For the ladies, as for the men, it was the grandest experience of their generation. (USAMHI)

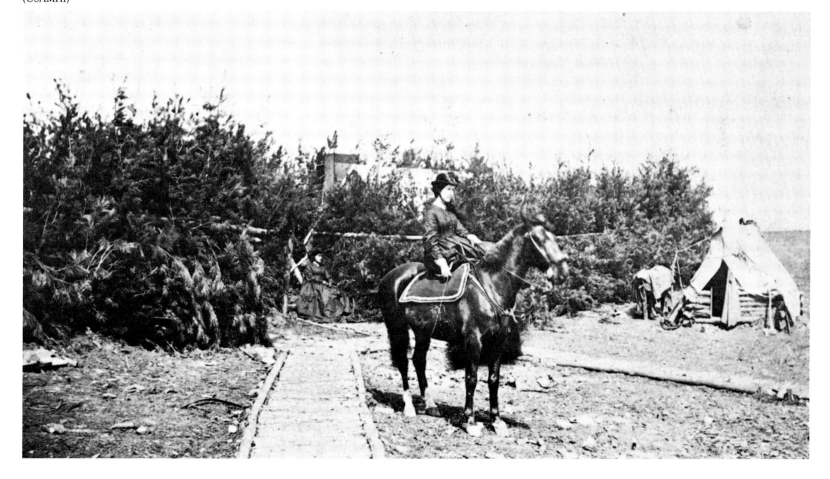

For all the role that American minorities played, both in bringing on the war and in waging it, nothing could be more fitting than the part played by Seneca sachem Ely S. Parker. Rising high on U. S. Grant's staff, he became a lieutenant colonel and Grant's military secretary. He was one of the few allowed to be with Grant and Lee in their Appomattox interview. And it was Parker who transcribed onto paper Grant's generous terms for surrender. (LC)

The Ravages of War

★ ★

Stephen B. Oates

IT BEGAN with a fanfare of bugles and patriotic oratory, with both sides promising that it would be over in ninety days. From Maine to Texas, volunteers flocked to recruiting centers and marched off to war as young women tossed flowers in their paths. Youths in uniform posed before exploding cameras and sent daguerreotypes of themselves back to their families and sweethearts. They gathered around glowing campfires and spoke in hyperbole about the excitement of battle and what they would do to the enemy when the shooting started. For the volunteers, for civilians in the North and South alike, it was all a picture-book war, a springtime of pomp and pageantry — of fierce drums and blaring bugles, of strutting drum majors and marching bands, of whipping banners and fluttering flags. It was a time when everybody was swept up in the romance of war, in the thrill and dreams of military glory.

What began as a ninety-day lark for both sides swelled instead into a national holocaust, a tornado of blood and wreckage that left scarcely a single family in North or South unscathed. Before it ended, 2.1 million men had gone to war for the Union, nearly 800,000 for the Confederacy. In Dixie, where most of the fighting took place, almost four-fifths of the white men of military age served the Rebel cause, "a *levée en masse*," wrote one historian, "made possible only by the existence of slavery."

There was nothing romantic about this killer war — a brothers' war, the worst kind of human conflict; it released a primordial fury still not understood. How can the cost of the war be reckoned? In numbers alone, the human devastation was staggering. Some 110,000 Federals and 94,000 Confederates lost their lives in combat or from mortal battle wounds. The injured often wished for a merciful bullet, for conditions in Civil War hospitals were ghastly. It was a medically ignorant time; both armies suffered from shortages of doctors and nurses; field hospitals were often pungent barns or chicken coops. In one infirmary a reporter found "the maimed, gashed, and dying" crowded together while a surgeon produced "a little heap of human fingers, feet, legs and arms" wherever he worked. After Gettysburg, Union surgeons consumed five days on amputations — more time than it took to fight the

battle. Those who survived combat had to contend with an even deadlier foe: disease. Diarrhea, dysentery, "camp fevers" like malaria and typhoid, and other maladies plagued both armies and claimed more lives than the battles did. On the Union side, diarrhea and dysentery alone killed 44,500 men. In round numbers, some 623,000 American servicemen — 365,000 Federals and 258,000 Confederates — perished in the Civil War. The Union by itself lost more men than the United States did in World War II. Total Civil War casualties almost equaled the combined losses of all of America's other wars.

The fighting in the Civil War was savage beyond computation — a savagery made possible by the most murderous arsenal of destruction Americans had ever assembled. There were the versatile 12-pounder napoleons, the workhorse artillery of both armies, whose canister and grapeshot could obliterate entire lines of advancing infantry. There were the new rifled cannons, macabre guns with flat trajectories and immense hitting power. There were the muzzle-loading Springfield and Enfield rifles, which became the basic infantry weapons for both sides; far more accurate than the smoothbores they replaced, the single-shot rifles had an effective range of four hundred yards and could be loaded and fired three or four times a minute. Add to these the breech-loading repeaters, rudimentary machine guns, and ironclad warships introduced during the conflict, and one understands why experts call it the first modern war in which weapons and machines played a decisive role.

Such weapons turned Civil War battles into human slaughter pens. In one day at Antietam, the bloodiest single day in the annals of American warfare, 2,010 Yankees and 2,700 Rebels were killed and 18,440 combatants were wounded, 3,000 of them mortally. More Americans died that one day than in the War of 1812, the Mexican War, and the Spanish-American War put together. The 12,000 Confederate casualties were double those of U.S. forces on D day.

Losses in the Civil War grew more appalling with every campaign: 23,000 Federals and 28,000 Confederates mowed down or missing at Gettysburg, 64,000 Federals and 32,000 Confederates killed, wounded, or missing in the fighting from the Wilderness to Petersburg in 1864. When ordered to attack entrenched Rebels at Cold Harbor, Virginia, Union troops pinned strips of paper to their coats that gave their names and addresses, so that their bodies could be identified. One doomed Yankee scribbled in his diary: "June 3. Cold Harbor. I was killed." He and 7,000 other Union men were shot dead or wounded in less than an hour of fighting. That was surely the bloodiest hour of combat in all American history.

Gruesome though they are, casualty figures cannot convey what it was like to be in the Civil War. For that we turn to eyewitness accounts, which include some of the most vivid descriptions of the ravages of war ever recorded. Here a Union veteran recalls the horrors of Shiloh:

The ear-piercing and peculiar Rebel yell of the men in gray and answering cheers of the boys in blue rose and fell with the varying tide of battle and, with the hoarse and scarcely distinguishable orders of the officers, the screaming and bursting of shell, the swishing of canister, the roaring of volley firing, the death screams of the stricken and struggling horses and the cries and groans of the wounded formed an indescribable impression which can never be effaced from memory.

A Confederate officer on the Union bombardment of Fredericksburg:

Ten o'clock came, and the hammers of the church clocks were just sounding the last peaceful stroke of the hour, when suddenly, at the signal of a single cannon shot, more then 150 pieces of artillery, including some of the enemy's most ponderous guns, opened their iron mouths with a terrific roar and hurled a tempest of destruction upon the devoted town. The air shook, and the very earth beneath our feet trembled at this deafening cannonade, the heaviest that had ever yet assailed my ears. . . . The howling of the solid shot, the bursting of the shells, the crashing of the missiles through the thick walls and the dull sound of falling houses united in a dismal concert of doom. Very soon the site of the unhappy town was indicated, even through the fog, by a column of smoke and dust and the flames of burning buildings. . . . About noon the sun, breaking through the clouds, seemed to mock the smoking ruins it revealed.

A Union lieutenant on the second day at Gettysburg:

All along the crest everything was ready. Gun after gun, along the batteries, in rapid succession leaped where it stood and bellowed its canister upon the enemy. They still advanced. The infantry opened fire, and soon the whole crest, artillery and infantry, was one continuous sheet of fire. . . . All senses for the time were dead but the one of sight. The roar of the discharges and the yells of the enemy all passed unheeded, but the impassioned soul was all eyes and saw all things that the smoke did not hide. How madly the battery men were driving the double charges of canister into those broad-mouthed Napoleons! How rapidly those long blue-coated lines of infantry delivered their fire down the slope! . . . Men were dropping, dead or wounded, on all sides, by scores and by hundreds. Poor mutilated creatures, some with an arm dangling, some with a leg broken by a bullet, were limping and crawling toward the rear. They made no sound of pain but were as silent as if dumb and mute.

A Union war correspondent on the battlefield the night after Pickett's charge:

I became possessed by a nameless horror. Once I tumbled over two bodies and found my face close to the swollen, bloody features of the man who lay uppermost, judging from the position of other bodies. A shower of grape and canister must have torn the ranks of a regiment into shreds, for 50 or 60 bodies lay there in a row. I came across the corpse of a drummer-boy, his arms still clasped around his drums, his head shattered by a shell. I realized what a price is paid for victories.

Noncombatants paid, too, as the storm uprooted whole communities. Before, during, and after battles, armies of homeless refugees clogged roads and byways. "I never saw a more pitiful procession than they made trudging through the deep snow," a Rebel soldier said of refugees from Fredericksburg.

I saw little children tugging along with their doll babies, holding their feet up carefully above the snow, and women so old and feeble that they could carry nothing and could barely hobble themselves. There were women carrying a baby in one arm and its bottle, clothes and covering in the other. Some had a Bible and a toothbrush in one hand, a picked chicken and a bag of flour in the other. . . . Where they were going we could not tell, and I doubt if they could.

Another class of refugees suffered even more. These were the fugitive slaves, hundreds of thousands of whom abandoned Rebel homesteads and set out for the nearest Union army. In the embattled Mississippi Valley, where fugitives swamped Union lines, an Ohio chaplain wrote that "their condition was appalling. There were men, women and children in every stage of disease or decrepitude, often nearly naked, with flesh torn by the terrible experiences of their escapes." As Sherman's army marched through Georgia, some twenty-five thousand slaves followed it at one time or another — whole families trying to keep pace with the soldiers, with children tied to their parents by a rope. An Indiana officer noted that slave babies "tumbled from the backs of mules to which they had been told to cling, and were drowned in the swamps while mothers stood by the roadside crying for their lost children." Though most of the blacks fell away, too sick or exhausted to continue, seven thousand toiled after Sherman clear to the sea.

It was Sherman, of course, who brought total war to the Deep South, contending as he did that modern wars were won by destroying the enemy's resources as well as his morale. "We are not only fighting hostile armies," Sherman asserted, "but a hostile people, and must make old and young, rich and poor, feel the hard hand of war." That he did, as his army first burned Atlanta — "the workshop of the Confederacy" — while a regimental band played "John Brown's Body." A witness recalled that Yankee soldiers "took up the words wedded to the music, and, high above the roaring flames, above the clash of falling walls, above the fierce crackling of thousands of small-arm cartridges in the burning buildings, rose the triumphant refrain, 'His truth is marching on!'" Then sixty thousand Union troops cut a swath to Savannah 40 miles wide and 220 miles long, visiting war on civilians on a scale unprecedented in America. "We had a gay old campaign," remarked one soldier. "Destroyed all we could eat, stole their niggers, burned their cotton & gins, spilled their sorghum, burned & twisted their R. Roads and raised Hell generally." Sherman estimated the damage at $100 million. Smoldering Georgia was out of the war, her citizens in shock.

Sherman's army now stormed into South Carolina, tearing

up railroads, burning down barns, pulverizing fields of corn and cotton, assassinating cows and chickens, wiping out everything that might sustain dwindling Rebel forces. Civilians fled their homes and evacuated their towns before Sherman's relentless columns. Columbia, the state capital, went up in an inferno of smoke, the conflagration started either by Confederates or Union troops. A Northerner wrote that

most of the citizens of Columbia had sons or relations in the Rebel army. Half of them were dead, and in the blackness of this terrible night their fortunes were all lost. Many wandered about wringing their hands and crying; some sat stolid and speechless in the street, watching everything that they had go to destruction. . . . Most of the people of Columbia would have been willing to die that night, then and there. What had they left to live for? *This, too, was war.*

By now Union forces were smashing up the Confederacy in East and West alike. In the Shenandoah, Philip Sheridan burned a broad path of devastation clear to the Rapidan River. In northwest Alabama, thirteen thousand Union horsemen launched the biggest and most destructive cavalry raid of the war; they crushed their Rebel opponents and burned and wrecked their way clear into southern Georgia. Such scorched-earth warfare earned Lincoln and his generals undying hatred in Dixie, but it brought them victory: within five months after Sherman began his march to the sea, the war was over.

The North suffered terrible human losses, but at least her economy was booming from war production. The South was not only defeated; she was annihilated. Half her men of military age were dead or wounded, two-fifths of her livestock wiped out, more than half her farm machinery demolished, her major cities in ruins, her railroads and industry desolated, her coastal and river ports out of commission, her commerce paralyzed, two-thirds of her assessed wealth, including billions of dollars in slaves, destroyed. "Have we not fallen on sad, sad times?" sighed a Georgia woman as she surveyed the misery around her. Perhaps Southerners now knew what Lincoln had meant when he vowed to teach them "the folly of being the beginners

of war." Perhaps they could all — as a young Texas veteran expressed it — "fall down in the dust and weep over our great misfortune, our great calamities."

Across Dixie the physical damage was everywhere in evidence. Near fire-gutted Columbia, sixty-five horses and mules slain by Sherman's men rotted for six weeks because there were no shovels or other implements with which to bury them. The wreckage in the Tennessee Valley was typical of the dead Confederacy. Here an English traveler found "plantations of which the ruin is for the present total and complete," and a trail of war visible "in burnt up gin houses, ruined bridges, mills, and factories." He added, in reference to the vanquished slave-owning class, that "many who were the richest men . . . have disappeared from the scene."

Few Southerners were more destitute than the former slaves. Owning little more than the skin on their backs, they streamed by the thousands into Union army bivouacs or the nearest towns and cities. The Freedmen's Bureau set up relief camps and throughout the summer of 1865 distributed 100,000 daily rations to suffering blacks. But the camps were so crowded that epidemics killed a third of the people in them.

Whites were scarcely better off, as roving bands of thieves pillaged defenseless homes and famine and disease plagued the land. An official of the Freedmen's Bureau reported as "an everyday sight" women and children "begging for bread from door to door." The bureau gave out thousands of daily rations to whites too (total rations to whites and blacks came to 22 million between 1865 and 1870). Into "the vacuum of chaos and destruction," as one writer phrased it, came 200,000 occupation troops, who managed to restore some semblance of order to war-ravaged Dixie.

How much did the war cost both sections? Exact figures are hard to come by, especially for the Confederacy. Surviving records indicate that by October 1863 Confederate war expenditures had exceeded $2 billion. By 1879, according to one estimate, Union expenses growing out of the war were more than $6 billion. But these sums excluded the war debts of the states. Adding up estimates of those debts, Union and Confed-

erate war expenses, total property loss, federal pensions to 1917, and interest to the national debt, one historian put the overall cost of the war at about $20 billion.

But this does not count the billions of dollars it took to rebuild the South. Nor does it include losses from reduced Southern production. The South's economy was so crippled that her per-capita output did not return to the antebellum level for more than fifty years after Appomattox. The South's per-capita income, 33 percent lower than the North's in 1860, was 40 percent lower in 1880 and stayed there until the twentieth century.

But dollars and percentages cannot gauge the full toll of the Civil War. One must look at the photographs to comprehend what it did to the land and the cities: the rubble of Richmond . . . the burned-out Gallego Flour Mills there . . . the fields of skull and bone . . . the maimed bodies of the wounded . . . the face of exhaustion in the North . . . the visage of defeat in Dixie.

But not even the photographs capture the emotional and psychological scars left by the conflict. Who knows what damage it did to the American spirit? Who can measure the mental anguish and human suffering that continued long after the guns were silent? Who can say how deep the bitterness and humiliation ran in the South, where millions of unrepentant whites embraced the legend of the lost cause and forged a bastion of white supremacy that lasted a century?

In time, though, some of the bitterness faded with the battle flags, and hard-bitten veterans of both armies, many with arms and legs gone, with eyes shot out and faces disfigured, marched in memorial parades and wept at speeches of remembered valor. And so in the veterans' reunions the war ended as it had begun — in an aura of glory.

But beyond the parades and reunions were grim reminders of what really happened in that war. There were the cemeteries in both sections, quiet fields where soldiers lay in ranks of white gravestones. There were the battlefield parks, with their polished cannons and statues of singular men frozen in marble. Here, if he listens closely, the visitor today can hear the echoes of the war — the rattle of musketry, the deadly whir of grapeshot, the ring of sabers, the shouts. He can almost see colliding lines of infantry and shell-torn flags in the smoke, can almost smell the acrid odor of gunpowder and the stench of death on the wind. The battlefields recall what madness beset Americans from 1861 to 1865 and what the nation paid, and paid dearly, for its survival. At every battle site there ought to be a shrine to those broken and bloodied men, with the inscription "Lord God of hosts, Be with us yet, Lest we forget, Lest we forget. . . ."

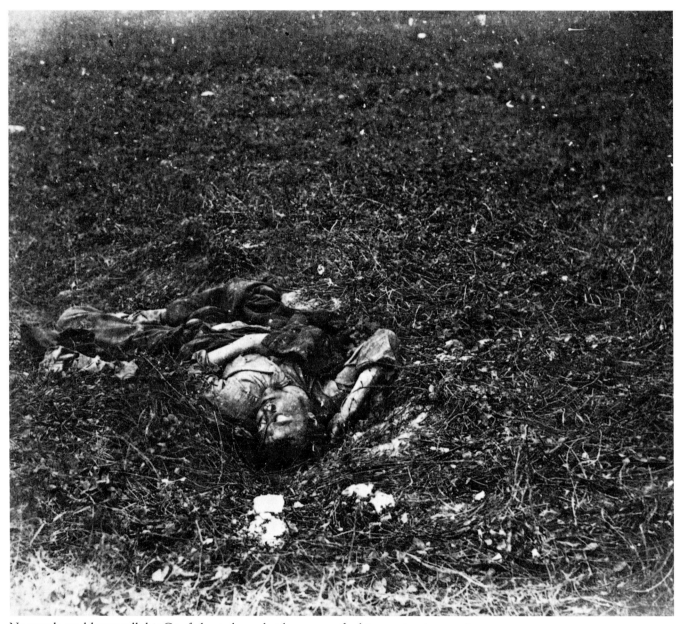

No words could ever tell this Confederate boy what he gave up for his country. (USAMHI)

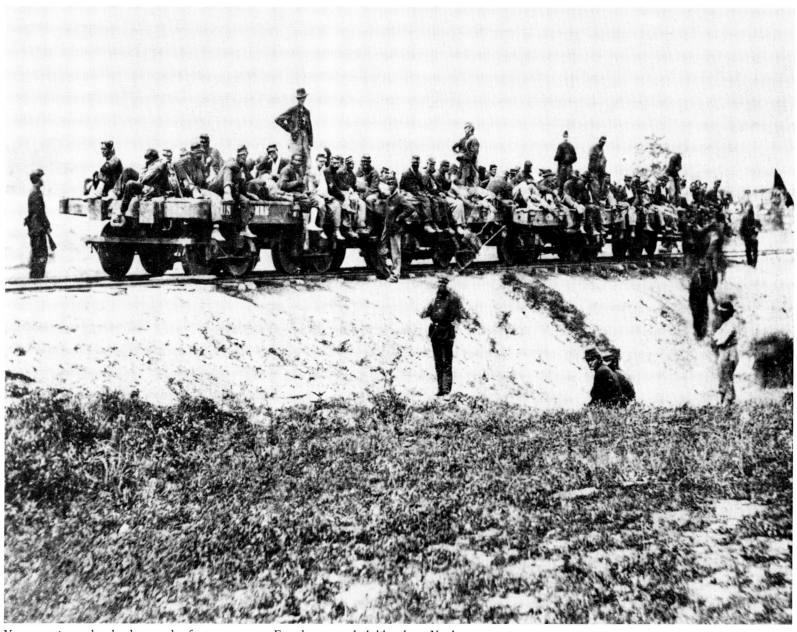

Yet sometimes the dead were the fortunate ones. For the wounded, like these Yanks in bandages and slings at Savage Station, Virginia, awaiting transport to hospitals, the real nightmare might lay ahead. Chances are that many an arm and leg, and life, in this image did not long survive. (CHS)

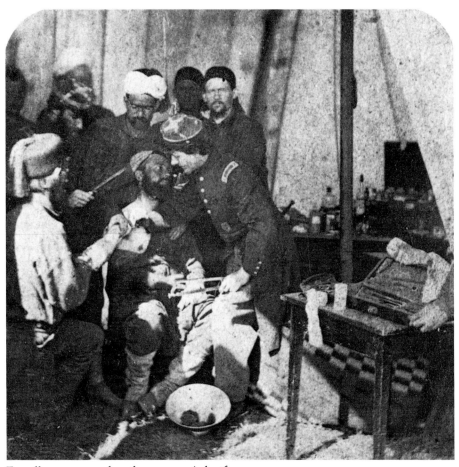

For all too many, alas, the surgeon's knife awaited. The Yank in this surgeon's hands at Fort Monroe is lucky: he is only posing in a mock scene. One bullet could put him in that surgeon's chair in extremis. (UR)

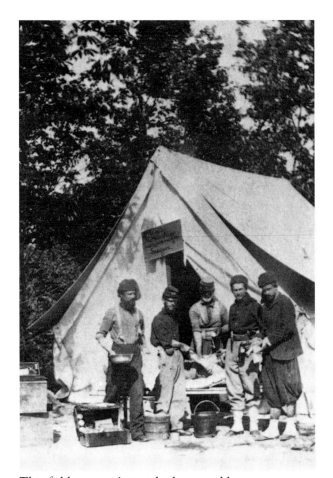

This field surgeon's tent looks more like what most wounded Yanks first saw, with its sign warning of "No Admittance except by permission of the Surgeon." But the chaos of battlefield surgery is still nowhere evident in this posed image. (JAH)

Top left: Their medicines were rudimentary, and their training often no better. (JAH)

Top right: For Confederate medicos like surgeon Watson M. Gentry, conditions were even worse when the war and blockade made medicines scarce. It was the soldiers themselves who inevitably suffered the most. (MC)

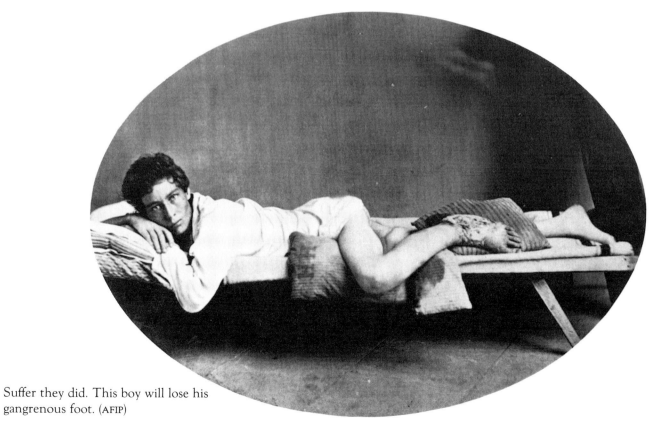

Suffer they did. This boy will lose his gangrenous foot. (AFIP)

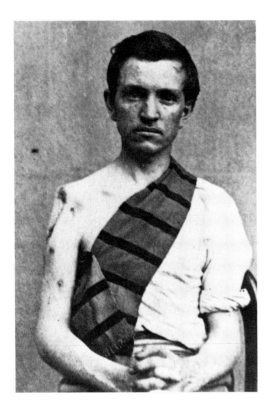

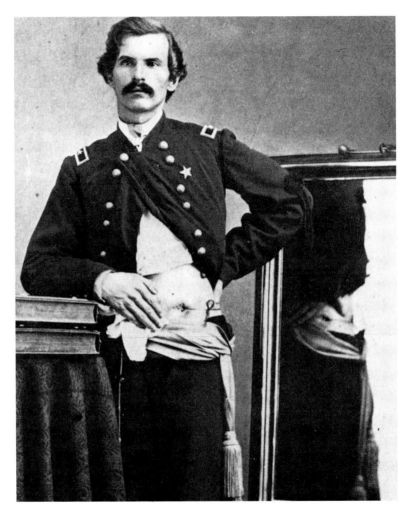

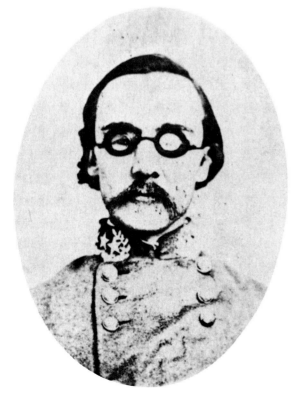

Top left: This youthful sergeant of the Sixteenth Pennsylvania may keep his arm, with luck. (RP)

Top right: The bullets paid little heed to rank. High and low alike could suffer. Brig. Gen. Henry A. Barnum suffered wounds three times in the war, and delighted in posing to display this one in particular — sometimes with a leather strap, here with a string, drawn clear through his body. (AFIP)

Bottom left: Generals on the other side felt the same sting of lead. Brig. Gen. Adam R. Johnson was shot accidentally by his own men in a mishap that almost completely destroyed his eyes, leaving him virtually blind. (WCD)

As the war ravaged landscape and inhabitants alike, more and more space had to be commandeered to house the wounded and recovering. Cities like Memphis became virtual hospital metropolises. This building may have been a stove works, judging from the small parlor stove atop the post at right. Here it has become Webster U.S. Military General Hospital. (CHB)

Memphis confectioners made candy here until the war transformed the factory into the Washington U.S. Military General Hospital. The only thing sweet at this point was getting out alive. (CHB)

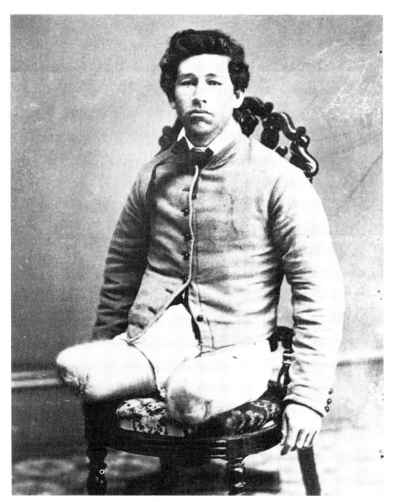

And all too often, those who lived through their wounds did so with grim prospects for the future. (AFIP)

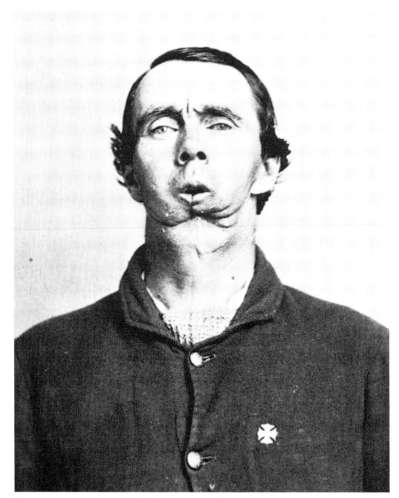

Primitive surgery could close a wound. Nothing of the time would replace a jaw shot away. (AFIP)

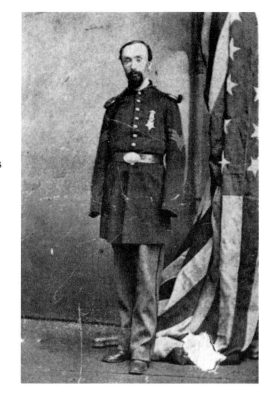

Top left: Streets North and South were full of empty sleeves after the war. (JAH)

Top right: A blindfold could hide the ravages of lost eyes, but not a lost future. (JAH)

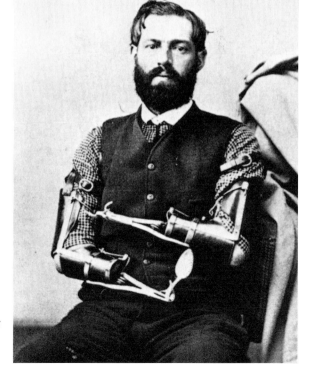

Inventive minds could equip this poor Yank with fork and spoon. He could feed himself. But his hands would never feel the softness of a woman's hair or the velvet of his child's cheek. (BA)

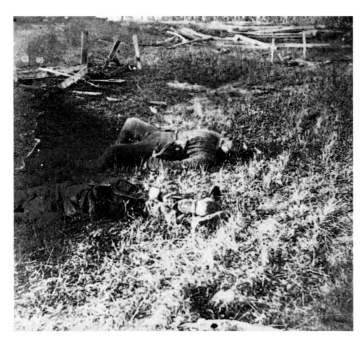

Behind the living lay the dead, scattered all across the continent. They covered the fields, like these Johnny Rebs at Antietam. (USAMHI)

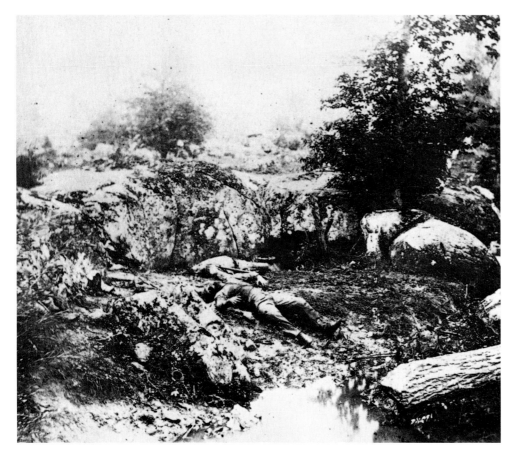

And like these Confederates sprawled in death at Gettysburg. (LC)

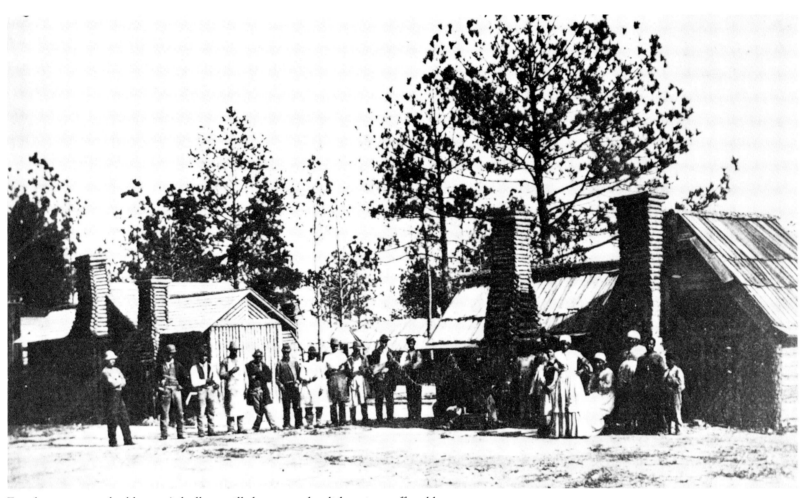

For those not touched by war's bullets, still there was the dislocation suffered by hundreds of thousands — especially the slaves. Escape from their owners and freedom were wonderful things. But who would feed them now, and where would they live and work? Freedmen at Petersburg late in the war. (CHS)

Until they could take care of themselves and be relocated, they were virtual wards of the Union, dependent, like these freedmen in South Carolina, for the rations being issued them and the clothes on their backs. (USAMHI)

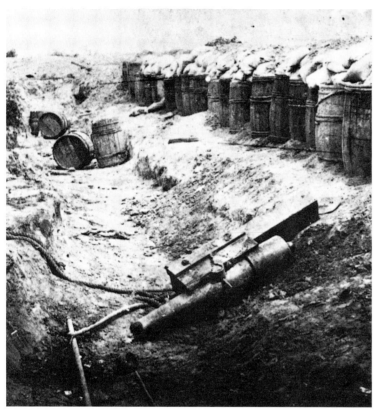

And how the land itself had been ravaged by
the passing armies. (USAMHI)

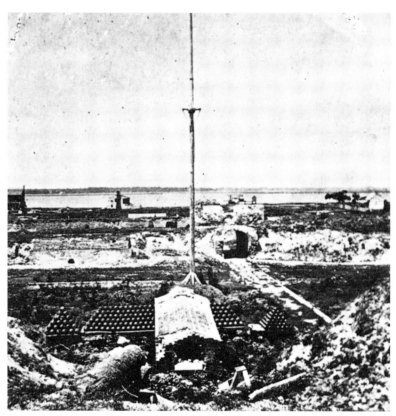

Everywhere was disruption and destruction,
as here at Fort Moultrie. (USAMHI)

Towns like Donaldsonville, Louisiana, lay in ruins. (ISHL)

The pitiful little industry of places like Port Hudson sat destroyed. (USAMHI)

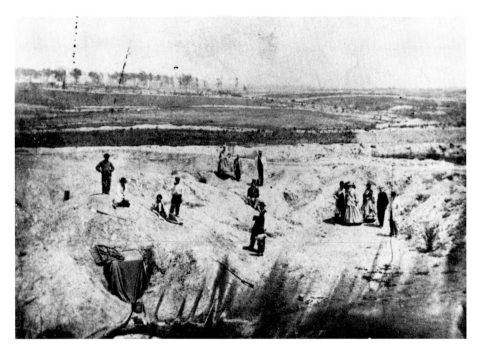

Two years after the war, the craters and trenches and earthworks still scarred the land around Petersburg. (LAW)

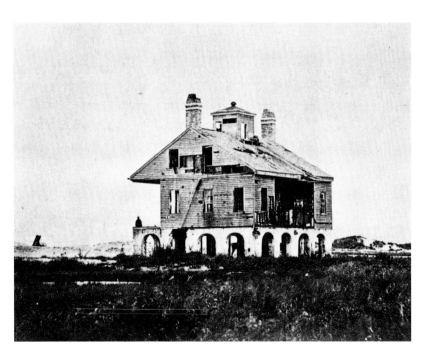

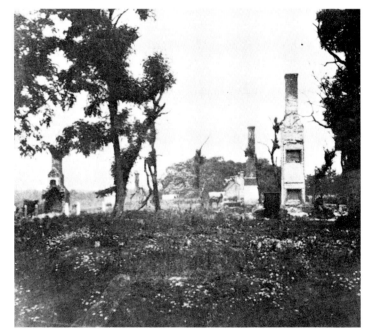

Bottom left: Light would never shine forth again from South Carolina's Beacon House. (USAMHI)

Bottom right: Nothing but charred chimneys remained to remind of the once-beautiful homes that fell victim to the fires of war. (USAMHI)

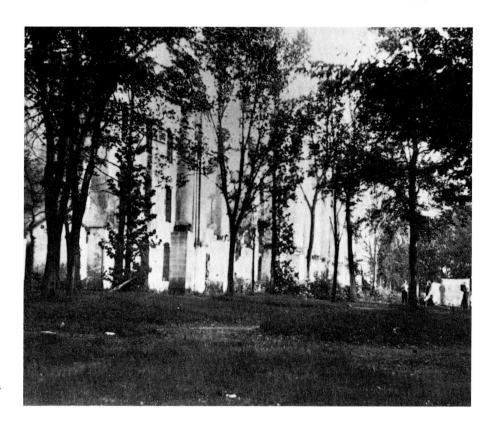

The lovely and stately Fauquier Springs Hotel . . . (USAMHI)

. . . was now only a stately ruin. (USAMHI)

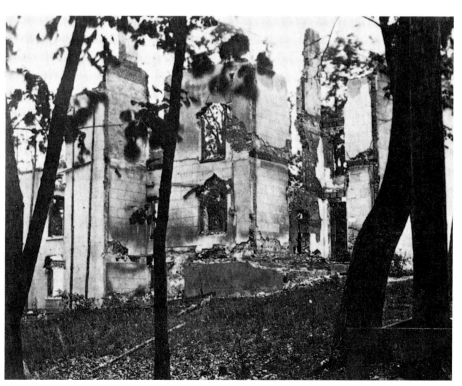

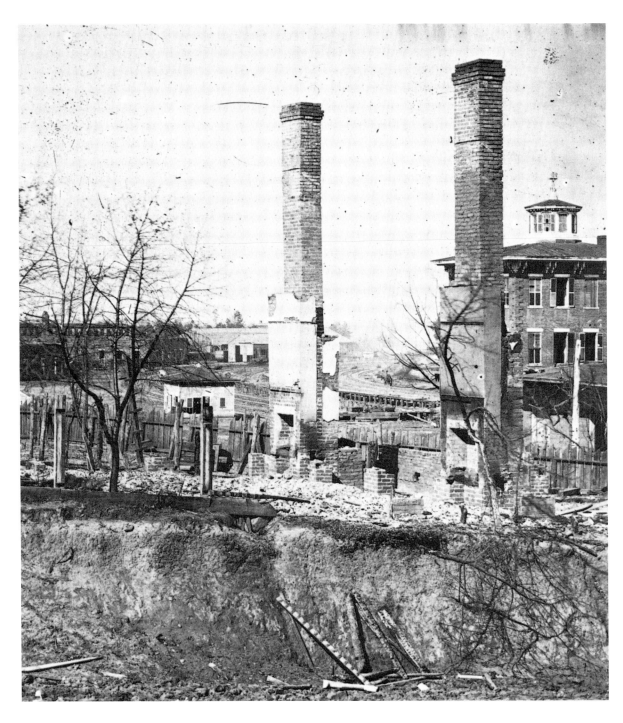

Major cities like Atlanta sat
ravaged. (LC)

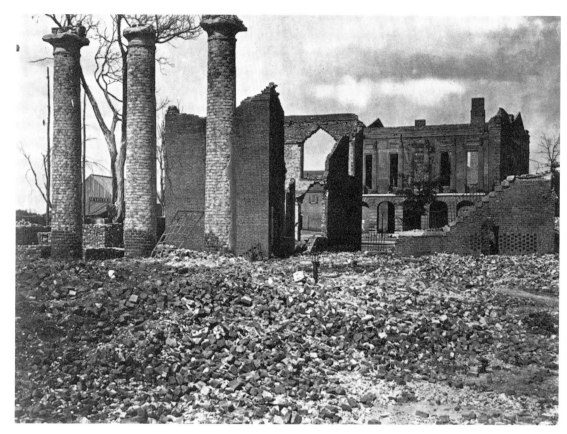

South Carolina's capital city, Columbia, was virtually laid waste. Months after the war, when George Barnard's camera came, the rubble of the capitol lay where it had fallen in the fires. (LC)

Of the South's major cities, only a few survived unscathed — notably, Savannah. (KA)

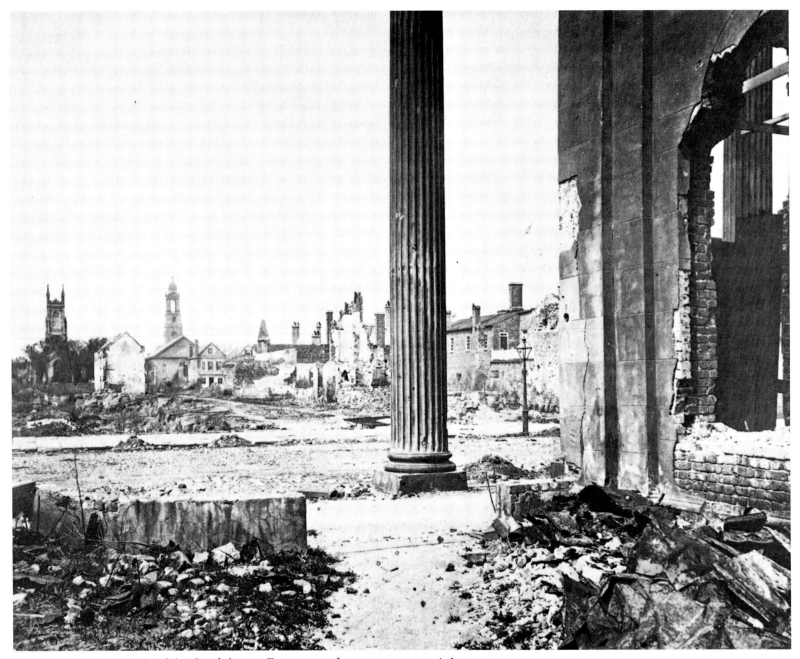

Not so Charleston, cradle of the Confederacy. Four years of intermittent siege left
much of the city in ruins. (USAMHI)

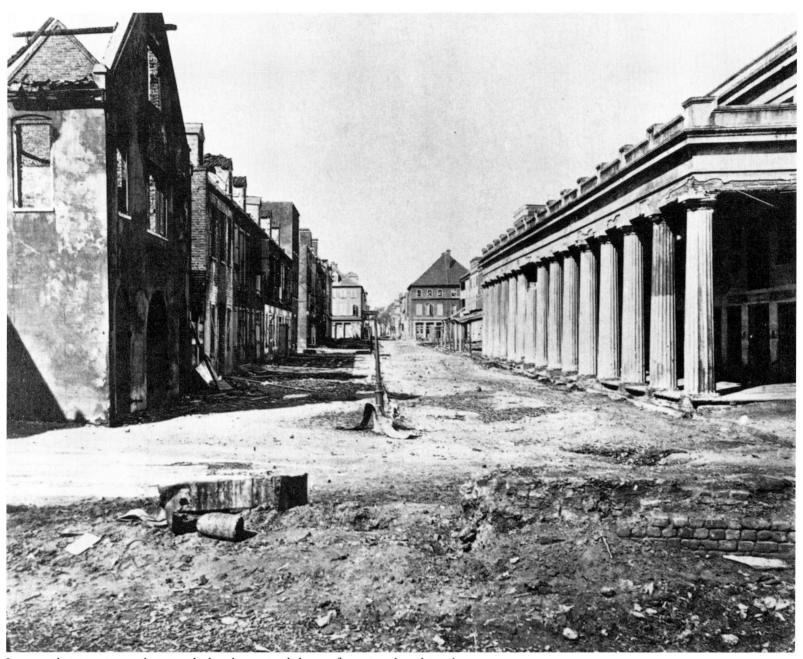

Its once-thriving city market at right barely survived the conflagration that claimed the block across the street. (USAMHI)

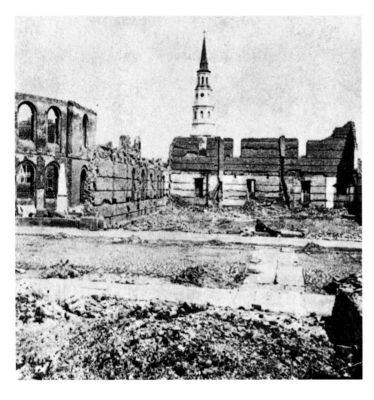

Secession Hall, where South Carolinians voted to leave the Union and thus precipitated the sections on the road to war, was left as nothing but a crumbling wall. (USAMHI)

The famous Circular Church next door, though severely mauled, would survive, to begin restoration almost at once. (USAMHI)

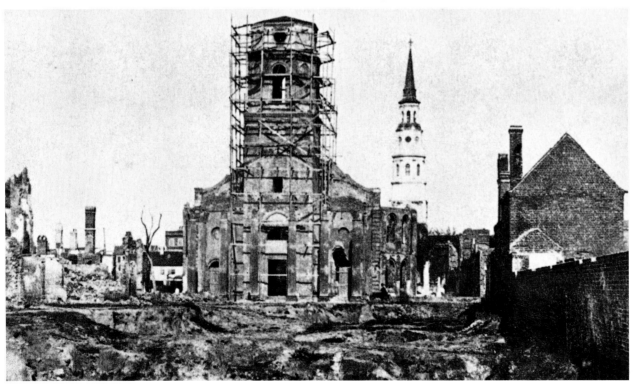

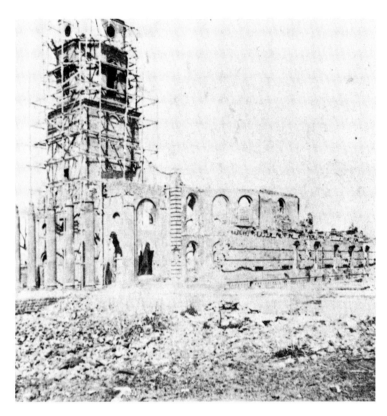

The task facing Charlestonians was awesome. (USAMHI)

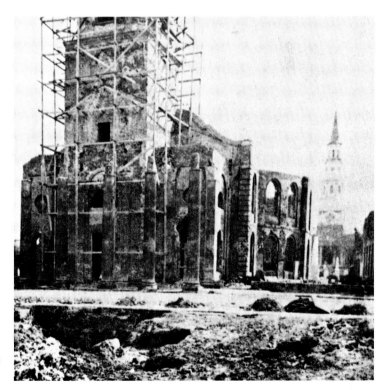

As with the nation itself, the work of rebuilding would take years, and some scars would always show. (USAMHI)

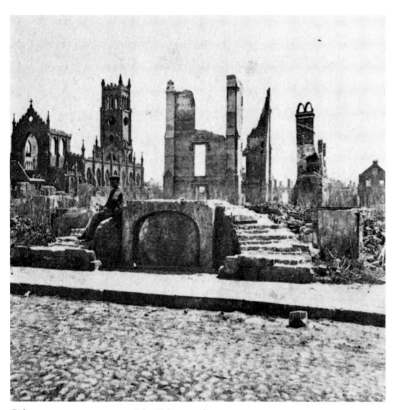

Of some once-treasured buildings, there was
nothing left to rebuild. (USAMHI)

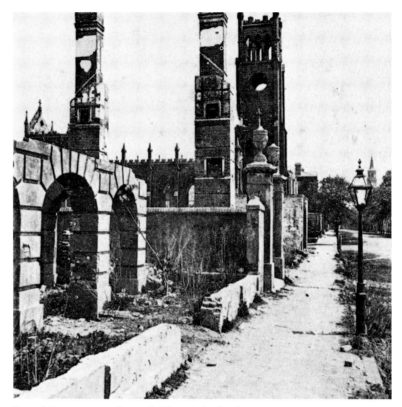

Broad Street once thrived. Now it looked
like a Roman ruin. (USAMHI)

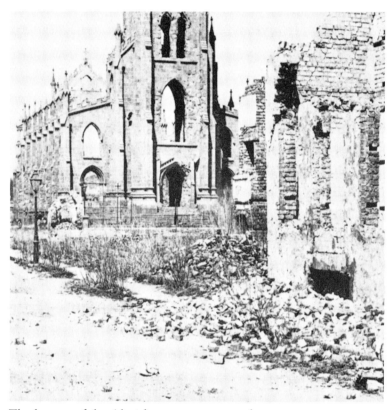

The houses of the Almighty were not spared
from the conflagration. (USAMHI)

Doors that once opened to the faithful now
lay open to the elements. (USAMHI)

Halls that echoed to the sound of voices raised in praise now heard only the howling of the winds. (USAMHI)

Charlestonians almost lost their hearts with their city. (USAMHI)

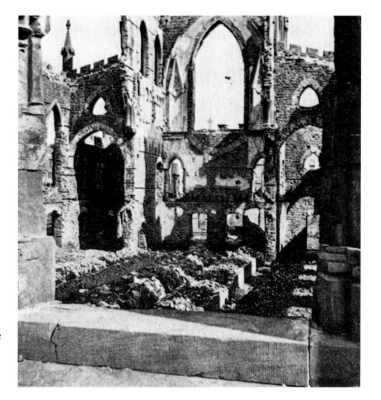

Worse, besides the destruction of shot and shell, the city had suffered an accidental fire in 1861 that ravaged much — as if even chance had conspired against the once-beautiful Southern metropolis. (USAMHI)

The flames knew no denomination, no politics. (USAMHI)

Some in the North would claim that the secession virus could only be eradicated by flames. (USAMHI)

If so, then surely by 1865 Charleston must have been cleansed. (USAMHI)

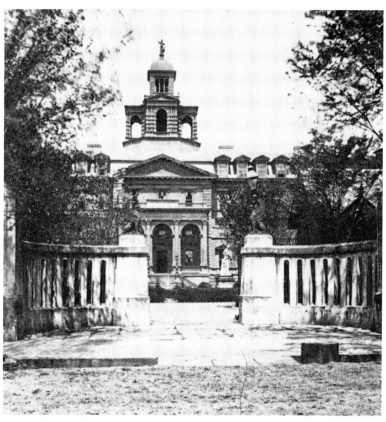

Miraculously, the city's orphan asylum was largely spared. (USAMHI)

But not so the graves of Charlestonians long gone, in the churchyard at the Circular Church. (USAMHI)

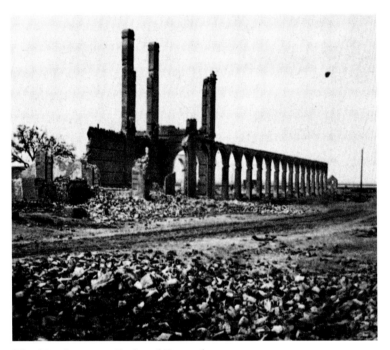

The Northeastern Railroad Depot lay in rubble. (USAMHI)

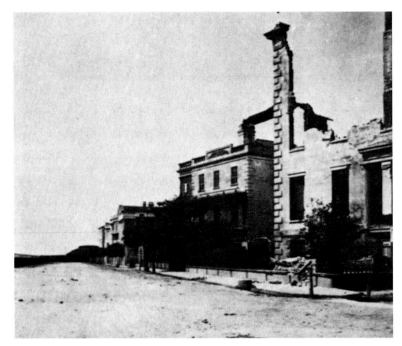

And the Battery, once the most beautiful seaside promenade in the South, saw many of the finest homes in America shattered. Charleston had paid dearly for her experiment in rebellion. (USAMHI)

Top left: The destruction spread everywhere the armies went. To the homes . . . (USAMHI)

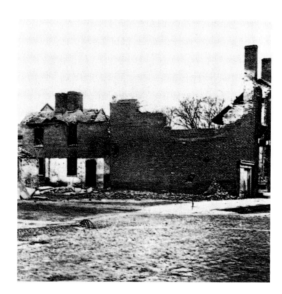

Top right: . . . and backyards of Petersburg, . . . (USAMHI)

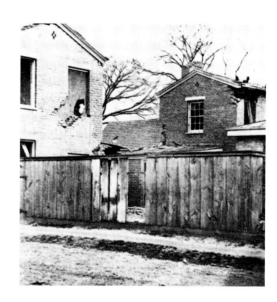

Bottom right: . . . and most of all to Richmond. The Virginia State House in the background, itself spared the conflagration, surveys a scene of unimagined ruin. (USAMHI)

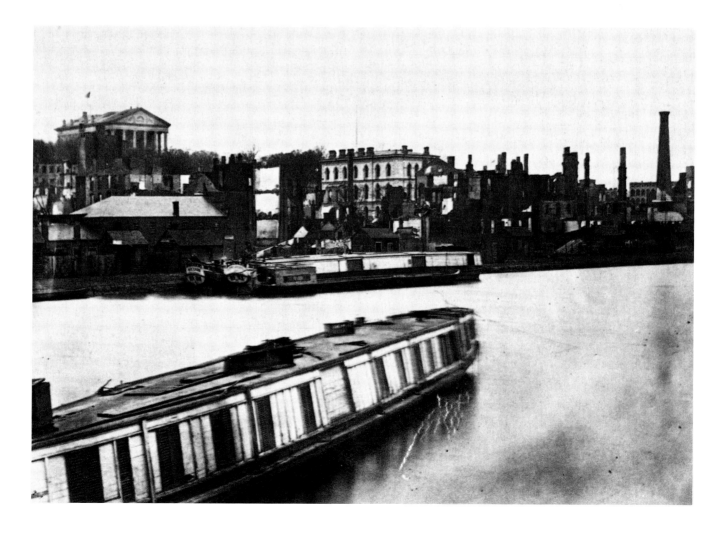

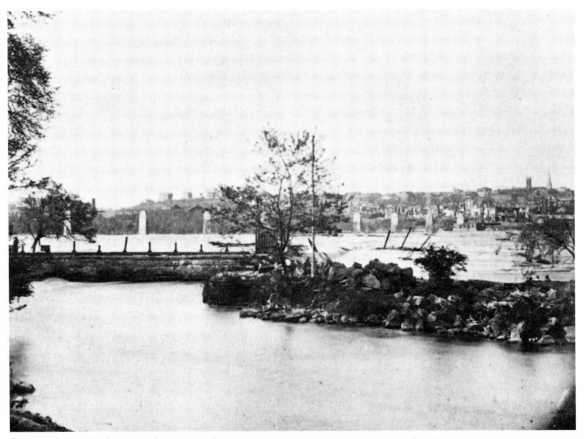

On April 6 in Richmond, four days after the city's evacuation, Alexander Gardner found a vista of devastation wherever he pointed his camera. (USAMHI)

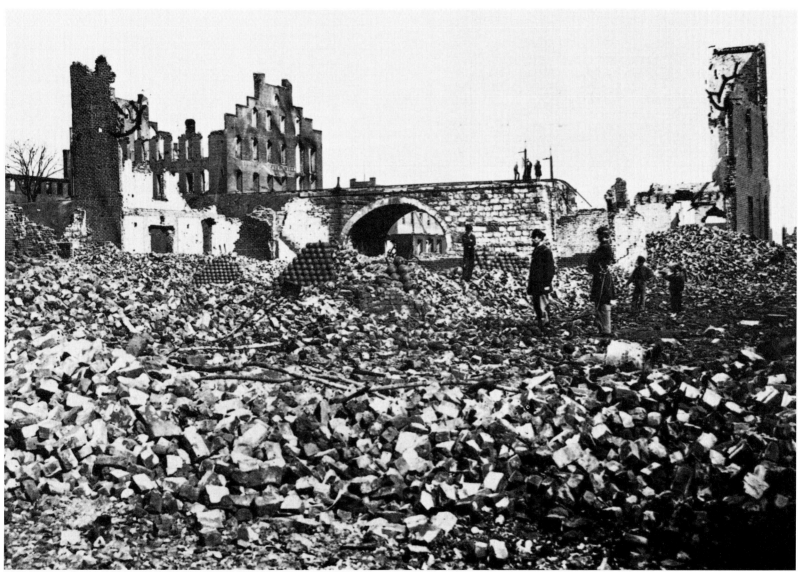

All that remained of the Richmond & Petersburg Railroad bridge over the James
was its northernmost arch. The Franklin Paper Mill behind it was nothing but
a hollow shell. (USAMHI)

Looking across the James from the South, the bridge piers rose starkly out of the river, pointing the way to the ruins of the city beyond. (USAMHI)

A cameraman could use the last arch of the bridge to frame a portrait of war's ravages. (USAMHI)

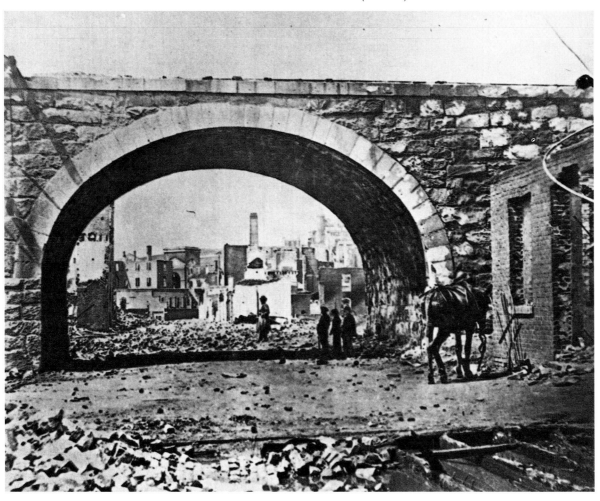

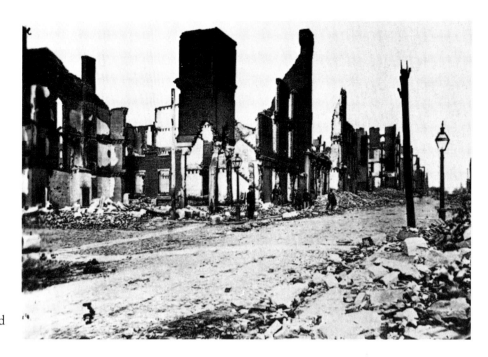

Whole blocks on Cary Street simply ceased to be. (USAMHI)

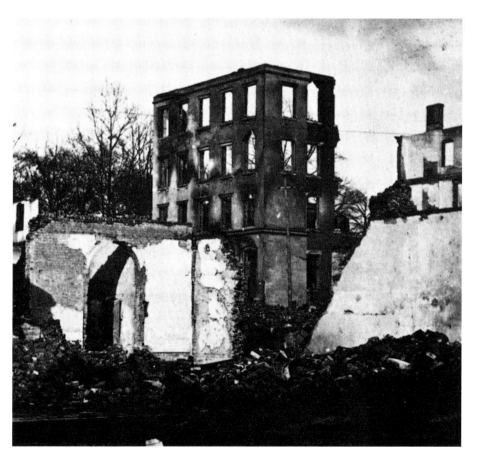

Richmond had become a city of brick skeletons. (USAMHI)

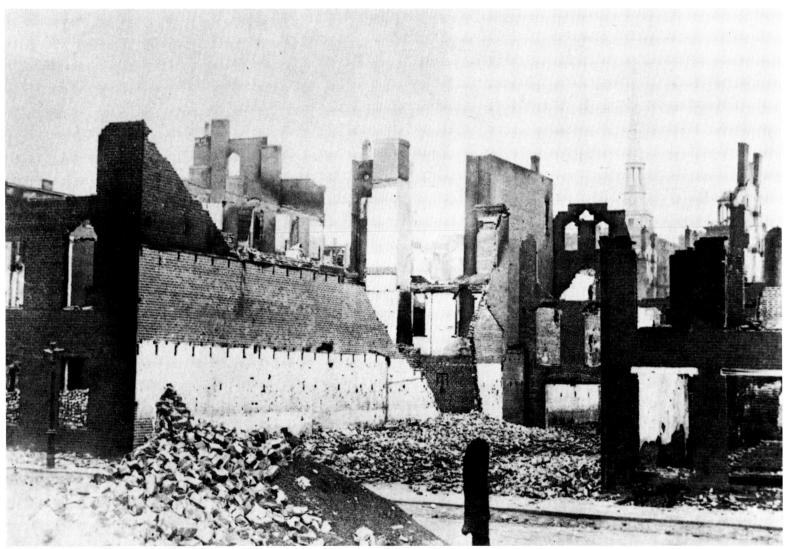

So traumatic was the fire that wasted the city on April 2, 1865, and the days following, that forever afterward Richmonders would refer to this one portion of their city simply as the "burnt district." (USAMHI)

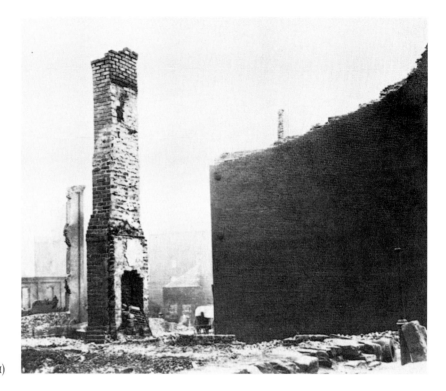

To the camera's eye, it was a dead city. (USAMHI)

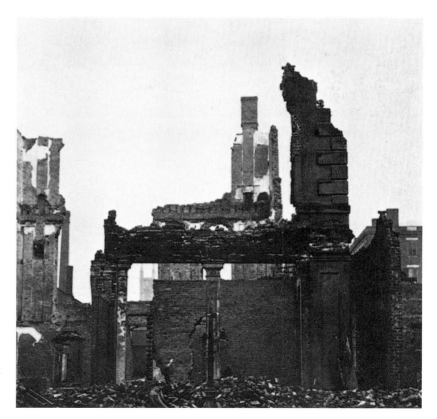

Its inhabitants were the ghosts of places that once teemed with the life of a capital at war. (USAMHI)

Its banks, like the Exchange, had nothing in their vaults now but dust. (USAMHI)

The rails were burned out from under the engines at the Richmond & Petersburg depot. (USAMHI)

Tredegar Iron Works, like its city and its
cause, was dead. (USAMHI)

Richmond, like the South itself, looked as if
it might never again rise from its ruins.
Such was the havoc of war. (USAMHI)

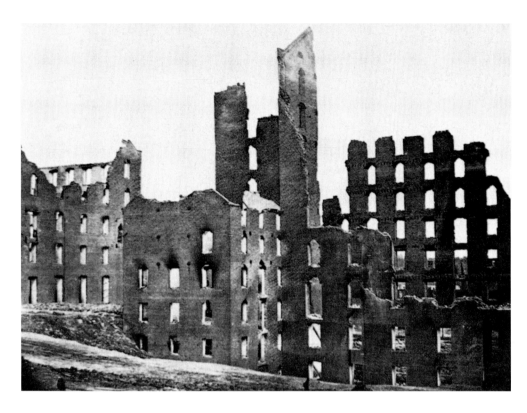

These Gallego Flour Mills, photographed by Gardner that April, once produced twenty-four hundred barrels of flour a day. (USAMHI)

Now they would produce only brick to be salvaged for the rebuilding of the city. (USAMHI)

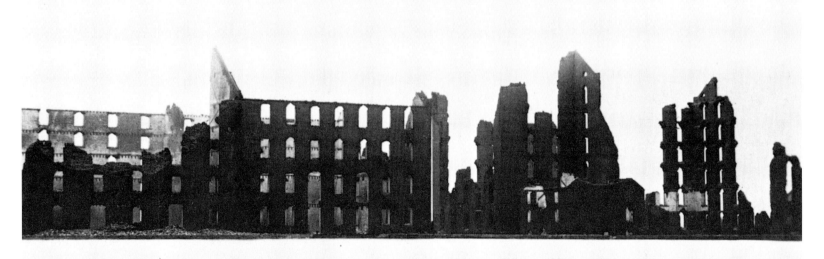

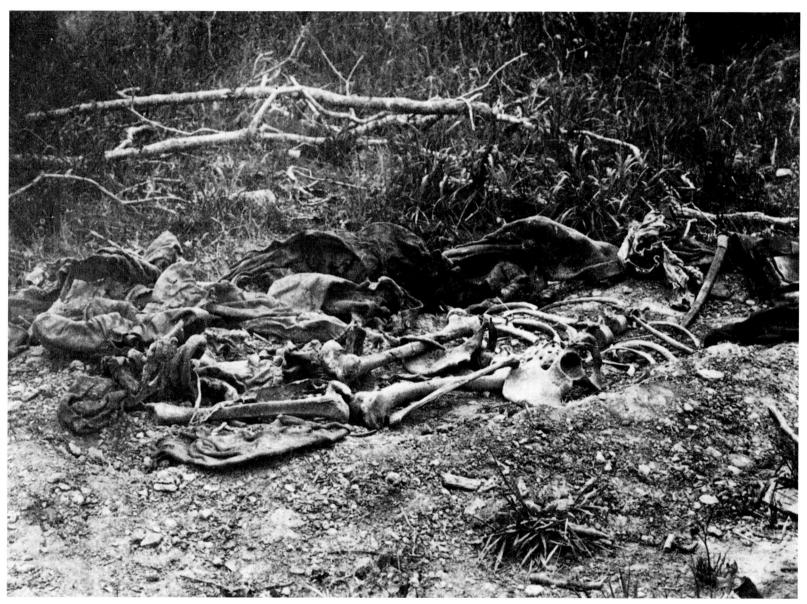

Hardest of all were the human costs, North and South. For years afterward, the soil
of Virginia and Tennessee and a dozen other states would sprout this bitter crop
after the spring rains. (USAMHI)

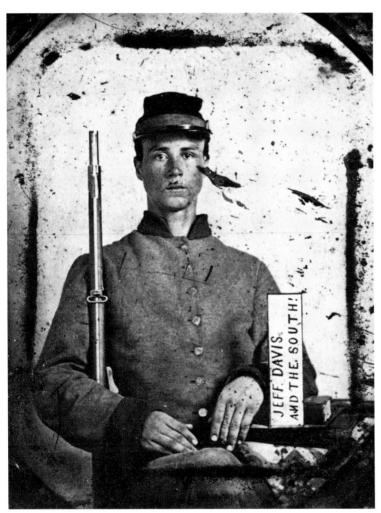

Enriching that soil was the lifeblood of the
nations' youth. Bright-eyed boys had gone off
to war. (FS)

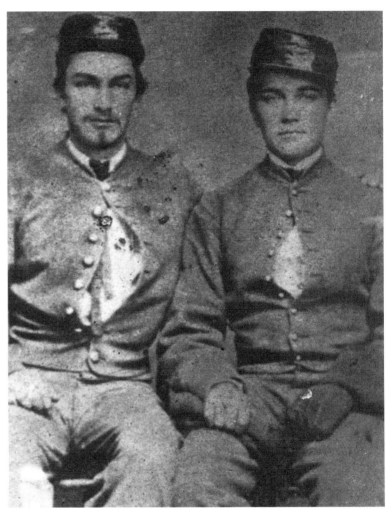

Some, like these cadets of the Virginia
Military Institute, actually prayed that the
war would last long enough for them to be
of age to fight. (VM)

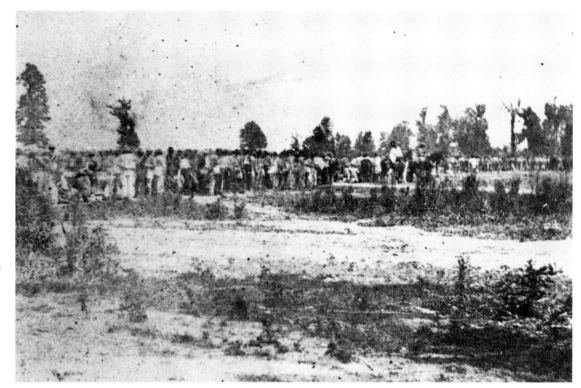

For those not killed or wounded, there were still other perils to face, still more ravages awaiting. These Confederates are the surrendered garrison of Port Hudson. Ahead of them lay prison camps, and hardship and disease such as Americans at war had never before experienced. (ISHL)

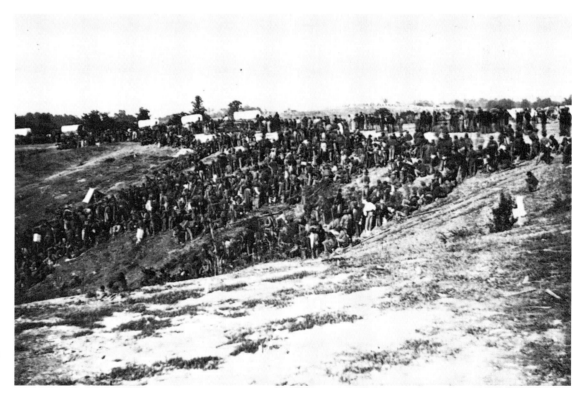

Over 400,000 men in blue and gray went to prison camps. Better than 56,000 of them died there. Some 12 percent of these Rebels awaiting shipment north at Belle Plain, Virginia, in May 1864, would die in captivity. (USAMHI)

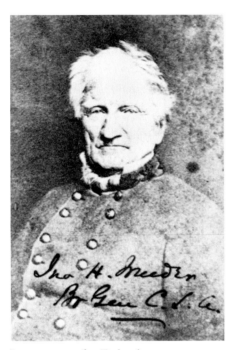

It was worse for Federals sent to Southern prison camps, thanks in part to the scarcity that plagued the Confederates and in part to the failures of Brig. Gen. John Winder, commissary general of prisoners. Unjustly accused of starving Yankee prisoners to death, he would likely have been tried and executed for war crimes had he not died shortly before the surrender. (SHC)

The infamous prisons appeared all over the country. Some, like the Texas State Penitentiary at Huntsville, were already standing. (USAMHI)

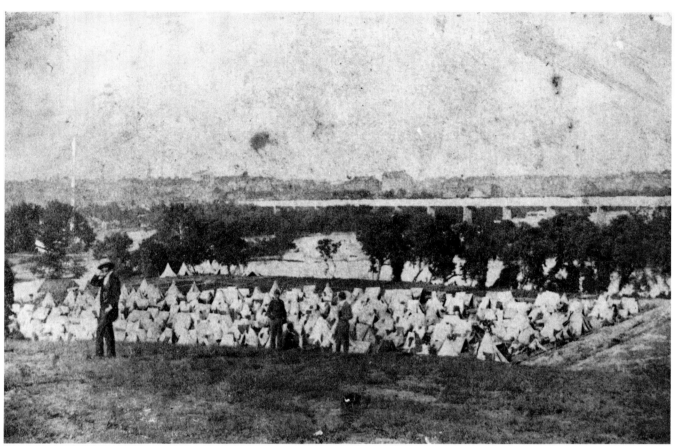

Others, like Belle Isle, in the middle of the
James opposite Richmond, were hastily
appropriated to house captured Federals.
This image by the Confederate photographer
David R. Rees shows the tents that gave
Yankee prisoners rude shelter in 1863. (VM)

Rees also photographed a far more infamous
Richmond bastille, Libby Prison. Once a ship
chandlery, it became home for thousands of
Union officers. (USAMHI)

The interior of Libby was stark, plain, and fatally overcrowded. (CHS)

In this room Union colonel Abel D. Streight was kept along with several hundred others. (CHS)

Top right: Most notorious of all, of course, was Camp Sumter in Georgia, known forever as Andersonville. Confederate cameraman A. J. Riddle photographed it on August 17, 1864, already crammed with some of the 33,000 men who packed its twenty-six acres that summer. (USAMHI)

Bottom left: They seemed literally to be living in standing room only. (USAMHI)

Bottom right: The few officers incarcerated at Camp Sumter had their own private pen — nothing more than a small stockade — photographed here just after the war by Engle & Furlong of Fernandina, Florida. (NA)

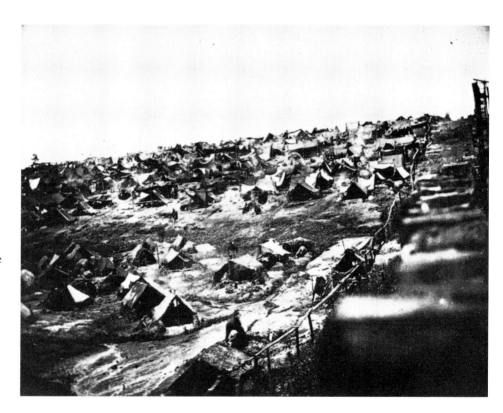

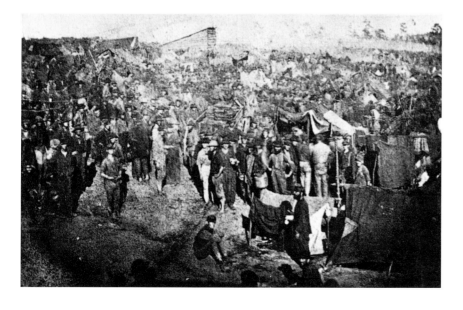

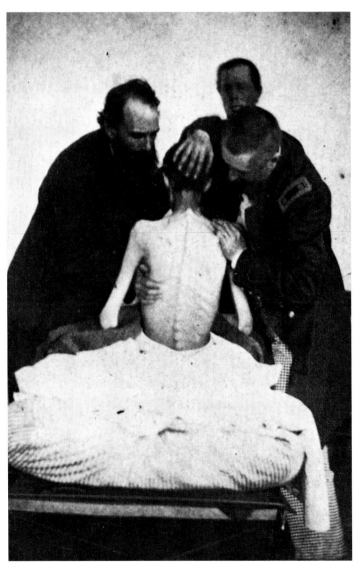

Thousands died. Of those who survived, many looked like the living dead. Pvt. Isaiah Bowker was released from Belle Isle in March 1864 and lived but two months. (USAMHI)

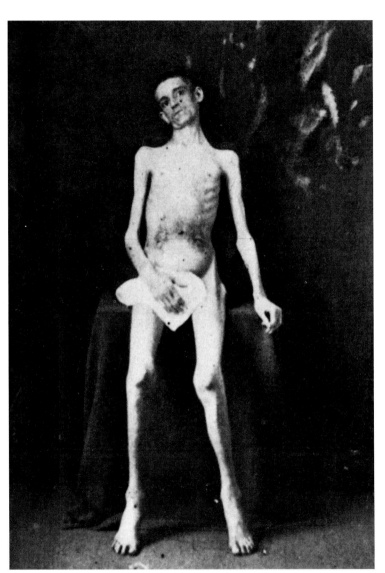

Pvt. William M. Smith was released two months after Bowker, little more than a skeleton. He would live. (USAMHI)

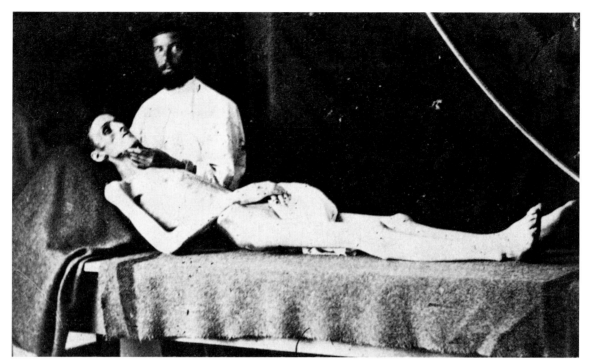

Pvt. John Rose of Kentucky was literally skin
and bones upon his release. (USAMHI)

While released Confederate prisoners seem
not to have been photographed like their
Yankee counterparts, many of them would
have looked no better than this freed Union
soldier. Overcrowding, disease, poor sani-
tation, and inadequate food made prison life
hell without regard for a soldier's politics.
(USAMHI)

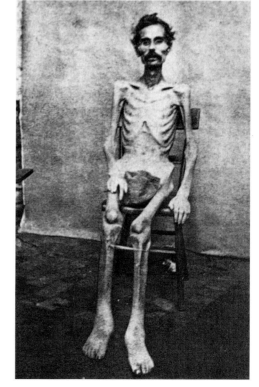

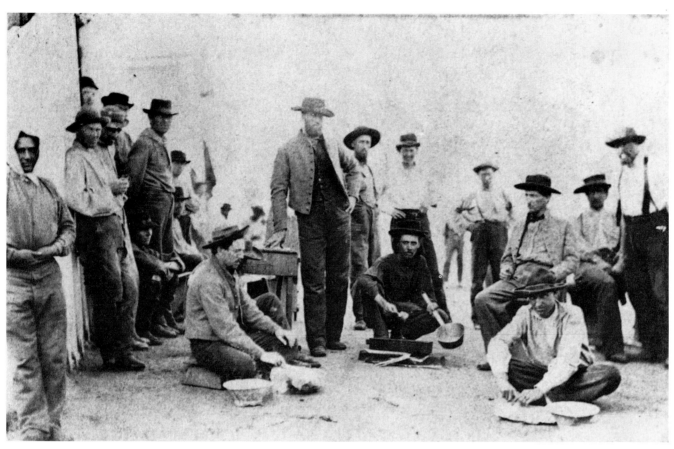

Food, when it came, was inevitably welcome. Josh Smith, "post artist" at Rock Island Barracks in Illinois, caught this picture of Rebel prisoners fixing their rations in the Rock Island Prison Camp. (KHS)

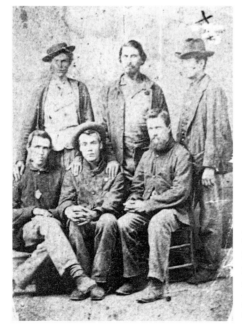

Hungry, lonely, far from home and perhaps even afraid, men of both sides would still sit for the camera—like these Johnny Rebs in Camp Chase Prison, in Ohio, sitting for M. M. Griswold. If they could pose, at least they were still alive. (RP)

The war had left so many others unable to pose ever again. The cemeteries North and South burgeoned with the dead. They were in vaults in the French cemetery in New Orleans. (USAMHI)

They were laid in a grassy plot called Hollywood Cemetery overlooking the James in Richmond. (USAMHI)

Many remained on the battlefields where they fell, their names scrawled on rude headboards like these near Bull Run. (USAMHI)

Some were remembered more permanently. These Billy Yanks died in the struggle for the Mississippi, and lie buried near Baton Rouge. (USAMHI)

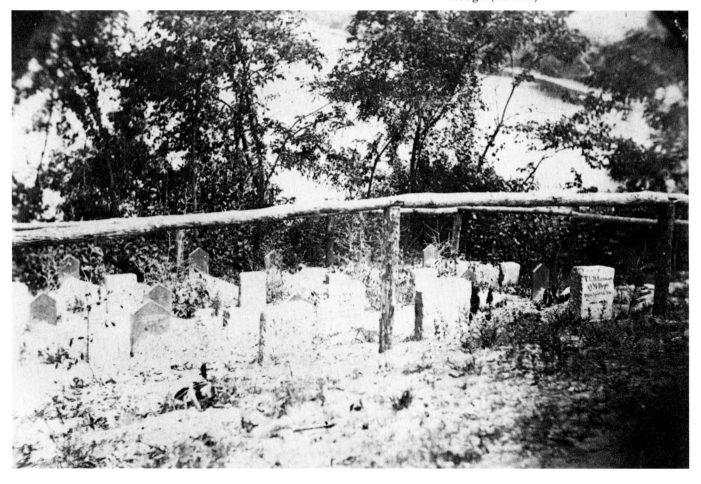

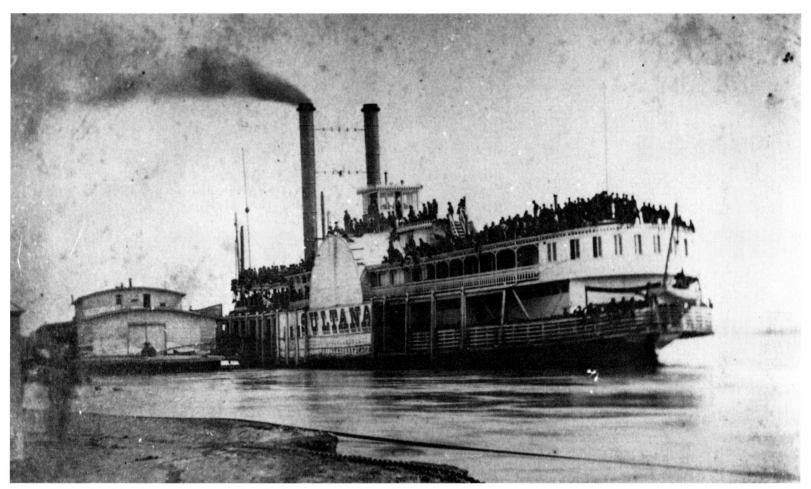

Alas, the tragedy of death did not even end with the cessation of hostilities. On
April 26, 1865, with all but one of the Confederate armies surrendered and the war
virtually done, photographer T. W. Bankes of Helena, Arkansas, took his camera to
the wharf on the Mississippi and took this image of the steamer *Sultana*, crowded
with 2,021 men, most of them released prisoners from Rebel camps farther south.
They were on the way home. The next morning, before dawn, the ship exploded,
burned, and sank. Estimates of the dead range from 1,238 to over 1,900 — one of the
worst ship losses in history. (SBS)

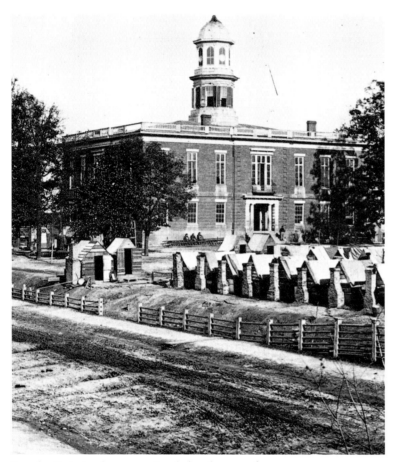

For the Rebels, there remained ahead years of living in humiliation as an occupied land. To maintain the peace and ensure that the South accepted the verdict of the war, Federal soldiers would be stationed in the former Confederacy for twelve years after the surrender. Their barracks, like these on the grounds of Atlanta's city hall, were a constant reminder of defeat. (LC)

And all across America there were other reminders of the ravages of war — among them buildings like this simple house in Gettysburg, where once the armies fought the greatest battle of the war. Now it served the ends of peace, as a school to educate the orphaned children of the men who went off to war, never to return. (USAMHI)

The War to Posterity

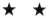

A portfolio of images capturing the
continuing impact and dwindling vestiges
of the greatest epic in American history

In May 1865, Maj. Gen. John Gibbon was ordered to take the captured and surrendered battle flags of Lee's army to Washington after the capitulation at Appomattox. Gibbon took with him some of the brave men who had performed special feats in capturing those flags, and here he posed with them and their flags for Alexander Gardner's camera. Gibbon himself stands, thumb in belt, directly in front of the tree at left. (AIG)

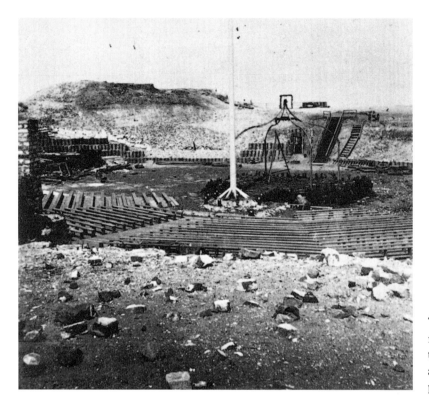

The vicious contest done, the commemo-
ration, more an expression of relief
than of exultation, began. First, and most
appropriate, it came here in the savaged
parade ground of Fort Sumter. (USAMHI)

Amid the rubble, the shot, and dismounted
cannons, the conquering Federals erected
seats. (USAMHI)

Top right: A makeshift pavilion went up in the center. (USAMHI)

Bottom left: Flags and bunting draped the frame. (USAMHI)

Bottom right: And on April 14, 1865, the fourth anniversary of Sumter's fall, Major — now General — Robert Anderson and a host of dignitaries gathered to raise once more the flag of the Union over the pile of rubble. (USAMHI)

Already the monuments began to sprout from the ground. Out in Mississippi, where Gen. John C. Pemberton met with Grant to surrender the Vicksburg garrison in 1863, a simple marker appeared to memorialize the surrender site. Cannons that once spat fire and shell at men now pointed skyward in peace. (USAMHI)

On the fields near Manassas, Virginia, veterans erected this simple monument "In Memory of the Patriots Who Fell at Bull Run, July 21st, 1861." (USAMHI)

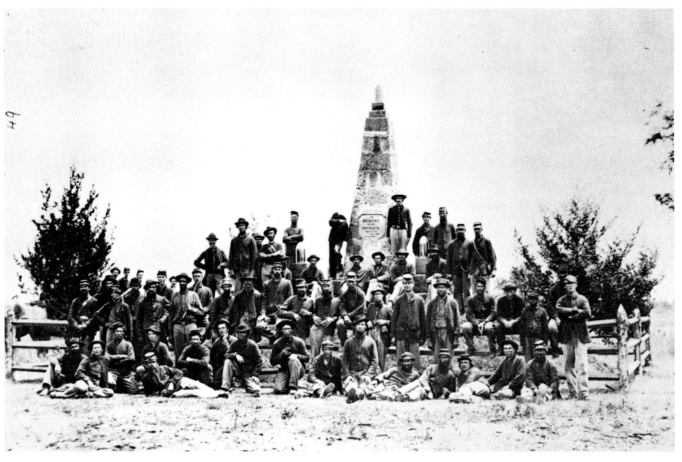

Soldiers erected it in June 1865 — one of the most unassuming monuments the war would inspire. Within a few weeks, some local birds found it so unassuming that they built a nest atop the pyramid. (USAMHI)

Soldiers returned to some of the battlefields while the smoke of war seemed still to linger. Hospitals and cemeteries were established on some. Here at Gettysburg in July 1865, some Federals have come back already to work on the Soldiers' National Monument. (USAMHI)

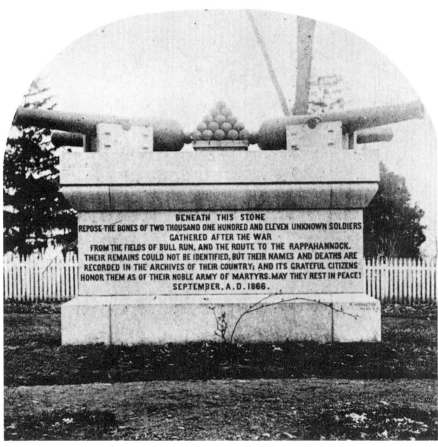

First among the monuments were those built to honor the dead. In the new Arlington National Cemetery, 2,111 of the unknown dead from Virginia's battlefields were put to rest in 1866 beneath this memorial. (USAMHI)

All across the country, in family plots and churchyards, the granite and marble markers remembered the dead. Lt. Charles H. Swasey, killed aboard his ship in 1862, lies here now at rest in Taunton, Massachusetts. (USAMHI)

And the monuments went up for those who did not die in the conflict, but who helped guide it and yet did not long survive. Lt. Gen. Winfield Scott survived the war by only a year. They laid him to rest at West Point. (USAMHI)

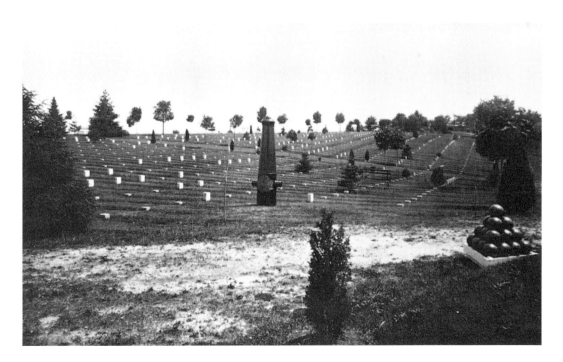

Fields of granite sprouted all over the reunited states. Some twelve thousand of these fifteen thousand graves at Arlington mark the unknown. (USAMHI)

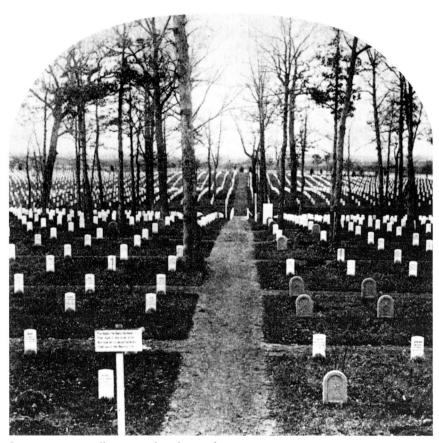

In row upon endless row they lie, in forma-tions more straight than any the simple farmers and clerks maintained in life. "The hopes, the tears, the blood, that marked the bitter strife," reads the sign, "are now all crowned by Victory, that saved the Nation's life." (USAMHI)

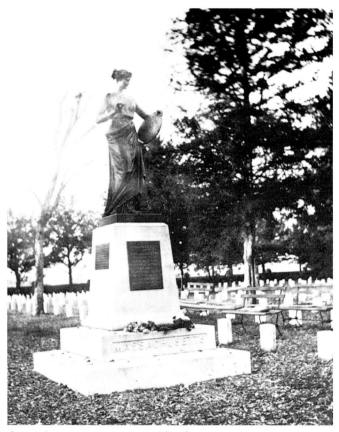

Soon the more prosperous Northern veterans, backed by their state legislatures, began to put up monuments in the South where their sons had fallen. Massachusetts usually led the way, as with this soldiers and sailors' monument for those who fell in North Carolina. (USAMHI)

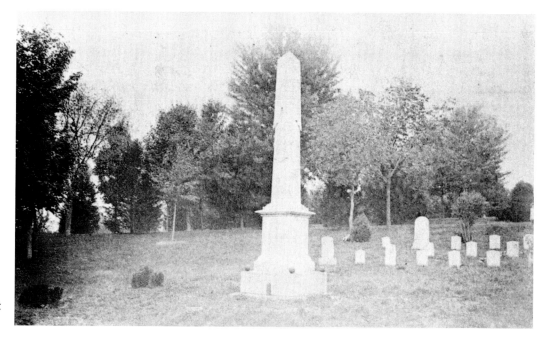

Confederate survivors, often struggling just to live, could ill afford much in the early years after the war. This simple marker at Shepherdstown, West Virginia, was the first such erected in the South. (USAMHI)

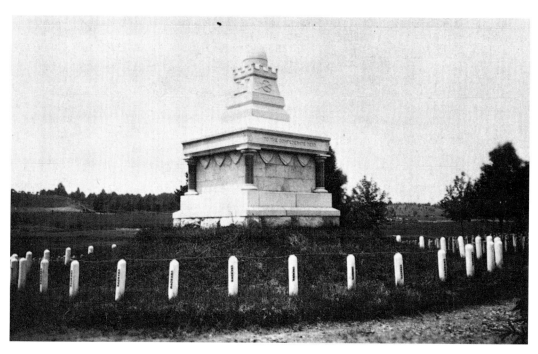

In time the South, too, would afford more imposing monuments—and it, too, had its share of unknowns to honor. (USAMHI)

Some of the known Confederate dead would always receive special remembrance, and few more so than the fallen general J. E. B. Stuart, whose grave in Richmond's Hollywood Cemetery was almost a shrine to one who was dead "yet immortal." (KHS)

The leaders who survived went on into the peacetime world, covered with their honors, able now to devote some of their energies to the pursuits of peace. Gen. U. S. Grant, standing with hand in pocket at center, and Adm. David G. Farragut, standing at far left, could turn philanthropist as trustees of the Peabody Fund, which was sponsored by George Peabody, seated at left, to promote education in the South. (USAMHI)

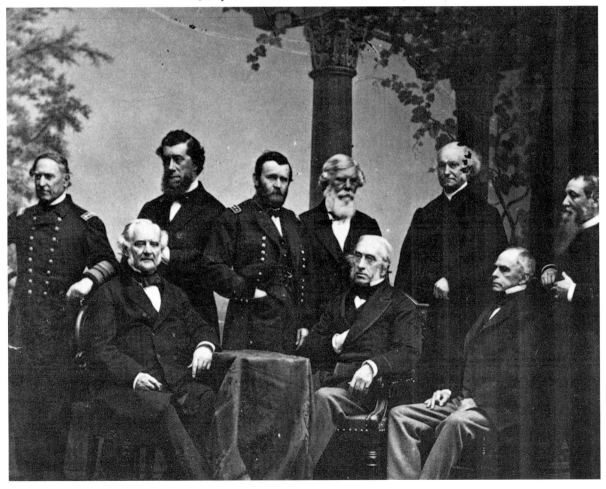

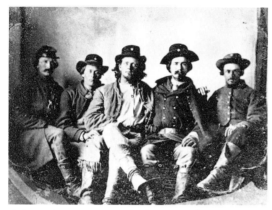

Others, however, saw little ahead for them in the years after the war. The so-called Wild West was a direct offspring of the Civil War. Thousands of deserters, refugees, guerrillas, and others too used to lawlessness to reform crossed the Mississippi to the frontier. Men like these rugged westerners of Terry's Texas Rangers furnished the raw materials of both outlaws and peacekeepers. (PPHM)

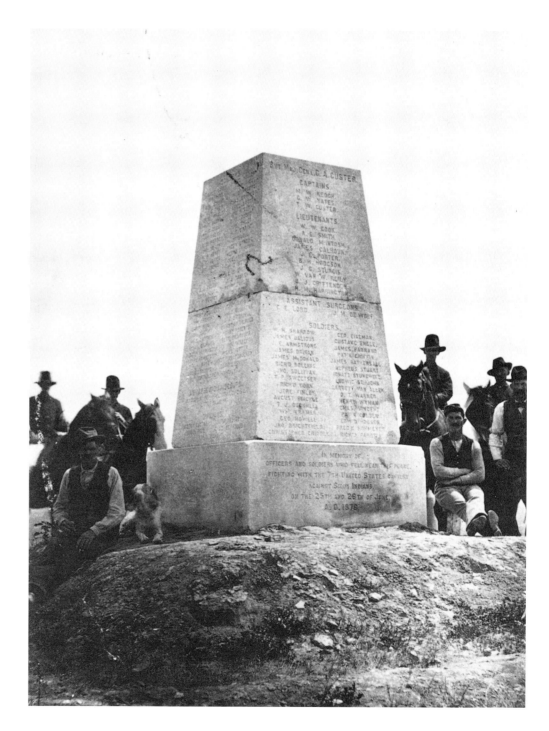

There were wild years ahead for many. The war of expansion that had been waged against the American Indian for two centuries before secession continued toward its inevitable conclusion, with only occasional setbacks. None so shocked the nation as the defeat at the Little Bighorn in Montana in 1876. Heading the list of names of the dead on the Seventh Cavalry monument was its commander, George A. Custer. (USAMHI)

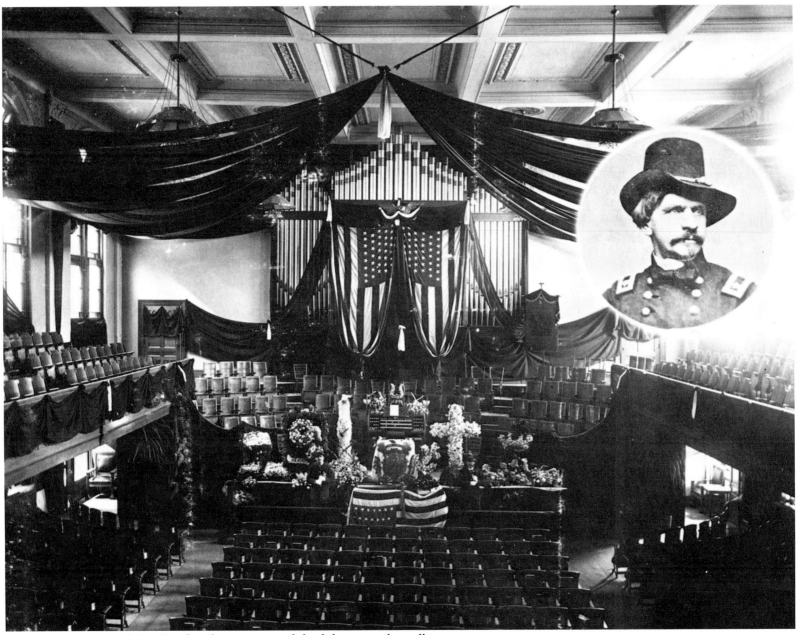

And within a couple of decades after the war, age and death began to claim all its surviving leaders. Nathaniel Banks had been a failure as a general, but Waltham, Massachusetts, gave his mortal remains a hero's farewell. (USAMHI)

Gen. James Longstreet, Lee's old war-horse, lost the respect of many former Confederates when he spoke critically of Lee after the war and became a Republican. But when he died in 1904, much was forgiven, and throngs of Southerners joined in his funeral procession. (USAMHI)

He was the last of the high-ranking Rebel generals, and they buried him in Gainesville, Georgia, as if he had been a Viking chieftain of old. (USAMHI)

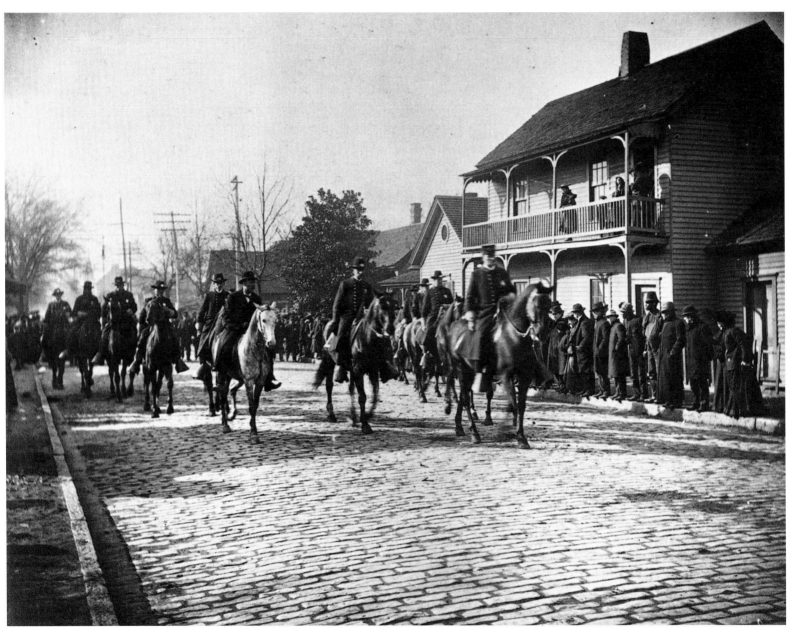

One week after Longstreet's death, another Confederate giant passed away.
Maj. Gen. John B. Gordon of Georgia was one of the premier organizers of the
Confederate veterans after the war, and served as the first commander of their
national veterans' organization. His funeral in Atlanta was a solemn occasion. (USAMHI)

Old veterans clad in gray bore his flag-draped coffin. (USAMHI)

The old and young alike stood reverently over his flower-strewn graveside. As the old soldiers were dying, only the memory of what they had done lived on. (USAMHI)

The Union, too, lost her heroes — none greater than Grant. Dying of throat cancer, he finished his memoirs in 1885, just days before his death. (USAMHI)

Bottom left: A far cry from the hardscrabble surroundings of his youth, this parlor in his summer home in Mount McGregor, New York, is where Grant spent his last days. (USAMHI)

Bottom right: And this is the sickroom in which he fought his battle with cancer and time. (USAMHI)

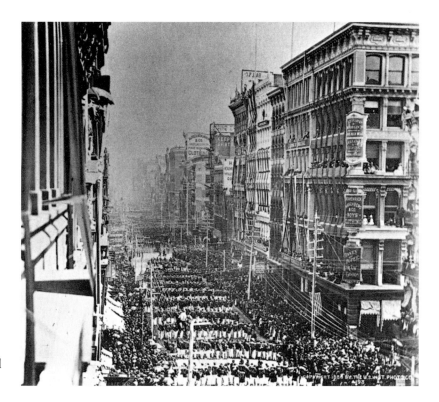

When Grant died, the whole nation mourned. For miles along its length, New York's Broadway stood packed for his funeral procession. (USAMHI)

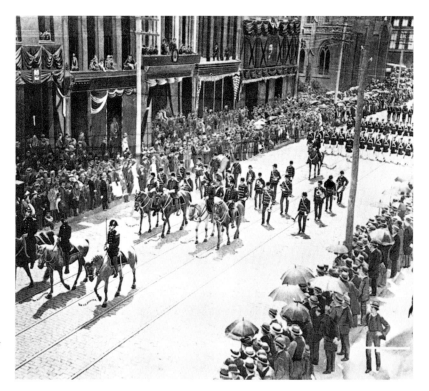

Even old enemies like the Virginians in this heavily retouched photograph, men of the old Stonewall Brigade, came to march and pay respect to one who had been magnanimous in victory. (USAMHI)

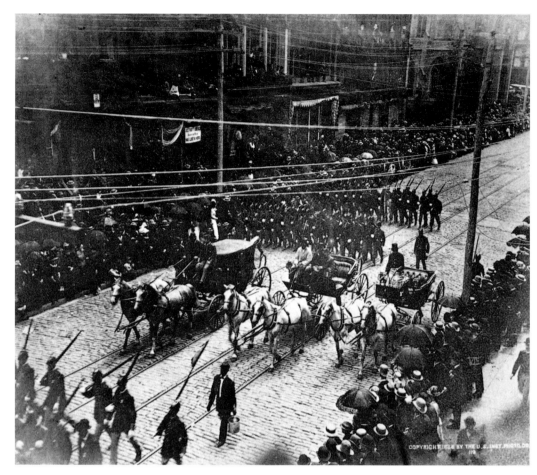

"The World Has Lost a Hero," proclaims a banner raised by Austrians watching the funeral. Grant's portraits lined the streets as the extravagance of his funeral marked a stark contrast with the humble beginnings of the Union's first soldier. (USAMHI)

Upon his tomb the honors were laid as the nation bade him farewell, his postwar failures forgotten in the surge of nostalgic reverie over his wartime achievements. (USAMHI)

With the soldiers dying rapidly as the years
wore on, Americans treasured the more
lasting relics of the great war. As early as
1866, Clara Barton displayed and sold
souvenirs of the hellhole at Andersonville to
raise money for veteran relief. (USAMHI)

Other relics were preserved with more
honored recollections, reminders of heroism
and sacrifice. The Western & Atlantic
Railroad engine *General* was kept in the
Chattanooga station to recall the epic story
of its theft and recovery in the daring 1862
"Great Locomotive Chase." (USAMHI)

Most lasting of all, of course, were the battlefields themselves. From the day the war ended, work began to preserve and mark them for posterity. By the turn of the century, Gettysburg was already the best-memorialized battlefield in the world. (USAMHI)

Distinguished visitors came to see where the victories and defeats of old had happened. President William H. Taft had been a mere child when the war began. In May 1909, within months after his inauguration, he came to Gettysburg to survey the field. Here, he sits at far left in the back of the automobile as it passes before the equestrian statue of Gen. John F. Reynolds. (USAMHI)

As the years went on, so did the work of
erecting more and more monuments to
commemorate the past. The huge chunks of
granite were common sights on the roads of
America. (USAMHI)

And so were the ceremonies after the stone
and bronze had been joined. (USAMHI)

The great cities dedicated squares and parks to their heroes. In Boston, men remove their hats as a crowd assembled at the State House eagerly waits for the flag and fabric veiling a statue to come down, . . . (USAMHI)

. . . revealing an equestrian of Maj. Gen. Joseph Hooker. Cameramen record the scene as musicians and dignitaries crane their necks and the audience applauds. The North would be in its glory for decades after the victory. (USAMHI)

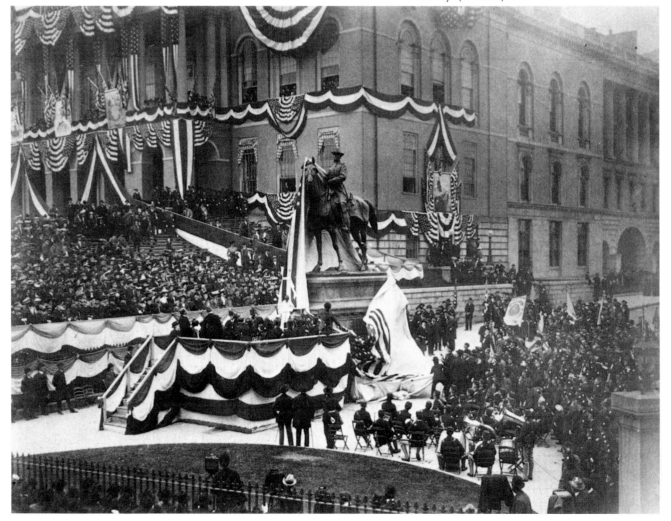

Top left: They had all, North and South, come a long way from those old war days when men like Joslyn & Smith of the Washington Photograph Gallery in Vicksburg captured the image of the war that so changed them all. (JAH)

Top right: Like Royan Linn, who kept his camera in a shed atop Lookout Mountain in Tennessee, they had a sense of history, of the meaning of what they had endured. (JAH)

Like the scores of photographers whose vans and wagons had followed the armies in the days of 1861–1865, they knew they had been a part of something special, for all its horrors. (USAMHI)

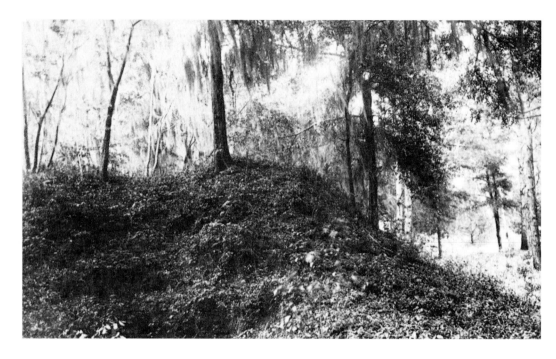

Many of the scenes of former glory were overgrown and lost, like Fort Bartow near Savannah. (USAMHI)

Nature reclaimed much that had been her own in days before the war — such as this powder magazine on Green Island, Georgia. (USAMHI)

But the memories of the men would last forever. They began to gather soon after the war itself was done. Men of John Hunt Morgan's Kentucky Confederate Cavalry met in reunion in the Ashland woods in Lexington in 1867, and would do so again and again. (KHS)

Old veterans of the Forty-first Georgia gathered in 1880 to talk of their old times. (WA)

At Gettysburg in 1913, thousands of veterans of both sides met for a fiftieth reunion — Johnny Reb and Billy Yank sitting side by side in comradeship. (LC)

The years took their toll. As time went on, there were fewer and fewer. At the annual Confederate Veterans reunion in Richmond in 1922, the numbers of Johnny Rebs had dwindled drastically. (WA)

Many of their comrades were so invalided as to be confined to the soldiers' homes like this one in Richmond, there to so end their last days with fellow soldiers, reliving in memory the days of old. (USAMHI)

They brought out proudly their holy relics. Col. D. H. Lee Martz, at left, displays the battle flag of his old regiment, the Tenth Virginia. (USAMHI)

At last, North and South, there came a time
when the veterans were no more. The last
Confederate reunion took place in Richmond
in June 1951. These three fading soldiers,
each well over one hundred, were all that was
left. Before the decade was out, they would
all be gone. (WA)

The battle flag of the Sixteenth Confederate
Cavalry flew over one of the last Rebel battle
lines, at Whistler, Alabama, in April 1865.
Silas Buck carried it then, and fifty years
later he still stood proudly with the old
banner. (KHS)

Behind them they left an indelible record of bravery and sacrifice. Behind them were the three million Rebs and Yanks who had fought and gone before them. Behind them they, like the nation of which they were all a part, left their innocence . . . and their youth. (WA)

Contributors to Volume Two

HAROLD M. HYMAN is one of the most distinguished historians of the Civil War, noted especially for his work on the legal and constitutional aspects of the conflict. For many years a professor of history at Houston's Rice University, he has authored highly acclaimed works on Union oaths and loyalty tests, and the definitive biography of Edwin M. Stanton.

MAURY KLEIN, Professor of History at the University of Rhode Island, is the author of a number of outstanding books, including a biography of Gen. E. Porter Alexander, a history of the Louisville & Nashville Railroad, and a forthcoming biography of financier Jay Gould.

ROBERT K. KRICK is Historian at the Fredericksburg-Spotsylvania National Military Park, and one of the leading students of the Army of Northern Virginia. In addition, he has compiled noted bibliographies of Civil War literature, and has authored several books, including regimental histories of Virginia units, and *Lee's Colonels*, a biographical directory of field officers who served in the Army of Northern Virginia.

STEPHEN B. OATES is one of America's most noted and popular biographers, the author of acclaimed biographies of Abraham Lincoln, John Brown, Nat Turner, Martin Luther King, Jr., and a forthcoming work on William Faulkner. Professor of History at the University of Massachusetts at Amherst, he conducts special courses and symposia on the art of biography.

EMORY M. THOMAS of the University of Georgia has achieved an enviable reputation as a Civil War historian. His most recent work, a biography of the Confederate general J. E. B. Stuart, follows a series of distinguished works on Richmond during the war, the Confederacy as a revolutionary experience, and a one-volume history of the Confederate nation.

WILLIAM C. DAVIS, Editor of this work, is the author or editor of twenty books dealing with the Civil War and Southern history, including the six-volume *Image of War* photographic series. In recognition for this last work, he was in 1985 elected a Fellow of the Royal Photographic Society of Bath, England. For many years editor of the magazine *Civil War Times Illustrated*, he now divides his time between writing and publishing.

WILLIAM A. FRASSANITO, Photographic Consultant for *Touched by Fire*, is the country's foremost Civil War photographic historian, having elevated the study of the old images from an antiquarian interest to a serious historical discipline. The author of a brilliant trilogy dealing with the images of Antietam, Gettysburg, and the 1864–65 campaign in Virginia, he resides in Gettysburg, where he continues his studies into the Civil War and its images.

Photograph Credits for Volume Two

Abbreviations accompanying each image indicate the contributor. Full citations appear below. Very grateful acknowledgment is extended to the individuals and institutions, both public and private, who have so generously allowed the use of their priceless photographs.

ADAH	Alabama Department of Archives and History, Montgomery
AFIP	Armed Forces Institute of Pathology, Washington, D.C.
AIG	Americana Image Gallery, Gettysburg, Pa.
ARCM	Augusta-Richmond County Museum, Augusta, Ga.
BA	Burns Archive Historic Medical Photographs
BHC	Burton Historical Collection, Detroit Public Library
BPL	Bridgeport Public Library, Bridgeport, Conn.
CHB	Charles H. Bournstine
CHS	Chicago Historical Society
CWTIC	*Civil War Times Illustrated* Collection, Harrisburg, Pa.
DWM	Drake Well Museum, Titusville, Pa.
FL	Frederick Lightfoot
FS	Fred Slaton
GDAH	Georgia Department of Archives and History, Atlanta
HEHL	Henry E. Huntington Library, San Marino, Calif.
HLY	Harold L. Yazel
HP	Herb Peck, Jr.
ISHL	Illinois State Historical Library, Springfield
JAH	John A. Hess
JCF	James C. Frasca
KA	Kean Archives, Philadelphia
KHS	Kentucky Historical Society, Frankfort
KKCPL	Knoxville–Knox County Public Library, Knoxville, Tenn.
LAW	Lee A. Wallace, Jr.
LAWLM	Louis A. Warren Library and Museum, Fort Wayne, Ind.
LC	Library of Congress, Washington, D.C.
LCP	Library Company of Philadelphia
LH	Louisa Hill
LO	Lloyd Ostendorf
MC	Museum of the Confederacy, Richmond, Va.
MDSSA	Michigan Department of State, State Archives, Lansing
MHC	Michigan Historical Collection, Bentley Historical Library, University of Michigan, Ann Arbor
NA	National Archives, Washington, D.C.
NCDAH	North Carolina Department of Archives and History, Raleigh
NHC	Naval Historical Center, Washington, D.C.
NLM	National Library of Medicine, Bethesda, Md.
NSHS	Nebraska State Historical Society, Lincoln
NYHS	New-York Historical Society, New York City
PPHM	Panhandle-Plains Historical Museum, Canyon, Tex.
RFC	Richard F. Carlile
RP	Ronn Palm
SBS	Stephen B. Smith
SHC	Southern Historical Collection, University of North Carolina, Chapel Hill
SHW	Spencer H. Watterson
SI	Smithsonian Institution, Washington, D.C.
SRF	Seventh Regiment Fund, Inc., New York City (copied by Al Freni)
TF	Thomas Ferguson, Springfield, Mo.
TO	Terence O'Leary
TPS	Thomas P. Sweeney, M.D., Springfield, Mo.
TU	Tulane University, New Orleans
UAL	Ursuline Academy Library, San Antonio, Tex.
UR	University of Rochester, Rochester, N.Y.
USAMHI	U.S. Army Military History Institute, Carlisle Barracks, Pa.
VHS	Vermont Historical Society, Montpelier
VM	Valentine Museum, Richmond, Va.
WA	William Albaugh
WAF	William A. Frassanito
WCD	William C. Davis
WCHS	Washington County Historical Society, Fayetteville, Ark.
WMA	William M. Anderson
WRHS	Western Reserve Historical Society, Cleveland
WVU	West Virginia University, Morgantown

Index

Unless otherwise indicated, italicized entries are vessels.